THE

CURSE

OF

BEAUTY

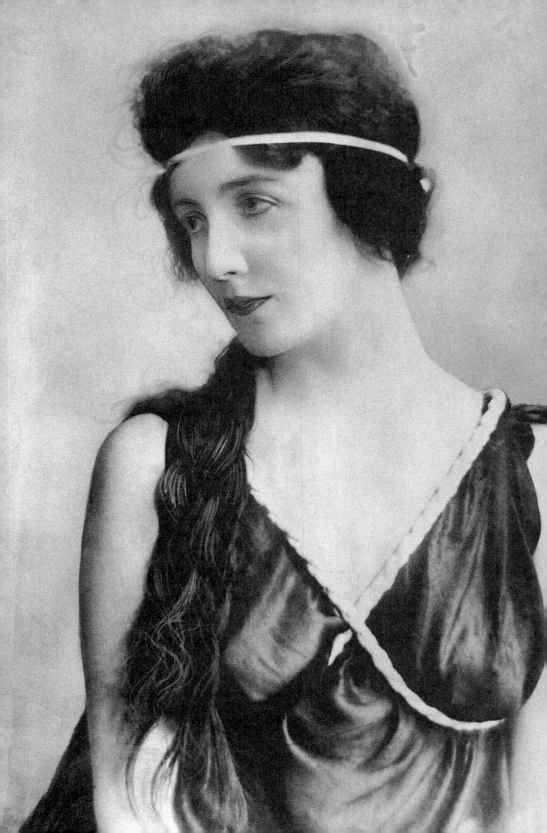

THE

THE SCANDALOUS & TRAGIC LIFE OF AUDREY MUNSON, AMERICA'S FIRST SUPERMODEL

CURSE

JAMES BONE

OF

REGAN ARTS
NEW YORK

BEAUTY

Title page: Audrey, photographed by
Oscar H. Sholin

Regan Arts.

65 Bleecker Street
New York, NY 10012

First Regan Arts hardcover edition, April 2016.

Library of Congress Control Number: 2015946538

ISBN 978-1-942872-03-0

Interior design by Nancy Singer
Cover design by Richard Ljoenes

Image credits, which constitute an extension of this copyright page, appear on page 326.

Printed in the United States of America

10 9 8 7 6 5 4 3 2 1

I am wondering if many of my readers have not stood before a masterpiece of lovely sculpture or a remarkable painting of a young girl, her very abandonment of draperies accentuating rather than diminishing her modesty and purity, and asked themselves the question, "Where is she now, this model who has been so beautiful? What has been her reward? Is she happy and prosperous, or is she sad and forlorn, her beauty gone, leaving only memories in its wake?"

—Audrey Munson, May 1, 1921

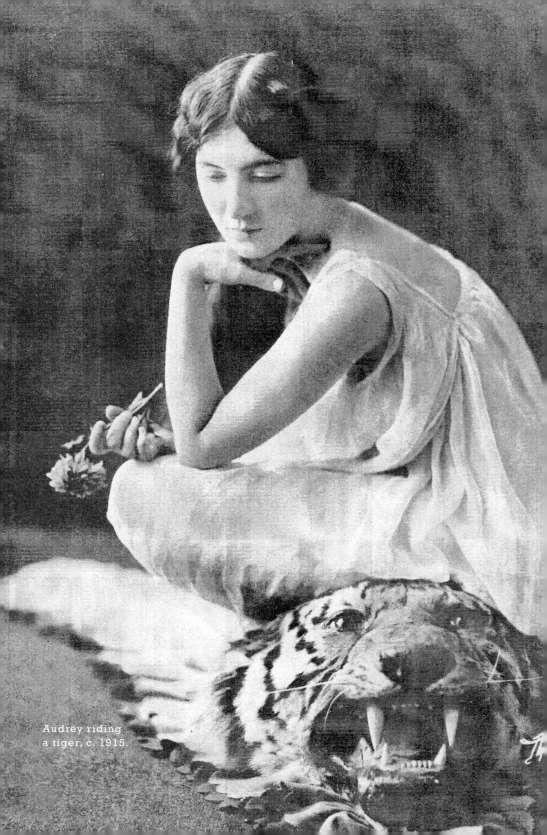

Audrey riding
a tiger, c. 1915.

CONTENTS

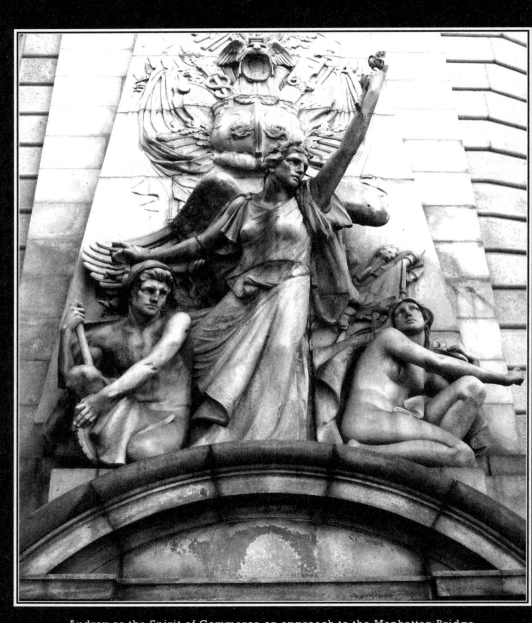

Audrey as the Spirit of Commerce on approach to the Manhattan Bridge.

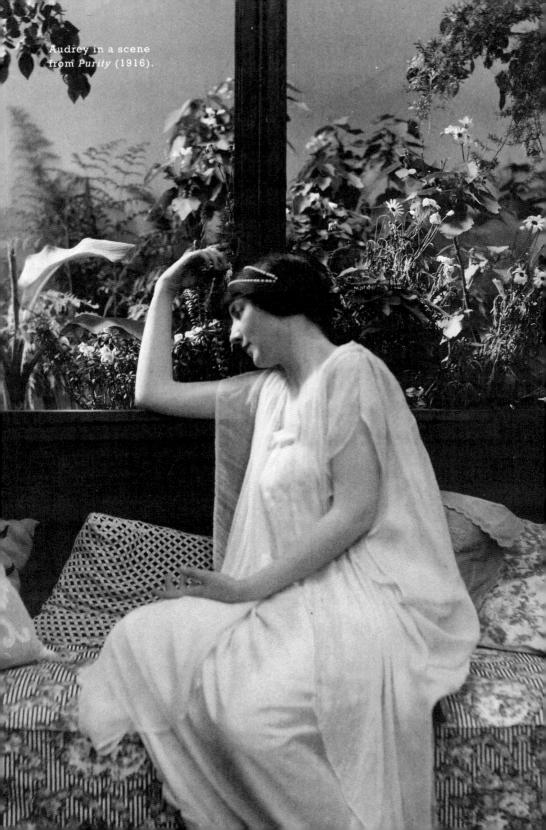

Audrey in a scene from *Purity* (1916).

1

THE CURSE

When Audrey Munson was a girl of five, the Gypsy Queen Eliza came to the United States from England. Eliza Cooper was just eighteen but had reigned over 55,000 Roma since succeeding to the throne at the age of ten. Touring the country by train, Queen Eliza stopped in upstate New York to be hosted by Plato Buckland's thirty-five-strong Gypsy band in East Syracuse. A colorfully painted wagon carried her from the railroad station to the camp on Eastwood Heights, and she was installed with her maidservant in a white tent filled with bright new rugs. In place of a crown, she wore an intricate lace cap on her head.

Bands of gypsies passed through East Syracuse each summer, before their caravans headed south for the winter. They set up their tents on the heights outside the village or near the railroad freight yards. The Gypsy men, though renowned for thieving, earned an honest living from horse-trading and tied up their horses all around. The women sold basketwork and lace and read palms.

Queen Eliza's presence provoked intense curiosity. Thousands of nearby residents turned up to catch a glimpse of Gypsy royalty. Many, believing superstitiously in the prophetic powers of the Romany women, "crossed their palms with silver" to have their fortunes told.

Audrey was taken to the Gypsy camp in East Syracuse by her mother as a child, possibly amid the excitement of the royal visit. She did not see the Gypsy queen. Queen Eliza stayed only thirty-six hours. Audrey was fascinated instead by the games the Gypsy children played amid the covered wagons. The tall, fierce men frightened her. But her mother insisted Audrey have her future read, and led her by the hand into the tent of a "bronze-faced seeress."

Though still just "a slip of a girl," Audrey was already possessed of a limber figure and long bones—she was to grow to 5′8″ tall. Her features were perfectly symmetrical and sleek: a high brow, chiseled cheekbones, an almond jaw, and that perfectly straight neoclassical nose. Set like gemstones in her milky skin, she had questioning, slightly impertinent gray-blue eyes. The question lurking in those eyes was one she would come to wish she had never asked: "What does my future hold?"

The soothsayer looked on Audrey's fresh beauty; then, mindful of her own sorrows and all the sorrows of the world, she spoke:

> You shall be beloved and famous. But when you think that happiness is yours, its Dead Sea fruit shall turn to ashes in your mouth.
>
> You, who shall throw away thousands of dollars as a caprice, shall want for a penny. You, who shall mock at love, shall seek love without finding.
>
> Seven men shall love you. Seven times you shall be led by the man who loves you to the steps of the altar, but never shall you wed.

For the rest of her life, Audrey considered the prophecy a curse.

Audrey did indeed become beloved and famous. Her "most perfect form" still reigns over New York City and across the United States. You probably already know her, without even knowing you know her. You may have passed her on the street many times, unbeknownst. For she was America's first supermodel. She is the second-largest female figure in

New York after the Statue of Liberty. Her gilded form stands twenty-five feet tall, holding a crown aloft as the symbol of the city, atop the vast Municipal Building across the street from City Hall. She frolics in the Pulitzer Fountain outside the Plaza Hotel at the southeast entrance to Central Park, her celebrated dimples on full display to the shoppers at the Apple Store. Every day, office workers tramp past her as the centerpiece of the Maine Monument in Columbus Circle at the opposite corner of Central Park. She stands on the arch at the end of the Manhattan Bridge as the Spirit of Commerce, waving on commuters to their toil. She once also stood sentry at the Brooklyn entrance of the Manhattan Bridge as Miss Manhattan and Miss Brooklyn. But those colossal forms now flank the entrance to the Brooklyn Museum. Audrey is immortalized in stone at the New York Public Library and on the Frick House on Fifth Avenue. She is the reclining bronze figure of Memory on the Straus Memorial on the Upper West Side. She is the two grieving stone figures on the Firemen's Memorial on Riverside Drive. Wherever you go in New York City, Audrey is looking at you.

Across the nation, from Florida to California, Audrey remains in our everyday lives. She stands as Liberty and Sapienta (Wisdom) on the Wisconsin State Capitol. She can be seen as the nymphs on the James McMillan Memorial Fountain by the reservoir in Washington, DC. She was the model for Allen George Newman's Monument to Women of the Confederacy in Jacksonville, Florida, and for his Peace Monument in Piedmont Park, in Atlanta, Georgia. She posed for the figure of Evangeline inscribed on the Henry Wadsworth Longfellow Memorial in the garden of the poet's house by the Charles River in Cambridge, Massachusetts. She inspired three-quarters of the statuary of the Jewel City built in San Francisco for the 1915 World's Fair. A famous bronze of one of those statues, *Descending Night*, was acquired by press baron William Randolph Hearst, and now resides at Hearst Castle in San Simeon, on the California coast. One of her surviving Star Maidens from the fair now stands in the courtyard of the Citigroup Center building in San Francisco.

It is even still possible to see Audrey in motion. She was the first

Audrey posed for Allen George Newman's
Monument to Women of the Confederacy in
Jacksonville, Florida, one of her many statues
still with us today.

movie star to go naked in an American film. *Inspiration* (1915) has been lost, but we can yet marvel at her in *Purity* (1916). Playing the scantily clad allegorical character Virtue, her breasts popping out of her robes at every opportunity, Audrey was quite literally a sex goddess.

This book is a biography of a naked woman, once the most famous nude in America. Of course, every woman is a naked woman, every man a naked man. Audrey herself once said: "If there is immorality in posing in the nude, anybody who takes a bath ought to be arrested." But Audrey was known above all, in art and in movies, for her naked body—and her daring readiness to put it on show. She was advertised as "the world's most perfectly formed woman." Audrey's defense of her public nudity, and some—but certainly not all—of her other views on women, made her an early feminist. Indeed, she once contributed five dollars to the

suffrage movement pushing to get women the right to vote, which was finally achieved in her heyday, with the Nineteenth Amendment in 1920.

Audrey strongly believed that women were naturally beautiful, and should cast aside corsets and high heels, yet she was never able to take full control of her own body. The facts suggest she was exploited at every turn. She was paid just fifty cents an hour to pose nude. Men besieged her. Hundreds of suitors tried to woo her by mail. Some who had seen her nude photos even wrote from faraway Japan. It was men who lavished her with rich rewards for her beauty; and it was men who made her pay the terrible price she did. This, perforce, is the story of those men—besotted, jealous, lustful, greedy men—as well as the biography of Audrey's sometimes glamorous, often scandalous, and ultimately tragic life.

Although Audrey lived a very long time and died in 1996, she was locked away for most of her life, her records sealed, and she was buried in an unmarked grave. A generation of her family even refused to utter her name. Her closest surviving relatives remain reluctant to speak openly about her to this day. The official historian of Oswego County, who got his hands on a treasure chest of Audrey's old possessions, tried unsuccessfully to have your author arrested, claiming he was being "protective" of Audrey. But Audrey left an indelible trace: in letters, court documents, newspaper clippings, in the FBI archive, in photographs, in oil paint, on film, and, above all, in bronze and stone. Once a household name, Audrey was disappeared from history. *The Curse of Beauty* is not just a biography but also an investigation into how and why she was erased. Although she was nameless in her many statues, she will be no more.

Audrey was born on June 8, 1891, into an America that was very different from today, and yet uncannily the same. America's Gilded Age is remembered as a period of robber barons accumulating great fortunes in the rapidly industrializing republic. But it draws its name from Mark Twain and Charles Dudley Warner's satirical novel *The Gilded Age: A Tale of Today* (1873), whose title contains the implicit warning that all that glitters is not gold.

Like today, it was a period of enormous invention, as new industries grew up with the telegraph, the telephone, the phonograph, the automobile, the aeroplane, and the motion picture. Those technological innovations transformed the globalizing world as much as the personal computer, the mobile phone, and the Internet and social media have changed our world. In her remarkable life, Audrey was in at the ground floor of vaudeville theater, the fashion industry, the movie business, and even aviation in the United States. She mixed with the most famous artists, the richest families, and the most swashbuckling entrepreneurs of her day. Plutocrats with newly built mansions on Fifth Avenue and vast "cottages" on the cliffs at Newport stalked the land, their social status measured by their excess. In 1899, when Audrey was eight, the economist Thorstein Veblen, who grew up as one of twelve children on a farm in Minnesota, coined the term "conspicuous consumption" in his book *The Theory of the Leisure Class*. Yet at the same time, the poor and huddled masses of immigrants were flooding into the expanding nation. By 1900, the population of New York City—then 3.4 million—while 98 percent white, was 37 percent foreign-born—roughly the same proportion as it is again today. Like our own, it was an era of great inequality, with the top one percent controlling a fifth of the national income, just as they do once again in our own New Gilded Age.

Audrey certainly was not born into the gilded 1 percent, though she would try to marry into it. Her name is inscribed in the baptism register of St. Patrick's Roman Catholic Cathedral in Rochester as (Audrie) Marie Munson, born to Edgar Munson and Kittie Mahoney. Her birth brought together two very different American family stories. The mismatch of their hopes and expectations scarred her life.

Edgar, born in Prattsville, New York, on January 22, 1857, was descended from Captain Thomas Munson, an English Puritan who was one of the founders of New Haven, Connecticut. This proud family records their lineage to this day in a publication known as the *Munson Record*. Audrey, who became more and more fixated on pedigree the more she mixed in high society, grandly claimed her father was not

only a "colonial American" but also "a descendant of the British peerage, being Baron Munson, 'House of the Seven Baronets,' a hereditary title which even King George can't change." She sometimes spelled it "Monson." There was indeed once a Sir Thomas Monson, first Baronet, who received his hereditary title in 1611 from King James I. He served as a Member of Parliament, the Master of the Armory at the Tower of London, and Master Falconer to the King. But there is no documented link to Edgar's line—and Audrey was certainly not his heir. Edgar's ancestor Thomas Munson came to America in the 1630s as an English soldier "of the lowest rank." Edgar was one of fourteen children. He became a wheeler-dealer real estate agent. In the words of one of his granddaughters, he was considered "a bit of a shyster."

Far from being a "colonial American," Audrey's mother was the daughter of recent Irish immigrants. While the Munsons were Methodist, Kittie's family was Catholic at a time when anti-Catholic feeling was still rife. She was born Catherine Mahoney, according to social security records, but generally spelled her name Katherine Mahaney, preserving the lilt of her parents' original Irish accents. Everyone always knew her as Kittie. She was born in Belleville, New York, on July 30, 1864. She and her family were simple churchgoing folk embarking on an adventure in the New World. Kittie's father died from a cold he contracted while doing decorative plasterwork on the interior of their local church. Kittie had one brother, Robert, and a sister, Alice, who became the beloved village dressmaker. Yet Audrey insisted the Mahaneys came from a line that was as distinguished in its way as the Munsons. Among their forebears, she claimed, was the early Irish nationalist Robert Emmet, who was hanged for treason against the British Crown after leading a failed attempt to establish a provisional government in Dublin in 1803. "This marriage united one of the finest Irish families with the English," Audrey optimistically declared of her parents' union.

Edgar wooed Kittie on the rocks by Sandy Creek, behind her homestead in Belleville. They wed on January 7, 1885, in the nearby village of Mexico, New York, where Edgar's father had a farm. Although Edgar

had worked on a farm out West, and as a teenager Kittie had worked in the woolen mills in Auburn, New York, the couple started out in service. Edgar got a post as a coachman for Harriet Disbrow, the widow of a wealthy tobacco manufacturer, on the same broad boulevard in Rochester where Kodak founder George Eastman lived. The newlyweds lived at 9 Factory Street. By 1891 Edgar was working as a driver at 267 State Street. And that is the street where, by her own account, Audrey was born. Toward the end of her life, Audrey was offered the chance to return to her native city, but she refused. Rochester, she declared, despite not having seen it for many decades, was "the dirtiest little town."

Both Edgar and Kittie harbored grand dreams. Unfortunately, they were not the same grand dreams. Edgar fantasized of hitting it big in real estate. He had already traveled west in his youth. When he was twenty, he had worked as a farm laborer in Coral, Illinois. After getting married to Kittie back home in Mexico, New York, Edgar headed west again. First he settled in Lemars, Iowa, 400 miles due west of Coral, where the new railroad was giving away one-square-mile lots along the line to develop the land. He bought a quarter lot of 162 acres for $562 and, after working on it for three years, sold it for $3,552. Next, he moved about 150 miles to virgin territory in Fairmont, Minnesota, and tried the same trick again. This time, he bought a similarly sized lakeside lot for $860. The farm lay between a banker's land and his water. Desperate for access to the lake, the banker bought Edgar out for $5,800. Edgar's next stop was about another 150 miles farther west in Hudson, South Dakota, where he bought a lot for $960 and flipped it for $3,900. He then followed the hardiest farmers another 150 miles even farther west to buy eighty acres in Tilden, Nebraska, but the land was dry, so he sold it after a year and a half for $1,600. It is not clear for how much of this real estate odyssey Kittie was with him. Though her father was a Methodist, as a child of three or four, Audrey went to the Cathedral School in Rochester, run by the Sisters of St. Joseph, while her father might still have been in the West. His pioneering seems to have been too much for Kittie to bear. The *Syracuse*

Herald, which spoke to Edgar, noted drily: "His wife was dissatisfied with the West because it was too lonesome on the prairie."

Audrey's parents divorced in 1899, when she was eight. The decree, issued in Kittie's new home of Providence, Rhode Island, awarded sole custody of Audrey to her mother. Kittie, though a Catholic, later complained that she had no choice but to divorce because Edgar had been carrying on an open affair with the woman who was to become his second wife, Cora Cook, whom he picked up while working as a trolleybus conductor after returning East. "He got to going with a woman, German, Cora Cook—Oswego County, New York. She has had eight children by him," Kittie later wrote in a letter. "They were not married so I divorced him."

Edgar and Kittie each loved Audrey in their own way—but they most definitely did not still love each other. Edgar struggled with the competing claims of his new family with Cora Cook and their five surviving children: Vivian, born in 1906; Lawrence, born in 1909; Gertrude, born in 1912; Gerald, born in 1914; and Harold, born in 1918. Although Edgar always came to Audrey's aid in a crisis, he disliked her nude posing and blamed her mother for it. "I wouldn't think she'd want to do it. She used to be such a nice quiet-mannered little blue-eyed thing, just the opposite of what you'd expect to see [in] an actress," he complained in 1916. "It was her mother who talked the stage into her head from the time she was a baby. I can remember taking her to the theater and she'd get so excited and so she'd stand through the whole thing. . . . I don't have any interest in what she's doing now. I'd rather she wouldn't but it's her affair and it brings her in lots of money and she spends it too just like water."

Kittie brought up Audrey as a single mother and steered her onto the stage. The two lived and traveled together almost the entire time until Audrey was forty. It was only a deep crisis that eventually tore them apart. When Audrey needed help, Kittie turned to other members of the Munson clan, not Edgar. Even decades after their divorce, Kittie tried to stop his second family from being listed in the *Munson Record,* even

though those children, unlike Audrey, went on to multiply and extend the line down to the present day. "We do not want her father's children's names to go into the history. Put his name with Audrey and myself," Kittie wrote a Munson family genealogist on October 30, 1934. "We do not curse him for what he has done. He is Audrey's father and a Munson from one of the old aristocratic race. If he lived in England he could be baron. Audrey, Lady Audrey, but he hates the idea."

When Edgar and Kittie first separated, Audrey, then six, went to stay on her paternal grandparents' farm in Davenport, New York, where Edgar himself grew up. While playing behind the house, Audrey tumbled into a stream and contracted typhoid from the polluted waters. Kittie rushed to retrieve her ailing daughter and accused the other side of the family of neglect. Audrey recovered but was often a sickly child, attentively nursed by her mother. One of Audrey's half nieces still has her childhood doll with a plaster head, which had to be reassembled after being broken into pieces—a poignant metaphor for what happened to Audrey herself.

Kittie started her new life as a divorced woman with Audrey in Providence, Rhode Island—at the time, the eleventh-largest metropolis in the United States. It was the hub of jewelry manufacture in the country. The city boasted the largest silverware factory, largest mechanical tools factory, largest screw factory, and largest file factory on Earth. Many large textile mills were also based nearby. The town had a burgeoning immigrant population with Irish, Italian, and Polish parishes. It was also home to Brown University, one of the only nine colleges founded before the American Revolution, and the Rhode Island School of Design. Hall & Lyons Co., on the corner of Westminster and Eddy Streets, claimed to be "the largest drugstore in the United States." The city had five theaters, including Keith's Theatre, offering continuous all-day vaudeville acts.

Home for Audrey was a rented boardinghouse that her mother ran at 47 Carpenter Street. It was a household of motley strangers—mostly men. When Audrey was nine, her mother's roomers included seven men—Clive Gill, thirty, a jewelry worker; John McMaugh, twenty-eight, a drugstore clerk; Harry M. Bartrum, twenty-four, a mechanic; Henry N.

Whiteman, sixty-three, a "solar artist"; Frank H. Watson, thirty, a railroad "gateman"; Joseph Crosby, twenty-six, clerk; and Henry G. Place, fifty, a bill collector—as well as two married couples—James Callahan, thirty-five, a waiter, and his wife, Mary, twenty-four; and Daniel A. Jordan, twenty-four, a painter, and his wife, Mary, twenty-two. When Audrey was twelve, Kittie and Audrey moved to 258 Pine Street. When she was fourteen, they moved again, to 107 Broadway in Providence.

Their home at 107 Broadway was yet another boardinghouse. Kittie no longer listed herself as a lodging housekeeper but as an "agent on corsets." The gateman from Carpenter Street had followed her, though now under the slightly different name of Frank H. Wilson—raising the question of whether the two had any romantic involvement.

Audrey went to Catholic school at the St. Francis Xavier Female Academy, run by the Sisters of Mercy. The Sisters of Mercy academies were tuition-based high schools catering to relatively well-off girls and sought to provide a cultured education within the confines placed on women at the time. The Sisters of Mercy offered art lessons in oil painting, watercolor, pastels, and decorating china. More important for Audrey, there were music lessons on the piano, violin, harp, mandolin, and guitar, as well as singing. At a young age, Audrey became an accomplished musician and performer. Thanks to the nuns, she—and her mother—could dream of a future on the stage.

Just twelve miles around the bay from Providence lay a scenic stretch of coastline known as Rocky Point that had been used for picnic parties by boat since it was first acquired by sea captain William Winslow in 1847. By Audrey's time, it was the site of the Rocky Point Amusement Park. Fun-seekers from Providence could reach it by trolleybus in just thirty-five minutes. It was here that Audrey made her first known performance onstage in 1908, as a teenage member of Gerald Hampton's Dancin' Dolls.

So young was Audrey when she had her fortune told that she only dimly understood the soothsayer's words. Kittie, however, remained preoccupied with the fortune-teller's prediction of both triumph and

World-Famous Model Cursed By Her Great Beauty

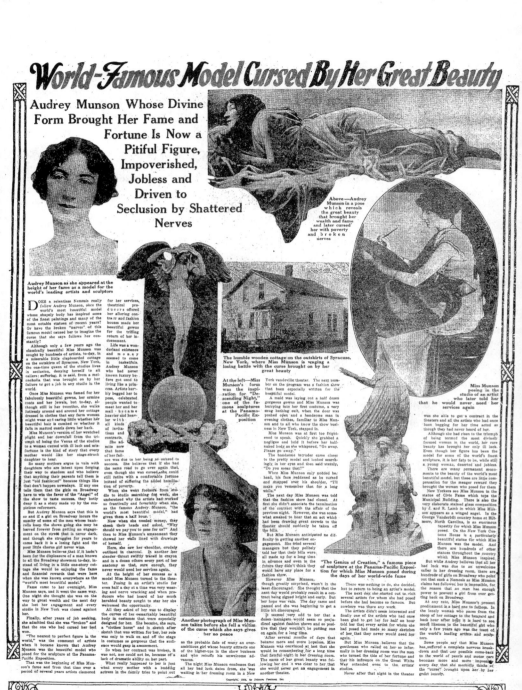

Audrey Munson Whose Divine Form Brought Her Fame and Fortune Is Now a Pitiful Figure, Impoverished, Jobless and Driven to Seclusion by Shattered Nerves

Audrey Munson as she appeared at the height of her fame as a model for the world's leading artists and sculptors

Above—Audrey Munson in a pose which reveals the great beauty that brought her wealth and fame and later cursed her with poverty and broken nerves

The humble wooden cottage on the outskirts of Syracuse, New York, where Miss Munson is waging a losing battle with the curse imposed by her great beauty

At the left—Miss Munson's form was the inspiration for "Descending Night," one of the famous sculptures at the Panama-Pacific Exposition

Miss Munson posing in the studio of an artist who would never need her services again

"The Genius of Creation," a famous piece of sculpture at the Panama-Pacific Exposition for which Miss Munson posed during the days of her world-wide fame

Another photograph of Miss Munson taken before she fell a victim of the curse which she says gives her no peace

DOES a relentless Nemesis really follow Audrey Munson, once the world's most beautiful model whose shapely body has inspired some of the finest paintings and many of the most notable statues of recent years? Or have the broken "nerves" of this famous model caused her to imagine the curse that she says follows her constantly?

Although only a few years ago the classically beautiful Miss Munson was sought by hundreds of artists, to-day, in a miserable little clapboarded cottage on the outskirts of Syracuse, New York, the one-time queen of the studios lives in seclusion, denying herself to all callers; suffering, it is said, from a melancholia that was brought on by her failure to get a job in any studio in the world.

Once Miss Munson was famed for her fabulously beautiful gowns, her ermine coats and her jewels, but to-day, although still in her twenties, she while listlessly around and around her cottage dressed in clothes that any farm woman might wear act of caring little whether her beautiful hair is combed or whether it falls in matted snarls down her back.

Miss Munson's version of her wretched plight and her downfall from the triumph of being the Venus of the studios to a woman cursed with ill luck and misfortune is the kind of story that every mother would like her stage-struck daughter to hear.

So many mothers argue in vain with daughters who are intent upon forging their way to stardom and who believe that anything their parents tell them is just "old fashioned" because things like that don't happen nowadays. If any one tells them that the girls on Broadway have to win the favor of the "Angel" of the show to taste success, they hotly deny it as a story made up by the suspicious reformers.

But Audrey Munson says that this is so and if a girl on Broadway leaves the sanity of scene of the man whose bankrolls keep the shows going she may be barred forever from getting an engagement on the street that is never dark, and though she struggles for years to come back it is a losing fight and the poor little chorus girl never wins.

Miss Munson believes that if it hadn't been for the displeasure of a man known to all the Broadway showmen to-day, instead of living in a little one-story cottage she would be enjoying the fame and financial rewards that were hers when she was known everywhere as the "world's most beautiful model."

Fame came to her overnight, Miss Munson says, and it was the same way. One night she thought she was on the way to great wealth and the next day she lost her engagement and every studio in New York was closed against her.

Finally, after years of job seeking, she admitted that she was "broken" and that the one who had cursed her had won.

"The nearest to perfect figure in the world," was the comment of artists when it became known that Audrey Munson was the beautiful model who posed for the sculpture at the Panama-Pacific Exposition.

That was the beginning of Miss Munson's fame and from that time over a period of several years artists clamored for her services, theatrical producers offered her alluring contracts and fashion houses made her beautiful gowns for the trifling return of her indorsement.

Life was a wonderland existence and money seemed to come in basketfuls. Audrey Munson who had never known luxury before got used to living like a princess. Artists begged her to pose, celebrated people wanted to meet her and her small houses heavier and heavier and heavier with all kinds of invitations and contracts.

She admits now that none of her failings was due to her being so unused to success. She believes that if she had the same road to go over again that, even though she was cursed, she could still retire with a comfortable fortune instead of suffering the added humiliation of poverty.

When she went footsore from studio to studio searching for work, she understood why the artists had worked so frantically and feverishly when she, as the famous Audrey Munson, "the world's most beautiful model," had given them a half hour.

Now when she needed money, they shook their heads and asked, "Why should we pay you to pose for us?" And then to Miss Munson's amazement they showed her walls lined with drawings of herself.

Here, she saw her shoulder, crudely outlined in charcoal. In another her slender throat swiftly traced in crayon and in a dozen others every part of her anatomy so that, sure enough, they never would need her services again.

At the height of her success as a model Miss Munson turned to the theater. Posing in an artist's studio for even half a day at a time was very wearing and nerve wracking and when producers who had heard of her much heralded beauty sought to star her she welcomed the opportunity.

All they asked of her was to display the curves of her remarkably beautiful body in costumes that were especially designed for her. She became, she says, a "clothes horse" and in sketch after sketch that was written for her, her role was only to walk on and off the stage in costumes so gorgeous that the audience would gasp in amazement.

So when her contract was broken, it was not, nor could not be, because of a lack of dramatic ability on her part.

What really happened to her is just what every mother with a budding actress in the family tries to point out as the probable fate of many an over-ambitious girl whose beauty attracts one of the higher-ups in the show business and who rebuffs his unwelcome advances.

The night Miss Munson confesses that all her bad luck dates from, she was waiting in her dressing room in a New York vaudeville theater. The next number on the program was a fashion show that been especially written for the beautiful model.

A maid was laying out a half dozen gorgeous gowns and Miss Munson was hurrying into her first costume, a very snug bathing suit, when the door was pushed open and a handsome man in evening clothes, familiar to Miss Munson and to all who know the show business in New York, stepped in.

Miss Munson was at first too frightened to speak. Quickly she grabbed a negligee and held it before her half-naked body as she whispered, "Go away. Please go away."

The handsome intruder came closer to the pretty model and looked searchingly in her eyes and then said sternly, "Do you mean that?"

When Miss Munson only nodded her head, his face reddened as he turned and snapped over his shoulder, "I'll make you remember that for a long while."

The next day Miss Munson was told that the fashion show had closed. At first she didn't associate the termination of the contract with the affair of the previous night. However, she was somewhat amazed to hear that an act which had been drawing great crowds to the theater should suddenly be taken off the bills.

But Miss Munson anticipated no difficulty in getting another engagement. She tried several managers but they politely told her that their bills were all made up for a long time in advance and even in the future they didn't think they would have any place for a fashion show.

However Miss Munson, though greatly surprised, wasn't in the least discouraged. She thought that the next day would probably result in a contract being signed bright and early. But her hope was vain. The day came and passed and she was beginning to get a little bit discouraged.

It seemed very odd to her that a dozen managers would refuse so prejudiced against fashion shows and so positive that they wouldn't be putting one on again for a long time.

After several months of fruitless effort and more jobless, Miss Munson was convinced at last that she would be remembering for a long time that fateful night in her dressing room. The sauce of her great beauty was following her and it was clear to her that she would never get an engagement in another theater.

There was nothing to do, she decided, but to return to being an artist's model. The next day she started out to visit several artists for whom she had posed before she had become so famous. But nowhere was there any word.

The artists didn't seem interested and finally one of the artists who had once been glad to get her for half an hour told her that every artist for whom she had posed had made so many sketches of her, that they never would need her again.

But Miss Munson believes that the gentleman who called on her so informally in her dressing room was the man who turned the tide of her fortune and that his influence on the Great White Way extended even to the artists' studios.

Never after that night in the theater was she able to get a contract in the theaters and all the artists who had once been begging for her time acted as though they had never heard of her.

Although she had risen to the triumph of being termed the most divinely formed woman in the world, her rare beauty has brought her only ill luck. Even though her figure has been the model for some of the world's finest sculpture, it is her fate to be, while still a young woman, deserted and jobless.

There are many permanent monuments to the beauty of the world's most beautiful model, but these are little compensation for the meager reward they brought the woman who posed for them.

New Yorkers see Miss Munson in the statue of Civic Fame which tops the Municipal Building. There is also the very elaborate stained glass composition by J. and R. Lamb in which Miss Munson appears as a winged angel. In the George Vanderbilt country home at Biltmore, North Carolina, is an enormous tapestry for which Miss Munson posed. On the New York Customs House is a particularly beautiful statue for which Miss Munson was the model. And there are hundreds of other statues throughout the country which Miss Munson inspired.

But while Audrey Munson believes that all her bad luck was due to an unwelcome caller in her dressing room, there are hundred of girls on Broadway who point out that such a Nemesis as Miss Munson claims has followed her is impossible, for the reason that no man has enough power to prevent a girl from ever getting back on Broadway.

At any rate, Miss Munson's present predicament is a hard one to fathom. In the lonely woman who paces from the stoop of her cottage to the haystack and back hour after hour it is hard to see much likeness to the beautiful girl who only a few years ago was the toast of the world's leading artists and sculptors.

Some people say that Miss Munson has suffered a complete nervous breakdown and that her possible nerves-back to the world of pearls and stones part that his influence on the Great White becomes more and more impossible every day that she morbidly thinks of the "curse" brought upon her by her great beauty.

The last major newspaper feature written about Audrey before she disappeared from history.

disaster. "I have forgotten many things that the [G]ypsy woman said, but mother has repeated her words to me so many times that I seem to remember them," Audrey said. The old crone's premonition would come to haunt her. The curse, as Audrey saw it, would blight her life.

The big question is whether the fortune-teller had discerned something essential about human nature. Did Audrey's exceptional beauty not only offer her opportunity and riches but condemn her too? Or did her "curse" become a self-fulfilling prophecy? Was Audrey to be responsible for her own doom? That very question was posed by the *Syracuse Herald*, then Audrey's local newspaper, in the last feature ever written about her in her extremely long lifetime—written when she was just thirty-five years old. WORLD-FAMOUS MODEL CURSED BY HER GREAT BEAUTY, the newspaper headline blared. "Does a relentless Nemesis really follow Audrey Munson, once the world's most beautiful model whose shapely body has inspired some of the finest paintings and many of the most notable statues of recent years?" the first paragraph asked. "Or have the broken 'nerves' of this famous model caused her to imagine the curse that she says follows her constantly?" It was a question that would haunt her for her entire life.

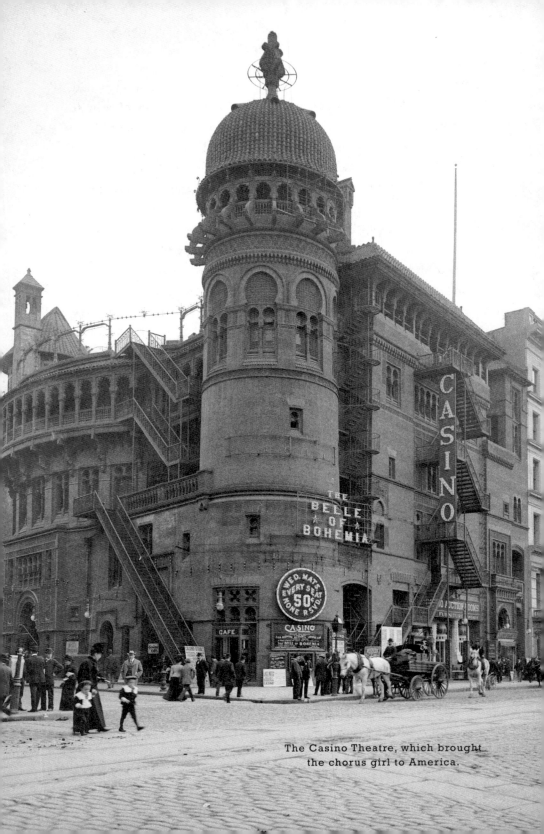

The Casino Theatre, which brought
the chorus girl to America.

2

THE CHORUS GIRL

At lunchtime on Thursday, October 7, 1909, three young chorus girls spilled out of rehearsals at the Casino Theatre in New York. With its seven-story tower topped by an onion dome on the corner of Broadway and Thirty-Ninth Street, the Casino had been the theater farthest uptown when it was built. Until then, the Theater District stretched up Broadway only from Union Square to Twenty-Third Street—the original Great White Way, so named because it was one of the very first streets in America to get electric light. Now, other theaters were following the Casino north.

The chorus girls, all working on Broadway for the first time, were in an effervescent mood. New York's main thoroughfare was a tangle of pedestrians—men in derby hats and women in bonnets—picking their way through the trolleybuses, horse-drawn phaetons, and the newly arrived automobiles. Opposite the Casino, a gang of bored bricklayers was building a new theater for the Shubert brothers to be dedicated to the exotic Russian Jewish actress Alla Nazimova.

The girls teased the bricklayers, taunting them that they were so slow, the chorus girls themselves could do a better job. The foreman wagered the three young women five dollars each—a quarter of their weekly

theater salary—that they could not do the job for even thirty minutes. It was a dare they could not resist. The girls doffed their coats, rolled up their sleeves, and began pushing wheelbarrows onto the site. Then they slashed the bricks with mortar and set them in place. To the delight of a crowd of onlookers, the women won their bet. Their names were Helen Edwards, Bertha Montague, and Audrey Munson.

Audrey never liked to admit she had been a chorus girl. Chorines, as they were once known, were viewed as young women of decidedly dubious morals who were only too happy to fall prey to the "stage-door Johnnies" who awaited them after the last performance. "The chorus girl of the stage," Audrey later said, ". . . needs no talent other than an ability to learn a few mechanical dance steps, smile a mechanical smile, and walk mechanically in a mechanical line." When Audrey headlined a revue at the Palace Theatre six years later, it was falsely billed as her first-ever appearance on Broadway.

By the time she arrived in New York, Audrey had already accumulated a lot of experience in what the show-business trade paper *Variety* called the "smaller time." Even as a young member of Gerald Hampton's Dancin' Dolls she may have gone on tour. As well as Rocky Point, Hampton took the act to sold-out audiences in New Bedford, Massachusetts, and Sohmer Park in Montreal. In the spring of 1909, shortly before Audrey moved permanently, Hampton also brought his troupe to New York—possibly Audrey's first-ever visit to the city.

The Dancin' Dolls played Keeney's Third Avenue Theater, where "[t]heir clever stunts pleased last night's audience very much indeed," the *Brooklyn Daily Eagle* reported. *Variety*, typically, gave a more sober assessment: "The program gives Hampton credit for five 'dancing dolls.' Four only appeared. The offering is made fairly amusing principally through the efforts of the four. The quartet look well. They make several costume changes, two very pretty. The girls, while not wonders in the dancing line, are lively and exceedingly well rehearsed. Hampton is a posey light comedian who doesn't get far enough away from himself at any time to make a good impression. He gets around the stage in a

rather good style, but all the dancing is of the hop-skip-and-jump order. The act did well at the 3rd Ave. It should do well for the smaller time."

After Dancin' Dolls, Audrey toured with the musical *Marrying Mary* to the Lyceum Theatre in Detroit, where it played from October 18 to 24, 1908. The show was on the road for a total of three years, making stops at Richmond, Virginia; Athens, Georgia; Champaign, Illinois; and Ogden City, Utah, before going on to Los Angeles, San Francisco, Spokane, and Seattle, but it is not clear how long Audrey stayed with it. She was part of the show's celebrated long-skirted chorus.

When Audrey and her mother moved to New York, the city was in the midst of the epochal transition that made it the "Capital of the World." America's gross national product was set to triple in the next decade. The fifty-story Metropolitan Life Insurance Company Tower on Madison Avenue at Twenty-Third Street, modeled after the Campanile in St. Mark's Square in Venice, Italy, became the tallest building in the world—until it was surpassed by the Woolworth Building opposite City Hall just four years later. The original Pennsylvania Station was under construction, as was Grand Central Terminal, which was to be the largest train station in the world, with 700 trains in and out every day. Financier John Pierpont Morgan had recently completed his Morgan Library on Thirty-Sixth Street and Madison Avenue, and the monumental New York Public Library was going up on the corner of Fifth Avenue and Forty-Second Street. The Blackwell's Island Bridge, now the Queensboro Bridge, became the third route over the East River and the first to link Manhattan to Queens. One of the first vehicles to cross was a farm wagon going back to Long Island after delivering its produce to Manhattan by ferry that morning.

The city was a glorious riot of striving immigrants: the Italians with their fruit and vegetable stands, the French florists, the German shoe shops, the Irish saloons, the Jewish clothing bazaars. This was the year that British Zionist Israel Zangwill wrote the play *The Melting Pot*, giving America, and New York in particular, a new definition of itself. It tells the story of a Russian Jew who flees the pogrom that kills his family and

comes to America, where he falls in love with the Christian daughter of the Russian officer responsible for the massacre. "Ah, Vera," he asks her, "what is the glory of Rome and Jerusalem, where all nations and races come to worship and look back, compared with the glory of America, where all races and nations come to labour and look forward!"

Culturally, the melting pot city was exhilarating. Composer Gustav Mahler had conducted at the Metropolitan Opera, and Arturo Toscanini was director there. The Brooklyn Academy of Music had just opened its doors. Jazz musicians coming up from New Orleans began to call New York "the Big Apple" in welcome contrast to their gigs on the road that paid only "small apples." It was the year that Sigmund Freud made his only visit to America. As he docked at New York Harbor aboard the *George Washington* liner, he reputedly turned to Carl Jung and said: "They don't realize that we are bringing them the plague."

But so much change could be wrenching. The old world coexisted uncomfortably with the present even as the future struggled to be born. Eleventh Avenue was known as "Death Avenue" because of the number of pedestrians killed by the New York Central freight trains that ran down the middle of the street. At the same time, the train tracks along Park Avenue were being buried as electric locomotives replaced those run by dirty steam.

Audrey, still a teenager, and her protective mother set out to forge a new life. Audrey was bursting into adulthood and looking for her break. Kittie, after her divorce, was seeking a second act, or perhaps a third, after her struggle as a boardinghouse keeper in Providence. The mother and daughter rented a modest apartment in the still-rural upper Manhattan neighborhood of Washington Heights, which was burgeoning with recently arrived Irish immigrants taking advantage of the Interborough Rapid Transit Co.'s new subway line up Broadway. Mother and daughter had always lived in boardinghouses, but this, finally, was a place of their own. There were no strange boarders for Kittie to watch after. It was a newly built apartment building named the Rosefield, at 4441 Broadway, at 190th Street, with shops at street level. Ads offered "high class elevator

apartments" with "very latest improvements" for "reasonable" rents of between twenty-five and thirty-five dollars a month.

The janitor proved an unexpected annoyance. Albert Mollock ruled with an iron hand. He was known as the building czar. So confident was he of his power that he even instructed residents on which stores they could patronize. Neighbors suspected he was getting a kickback from the favored shop owners. Not long after Audrey and her mother moved in, Mollock got into an ugly spat with a resident artist, Walter Wellman, over the trash. The building was equipped with a small trash elevator to take garbage bags down to the basement. Mollock had ordered the tenants to use the dumbwaiter only before 7:00 a.m., when it suited him to clear it. The late-rising artist tried to dump his garbage one evening and found the dumbwaiter stuck. When he went down to the basement, he discovered it was tied with a rope. As he tried to untie it, the janitor struck him over the head with a monkey wrench. "Of all the tyrant janitors, this man was the worst," Wellman testified in court. "He made up rules for his tenants that nobody could live up to. . . . I went down to remonstrate and he almost split my skull." The judge sent Mollock to jail for three months.

For Audrey and Kittie, the Rosefield was a first port of call in New York. The new subway station at 191st Street was still being built and did not open until 1911, so Audrey had to use the Dyckman Street stop, but for a five-cent fare she could commute downtown to the Theater District on a comfortable cushioned seat.

Audrey was determined to launch her stage career, and Kittie was right behind her. But like any young hopeful in New York, Audrey needed money. Kittie brought in a pittance working as a nurse in general practice. Kittie's father and brother had both died, and her sister lived a humble existence as a dressmaker in their tiny hometown upstate. Kittie had no one to turn to in time of need; she certainly could not ask her former husband. But Audrey could. And Audrey did. Two months after they arrived in New York, Audrey wired her father asking for a fifty-dollar loan.

Edgar, who was becoming established as a real estate broker selling

farms around Syracuse, found himself in a delicate position. He had started a new family with his second wife, Cora. They already had two small children, and, as his second wife reminded him, Edgar had obligations to them, too. He openly disapproved of Audrey trying to become an actress. That poppycock had been put in her head by her mother, he thought. But however much he disliked Kittie, Edgar always had a soft spot for his firstborn. When Audrey asked, which was seldom, he invariably gave. No doubt muttering something under his breath about his ex-wife, he wired the fifty dollars.

Audrey had arrived in a city where she had few friends apart from her mother. She sought out a well-connected cousin, Harriet Lyman Munson. Audrey was eighteen, Harriet forty. Audrey liked to dine with Harriet and her husband, Robert, at their home at 204 West Seventieth Street. Audrey's friendship with Harriet gave her a welcome break from her mother. Kittie, though a nominal Munson, was estranged from the family because of her divorce and did not attend.

Harriet's father was one of the richest Munsons of his generation. Samuel Lyman Munson had built a successful factory producing linen shirt collars in Albany and a second for shirts in Cobleskill, New York. Despite his business acumen, friends described him as a "man of literature," and he enjoyed an unusual hobby. With the earnings from the shirt factories, he had built up one of America's finest collections of early almanacs. It is thanks to him that the Munson family is well-documented to this day in the *Munson Record*, which he set up.

Harriet's husband Robert Hunt Lyman, had joined James Gordon Bennett's *New York Herald* after leaving Yale and then gone off to Britain to edit the *Herald*'s London edition. On his return to New York, Lyman had served as Joseph Pulitzer's secretary during the 1898 Spanish-American War. By the time Audrey came to New York, Lyman was the powerful managing editor of Pulitzer's *New York World* newspaper, part of the city's rambunctious "yellow press." Indeed, when Audrey was in the city, President Theodore Roosevelt had both Pulitzer and Hunt Lyman indicted for criminal libel against the United States government

for articles they had written about the building of the Panama Canal. The case was thrown out by the courts.

Although he wielded his power behind the scenes, Robert was an influential figure. The dinners he and Harriet hosted gave Audrey access and insight into New York's cultural life and allowed her to believe that she had arrived—which indeed she had.

Whatever she might later think of the profession, Audrey had worked hard to become a chorus girl. Performing on Broadway was a dream come true. All her extra lessons in music and dance, and all her practice, had paid off. She had worked her way up from a local venue, via a touring production, until she finally reached the Big Apple.

Audrey made her Broadway debut shortly before her eighteenth birthday, appearing in drag as a footman in a musical comedy called *The Boy and the Girl*. It was a walk-on part in a "silly season" "song show." But she was still very young, and it was the Great White Way. It was a huge achievement for Audrey—the fantasy of countless provincial girls, and something sure to make Kittie glow with pride and mutter to herself, as if to her former husband, "I told you so!"

The Boy and the Girl ran for three weeks, from May 31 to June 19, 1909, at the Aerial Gardens, atop the New Amsterdam Theatre on Forty-Second Street, one of Broadway's new rooftop stages built to spare audiences the sweltering summer heat in an era without air-conditioning. Spectators sat in the cool evening breeze surrounded by 10,000 potted plants, flowers, and palms. The two-act show, set in Florida and Havana, starred singer Marie Dressler hamming it up—and at one point kicking the drummer in the face. Ads called it a "singy, swingy hit." "The only trouble with it is that you don't know what it's all about," the *New York Sun* reviewer complained. "Still that isn't a serious consideration where a summer show is concerned so long as it has lots of pretty girls and novel effects and songs that you whistle while the elevator descends and regular folks in the cast—all of which 'The Boy and the Girl' may lay claim to."

Next, Audrey auditioned for the chorus of *The Girl and the Wizard* at the Casino—the theater that had first imported the chorus line from

Europe to America in the 1890s. The Casino was famous for its chorines. In 1900 the Casino had presented the British import *Florodora*. The theater found itself with a hit on its hands—arguably the first hit Broadway musical of the twentieth century. It was to run for 505 performances before being immediately revived elsewhere.

Florodora was a torrid tale of the skulduggery surrounding a perfume factory on the Philippine island of Florodora. But the plot was not the reason for the production's success. The musical featured a singing, dancing sextet of "English girls," each standing exactly 5′4″ and weighing 130 pounds, who paraded around the stage waving parasols and singing "Tell Me, Pretty Maiden" with a sextet of male partners. The young women's nightly performances were discovered by a group of young college men from Yale, who began attending so they could give the girls a standing ovation. Each of the original six *Florodora* Girls—Daisy Greene, Marjorie Relyea, Agnes Wayburn, Margaret Walker, Marie I. Wilson, and Vaughan Texsmith—married a millionaire.

It was partly the belief that every *Florodora* Girl married a millionaire that lured perhaps the most famous *Florodora* Girl of all to the part: Evelyn Nesbit. Nesbit went on to become the notorious "girl in the red velvet swing" at the center of one of New York society's most notorious murders, immortalized in a 1955 movie of that name and in the 1998 musical *Ragtime*. Nesbit was just sixteen when she was picked out of the *Florodora* chorus by forty-seven-year-old Stanford White, a partner in the architectural firm of McKim, Mead & White, which defined the era's style. Among White's designs was the triumphal arch in New York's Washington Square, built in 1882 to belatedly celebrate the centennial of George Washington's inauguration as the first president of the United States in 1789. A redhead with an enormous red mustache, White had tickets to *Floradora*. He lured Nesbit to his opulent home with the red velvet swing on Twenty-Fourth Street, where he plied the teenage virgin with alcohol and deflowered her. Like the other *Florodora* Girls, Nesbit married a millionaire, Harry Thaw, a coal and railroad heir. Thaw, harboring a vendetta against the man who had stolen his wife's virginity,

shot White dead with three bullets to the head and back at the climax of a performance at a rooftop theater in New York on June 25, 1906. Thaw pled temporary insanity at the ensuing "Trial of the Century" and was dispatched to an asylum.

The longtime mistress of press baron William Randolph Hearst was also a *Florodora* Girl of sorts. Marion Davies never actually appeared in the show, but she did star in the movie *The Florodora Girl* (1930). It is the story of a chorus girl who, predictably, falls in love with a wealthy suitor. Her beau soon gambles away his fortune at the races, and his mother insists he regain it by marrying an heiress. Davies, who later became a so-called Ziegfeld Girl in Florenz Ziegfeld's stage "Follies," described the magnetic allure of the chorus girl in her autobiography, *The Times We Had*:

> My first admirer while I was on the stage was called the "Boston Millionaire." That's how it is when you are on the stage; you get admirers and proposals of marriage or something. It doesn't matter what your face looks like; it's all how you look from across the footlights. And every girl in a show looks glamorous to the audience. Now this one was a bachelor. He sat in the first row and was very elegant. But he had to have an introduction, through my mother. Ziegfeld would always insist that the stagedoor-Johnnies had to be introduced properly. And there were so many, and all with proposals. It was preposterous, in a way, because they were looking over the footlights. We were looking the other way, into the audience, no matter how well dressed a man was, it wasn't as exciting as the stage. The glamour was all on the stage.

Ziegfeld had Americanized the concept of the famous Folies Bergère of Paris in his first "Follies," *Follies of 1907*, set in a rooftop theater he renamed the Jardin de Paris. Its mix of singing, dancing, and comic commentary on current events proved a hit. *The Ziegfeld Follies* became an

annual New York extravaganza until his death in 1932, and then irresistibly reappeared from time to time, as in the Stephen Sondheim musical *Follies* (1971).

Ziegfeld rather disingenuously claimed the mission of his sexy cabarets was to "glorify the American girl." He considered himself the ultimate arbiter of female American beauty. "Five percent of all American women are beautiful. Five of every hundred conform to the established canons of perfection in loveliness. Fifty per cent are pretty, pleasing or personable. . . . Over the remaining forty-five percent we will draw the veil of kindly silence," he once said. To add insult to injury, he added, "Beauty and brains are not often found together."

A host of Ziegfeld Girls went on to become early movie stars: Mae Murray, Marion Davies, and Olive Thomas, who all had an impact on Audrey's life, as well as Fanny Brice, Billie Dove, Lilyan Tashman, Louise Brooks, and Charlie Chaplin's future wife, Paulette Goddard. Perhaps inevitably, several others ended up marrying or having long-term relationships with the maestro himself: Anna Held, Lillian Lorraine, and Billie Burke.

Producers recognized that Audrey had the glamour of a chorus girl. She could sing, she could dance, and she was undoubtedly beautiful. But she was just one of a large crowd of chorines. It could be grueling work. Some nights, the performances ran on until one in the morning, and Audrey still had to get home. Chorines were notorious for going to bed at two in morning and not waking up until one the following afternoon. *New York Times* society columnist Richard Barry estimated that the average stage life of a chorus girl was just seven years—about the same as a "reporter on a yellow newspaper." Adrienne Kroell, a chorus girl who was one of the very first to switch into silent movies, made fun of the many myths about the chorus girl's life. "All this talk one reads about their nightly after-the-theatre supper at lobster emporiums is fiction. . . . It is a safe bet the four-fifths of them slide for the home plate just as soon as they have washed the cosmetic off their eyebrows," she wrote. "Just

because a few of them make a big noise, why blame the majority? The chorus girl is just like any other girl."

After *The Girl and the Wizard*, Audrey was picked for *Girlies*, which ran at the New Amsterdam Theatre from June 13 to August 27, 1910. It had a chorus line of sixty girls. The pitch for the show was simple enough. Newspaper ads read:

GIRLIES. 60 of Them.
NONE OF THEM TWENTY.
NONE OF THEM MARRIED.

The critics panned *Girlies*. "It is the same old plotless piece, with the same old tunes and the same old business," the *Brooklyn Daily Eagle* reviewer moaned. The public loved it nevertheless and filled the theater all summer.

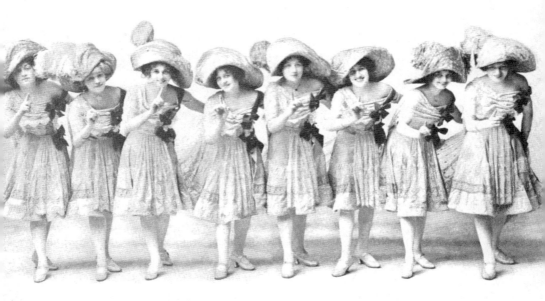

Audrey, identified by a family member as fifth from left, appearing in the musical *Girlies* at the New Amsterdam Theatre.

Audrey's next chorus was even bigger. One critic estimated that there were 200 chorines in *La Belle Paree*, a musical revue of skits of American tourists in Paris. The official cast list named a mere eighty-five. The show was the first extravaganza at the vast new 1,800-seat Winter Garden, built in the former American Horse Exchange. It played for 104 performances until September 16, 1911. Despite her anonymity in the huge cast, Audrey got to perform alongside another future star. Making his Broadway debut in blackface as the minstrel Erastus Sparkler was the young Al Jolson, who would go on to make the most famous early "talking picture," *The Jazz Singer* (1927). *La Belle Paree* launched his career.

Audrey never became a Ziegfeld Girl, which was considered by many to be the pinnacle of the chorine's career. Ziegfeld was not her type. Too cynical. And she was not Ziegfeld's type. Too serious. Not sexy enough. "Grey eyes cannot be beautiful. They are too hard, too intellectual," he complained. "They are the eyes of the typical college girl."

Audrey had other admirers.

3

THE PHOTOGRAPHER

Audrey and Kittie entertained themselves by going window-shopping on Fifth Avenue. They liked to daydream about all the beautiful garments they could not afford. One day, as Audrey was wondering whether she would ever be rich enough to buy one of the expensive hats on display, she noticed a man following her. He walked behind her, studying her intently. Then he hurried in front so he could look back. Angered and a little fearful, mother and daughter dodged into a store. But the stranger waited outside. Eventually, Kittie plucked up the courage to confront the stalker.

The man politely raised his hat and apologized for his unwanted attentions. He asked whether Audrey was a model. "No," Kittie told him firmly. He went on to explain that he was a photographer, still a novelty at the time, and asked whether Audrey might not come to his studio to have some studies made of her face. To maintain propriety, he suggested Kittie should accompany her still-teenage daughter, and presented his card.

It was Audrey's entrée into the art world.

"It was all an accident, and until an hour or so before I did pose such a thing never entered my mind," she later told the *New York Sun* in her first-ever press interview. "We did not like the idea at all, but finding out that

he was one of the best photographers in town mother and I went. He took some photographs, said I had a head almost antique in line, and began to tell his artist friends about me. From that [time] on I have posed."

Audrey told several versions of this story over the years. She described the photographer differently at different times: "a young man," "middle-aged," and even "aged." She once, in a ghostwritten article, gave the name on his card: Ralph Draper.

No one has ever found an early New York photographer named Ralph Draper—because he does not exist.

Draper is indeed a surname recognizably linked to a famous photographer. Two generations earlier, John William Draper, born in England in 1811, became a professor of chemistry at New York University and experimented with the newly discovered processes of photography, making a camera out of a cigar box. He later set up a photography studio on the roof of the NYU building on Washington Square with his friend Samuel Morse, the inventor of the telegraph and Morse code. City dignitaries flocked to the studio to have their picture taken. Draper is still famous today for taking the first-ever photograph of the moon from New York in 1840, the first example of astrophotography, which has since seen humanity take close-up photographs of faraway planets. That same year, Draper took a photograph of his sister Dorothy that is considered the first-ever photographic portrait of a human being. But John William Draper died in 1882, before Audrey was born, and he had no descendants named Ralph.

A quite different name for Audrey's photographer, however, has come down through her family via her mother. That name is Herzog.

Now totally forgotten, Felix Benedict Herzog was one of those remarkable American polymaths of a bygone era. The *New York Herald*, in his obituary, described him as an "inventor, artist and patent attorney." On census forms, he described himself simply as an "electrician"—a job description that carried a lot more excitement than it does today. But Herzog, the son of Austro-Hungarian immigrants, was also indisputably an artist. When he met Audrey, he had a full face with tangled, graying

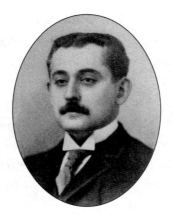

Felix Benedict Herzog, the photographer who
discovered Audrey, "could . . . open a model agency."

hair and a thick mustache—and was almost exactly the age of her father.

Herzog graduated from Columbia University in 1881 with a degree in political science, in 1882 with a bachelor of law, and in 1883 with a PhD. At the university, he also distinguished himself by becoming one of the most prolific cartoonists on the recently founded college newspaper, the *Columbia Spectator*. A reviewer called him "the strongest, most original and most finished of these college cartoonists," and his cartoons were among those published in a book titled *College Cuts*.

After Columbia, Herzog became a pioneer of telephony. He invented a telephone switchboard, a police emergency calling system, and a signaling system for elevators. Eventually, he ran his own Herzog Teleseme Company. It made a contraption for hotels with a circular chart that enabled guests to call for room service items, ranging from "chamber maid" and "my manservant" to "cognac" and "Bass ale." In an era before telephones were common in rooms, the Herzog Teleseme became an emblem of luxury. One was installed in the Élysée Palace Hôtel in Paris.

Combining his talents of composition with his scientific savvy, Herzog embraced the emerging art form of photography. He was drawn to the pictorialist movement of photographers who used the new form to present artistic images rather than true-to-life scenes.

To get to Herzog's studio, Audrey and Kittie had to walk over to

Lincoln Square, the bustling crossroads where Columbus Avenue met Broadway. The IRT subway grumbled below the ground and the Ninth Avenue el train clattered overhead. Herzog had his studio in the Lincoln Arcade Building at 1947 Broadway, between Sixty-Fifth and Sixty-Sixth Streets. The block-long, six-story loft building had recently become an uptown outpost of the New York art world in Greenwich Village and Gramercy Park. The *New York Times Magazine* called it a "new Bohemia." The artists spilled into the surrounding streets, and people began to speak of the "Sixty-Seventh Street Studio District."

At street level, the Arcade Building had a row of shop awnings along Broadway with a candy store, a barber, a clock maker, a milliner's shop, a billiard parlor, and two corner saloons. A hall was rented out for "spiritualistic" lectures by the Rev. Rufus A. Macurda, "pastor and psychic" of the First Liberal Thought Church. Upstairs was even funkier. Dentists worked next door to dance instructors, stenographers next door to quacks peddling miracle health cures. The cheap lofts on the top floors at the back of the building were populated by students, musicians, illustrators, and artists. Owen Johnson described the atmosphere in his popular novel *The Woman Gives* (1917): "It was a place where no questions were asked and no advice permitted; where, if you found a man wandering in the long drafty corridors, you piloted him to his room and put him to bed and did not seek to reform him in the morning. This was its etiquette." The building's artistic legacy lives on in Lincoln Center to this day.

Inside, Audrey and Kittie encountered an extraordinary scene.

Herzog was a virtuoso of drapery. In his studio, he photographed carefully staged scenes of young women swathed in silk wraps—sometimes solo, sometimes together, and sometimes nude. In a single afternoon, he could conduct forty or fifty exposures, with some compositions containing twenty or thirty figures. He approached his work with scientific precision. "To costume, pose, light and arrange the bodies, draperies, hands and faces of a group of even only two or three of the most adaptable and willing models, to watch until the end of the exposure every fold of the drapery, every changing shadow which may

be cast at some undesired point as the models are moved tentatively; to study every movement of the head or expressive feature of the face or the nervous and often unconscious change in the fingers or hands of the nerve-strained models—all this furnishes an exercise in patience, invention and concentration of faculties which I find about as good a test of what engineers call 'the maximum efficient' as any task I have ever performed," Herzog wrote.

Sadakichi Hartmann, the German-Japanese poet and New York art world figure who was one of the first-ever photography critics, met Herzog at the Camera Club of New York, an association of photography enthusiasts, around 1902 and kept up the acquaintance for years. "It was a chance meeting. I was introduced to him as a man who 'was trying to do some new stunts,' and soon after Herzog produced a wallet containing some hundred photographs of draped figures and nudes," Hartmann wrote. "I did not remember of ever having encountered in painting, as well as in photography, a more decided talent for the handling of drapery as was revealed to me in those tattered proofs." Hartmann, who also wrote under the pen name Sidney Allan, called Herzog "an independent pictorialist, with plenty of leisure and working solely for his pleasure."

A lifelong bachelor, Herzog recruited young women from among the city's dancers, actresses, and professional artists' models—as well, apparently, as on the street, like Audrey. *The Camera*, a photography magazine, wrote snidely: "Herzog, at this minute, could open a costume and drapery shop and a model agency besides."

The few of Herzog's photographs that survive today are either elaborate compositions of multiple posed figures in mythic scenes resembling Old Masters or more intimate lolita-esque portraits of young dark-haired girls, titled just *Angela* or *Marcella*.

Herzog had once been on the cutting edge. The early photography scene in New York was dominated by one man, today lauded as the father of American photography. The visionary Alfred Stieglitz, through his pioneering gallery, talks, and journals, became the single greatest promoter of modernist art in the United States and the arbiter of what

was considered modern. When Stieglitz was growing up in Hoboken, his father had wanted him to become a mechanical engineer, but he became fascinated by the possibilities of photography and then by modern art, which he sometimes provocatively called "anti-photography."

At first, Stieglitz smiled on Herzog. Indeed, Herzog helped him select the 162 works for the seminal 1902 Photo-Secession show at the National Arts Club. The name Photo-Secession was conceived by Stieglitz as a deliberate tribute to the breakaway art movements of the same name in Vienna, Munich, and Berlin, in a quest for more artistic freedom. Stieglitz was inveterately opposed to the institutional or academic. Puzzled by the new movement known as the "Photo-Secession," Charles de Kay, the director of the National Arts Club, asked Stieglitz: "Who is it?" Stieglitz, with his uncanny confidence, replied: "Yours truly, for the present, and then there will be others when the show opens." The *New York Times* reported on an informal talk by Stieglitz at the show: "They believe that the artistic sense and individuality of a photographer can be shown in his pictures, although the camera, a machine, is used to perform the raw work upon which he then begins to exert his own talents."

In 1905 Stieglitz set up the Little Galleries of the Photo-Secession in the attic of a building at 291 Fifth Avenue with a group of photographers who had walked out of the Camera Club in a quest for greater artistic freedom. The tiny space, which soon moved to an even smaller room across the hallway, also began showing paintings and was to introduce America to the art of Cézanne, Matisse, and Picasso. It was precisely at this time, as it was facing its greatest rebellion, that Herzog was elected president of the Camera Club. Yet Herzog urged members not to despair of the club's future. "Photography is said to be near art and certainly will increase as an aid as time goes on," he said.

Herzog and Stieglitz went their separate ways. Herzog exhibited at the Camera Club in 1905, 1908, and 1910, and showed in Vienna, Dresden, and Montreal. In May 1907 he won the endorsement of a laudatory review in the *Century* magazine. A print of his *Tale of Isolde* went on display in London in 1905. He offered it for sale at 500 pounds, while

Stieglitz sold for just twenty-five to forty dollars. When Herzog exhibited his compositions of figures in the International Exhibit of Pictorial Photography at the National Arts Club in February 1909—just months before spotting Audrey on the street—the *New York Times* praised the works for their "astonishing qualities." He deserves at least a footnote in art history for his feat at the Architectural League of New York, where his *Tale of Isolde* became the first photograph to be accepted into an art show in the United States on full equality with paintings.

Herzog, though, represented a painterly past that was increasingly out of tune with the rapidly transforming world. Stieglitz included three of Herzog's photographs in the October 1905 issue of his *Camera Work* magazine, and two more in the January 1907 edition. By then, however, they were accompanied by a harshly critical review. Herzog's work was panned, as by Charles H. Caffin, as "academic." "While photography, like painting, has been striding toward a new light, he has made a strategic movement to the rear, and set his face backward, to where the sun has long since set." Indeed, Herzog was just the first of many artists in Audrey's life who would be swept away in art history by the crashing wave of modernism.

Because it marks her first entry into the art world, the precise date of Audrey's window-shopping encounter with Herzog is key to the attribution of later artworks she claimed to have posed for. In a major interview published with *Movie Weekly* in 1922, Audrey asserted she was just fourteen but also said she was taking a break from rehearsals while a chorus girl at the Casino Theatre. This dates the encounter pretty close to the second half of 1909 when she was rehearsing for and performing in *The Girl and the Wizard*, which ran at the Casino between September 27 and December 18, 1909, when she was eighteen. She later confirmed this date in court papers and in her first-ever press interview with the *New York Sun* on June 8, 1913—her twenty-second birthday—in which she said she met the photographer "about four years ago."

Audrey worked at Herzog's studio several times a week. She posed in Greek and Roman draperies — "now as a naiad, now as a dryad, now as a

caryatid—as Venus, the goddess of beauty, and as Diana, the goddess of wisdom and war." Herzog, a member of the National Arts Club as well as a former Camera Club president, began introducing Audrey to his artist friends to get modeling work.

He was besotted with Audrey. Already in his fifties, he had never married. He still lived with his Austro-Hungarian mother, Henrietta, and his two younger sisters, Beatrice and Helene, in the family home at 45 East Thirty-First Street—just steps from Fifth Avenue, where he met Audrey. Herzog could contain his desire no more. Audrey confided that, "The first declaration of affection I heard came from a man old enough to be my father. He asked me to wed him that he might protect and safeguard my beauty. I was a slip of a girl, wide-eyed, impulsive, trusting. This man had guided my feet along the pathway of art. I told him I would wed him if he wished. But before the arrangements were made—he died."

Indeed, Herzog expired unexpectedly on April 21, 1912, after undergoing intestinal surgery at New York's Roosevelt Hospital. He was fifty-two. It is not known whether Audrey lost her virginity to Herzog. She called him her "first love"—but not her "first real love." Despite lasting less than three years, the relationship that began with a chance encounter on the street totally transformed Audrey's life and secured her a place in the art world.

Audrey defended
women's right to wear
one-piece "bathing
suits that men wear."

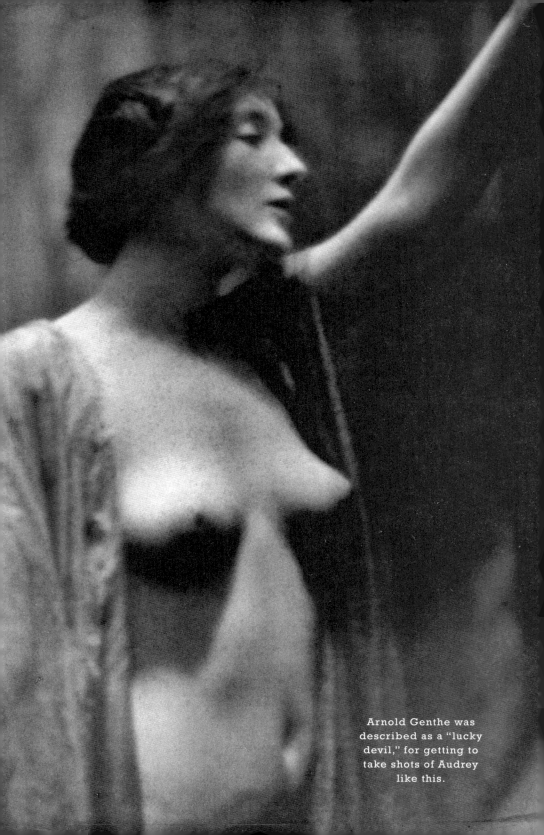

Arnold Genthe was described as a "lucky devil," for getting to take shots of Audrey like this.

4

THE QUEEN OF THE ARTISTS' STUDIOS

Audrey called at the artist's studio at 145 West Fifty-Fifth Street not knowing that the encounter would change her life forever. A petite Hungarian with a pointy Van Dyke beard opened the door and studied her attentively. He had once been a dashing young man, but now, in his late fifties, his hair had grayed and retreated from his brow. He had a kindly manner and a glimmer of humor in his eyes. His name was Isidore Konti, sculptor.

Audrey, still only eighteen, hesitantly explained that she had a letter of introduction from his painter friend, William de Leftwich Dodge, who had done studies of her for his murals. She also had to explain one other, more inconvenient fact: her mother. For Kittie had insisted, as with Herzog, on escorting her starry-eyed teenager into what she was sure was the lion's den.

Konti, unlike many of his kind, was a gracious and punctilious man. Born in Vienna, the capital of the Austro-Hungarian Empire, he had been a precocious student, entering the Imperial Academy at age sixteen and then winning a two-year scholarship to Rome. He immigrated to New York in 1892 at age twenty-nine to find work in America's building

boom. Within a year, he was contributing sculpture to the World's Columbian Exhibition in Chicago. For the 1901 Pan-American Exposition in Buffalo, he did the ornamentation for the Temple of Music—the building where President William McKinley was assassinated.

Konti invited Audrey and Kittie in. His studio was alive with work. Set on the bare floorboards was a clay-smeared workbench and a high wooden stool on which to mold small sculptures. The room was full of studies for larger pieces.

Konti had moved out of New York City in 1903 when his mother and sister came to live with him from Vienna. He set up his expanded household on Riverdale Avenue in Yonkers, but he kept his Manhattan studio. At first, he shared the space with fellow sculptor Hermon MacNeil, who then moved out into the Lincoln Arcade Building, where Herzog worked. Later, Konti employed Evelyn Longman—one of the first female sculptors to be taken seriously in America—as his studio assistant, and she would also portray Audrey.

Isidore Konti, the sculptor who first
persuaded Audrey to pose "in the altogether."

Konti's first words came as a crushing disappointment to Audrey: he had no need for a model. Out of politeness, though, or perhaps beguiled by her beauty, he suggested she and Kittie stay for tea. All of a sudden, he was seized by an idea. He rose from the table, walked around Audrey, and asked her to stand and parade before him. Perhaps, he said, he could use her after all. He had an unfinished work that he had set aside for three years because he could not find the right model. Maybe Audrey was the one. Audrey brightened. Kittie did too—momentarily.

"But you will have to pose in the altogether. The subject is one which will depict your entire form—not only one pose, but three," Konti announced.

Kittie was aghast. She stood to scold the presumptuous Viennese. As Kittie turned to stalk out, though, Konti unleashed a lecture of his own. Audrey looked on, caught between terror and anticipation, caught between her mother and an artist.

"You don't know the meaning, Mrs. Munson, of posing for an artist," Konti rebuked Kittie. He was a quiet man, but his vehemence surprised her. She stopped. Konti pressed on. "To us it makes no difference if our model is draped or clothed in furs. We only see the work we are doing."

The piece that Konti had been stuck on for three years was of the three goddesses known as the Three Graces, a popular classical theme that had been interpreted by artists from Botticelli and Raphael to Rubens and Canova. Konti's statue was to be installed in the grand 1,000-room Hotel Astor, which had opened in 1904 on what used to be Longacre Square but had recently been renamed Times Square after the *New York Times* moved there. Dodge, who had given Audrey the letter of introduction to Konti, had done four murals for the lobby. Konti's contribution was destined for a prime position above the stage in the new Main Ballroom, to be inaugurated in September 1909 with the Hudson-Fulton Celebration commemorating the 300th anniversary of Henry Hudson's discovery of the Hudson River and the 100th anniversary of Robert Fulton's paddle steamer.

It cost Konti a Herculean effort to convince the stubborn Kittie that her tender teenager was safe in his care. Every day, Audrey would arrive to

pose with her mother in tow, and Konti would explain to Kittie why artists did the things they did. There was nothing wrong, he argued, with Audrey imparting her beauty to create a beautiful object in marble or bronze. Indeed, it was the duty of every woman, he insisted, to "contribute what she could to art and loveliness." In those studio sessions, Kittie, as much as Audrey, was being inducted into a new way of life. The life of art.

Audrey was young and bold and insouciant. For Audrey, Konti represented a career opportunity—and an adventure. She was already an accomplished stage performer who had toured the country as a chorus girl. Posing for an artist was just performing onstage for an audience of one. She had let Herzog wrap her in drapery for his mildly erotic photographs. She was confident of her beauty, and she was ready to model nude.

Kittie remained unsure, but certainly she could sense her daughter's desire and excitement. After three months, she finally relented and gave her consent to Konti. For the first time, with Kittie's blessing, Audrey stood before an artist entirely unclad.

The finished version of Konti's statue is a sensual ensemble of the three female muses lying against each other. Though their lower regions are covered with folds of drapery, two of the women are bare-breasted. Their full bosoms and well-defined, almost muscular torsos capture Audrey in the prime of youth. The face of the dominant central figure, who is embracing the other two, particularly resembles Audrey, with her sleek features and narrow jaw and an expression of bliss.

For Audrey, the piece represented her first triumph over her strong-willed mother. Both learned from the experience. Audrey later described *Three Graces* as "the souvenir to my mother's consent for me to pose as Mr. Konti wished."

Audrey, her body still lithe and supple, would make her reputation as a nude model. A beautiful young woman who was willing to take her clothes off for fifty cents an hour was a relatively rare find in America in the first decades of the twentieth century. As Audrey herself put it: "That which is the immodesty of other women has been my virtue—my

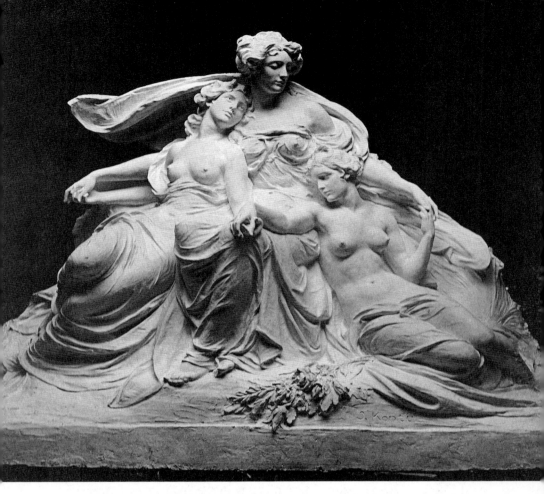

Audrey called the *Three Graces* a "souvenir to my mother's consent for me to pose as Mr. Konti wished."

willingness that the world should gaze upon my figure unadorned."

Although she became famous as a nude, Audrey was not naturally an exhibitionist. She had to overcome her inhibitions like everyone else, and worked hard to do so in the interest of her paycheck—and art. Early in her nude modeling career, she said, she decided to "brazen it out." She developed a mental trick to help defeat her shame at appearing before a stranger in the altogether. "In position, holding a pose while a sculptor or painter worked, I thought of myself only as a model—a mere piece

of human flesh," she said. "The moment the artist dropped his brush or mallet or modeling tool I became the human young woman again, ashamed to have my body seen."

As she grew more confident, Audrey applied the direct approach of a door-to-door saleswoman—learned from her mother's corset peddling—to the art world. She would go door-to-door in studio buildings seeking out modeling work. Audrey was not just bold, she was also a little reckless, or perhaps desperate—or perhaps it was Kittie's poverty that infected her.

One icy day in the winter of 1912, Audrey rang the doorbell of a studio in the Arcade Building where the recently deceased Herzog had worked. The studio belonged to Robert Ingersoll Aitken, a thirty-four-year-old San Francisco–born, Paris-trained sculptor with smoldering good looks. He was a rare artist to go clean-shaven. "Of sturdy aspect, physically broad and strong, capable of tender and sudden emotions, he is a jolly correct gentleman of rare distinction, possessing lofty qualities of mind," *Arts & Decoration* magazine raved about him. As a young art instructor, Aitken had been hired to sculpt the figure of Victory, a woman armed with a trident and a wreath, atop the towering column that still stands in San Francisco's Union Square commemorating Admiral George Dewey's victory at Manila Bay in the Spanish-American War in 1898. President McKinley broke ground for the monument shortly before he was shot at the 1901 World's Fair in Buffalo, and Aitken crafted a memorial to him, too, in San Francisco's Golden Gate Park. Perhaps his most famous commission was to carve the west pediment of the United States Supreme Court building, which bears the inscription "Equal Justice Under Law." On the day that Audrey called, however, this sober and somewhat reticent artist was buried in his work. It was a friend who answered the door.

Audrey, in a black hat, was alone. She seemed troubled and discouraged. Perhaps she was still mourning Herzog's sudden death and the uncertainty it had brought. Perhaps she was doubly nervous calling on the handsome and successful Aitken. She asked in a timid voice if there was

any work for a model. Aitken did not even look up as he barked: "I never use models."

The friend had immediately noticed Audrey's finely chiseled features. As if to soften Aitken's directness, he asked Audrey for her address. "I may be able to use you for some of my photographs," he said.

The friend, as Audrey's luck would have it, was the remarkable photographer Arnold Genthe. Originally from Berlin, Genthe was an austere and erudite man who wore starched collars. In his self-portraits, he portrayed himself as a deeply thoughtful man. Genthe was a born intellectual but had an adventurous spirit that brought him an exciting life. The son of a professor of Greek and Latin, he himself earned a PhD in classics. Fellow artists called him "Herr Doktor."

Genthe had immigrated to San Francisco in 1896 to become the tutor of the children of a German baron who had married the daughter of a California mining tycoon. Once in the New World, he taught himself photography. He became fascinated by the inhabitants of San Francisco's Chinatown and would prowl the streets to take photographs, sometimes hiding his camera to avoid protest.

By the time he met Audrey, he was already fabled for his most famous image: a shocking but beautifully framed photograph of the aftermath of the 1906 San Francisco earthquake. Genthe's studio had been destroyed by the quake, and he watched as militiamen dynamited the entire block. Borrowing a camera from his dealer, he photographed the devastation and the stunned reaction of the city's inhabitants. *Looking Down Sacramento Street, San Francisco, April 18, 1906* showed residents sitting on chairs on the sidewalk outside their collapsed homes at the top of the hill and watching the approaching inferno that would eventually engulf their houses.

When Audrey called, Genthe had only recently moved to New York. He had just become the first person to have a color photograph on the cover of a magazine—a rainbow over the Grand Canyon. He would eventually take portraits of many of the leading lights of his day, from the poet William Butler Yeats and conductor Arturo Toscanini to oil baron John

D. Rockefeller and President Woodrow Wilson—and, eventually, glamorous shots of Greta Garbo that boosted her career. He would include Audrey in his *The Book of the Dance* (1915) alongside such now-legendary modern dancers as Anna Pavlova, Isadora Duncan, and Ruth St. Denis.

In the weeks after Audrey called at Aitken's studio, Genthe made a number of images of her, including several color plates. One in particular showed her in a revealing pose, with thin drapery over her graceful figure. Aitken saw the alluring photograph lying out on the table when he visited Genthe's studio. "You certainly are a lucky devil," he exclaimed. "If I could get a model like this, I certainly would use her. Who is she and where did you find her?"

"Her name is Audrey Munson, and I found her one rainy afternoon when she came to the door of the studio of Robert Aitken," Genthe replied.

Arnold Genthe photographed
Audrey for a book with famous
dancers Isadora Duncan, Anna
Pavlova, and Ruth St. Denis.

Audrey posed for photographers, illustrators, painters, sculptors, and one tapestry weaver, generating hundreds of works—illustrations for books and magazines, stained-glass windows, oil paintings, and bronze and marble sculptures. As all the work came to completion, she found her way onto monuments, mansions, bridges, fountains, public buildings, and even steamships. She claimed there were once forty images and sculptures of her in the Metropolitan Museum of Art alone. By no means have all the works inspired by Audrey been identified. Some are identified here for the first time. And others that have been previously named now have their attribution put in question.

Her beauty coupled with such industriousness made Audrey a sensation in the art world. She became the Queen of the Artists' Studios. At times, her unsolicited house calls could lead to hilarious confusion—as the British humorist P. G. Wodehouse would find out.

Wodehouse is famous for his comic characters Bertie Wooster, the hapless idler, and his ever-capable manservant Jeeves. But before those two ever saw the light of day, Wodehouse wrote show songs for London's West End with composer extraordinaire Jerome Kern, one of the great pioneers of the Broadway musical. It was Kern who wrote *La Belle Paree*, in which Audrey appeared as a chorus girl alongside Al Jolson. Kern went on to create perhaps the greatest musical of all, *Show Boat* (1927), to which Wodehouse contributed some lyrics. Kern had introduced Wodehouse to fellow Englishman Guy Bolton, who became a lifelong collaborator and friend. Together, the trio revolutionized American musical theater. Kern would write the catchy music, Bolton the engaging plot, and Wodehouse the witty lyrics. Wodehouse and Bolton moved to New York to write shows for Broadway.

Crashing to complete the book for Kern's *Oh, Lady! Lady!*, Wodehouse and Bolton camped out at an apartment in Greenwich Village that had previously been occupied by the painter and sculptor Leon Gordon. And that is where Audrey stepped unwittingly into their world.

Before leaving for the day, Wodehouse's wife, Ethel, had alerted the two writers that a "lady decorator", would be calling at the apartment to

take away a sofa that was in need of repair. Wodehouse and Bolton took note and set to work. After a stint of writing, however, Bolton found himself in need of further inspiration and went out to buy some tobacco. While he was out, the doorbell rang. Wodehouse, awaiting the "lady decorator," opened the door. It was Audrey, calling to see whether the resident sculptor needed a model to pose.

There was confusion on both sides.

Still musing on his lyrics, Wodehouse was in a distracted state. He was expecting a "lady decorator" to remove the sofa. In his plummy accent, he launched into a rambling explanation of the job that needed to be done.

"It's the legs that are the problem," he said.

Audrey, believing she was speaking to a sculptor in need of a model, was perplexed by the bumbling Englishman's concern, and quickly reassured him.

"You need have no anxiety about those," she replied tartly.

Wodehouse seemed satisfied and moved on, in a very English way, to the matter of the price.

"And how much will it be altogether?"

Still struggling to understand this strange transatlantic specimen, Audrey sought clarification.

"You want the altogether?"

Wodehouse, his mind unable to focus fully on the shabby sofa, continued to dig himself deeper and deeper into his hole.

"Oh, while I remember, the seat. It should be covered with a piece of chintz," he said. "To hide the legs, if they show too much sign of wear and tear."

Audrey, following his instructions, walked straight into the bedroom and stripped off her clothes. Moments later, she emerged in what the shocked Wodehouse described as "an advanced state of nudity."

This was no lady decorator, he realized.

The mix-up was compounded by a second ring at the doorbell that brought the real lady decorator, along with a male assistant in overalls.

Seeing the naked Audrey, the female decorator suggested it would be better if she returned another time. Her male assistant, on the other hand, seemed reluctant to go. "His eyes, as they rested on the bedroom door, were protruding some inches from the parent sockets," Wodehouse noted.

The comedy came to an end only when Bolton, who knew Audrey from the New York scene, returned with his tobacco. Audrey found it all too funny. She hurriedly put on her clothes, enabling Bolton belatedly to make the formal introductions. She left the apartment chuckling so loudly that her laughter echoed after her down the hall. It was then that Bolton realized he had found his inspiration: he would write a scene in the musical of an artist meeting his love interest in this way.

The next day, in response to the farcical encounter, Wodehouse wrote a song in *Oh, Lady! Lady!* parodying the art scene in Greenwich Village:

> *Oh, down in Greenwich Village*
> *There's something, 'twould appear*
> *Demoralising in the atmosphere.*
> *Quite ordinary people*
> *Who come and live down here*
> *Get changed to perfect nuts within a year*
> *They learn to eat spaghetti*
> *(It's hard enough you know)*
> *They leave off socks*
> *And wear Greek smocks*
> *And study Guido Bruno.*
> *For there's something in the air*
> *of Greenwich Village*
> *That makes a fellow feel he does not care.*

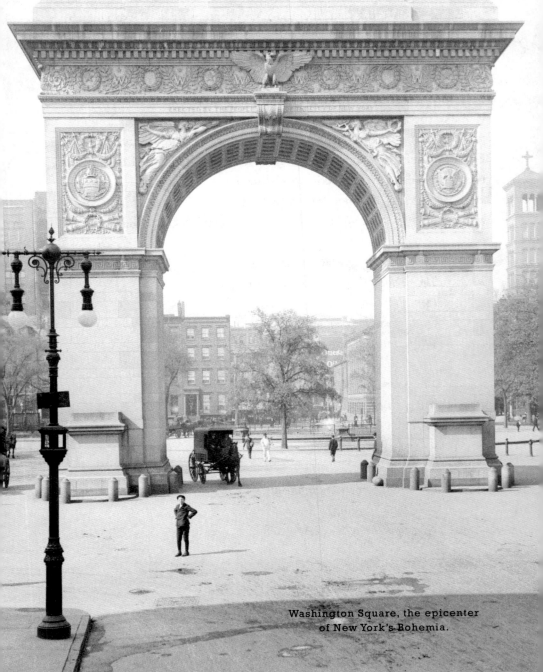

Washington Square, the epicenter
of New York's Bohemia.

5

BOHEMIA, NEW YORK

Knocking on studio doors, Audrey quickly realized that New York's art scene was divided into two categories of inhabitants: artists and "pseudo artists." It was easy, she found, to tell them apart; their furnishings gave them away. Pseudo artists decorated their studios with oriental carpets and velvet curtains and lit them with candles to create an atmosphere of the exotic, where they could dream great dreams, as if in an opium den. True artists worked in messy, unadorned workshops and bone-chilling cold stables.

Such was the intoxicating brew of New York's Bohemia, where men in corduroy and without ties breakfasted at five o'clock tea and dined the following day, and women could smoke, go hatless, and say "damn" in public—and even become artists themselves. "Some of the men dress like women and some of the women dress like men. It is their way of expressing individuality," the *New York Sun* observed. "That is the long and the short and the thick and the thin of their cult—of all bohemianism—the expression of individuality."

Audrey, the former Catholic schoolgirl, and mommy's girl, found the freedom of this world alluring. The dedication to art and the disregard for money and class was liberating for a poor girl from upstate. She had

the one commodity that the artists prized most: beauty. "The lure of the studio is an intangible glamour which few workaday people of an everyday world can understand," she purred.

The concept of Bohemia was itself imported from France, as New York began to challenge Paris for cultural supremacy. The French term was based on a misunderstanding. French artists, when they moved into the cheap garrets of the Gypsy quarter of Paris, mistakenly believed that the Romany had arrived in France in the fifteenth century from the central European region of Bohemia. French writer Henri Murger, a friend of the poet Charles Baudelaire and the painter Gustave Courbet, published a series of short stories in a small literary magazine romanticizing the artistic life in the Latin Quarter of Paris in the 1840s. His *Scènes de la Vie de Bohème* (1845) became a successful stage play and went on to inspire perhaps the most popular opera of all time, Puccini's *La bohème* (1896).

The cult of the artists' model first became firmly established in the popular imagination in America with George Du Maurier's runaway bestseller *Trilby*, set in the Bohemia of Paris in the 1850s. The novel, serialized in *Harper's* magazine in 1894, told the story of the model Trilby O'Ferrall, who is hypnotized and seduced by the roguish Svengali, a name that continues to epitomize a domineering and manipulative man today. It was *Trilby*, which sold 200,000 copies in the United States alone, that first introduced the phrase "in the altogether."

Audrey was one of many young women posing for the artists. She worked hard, as she always had, and was a quick study. She devoted herself to understanding her artists' sometimes peculiar demands. By taking her job seriously, she distinguished herself from many other models who were just there for the easy money and the fun. Audrey knew her mother, who was still living with her and monitoring her every move, would not tolerate any dallying.

"If an artists' model wants to keep the place she has won she must be business-like," Audrey insisted. "Every model who is a real success must study the work of the persons she is with. Many think that posing is simply taking a certain prescribed position and holding it for a stated length

of time, and that outside the physical strain it is easy. Try it and see."

Among the other girls that Audrey encountered starting out as an artists' model was the future film star Mabel Normand, later hailed as "the female Charlie Chaplin." A year younger than Audrey, Normand had posed for illustrators Charles Dana Gibson, James Montgomery Flagg, and Henry Hutt. "She had come over from Staten Island to seek a career among the studios, and was struggling hard to keep serviceable shoes on her feet and achieve three meals a day with anything like regularity. Through all her struggles, she was bright and cheerful, and always prompt and willing to work long hours if an artist was hurried," Audrey said.

The artist's studio could be a gateway to fame and fortune, but the perils and temptations of Bohemia were many. On the studio circuit, Audrey heard innumerable stories of models led astray by the blandishments of so-called artists who were more interested in enjoying women's flesh than sculpting it.

The point was driven home when a former school friend named Elsie Weller came to stay from Syracuse. Elsie came from a good family but had lost her father as a child and wanted to become a model to help support her mother. Audrey considered her exceptionally pretty, with a fine figure—but Elsie was a little too confident of her looks, and that made Audrey worry. Elsie seemed to be positively looking forward to posing nude.

Elsie moved in with Audrey and Kittie in their small apartment. Audrey introduced her to artists she knew and trusted, and warned of the unscrupulous womanizers she might encounter in Bohemia. Elsie always reassured her that she was strong enough to resist such pests. After several weeks, however, Audrey noticed that Elsie had stopped working in the daytime and was now posing in the evening hours. She said she was working for an artist Audrey knew but had never worked for. A claxon went off in Audrey's head.

"The artist she named was one whose studio was a thing of beauty, with soft, rich draperies of ancient textiles; with rugs that were softer to the feet than any velvets, and with decorative corners imported from some

foreign collector of things left behind by the Medicis," Audrey said. "It was the studio of a dilettante, and not the workshop of a real artist. And yet some fairly good things had been done there. The artist often had asked me to work for him, but I had been warned to stay away from studios where there was too much luxury, and where there seemed to be too much of the equipment for midnight revels, and I always had followed that advice."

Elsie came home later and later each night. She acquired a ring, and then another. Occasionally, she'd take an expensive taxi ride back uptown. The crisis point came when Elsie arrived at the modest apartment wearing a new dress from a fashionable Fifth Avenue dressmaker. Elsie insisted that the artist was just paying her extra for evening sessions. But both Audrey and Kittie knew immediately that Elsie had gone too far. Audrey wanted to write to Elsie's mother to alert her to the danger, but Kittie stopped her. "I know how unhappy it would make her," she explained. "Perhaps we are doing Elsie an injustice." Perhaps Kittie was trying to spare her friend's feelings, but perhaps she was just more worldly than Audrey and thought nature should take its course.

Determined, and possibly curious, or even jealous, Audrey decided to investigate. When Elsie did not return home by almost midnight, Audrey went to the artist's studio in a building by Bryant Park. The elevator attendant knew Audrey and took her right up. The Japanese butler opened the door to her. Inside, Audrey could hear singing and raucous laughter coming from behind a curtain. She demanded to see Elsie, and the Japanese butler bowed and complied. A brief hush fell over the assembled carousers and Elsie emerged, her hair disheveled, her face flushed with alcohol, clutching a robe to her naked body as if she had just stepped off a pedestal.

Outraged, Audrey marched into the studio to confront the artist. There she found just what she had feared. All the young women were so-called models. And as for the men . . . "The men were the kind of men who were known as frequenters of just such studios, the usual friends of the men who support elaborate, luxurious studios and play at art for no more serious reason than to lure into their clutches beautiful young women with whom they may do as they like after they have broken down

their reserve by initiating them into the freedom of posing in the 'altogether,'" Audrey said.

Audrey dragged her childhood friend out of the room. But Elsie soon moved out of Audrey and Kittie's apartment and took a room of her own so she could continue her profitable carousing.

The incident left Audrey with a disdain for the rich pleasure-seekers of Bohemia. It was a snobbery she had learned from the dedicated, serious-minded artists for whom she posed. She clearly did not classify herself a Bohemian. She found the term pejorative. "This word 'Bohemia' which is so often used to designate the world in which painters, sculptors and models work has done immeasurable injustice to many hard-working models and conscientious artists," she complained. "There is no such thing about the world's real artists. What is generally known as 'Bohemia' in New York is peopled by only two classes—rich men who are only pseudo artists and models who are only pseudo models."

Audrey shunned the dinners and late-night parties that other models enjoyed, and avoided the jewels and wads of cash some girls received as sexual bribes. "There is no time for late suppers and I shouldn't go to them if there was: a model who means business cannot go out and stay up all hours of night," she told the reporter who interviewed her on her twenty-second birthday. "Another thing against late hours is your appearance. Models who take their work seriously know they must look well, they take care of their complexions and their tempers, for it does not do to carry a nervous grouch to a studio with you."

To the extent that there was a geographic center of New York's Bohemia, it lay in Washington Square in the heart of Greenwich Village. Once a potter's field burial ground for the city, the square contains some 22,000 paupers' graves. A yellow fever epidemic in 1822 pushed many New Yorkers to flee to the area outside the quarantine zone, and by 1833 The Row, a group of elegant town houses along the north edge of the square, had become a fashionable address. As artists moved in, the streets north of Washington Square became jokingly known as Upper Bohemia. The poorer area to the south of the square, once known as

Little Africa because of the many blacks who lived there, was now popu-
lated by recent Italian immigrants and became a rabbit warren of smoke-
filled restaurants and tiny basement tea shops. Villagers lived "la vie
bohème," eating at Polly's, originally at 137 MacDougal Street and then at
5 Sheriden Square, and the Black Cat, at 557 West Broadway, or debating
at teahouses such as the Purple Pup, the Pirate's Den, or the Mad-Hatter.
Anna Alice Chapin, in her book *Greenwich Village* (1917), wrote: "The
Village is a protest against Puritanism."

When Audrey arrived, Greenwich Village was in ferment with new
ways of living and new ideas: anarchism, socialism, psychoanalysis,
cubism, women's suffrage, birth control, vegetarianism, Esperanto, and
free love. In January 1913 the wealthy bisexual banker's daughter Mabel
Dodge launched a salon at 23 Fifth Avenue that was an early manifesta-
tion of "radical chic." She gave the discussions provocative names: "The
Dangerous Characters Evening," "The Sex Antagonism Evening," and the
evenings of "Art and Unrest." A few blocks away at 91 Greenwich Avenue,
Max Eastman published the *Masses*, the influential socialist magazine
run by a workers' cooperative to which Mabel Dodge contributed several
articles. Dodge would soon also help set up the Provincetown Players,
an artists' collective at 139 MacDougal Street that launched playwright
Eugene O'Neill. Dodge's sometimes lover John "Jack" Reed was the star
correspondent of *The Masses* and, with Max Eastman, a founding mem-
ber of the Players. The group's first production in New York was a thinly
veiled portrayal of Reed and Dodge's affair. Reed, mostly remembered
now for his account of the Russian Revolution in his book *Ten Days That
Shook the World*, described the atmosphere in the Village in his book *The
Day in Bohemia: Or Life Among the Artists* (1913):

> *Yet we are free who live in Washington Square,*
> *We dare to think as Uptown wouldn't dare,*
> *Blazing our nights with arguments uproarious;*
> *What care we for a dull old world censorious*
> *When each is sure he'll fashion something glorious?*

Audrey lived in the crucible of a new world coming into being. She enjoyed the newfound liberties for women and adopted the casual style of downtown, shunning the corsets that her mother had once sold, and, on Konti's advice, high heels. Unlike uptown, it was quite acceptable for a young woman to appear in public in a work smock. Yet Audrey stayed clear both of the politics and the partying.

She had met her first real boyfriend—the one she called "my first true love." The boy was not a penniless spaghetti-eating Bohemian with a paintbrush and extravagant ideals. Nor was he a wealthy pseudo artist. He was a humble pastor's son.

In fact, Kittie met him first. According to Audrey's meager account, she arrived home from running an errand to find him sitting in the kitchen with her mother. Kittie was covered by her big blue-and-white-checked apron and cooking. The air was sweet with the smell of freshly baked apple pies—and romance. "My hero had just taken one large-sized bite out of cookie fresh from the oven," Audrey said. One night, on their way back from the movies, he asked her to marry him.

Albert Otto Stark, born April 25, 1889, was the son of a German-born minister. His father, William A. Stark, an "eloquent, logical and forceful preacher," had served as a pastor of churches in Buffalo, Hoboken, and Baltimore before moving to the Second German Methodist Episcopal Church at 348 West Fortieth Street in Manhattan in 1906—although Audrey later misidentified the church. The fact that Audrey's boyfriend was a preacher's son must have pleased the conservative Kittie.

A "slender" man of "medium" build with blue eyes and brown hair, Albert worked as the manager of the export department of the Atlas Portland Cement Company. He also lived far uptown at 55 West 112th Street. He was one of seven children, but he came from a sickly family. Two of his siblings died in infancy. His father died of heart disease at home at 250 West Fortieth Street on April 5, 1907. In those days, a woman could expect to have to rely on her husband to earn a living. The Stark family's recurrent heart problems—which continue to this day—cast doubt on Albert's ability to do so, however much he loved Audrey.

Audrey was much too poor and vulnerable to take such a big risk. Her concern about his rickety heart would turn out to be misplaced: Albert died in Bradentown, Florida, in July 1967, at the age of 78. Nevertheless, Audrey was merciless. "His father died of heart trouble and his son inherited it," she complained. "Dismissed him when I discovered he had valvular heart trouble and occasional attacks." Her career as an artist's model guaranteed that there would, as the fortune-teller predicted, be plenty more eligible young men.

In the meantime, Audrey had a living to make. She discovered that a good model, particularly a good nude model, got passed among the artists from hand to hand. With letters of introduction, diligent door-knocking, and her characteristic pluck, Audrey had worked her way up the artistic food chain from photographers to illustrators who put her in magazines to painters who reproduced her in oil to sculptors who carved her into stone for eternity on a colossal scale.

Audrey joined the Art Workers' Club for Women, a voluntary organization that functioned as a union for female models and artists. The club had been set up in 1898 by the artist Helen Sargent, who noticed the model in her life class at the Art Students' League was badly ill and did not have money for a doctor. The Art Workers' Club operated an employment bureau for models, whose goal was to "help the models, dignify the profession of posing, and enable the artist to procure prompt and reliable service." Male artists who wanted to pore over photographs of the models available had to become subscribers at a two-dollar annual fee. By the time Audrey arrived in New York, the club had more than 150 members.

Artists were soon on first-name terms with Audrey. Her fine features made her an easily recognizable figure in the Village. Although the art community was often ridiculed by outsiders for its pretensions, it was like a family. Hungry artists who couldn't even scrape together a living would spend their last dollars to buy a picture to help a friend or to entertain at Polly's. Audrey, whose own family was fractured, appreciated this mutual support. The artists became like family to her, albeit briefly.

For half a century, the art world had revolved around the Studio Building at 51 West Tenth Street. Opened in 1857, the redbrick building on the north side of the street was the first in America to be devoted entirely to artists' studios. It was designed by Richard Morris Hunt, the first American architect to train at the prestigious École des Beaux-Arts (School of Fine Arts) in Paris. Twenty-three artists' studios surrounded

The Tenth Street Studio Building where Audrey worked.

a double-story exhibition space. From the very beginning, the concept attracted leading talents such as Frederic E. Church, Albert Bierstadt, Winslow Homer, and John La Farge. Hunt taught a generation of architecture students at his atelier in the building. In 1878 the artist William Merritt Chase moved into the exhibition space, creating an opulent studio that helped set the style for years to come. In the second half of the nineteenth century, the Tenth Street Studio Building became known as a center of the Hudson River School. But it accommodated all stripes of artists—as Audrey found out. Many of its residents were inspired by her, such as sculptor Alexander Stirling Calder, whose even more famous sculptor son, also named Alexander Calder, lived in the building as a child.

Audrey looked on the Tenth Street Studio Building almost as a temple. "It is a building of some fifty studios—each with its reception room, its dressing room for models, and its big work room with the precious north light shining through great window panes," she said. "The halls are dark and dingy; the studios are barren and cheerless—for these are not the kind of studios . . . where pseudo artists set themselves amidst an atmosphere of Oriental luxury with soft rugs and costly draperies, and then, because they surround themselves with bizarre and Babylonian settings, they are 'artistic.' They are the studios where great men work hard and care little for the atmosphere in which they work."

The muralist William de Leftwich Dodge, who had given Audrey her letter of introduction to Konti, had his studio there. A man with a lush brown beard, he liked to wear a contrasting white suit in the style of Mark Twain. Dodge had grown up in Paris after moving to Europe with his artist mother as a child and took first place at the prestigious École des Beaux-Arts in 1881. By the time he met Audrey, he had already painted richly colored murals for the Library of Congress, the Surrogate's Court in New York, the Algonquin Hotel, and the 1893 World's Columbian Exhibition in Chicago. In 1904 he had won a landmark lawsuit on artists' rights to prevent the King Edward Hotel in Toronto from changing his History of Canada murals.

Dodge used Audrey as a model for one of her most unusual jobs. He put her image on the largest side-wheel steamboat in the world, the *City of Detroit III*. Dubbed the Queen of the Great Lakes, the ship went into service on the run between Detroit and Buffalo in 1912. It boasted lavish interiors, including a breathtaking grand salon decorated by Dodge with a painting of a seductive siren inspired by Audrey.

The Tenth Street Studio Building even had its own in-house photog-

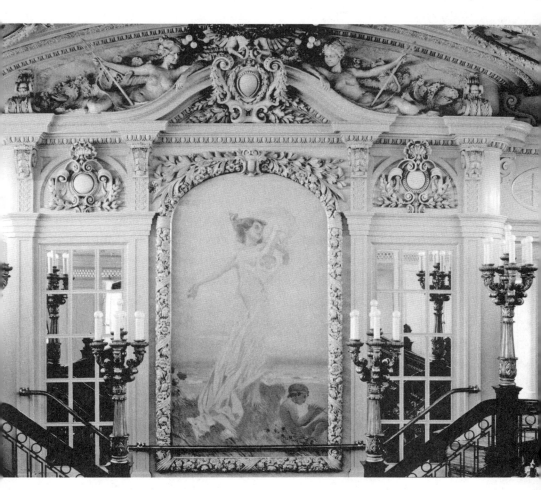

Audrey inspired William de Leftwich Dodge's murals aboard
the *City of Detroit III* paddle-steamer.

rapher. Oscar H. Sholin, grew up in the building because he was the son of the live-in janitor and "janitoress," Peter and Agnes Sholin. Oscar was only twenty when he took a series of portraits of Audrey in costume in 1915. They showed her in a simple ancient Greek gown, her hair neatly held back by a cord around her forehead. In one, she stares straight into the camera, holding a bouquet of roses on her lap, with her long, black ponytail draped forward over her left shoulder. Her Greek gown has a plunging neckline, and even in the sepia print, her skin seems preternaturally smooth and lucent.

A short walk from the Tenth Street Studio Building lay the artists' studios on MacDougal Alley, a mews of former stables behind the mansions of Washington Square North. In Audrey's time, the mew was so crowded with sculptors that it was known as Donatello's Alley. "Every time that a dweller on Washington Square or Eighth Street decides he can't afford a carriage any more or that his stable won't do for a garage, and offers the said stable for sale there is a sudden rush of frenzied artists to the spot," the *New York Times* said.

The alley generated such a tight-knit artists' community that when the *New York Times* wrote about it, the newspaper deliberately did not say where it was, so as not to attract gawkers. In the summer the artists left their doors open while they worked, and their wives—with one notable exception the artists were all men—sat on chairs outside, with their children playing around them. "For the denizens of Macdougal alley are like one large family," the *New York Times* gushed. "They dash about, bareheaded, and duck into their neighbors' houses without ceremony. Artists and literary folk from the outside world find their way to jovial nocturnal entertainments in the studios, or sit about for hours while the light is good watching art in the making. When the weather is fair sculptors and painters issue forth from their dens to play ball in the middle of the alley, occasionally making way for the carriage returning from afternoon teas and receptions, to the stables not as yet transferred into art factories."

Daniel Chester French, regarded as the leading American sculptor

of his generation, worked in the alley. Audrey was to become one of his favorite models. The neatly mustachioed French, who often wore bow ties, worked first at No. 11 MacDougal Alley and then at No. 17. He is best remembered today for the dramatic seated Abraham Lincoln of the Lincoln Memorial in Washington, DC.

Next door at No. 19 MacDougal Alley, now 17½, lay the studio of the heiress sculptor Gertrude Vanderbilt Whitney, who would go on to found the Whitney Museum of American Art in three houses on West Eighth Street that backed onto the alley.

Mrs. Whitney, as she became universally known, came from one of the richest families in America. She was the great-granddaughter of the legendary Cornelius Vanderbilt, "the Commodore," who had started out rowing his skiff as a ferry to Manhattan before moving into railroads and ending up, according to *Forbes* magazine, as the second-richest American of all time. Gertrude grew up in the French Renaissance château that her father built on Fifth Avenue between Fifty-Seventh and Fifty-Eighth Streets, where the Bergdorf Goodman department store now stands. At the age of four, she cut off her curls in the hope of being treated the same as her brothers, but she received a stern reprimand instead. At twenty-one she married the boy across the street, Harry Payne Whitney, who also came from a vast fortune and became a polo player and racehorse breeder—although he had the unpromising nickname Moody. She bore him three children but became disenchanted with the marriage when he started cheating on her, and by the time she met Audrey, she was having affairs herself.

Mrs. Whitney yearned to escape her gilded cage and become an artist. It gave her life meaning. Friends and family feigned to take her passion seriously, but she was serious indeed. She took classes at the Art Students' League and went to study in Paris, where she received private critiques from sculptor Auguste Rodin, then one of the most admired artists in the world. She became a trailblazer for women in the crushingly male art world. Old photos show her split personality: formal portraits portray her in elaborate ball gowns draped with pearls, her hair carefully

Audrey was known as the Venus of MacDougal Alley where many famous
sculptors had their studios.

coiffed, but casual snapshots catch her grappling with muddy clay in her
studio in a simple white smock with no makeup. She had a penchant for
loose English slacks, and was one of the first women to make it fashion-
able to wear pants.

Mrs. Whitney was the seventh sculptor to move into MacDougal

Alley when she transformed the former stable into her studio in 1907. One shocked headline writer spouted: DAUGHTER OF CORNELIUS VANDERBILT WILL LIVE IN DINGY NEW YORK ALLEY. Her studio was the only one with windows on the ground floor, and she was so annoyed by curious onlookers that she threatened to douse them with ammonia or pour a kettle of hot water on them from upstairs. "They seem to have the idea that artists are not like other people, and spend their lives eating spaghetti," she complained. "They come to the window and stare and stare, when I am at work or at my meals, and if they find the door unlocked they actually walk in to take a look at the interior of the studio."

As a sculptor, Mrs. Whitney began with sensuous statues of the male nude. With the onset of the Great War, her art assumed a harder and more worldly edge.

Audrey was a rare female model invited into Mrs. Whitney's commodious studio. Audrey found the experience soothing. Mrs. Whitney, though sixteen years older, was tall and slim and graceful, like Audrey. Perhaps she saw in Audrey the innocence and anonymity she never enjoyed herself. Audrey's genuineness won Mrs. Whitney over. As Audrey posed in the converted stable, sometimes kneeling naked as if in prayer, her head bowed, Mrs. Whitney carried on a one-sided conversation with her. The sculptor could talk, but the model could not. While she worked, the multimillionaire confided in the former chorus girl about her struggle to be recognized as an artist. "When I began to be a sculptor and it was whispered about, my friends took the attitude of a group of well-bred people condescendingly watching one of their number trying to do a parlor trick," Mrs. Whitney lamented. "They just couldn't get the idea of a Vanderbilt actually working." Life as a Vanderbilt was an alien world for Audrey. She marveled that Mrs. Whitney seemed delighted to sell a small figure for $1,000 while her fortune had multiplied by twenty times that amount in the time it had taken her to craft the sculpture.

At the time Audrey was posing for her, Mrs. Whitney decided that contemporary American artists, overshadowed by European art, needed a space to show their work. It was a gesture that would change the Amer-

ican art world. In 1914 she turned her Eighth Street house into the Studio Gallery for art shows. The following year, at the urging of New York "society sculptor" C. S. Pietro, another of Audrey's modeling clients, Mrs. Whitney set up the Friends of the Young Artists with its headquarters in Pietro's studio at 630 Fifth Avenue. It was the forerunner of the current Whitney Biennial.

When Pietro died in 1918, Whitney opened the Studio Club, a meeting place and exhibition space for young artists, first at 147 West Fourth Street and, from 1923, in Whitney's Eighth Street house. That was the origin of today's Whitney Museum of American Art, established in 1931 at 8, 10, and 12 West Eighth Street after the Metropolitan Museum of Art rejected Mrs. Whitney's donation of her collection of 700 pieces as too modern. Flora Miller Biddle, her granddaughter, concluded in her family memoir: "Making sculpture freed her from a constricting world, her lovers represented the hurt and anger she felt at her husband's affairs, and her patronage, culminating in her creation of the Whitney Museum of Modern Art became her expression of her family's wealth and power."

Audrey remained a staunch admirer of Mrs. Whitney, despite her many naysayers. "There are scores of artists in New York, San Francisco and Chicago who are at least moderately prosperous now, some of them even extremely popular and busy, who owe their start towards financial success to this 'Poor Little Rich Girl of the Art Set,'" she said. Newspapers dubbed Gertrude Vanderbilt Whitney the Godmother of Greenwich Village and Audrey the Venus of MacDougal Alley.

6

THE CLASSICAL IDEAL

On the clear, fresh morning of September 9, 1913, America's leading sculptors and architects bundled aboard the train in New York City and rode through the newly completed railroad tunnel under the Hudson River to gather at the Englewood Country Club in New Jersey. It was their annual Field Day.

Audrey joined them excitedly. She was by now the most popular model in the art world. These sculptors not only knew every curve and crease of her body, they also adored her. Each saw her as his ideal of womanhood. Although she did not like the word, they had become her Bohemian family. Audrey knew she had a special role to play at the Field Day.

New York's artists fancied themselves to be in ancient Athens, even when they were in New Jersey. Their idea of fun was to stage a mock Olympic Games. The real Olympics, which once featured athletes running and jumping in the nude, had been revived in modern form in Athens in 1896 after a two-millennium hiatus. But the modern Olympics bore little relation to the contest in Englewood. The sculptors and architects battled merrily at tennis and golf and staged a chaotic "burlesque baseball game." The event showed the extraordinary heights of the classical craze.

The Field Day was organized by a number of architects' societies, including the Architectural League. All the leading American sculptors of the day were members—and all had portrayed or were to portray Audrey in one form or another: the handsome Robert Aitken, in whose studio she had met Arnold Genthe; the punctilious Isidore Konti, who first persuaded her to pose nude; the Sicilian Salvatore Scarpitta, who did a silver Lady Godiva of her for a shop window on Fifth Avenue; Adolph Weinman, who put her atop the New York City skyline; the grandee Daniel Chester French, who christened her Miss Manhattan and Miss Brooklyn; Alexander Stirling Calder, who made her his Star Maiden; Attilio Piccirilli; Allen George Newman; Sherry Fry; Augustus Lukeman, who used her for the Straus Memorial to the *Titanic* disaster; Frederick MacMonnies, who put her on the New York Public Library; and Konti's lifelong friend Karl Bitter, whose fountain of Audrey outside the Plaza Hotel was the very last work of a life tragically cut short.

The exhausted and exhilarated contestants ended the day at a faux Athenian ceremony staged in a reproduction of a Greek theater. Cass Gilbert, who had designed the new Woolworth Building in lower Manhattan, the tallest skyscraper in the world, gave out the prizes. The President's Cup for winning at golf went to architect Frank A. Moore. The Champion's Cup for tennis doubles was won by Yale-educated New York architect George Chappell and his Columbia-educated partner Charles MacMullen.

After a banquet dinner in the sprawling clubhouse overlooking the final golf hole, the 140 guests were treated to the carefully prepared Englewood Ballade. It was an extravagant celebration for a confident and booming profession. The "Russian dancers" alone cost $126. The bill for the performance came to $578.20—more than double the $230.05 taken in from ticket sales to members.

At the climax of the evening, architects and sculptors and models from the Art Workers' Club for Women donned flowing Greek robes to reenact the ancient Eleusinian Mysteries. The glamorous Aitken modestly played the great Renaissance sculptor Michelangelo. He was a vice

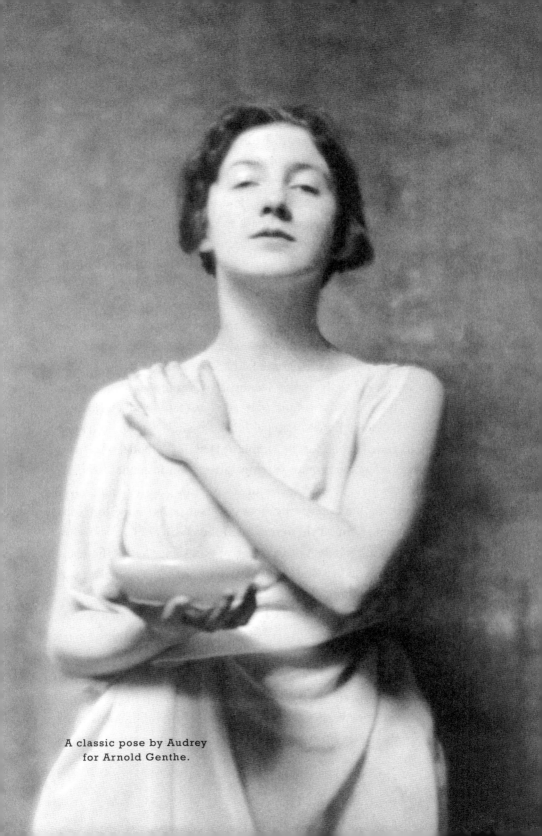

A classic pose by Audrey
for Arnold Genthe.

president of the Architectural League and no doubt chose the part himself. Audrey was cast as the Spirit of Truth and, in keeping with the mythological theme, the Spirit of Truth did not wear many clothes.

Ever since ancient times, artists had striven to find the perfect beauty. As early as the fifth century BCE, the Greek sculptor Polykleitos wrote in his "Canon" that beauty was achieved through the precise mathematical proportion of the parts to one another and to the whole. "Excellence is achieved through many numbers," he argued. This was the classical ideal.

Artists hailed Audrey as its modern reincarnation. The press dubbed her "the Most Perfectly Formed Woman in the World." William de Leftwich Dodge paid her the ultimate tribute of portraying her in a mural for a Fifth Avenue ballroom as Phryne, the foremost beauty of ancient Athens. The fourth-century BCE courtesan was known for shedding her clothes as she entered the sea, but she was acquitted of impiety after baring her breasts to her judges. Phryne had been a favored artists' subject ever since she served as the model for the first-ever life-sized statue of a female nude, the *Aphrodite of Cnidus*, by the most famous of all classical sculptors, Praxiteles, who was also her lover. Praxiteles also paid tribute to Phryne in gilded bronze at the temple at Delphi. "A model who loves the art to which she contributes is never satisfied until she has been selected to impersonate the famous beauty of Athens," Audrey said.

Audrey had come a long way since she first posed nude for Konti's *Three Graces*. Although she represented the classical ideal, she soon learned that each artist fetishized a different part of her body. The realization first dawned on her when she was frozen—in position, naked—in the studio of Konti's friend Salvatore Scarpitta.

Scarpitta, with his slicked-back hair, was part of an extended household of Sicilian-born immigrant artisan-artists. His sister Stella was married to his cousin C. S. Pietro, Mrs. Whitney's friend. Also living with them was Pietro's brother C. S. Paolo, who was also a sculptor. Scarpitta modeled Audrey as a silver Lady Godiva, which went on display in the window of the Fifth Avenue store of expensive silversmith Gorham's, a company from Audrey's former hometown of Providence that was an

early rival of Tiffany. Scarpitta eventually moved to Hollywood and made the sleek nude statue of Marlene Dietrich that is featured in her film *The Song of Songs* (1933), in which she plays an artists' model. Scarpitta's son, of the same name, followed the family tradition and also became a famous sculptor and was one of the Monuments Men who searched out artworks in Italy with advancing Allied forces in World War II.

"I see you have my model," Konti observed.

"Yes, and I wager you like her especially for the same reason," Scarpitta replied. "The dimples."

"You are right. I know of no other model who has them."

What had captivated the two artists were the two charming dimples in the small of Audrey's back. Audrey didn't even know she had them.

As soon as she got her rest break, Audrey asked Scarpitta which dimples exactly the two men had been talking about.

"Don't you know? Why, those dimples in your back," he said. "Few women have them. They are nature's rarest and most attractive beauty spots. I have never had a model whose complete back I could copy without suggesting a touch of indelicacy, no matter how beautiful her lines. But two dimples nestling on either side of the hips in the back seem to rob the most unattractive part of the feminine form of its unrefinement and increase its grace and symmetry, and, above all, the daintiness which takes away the effect of boyishness from lean hips."

Scarpitta gave Audrey a note of advice for the future. It remained with her for a lifetime: "Guard those dimples, my girl, and if you ever see them going—cut out the apple pie."

Scarpitta obviously knew about Kittie's home-baked apple pie.

Scarpitta's lecture on her dimples was an education for Audrey. "I learned," she said, "of the eternal search by artists, beginning in the time of the ancient Greeks, for two little dimples nestling in the flesh of the back just over the hips, and why, when it was seen that these two dimples were pressed by a kind nature into my back they proved to be as valuable to me as government bonds."

The discovery changed her attitude toward her own body. All of a

sudden she understood that men saw in her qualities that she did not see in herself.

Men like Adolph Weinman.

The German-born Weinman was sent to America at age fourteen to live with a relative who was a grocer. His first job was carving mirror frames, ivory pistol grips, mother-of-pearl ladies' powder boxes, and meerschaum pipes. He went to study at the Art Students' League, where he was a pupil of the influential sculptor Augustus Saint-Gaudens and later became an assistant to Daniel Chester French. Weinman's work ranged from the tiny Mercury dime to the colossal female figure of *Civic Fame* that still tops the Manhattan Municipal Building in New York. One of the oddest works in his long career would be the portrayal of Muhammad clutching a sword in a frieze of "great lawgivers of history" inside the US Supreme Court chamber. A Muslim group once sought unsuccessfully to have it removed as idolatrous.

It was Weinman, Audrey said, "who carved me into more marble than perhaps any other artist."

She first met him when she was still a nervous novice model. Konti had promised that Weinman was one of the most distinguished sculptors of the day, and given her a letter of introduction. She went unannounced to Weinman's workshop in the Tenth Street Studio Building. It was the first time she had ever cold called on an artist seeking modeling work by herself, without Kittie escorting her. When she knocked on the door, it was opened by a man with rumpled hair wearing a long apron with splotches of dust and clay all over his clothes. She thought he was the janitor.

"I wish to see Mr. Weinman," she announced.

"Come in; I am Mr. Weinman. What can I do for you?"

Flustered, Audrey presented her note from Konti. Weinman read it attentively.

"Well, let's see. You are a young girl, aren't you? How much experience have you had?"

Audrey was forced to admit that she had posed only very few times.

"Well, you look as if you should pose all the time. You are quite

Grecian—and yet you seem to have the warmth of emotion that the modern public likes to see in its models."

This was music to Audrey's burning ears. Weinman asked Audrey to disrobe so he could see what she looked like. At first, she was bashful and reluctant to emerge from behind the screen. She stuck a toe out. But Weinman grew impatient, and she tossed her head, squared her shoulders, bit her lip, and decided to, as she said, brazen it out.

When she stepped out into the studio's calm, even north light, her body was trembling. She was not in the least aware of her position. She just stood there, her hair cascading over her shoulders.

"There—stop—just as you are—hold that now," Weinman barked. "Put up your hands slowly—don't move the rest of your body—get the hands up—over your head as if you were fixing your hair—there—never saw anything like it. Hold it. Don't budge!"

He rushed to his easel and hauled it into the light in front of her. He began sketching furiously with charcoal in big, broad strokes. Every minute or so, he stepped back to survey his work and comment to himself. "That's it. Good," or "No—not that. That's not the hipline. The leg's out more than that."

Every one of Weinman's exclamations cut through Audrey. She was on edge. Weinman kept working for what seemed an eternity. She focused on keeping her pose, but she began to wither. Her arms were aching, her legs began to quiver. After what must have been thirty minutes, Weinman stopped and apologized. "Forgive me for keeping you in position so long. I was so interested I forgot. But you gave me an idea—a great idea—that pose of yours. It was splendid—so natural. Come look."

Forgetting she was naked, Audrey rushed over to the easel to take a look. She was so curious. She did not yet understand how artists transformed her image into art. What she saw was simply a basic scrawl of outlines. "It was just a rough—it seemed to me awfully crude—sketch of a girl's body, drooping and modest, and yet seemingly unafraid and fearless. Her upraised hands seemed to be carrying a burden, heavy, yet without weight; the body was beautiful, graceful and yet fragile. I saw in

it a vague resemblance to myself, but I could not imagine I could have been so dainty and graceful in my unconscious pose of bashfulness."

Transformed into sculpture, the hurried sketch became *Descending Night*, an instantly recognizable figure of a winged woman with her head bowed and her hair draped over her uplifted arms. It became one of Weinman's most famous, and most sensuous, works. The withdrawing posture of the figure, bent slightly at the knee, and the downcast face, the cheek turned slightly against the observer, were meant by Weinman to express the melancholy of nightfall, but they captured something essential and sad about Audrey too.

Descending Night created a magical chemistry between Weinman and Audrey. The sculptor used her as his muse for another of his most famous statues, *Civic Fame*, the gilded symbol of New York atop the new Municipal Building, which towers over the city to this day. Weinman also paid tribute to Audrey's resemblance to the Venus de Milo by using her as his model for a copy of the goddess of love discovered by a peasant on the Greek island of Milo in 1820, now in the Louvre Museum in Paris. According to Audrey, Weinman was commissioned by the queen of Denmark to re-create the statue with her missing arms. Audrey was his "Venus with Arms." She was the "American Venus."

Audrey later claimed she also served as a model for Weinman's Mercury dime for the US Mint, one of the nation's best-known coins. The tiny 90 percent silver coin served America through two world wars from 1916 to 1945, finding its way into the pockets of virtually every American. Bing Crosby sang about it in his Depression-era hit "Brother, Can You Spare a Dime?" More than 2.6 billion were minted until it was replaced by the profile of the recently deceased President Franklin Delano Roosevelt. The commonly used name of Mercury dime is based on the mistaken belief that the wings represented the Roman god. Weinman's coin is properly known as the Winged Liberty Head dime because the figure is wearing a winged Phrygian cap that was used in ancient Rome to symbolize being freed from slavery.

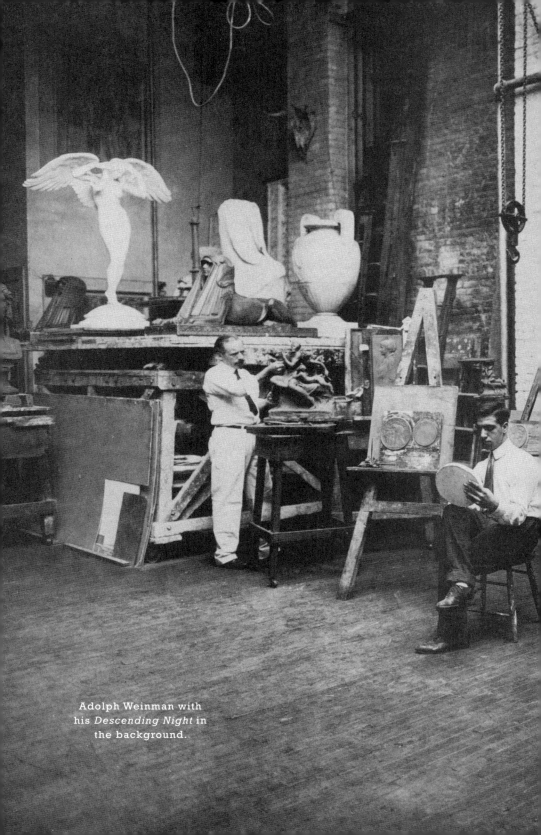

Adolph Weinman with
his *Descending Night* in
the background.

In 1915 Weinman won a government competition to design both the new dime and a new half-dollar coin: the Winged Liberty Head dime and the Walking Liberty half-dollar. Audrey was certainly not the main inspiration for either coin—but she may have played a more minor role. The Walking Liberty half-dollar was based on Weinman's Union Soldiers and Sailors Monument at West Twenty-Ninth Street and West Charles Street in Baltimore, which is still there today. The monument was dedicated in 1909, but the creative work on it began in 1905—far too early for Audrey to have been its model.

Weinman's design for the Winged Liberty Head dime was based on his 1913 bust of a beautiful tenant at his brownstone at 441 W. Twenty-first Street in Manhattan. The woman was named Elsie Kachel Stevens, a twenty-seven-year-old newlywed at the time. She had just become the wife of the poet Wallace Stevens. Roger Burdette, the leading authority on the two coins, says bluntly: "Audrey Munson was not Weinman's model for the dime." But Audrey's claim, transmitted through her family, was actually much more modest: Audrey said she was just one of several models who posed for Weinman when he created the dies to strike the coin.

Sculptors like Konti, Scarpitta, and Weinman were far too polite and high-minded to mention another reason for Audrey's success. Others, however, saw a more obvious explanation for the universal praise of Audrey's physical perfection: her fulsome breasts. The syndicated health columnist Dr. Lillian Whitney attributed Audrey's appeal to her ample bosom. "There dwells within the slim, graceful, well covered forms of Audrey Munson the soul of chaste womanhood and this finds its highest expression in the feature that is preeminently feminine—the female breast," the doctor wrote. "The desire of every right-minded girl and woman to possess a well-formed, well-rounded bosom springs from the very roots of her being. She may ascribe it to vanity; to a wish to compare favorably with others of her sex; to a pride

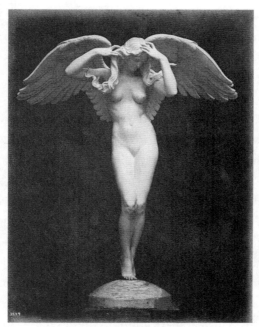

Audrey's iconic pose for Weinman's
Descending Night.

in her appearance, or a dozen other reasons, but fundamentally there is only one reason—she glories in her womanhood and in her possible motherhood."

American sculpture had come to express its highest ideals through the female form. It bordered on obsession. Allegorical female figures in few or no clothes were used to express abstract concepts such as truth, beauty, memory, and justice. Nevertheless, the nation remained surprisingly conflicted over public nudity—even in neoclassical statues. Audrey learned the unspoken rules of thumb for posing in the buff. "No model posing undraped must ever smile. If she does the representation of her becomes common, disagreeable, offensive," she said. Even odder was the widely held belief that motion itself suggested sexuality. Censors allowed static "poses plastiques" in the theater but balked at any moving nudity.

"[T]o keep the illusion of beauty and purity the artist must take care not to detract from the complete harmony of his model's beauty by

putting her in action," Audrey explained. "If the figures seems to be mov-
ing or if it seems to be engaged in any sort of action the mind is at once
offended by the thought of a woman going about some pursuit without
her garments or of flaunting her nudity by moving about."

When it came to female beauty, Audrey herself was definitely a
latter-day disciple of Polykleitos. She believed fervently in the "classical
ideal." She was an uncompromising proponent of perfect proportions.
"Few young women possess figures which, separated into their details, are
beautiful," she complained. "One who beholds a young woman walking
down the street sees her ankles and her face. If the ankles are trim and her
face pretty and her weight in good proportion to her height, the spectator
judges her completely attractive and of good figure. As a model, however,
her ankles might prove to be, no matter how attractive in themselves, out
of proportion to her calves, perhaps too trim or too full, or her lower limbs
might be well-shaped but too slender or too full for her hips—and so the
artists might find glaring imperfections in the ensemble, the altogether."

Her prescription for beauty was as exacting as any ancient Greek
sculptor. "The limbs should be straight in their tapering, the hips in pro-
portion to the waist and shoulders, with thighs thinning gradually to the
knee cap, and not with the well-marked 'curve' so many young women
are proud of," she said. "The knee at the cap should not be too slender
for the thigh above, and should swell with reserve into the calf. The inner
line from upper thigh to the heel should be almost straight, a slight part-
ing just below the knee, to touch again at the calf, and part again at the
heel. The ankle should not be a slim structure of bones, with tightly drawn
skin—the 'silken ankle.' It should be rounded and soft, sufficiently full to
detract attention from the ankle bone." Evidently she thought, and had
been told, she had all these traits.

America's "beauty industry" was developing as women gained greater
independence—particularly, the independence to shop for clothes. The
emergence of the "new woman," liberated from her corset, coincided
with the advent of "bathing beauty" contests, comely images of women
in illustrated magazines, and scantily clad theatrical revues. Audrey's was

to be the era of the illustrators' Gibson Girl and Christy Girl, and onstage, above all, the Ziegfeld Girl. "I have never met a beautiful woman, of society environments or working class, who does not want to be painted or sculpted," Audrey declared.

Famed for her perfect form, Audrey herself briefly became a beauty guru, dispensing tips in newspaper columns. She wrote the new wisdom she had learned in the artists' studios. Despite her mother, who was still looking after her at home, having worked as a corset saleswoman, or perhaps precisely because of that, she counseled against confining corsets, high French heels, garter belts, and even reading propped up in bed. But she perhaps betrayed her own overworking when she warned the new woman not to get too exhausted by her active lifestyle. "While the women of our country have many charms, regular features, well-kept figures, smartness in apparel, and, most of all, a keen and alert intelligence, there is one charm of which they show a serious lack," she wrote. "It is, to my mind, the greatest of all charms in women—repose."

For all the focus on the female form, Audrey rightly pointed out that the sculptors of antiquity saw beauty mostly in the male. Ancient statues depicted male athletes or male warriors, or even male slaves. But mortal women were seldom portrayed. Females had to be mythological goddesses in order to merit the ancient sculptor's attention.

Audrey found that the few women sculptors with whom she had worked, such as Evelyn Longman and Gertrude Vanderbilt Whitney, did their best work from the male. Mrs. Whitney once told a group of art students in her presence, "Beauty is masculine. Femininity in the nude is loveliness, grace, charm, allurement, and all that sort of thing, but uncovered masculine beauty is above charm or grace or lure—it is beauty itself, with strength, determination, symmetry, proportion and stateliness all combined to make it expressive of nature's best inspiration. No one would think of calling a real man 'pretty' and yet that is the best we can say of nine-tenths of our feminine models."

Audrey was scathing about the physical state of American manhood. "An artist must have, of course, well-proportioned, firmly fleshed and

shapely models, whether male or female," she observed. "A man with broad shoulders, thick, muscular arms, short stubby hands and with thin bony legs will not do at all for him. Nor will one with a protruding stomach. Yet ninety-nine men out of every hundred have one or more of these faults." The most common fault that sculptors find with male models, Audrey revealed, was that they have small feet.

The male artists also had their shortcomings: they were always looking for an excuse to get Audrey to remove her clothes—even if the work didn't require it. Although in her early twenties, Audrey was still an ingénue. She tended to believe their rather incredible reasons. They were paying, after all.

Arnold Genthe, who had a Japanese butler and had traveled and taken photographs in Japan, introduced Audrey to a Japanese photographer who had a commercial portrait studio on New York's Fifth Avenue. Unfamiliar with Japanese names, she knew him as "Toyo Kitchui." His real name was Toyo Kikuchi. He had been in America since 1904, working first in a photo lab in Seattle, Washington, and then in Portland, Oregon, before opening his studio at 418 Fifth Avenue in 1910. "Portraits at your home a specialty—The background of each picture is beautified—An artistically perfect natural expression guaranteed under any condition of light," promised Kikuchi's ads in *The Oriental Review*.

Kikuchi told Audrey in all seriousness that he had received a special commission from the mikado, the emperor of Japan, to take pictures of a "representative American girl" to be studied by students at the Imperial University back home. He convinced her to spend three weeks posing for him in the nude. He took more than 300 images, she counted, both "full figure" and draped, and including close-ups of her hands and feet. Audrey felt "very nervous" about the experience. It was the first time she had shed her clothes for the camera.

Audrey's newfound faith in art abounded, but it blinded her to men's other motives. There is no evidence from his subsequent biography that Kikuchi ever received a commission from the mikado. When he returned to Japan in 1918, he set up the Oriental Photographic Company selling photographic paper. He died in 1939, but two albums of his New

York images were rediscovered in his family's traditional *kura* warehouse in Japan in 1993. The surviving photographs appear to be his commercial portrait work and include no pictures of Audrey. No doubt Kikuchi made extra money from the nudes. Audrey should have been worried when she started to receive fan mail from Japan. Instead, she rather enjoyed the attention. She said she received more than a thousand letters, all scrupulously polite, from Japanese men who wanted to marry her. "Objective matrimony," they wrote.

Sometimes, Audrey found that posing nude could be truly shocking, particularly for the model.

On one occasion, she was hired to pose for a painting of a waterfall commissioned by the government of Mexico. She arrived at the studio to find that the artist, apparently the Philadelphia-born painter and etcher Earl Horter, had rigged up a basin of water on planks overhead. He asked her to stand beneath it.

"There—stand right there—turn a little this way—head forward, no, not so much. That's it! Hold that pose," he exhorted her. "Now I'll turn the water on—I want to get the splashing over your form."

Before she realized what was happening, Audrey was hit by a deluge of icy water from above. She jumped, screaming, from the torrent. The artist implored her to return, but she refused.

The painter opened his desk and pulled out a pistol. He threatened to shoot her if she did not get back beneath the freezing shower.

He kept her the full hour before he released her—so long that she suffered a bad chill. As soon as she relaxed, she fainted. The artist only partly redeemed himself by agreeing to pay for her to see a doctor to treat the pneumonia she contracted. The painting went on show at the National Gallery of Mexico, where thousands admired Audrey's beauty without ever knowing her name or what trauma she had suffered in it its creation.

There were other days in the studio that repaid the anxiety and discomfort of posing, though. It was not only artists who appreciated the "classical ideal." Audrey met her "third love" this way.

Audrey said of Paul Hardaway:
"Dismissed him for my career."

A man turned up at the artist's studio where she was posing and pleaded to see her. He had seen a figure of Circe, the Greek goddess of magic, for which she had posed, and fallen in love with her statue. Now he wanted to meet the woman in the flesh, not in stone.

Audrey found him handsome and engaging and pleasantly obsessed with her. He knew her former hometown of Providence but had a charming "southern" accent. He was Paul Alfred Hardaway, born August 16, 1884. Though seven years older than Audrey, he was two inches shorter at just 5´6˝ tall with brown eyes and black hair. Audrey considered him a "southerner" because he grew up in Orange County, Florida, where he became a telegraph operator at the age of fifteen. He had moved up north to Providence, working as a railroad telegrapher in Bristol, Massachusetts, and Saylesville, Rhode Island. He claimed his father, George Washington Hardaway, was a second cousin of George Washington. Perhaps more important for Audrey, he was, like Albert O. Stark before him, a preacher's son, not a Bohemian. She knew her mother would approve.

"Paul, my third love—entered my life and swept me off my feet. We became betrothed," Audrey said. "He was a railway executive of wealth.

He bought me a beautiful diamond and started building a palace for our home. But soon I realized I did not love this man enough to be his wife. I arranged a meeting with a beautiful model I knew. She and Paul are married now and have three chubby children." It was a devious strategy, showing a new manipulative side to Audrey's character, and it worked well. In 1914 Hardaway married Mary E. Wood in Rhode Island, and the two eventually had four daughters: Barbara, Evelyn, Janet, and Nancy.

After seeing what was possible in New York, and beginning to enjoy her first true recognition, Audrey cherished greater ambitions than a railroad telegrapher could fulfill. In a private letter, she declared unsentimentally: "Dismissed him for my career."

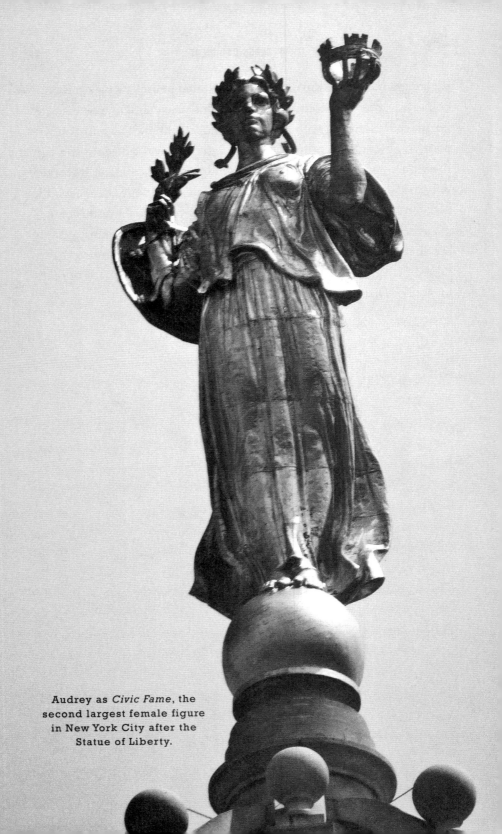

Audrey as *Civic Fame*, the second largest female figure in New York City after the Statue of Liberty.

7

MISS MANHATTAN

Audrey and Kittie moved into a small apartment at 288 West Seventieth Street, just a block from cousin Harriet and easy walking distance to the Arcade Building and the Sixty-Seventh Street Studio District. Audrey began describing herself as an artist. Her mother, though still only in her early forties, had come to rely on Audrey's modeling income and considered herself retired. When Audrey returned home exhausted after working late in the studios, her muscles aching from holding a pose, Kittie would massage her, as she had done since childhood.

Nina Carter Marbourg, a magazine writer, visited mother and daughter at home and found Audrey studying music, dance, and singing in her spare time. "One of the greatest charms about this young woman, outside of the fact that she is good to look at, is that she is absolutely unspoiled," Marbourg reported. "A little girl once said to her mother: 'You can pet me all you want to and not spoil me.' That seems to be the case with Audrey Munson: she is certainly petted, but has remained simple, sweet, homelike. One would rather picture her in a little plain dress in the country, in the woods, or roaming about the hills and pastures, than posing in the city studios, and still she says earnestly that the praises of the artists certainly are a delight to her."

Audrey counted that she had posed for 200 artists. Occasionally, one would send theater tickets for her and Kittie, or invite her to an artists' ball. Daniel Chester French made her a gift of a marble bust of herself, and Ulysses Ricci gave her a bronze cast of his life-sized figure of her. But standard pay for posing was fifty cents an hour—at a time when a pint of milk or a small loaf of bread cost a nickel and a dozen eggs a quarter. In all her years as an artists' model, Audrey complained, she never made more than thirty

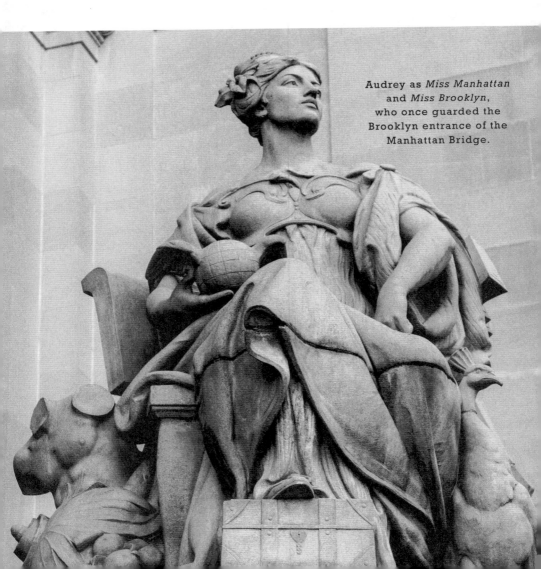

Audrey as *Miss Manhattan* and *Miss Brooklyn*, who once guarded the Brooklyn entrance of the Manhattan Bridge.

dollars a week. "It was just enough to pay our rent, grocery bills and buy a few clothes once in a while—almost nothing for amusements," she said.

New York was in the grip of a Beaux-Arts building boom—and Beaux-Arts buildings required sculptures. Suddenly copies of Audrey were springing up all over the city, and she was increasingly recognized as the model. Her body was displayed on Fifth Avenue mansions, atop the world's largest office building, on the new bridge, and on fountains

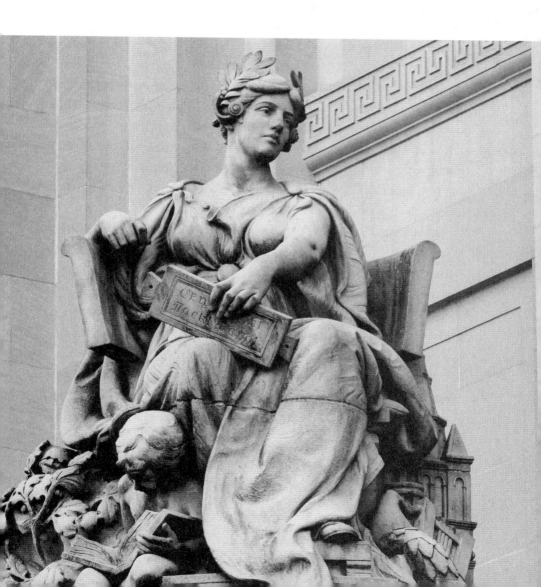

and numerous monuments. The press called her "the Most Copied Girl in America." The *New York Sun* declared in a banner headline: ALL NEW YORK BOWS TO THE REAL MISS MANHATTAN.

"It seems funny to be called Miss Manhattan," Audrey said, laughing. "Nevertheless I suppose I must get used to it, for a lot of artists call me by that name now and even folks outside of the artists."

Audrey now dominated the city's skyline as Adolph Weinman's twenty-five-foot-tall *Civic Fame* atop the new Municipal Building. The forty-story building was the first skyscraper by the architecture firm of McKim, Mead & White of the murdered architect Stanford White. The design was based on White's unsuccessful entry into the competition for Grand Central Station. At a height of 580 feet, the Municipal Building was the third-tallest building in the city. The gilded copper figure of Audrey on top wears a laurel wreath and holds aloft a crown with five parapets representing the five boroughs of New York, which had only consolidated in 1898. With her other arm, she carries a shield emblazoned with the city's coat of arms. There, to this day, her golden form perches, proud and joyous, on a gilded sphere, with her back arched as though she is pushing against the wind.

When installed in March 1913, *Civic Fame* stood taller than either of its closest competitors: Augustus Saint-Gaudens's eighteen-foot gilded *Diana* placed in 1891 atop the old Madison Square Garden, and the copper copy of John Dixey's smaller female figure *Justice* installed in 1887 on the dome of city hall. But Audrey's *Civic Fame* was still dwarfed, of course, by the soaring 151′1″ Statue of Liberty across New York Harbor, donated to the United States by the people of France in 1886.

Although Weinman made her the symbol of the city, what really secured Audrey her reputation as Miss Manhattan were her colossal figures, by sculptor Daniel Chester French, on the newly constructed Manhattan Bridge. French's twin thirteen-foot seated figures of Miss Manhattan and Miss Brooklyn originally guarded the Brooklyn entrance of the new bridge. But the two granite statues were removed in 1963 to make way for traffic, and now sit impressively flanking the entrance to the Brooklyn Museum.

French was beguiled by Audrey. "I know of no other model with the peculiar style that Miss Munson possesses. There is a certain ethereal atmosphere around her that is rare. She has a decidedly expressive face, always changing. There is no monotony in her expression, and still the dominant feeling is that she is just such a type as many of the early painters would have selected for a Madonna," he said. "It is a great satisfaction to find so much grace and fineness of line combined. Those who are not artists can hardly realize what a really serious question the model is, and perhaps, too, they cannot quite grasp the feeling of enthusiasm that comes to a man or woman in this work when such a model comes to their knowledge."

Audrey later rather awkwardly claimed to have been the model for all the feminine figures by French at the impressive US Customs House at One Bowling Green at the southern tip of Manhattan, now the National Museum of the American Indian. This seven-story building was once the powerhouse of the American state, since the government received most of its revenues from customs before the institution of income tax in 1913. French carved four colossal figures, still there today, representing the four continents—Africa, Asia, Europe, and America. Audrey showed she was becoming increasingly comfortable with publicity hype by claiming she was the model for French's America and the other continents. The building's foundation stone was laid in 1902 and the sculptures were in place by March 1906—years before she moved to New York.

Audrey also described posing for Evangeline in French's marble relief for the Longfellow Memorial at the poet's home in Cambridge, Massachusetts. The work was carved between 1912 and 1914, during the time Audrey was posing for French. But she can only have been one of his models. There is a photograph of French's own daughter, Margaret, posing in front of the figure in her father's studio. Similarly, Audrey can only have been one of a number of inspirations for French's *Memory*, now in the Metropolitan Museum. He made the first clay version in February 1886, before she was born, although he revised it in 1909, and it was carved in stone from 1917 to 1919.

Audrey is still seen on the Manhattan Bridge today in the form of Carl Augustus Heber's *Spirit of Commerce*. Heber adored her. "Yes, she

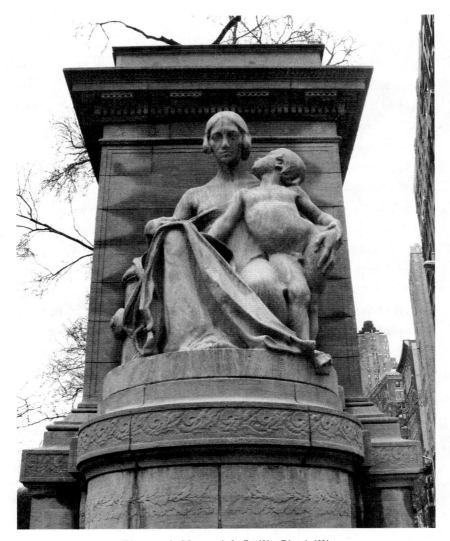

Firemen's Memorial, Attilio Piccirilli.

is the real Miss Manhattan now, and really she ought to be, too. She has grit, determination and, best of all, a sense of humor," he said.

To make the piece, Audrey braved the cold at Heber's studio at the back of a stable at Eighth Avenue and Twenty-Fourth Street. One rainy day, the fire went out and the sculptor could do nothing to coax it back to life. When Audrey showed up punctually, he told her that it would be

impossible for her to pose in such cold. She looked disappointed, and even scornful. She was a can-do country girl. Audrey sent out a studio boy to get some braziers, and he obtained some from a local Italian. "We worked all the morning with the open coals glowing in their kettles," Heber said. "She always has a way to get out of a difficulty, and that appealed to me as being a very clear stroke on her part."

Audrey was similarly affectionate about Heber but once accidentally tried to "scalp" him when she fell from the pedestal. She had to make a sudden choice between grabbing onto his hair, or grasping, and destroying, the wax model he was working on. She chose his hair.

Many of Daniel Chester French's sculptures—including both *Memory* and the celebrated Lincoln Memorial—were carved by a band of Italian immigrant brothers from the marble center of Massa in Tuscany. The six Piccirilli brothers—Ferruccio, Attilio, Furio, Masaniello, Orazio, and Getulio—worked together for decades, wearing four-cornered hats made of old newspaper, at the studio they built in the Bronx. They had learned their craft from their father, Joseph, who used to own a Carrara marble works back home. Several of them became recognized as artists in their own right. Attilio, the best-known, put Audrey on the Maine Memorial at the entrance to Central Park in New York's Columbus Circle. He also used Audrey as a model for the figures on either side of his Firemen's Memorial on New York's Riverside Drive at One Hundredth Street. His brother Furio was also inspired by Audrey, producing numerous works.

Audrey was also the model for New York's monument to the worst disaster of her youth: the sinking of the *Titanic*. The sculptor Augustus Lukeman was commissioned to commemorate Isidor Straus, the co-owner of Macy's, then the world's largest department store, and his wife, Ida, who were among the more than 1,500 people who perished in the *Titanic* disaster on April 15, 1912. The elderly couple were offered a place in a lifeboat, but Isidor refused while there were still women who needed to escape. He urged his wife to get aboard, but she refused. "We have lived together for many years," Ida told him. "Where you go, I go." The balding Lukeman, a former studio assistant to Daniel Chester French,

had a studio in the same building as Konti, who may have introduced them. Lukeman's memorial was installed just a block from the Strauses' former home on 106th Street and West End Avenue, where it now has its own handkerchief-sized park. The Audrey-inspired bronze portrays the recumbent figure of "Memory" lost in thought, her head held delicately in her hands. The memorial is inscribed with a passage from Second Samuel 1:23: "Lovely and pleasant were they in their lives and in their death they were not parted."

The dazzling array of sculptures of Audrey around Manhattan seemed to know no end. Audrey said she modeled for a statue by Frederick MacMonnies at the New York Public Library, then known as the Astor Library. The piece, now known as *Beauty* (1911) but originally titled *Beauty Overcoming Ugliness*, is southernmost of the pair of fountains flanking the library's main entrance, the other being *Truth,* or *Truth Overcoming Falsehood.* The attribution is questionable, because Mac-Monnies was living mostly in France at the time—although it is not impossible Audrey could have posed for him there. *Beauty*'s chubby cheeks and fulsome hips bear little resemblance to Audrey, but she explained why: "When Mr. MacMonnies made this charming work he showed the face and torso of a model who fitted closer in these respect to his inspiration than did mine, but my legs were better for his purposes." Audrey was also reported to have modeled for Sherry Fry's *porte cochère*, or porch, on industrialist Henry Clay Frick's new mansion on Fifth Avenue between Seventieth and Seventy-First Streets, now home to the Frick Collection, as well as a *Music of the Waters* fountain by Allen George Newman on Riverside Drive, now lost.

Perhaps the most easily approachable of all Audrey's statues in New York, then and now, is the naked half-turned figure of Pomona, the Roman goddess of abundance, sowing fruits upon the earth atop the Pulitzer Fountain outside New York's Plaza Hotel. The graceful bronze nude, however, has a tragic story that remains unknown to the hordes of office workers and tourists who pass it each day.

The figure of Pomona was originally designed by Konti's lifelong

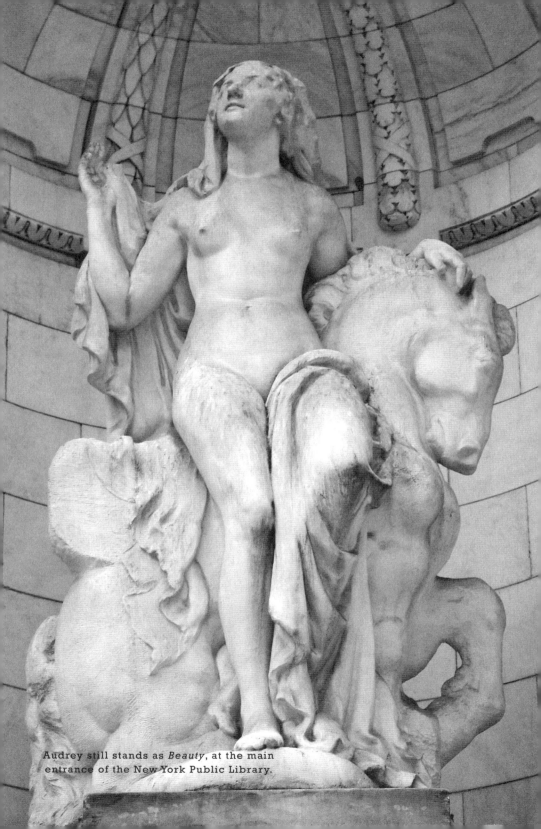

Audrey still stands as *Beauty*, at the main entrance of the New York Public Library.

AUDREY MUNSON'S
Strange Life

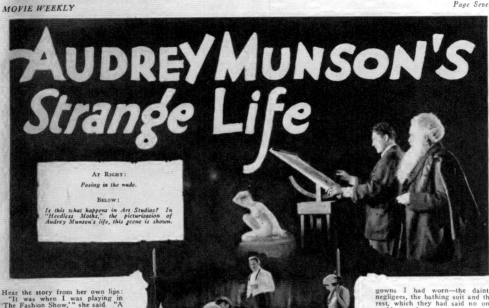

AT RIGHT:

Posing in the nude.

BELOW:

Is this what happens in Art Studios? In "Heedless Moths," the picturization of Audrey Munson's life, this scene is shown.

Hear the story from her own lips: "It was when I was playing in 'The Fashion Show,'" she said. "A man prominent in the theatrical world came into my dressing room. I was in a bathing suit. He passed his arm around me and pressed his burning lips against my shoulder.

"I struggled to free myself. I struck at him.

"Get away from me!" I cried out. "Don't touch me. I hate you. Your touch is repulsive to me. I would rather have a snake crawl over me than to feel your hand upon me.

"He released his hold.

"'Do you mean what you have just said?' he asked.

"'I do,' I replied defiantly. But even as I spoke I shuddered.

"'You will have cause to remember this,' he said—and left me.

"A few days later I was told that 'The Fashion Show' was to close. I had no explanation. The playlet had been drawing immense houses, but it was closed at almost a moment's notice. Later it was put on again with another to wear the

gowns I had worn—the dainty negligees, the bathing suit and the rest, which they had said no one could wear but me.

"I went everywhere and tried to obtain an engagement on the stage or screen. There was no place for me. Even the studios of the artists and sculptors were closed against me. There were excuses, in the latter case, of course. It was war time. Many painters and sculptors were in France. Those who remained were finding no market for work.

"I offered my services to the Government in an effort to trail down German spies. My offer was accepted, but soon I became conscious that the powers had no confidence in me. I was watched more closely than I tried to watch those whom I was told to shadow.

"Since the death of my old friend who was so good and kind to me, I had had several lovers—men who declared that they were mad about me. Three times I was ready to

(Continued on page 30)

BELOW (AT LEFT):

A scene from "Heedless Moths," showing Miss Munson gazing at an art study for which she posed.

BELOW (AT RIGHT):

Posing for a group of art students in the heyday of her fame.

Audrey's life story was stranger than any movie.

friend, Karl Bitter. It was probably Konti who introduced Audrey to Bitter. In their youth, the two sculptors had been fellow pupils at the Imperial Academy in Vienna. A notoriously gruff man with a dense beard and a spectacular handlebar mustache, Bitter had an extraordinary talent for organizing and was a force to be reckoned with in the art world. The Viennese-born sculptor made his name shortly after arriving in America in 1889 by winning a contest to craft the $200,000 bronze doors of Manhattan's Trinity Church when he was just twenty-one. Bitter worked with many of Audrey's other sculptors when they built the neoclassical White City at the 1893 World's Columbian Exposition in Chicago. Bitter then served as director at the Pan-American Exposition in Buffalo in 1901, which Audrey visited as a child. He went on to become head of sculpture at the Panama-Pacific International Exposition in San Francisco in 1915, where Audrey would be the star.

When the press baron Joseph Pulitzer died in 1911, he bequeathed $50,000 "for the erection of a fountain like those in the Place de la Concorde, Paris, France." Bitter, who had given Pulitzer the idea of placing the fountain in a plaza at the southeast entrance to Central Park, won the commission. The sculptor kept a studio known as the Castle on the cliffs in Weehawken, just across the Hudson River from Manhattan. So that he could work on the piece night and day, he fitted out the studio to sleep there. The early spring sunshine in 1915 allowed him to sculpt on his terrace overlooking the city. One day he called his wife, Marie, at their home at 44 West Seventy-Seventh Street in Manhattan to tell her elatedly that he had all but completed the plaster model and wanted to celebrate. That very evening, April 9, 1915, the couple went for a night out at the Metropolitan Opera, then at Thirty-Ninth Street and Broadway. During the interval, Bitter chattered excitedly of the future. After the performance, the couple stepped outside onto Broadway to catch a streetcar home. Seconds later, a Ford automobile driven by an electrical engineer named Edgar K. James swerved to avoid a taxi and careened into them. Marie fell between the wheels. Some say she was saved by a shove by her husband. It would be the last thing he ever did. The sculptor

himself was crushed and died in New York Hospital the next morning.

It fell to Bitter's old friend Konti to complete the Pomona, who has stood 7'9" tall ever since, opposite the southeast entrance to Central Park above granite basins carved by Orazio Piccirilli.

Bitter's original model was the actress Dorothy Doscher. That same year, Doscher was to appear in the film *The Birth of a Race* (1918)—an antiracist rejoinder to D. W. Griffith's Ku Klux Klan–glorifying *The Birth of a Nation* (1915). Doscher described the making of Pomona in a letter to the *New York Times* published many years later on May 15, 1931, in which she insisted she was the "original Lady of the Plaza." "I worked with Carl [sic] Bitter as the original model for the measurements and modeling of the body," Doscher wrote. "Audrey Munson modeled a few days just for the head, although some time later she claimed full credit for being the model for 'The Lady of the Plaza.'"

In fact, Bitter had left behind a small "sketch model" and a full "staff model" made of rough plaster. Konti wanted to install the incomplete staff model on the fountain as an undying memorial to his friend's last work. But his proposal was rejected as impractical because the unfinished plaster version would not have survived the elements. Doscher does not claim to have posed for Konti when he finished the piece, and it seems that he continued to use Audrey for the final product. In *A Loiterer in New York*, published the year after the statue was erected, Helen W. Henderson says the figure "as she stands, is entirely the execution of Mr. Konti, read from the small model left by her creator."

In constant work, often seven days a week, Audrey began to hint at the toll taken by her modeling. Even on the brink of her greatest successes, she suggested she was feeling the strain—a worrying precursor of her later troubles. She used a word she would return to later in life: "nerves." "Posing is very nerve-trying," she complained. "To stand in one position for half an hour, no matter how easy the position may be, is really a strain. To sit still in the same position when one is not thinking is not simple, but when you come to concentrate your mind on the work and endeavor to hold expression of face as well as figure for thirty

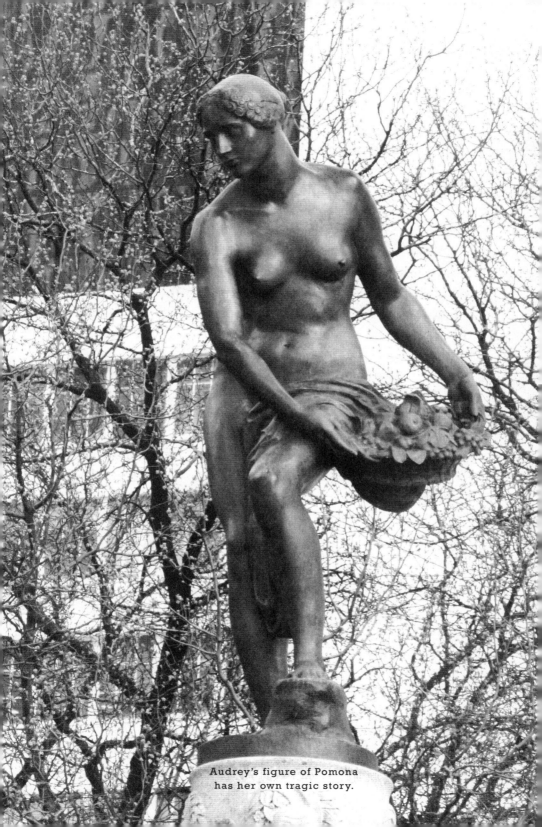

Audrey's figure of Pomona
has her own tragic story.

minutes without resting, it is pretty tiring. If a girl's nerves are not in excellent condition and her muscles strong and ready for such a test, she makes but a wobbly sort of model and the artist cannot work."

Her relationship with men may have added to the strain. It was perhaps during this period that Audrey became involved with Robert Barbour, whom she would later angrily denounce. Barbour, who had been a mechanical engineering student at Columbia University, was a wealthy young man from across the river in New Jersey. His father had been an Irish immigrant who had established the family's Barbour Flax Spinning Co. in Paterson. Born on July 5, 1886, Barbour described himself as "tall" and "stout" with "dark hair" and "blue eyes." His passport photo showed him in a tuxedo and bow tie. Barbour claimed a draft exemption in the Great War on the grounds that he was a "merchant, manufacturing, banker" who was president of the family firm and served on the boards of a host of other companies.

Little is known about Audrey's relationship with Barbour, but a clue may lie in a mysterious article about Audrey's love life that appeared in the *Washington Post* on June 27, 1915. The article reported that Audrey had been betrothed to a Robert Briggs. It was not uncommon at the time for newspapers to use pseudonyms. Audrey herself did it by renaming her photographer F. B. Herzog as Ralph Draper. It is possible the Robert Briggs in the *Washington Post*, who has left no trace, was actually Robert Barbour. The article says he called off his engagement to Audrey after becoming "incensed" when he saw a nude poster of her in an art dealer's window.

8

THE INSANITIES OF MODERN ART

Audrey was used to posing in the workmanlike spaces of neoclassical sculptors, but nothing had prepared her for the chaotic scene she encountered when she went to pose for the visiting French-Cuban painter Francis Picabia. In the center of the studio sat a large tin basin that the chain-smoking artist had filled with half-smoked cigarettes. The room was covered with days of accumulated dust, and the floor was littered with pieces of torn paper. She had to take care not to step on the half-dozen paintbrushes scattered on the ground.

The artist himself was a volcanic presence. On the walls hung strange distortions of color and line that left Audrey shocked and confused. He told her one painting was "a lady on horseback" but Audrey could see no hint of either horse or lady. Audrey could not understand why Picabia even needed a model. She accepted the engagement more out of curiosity than anything else. It was a bewildering experience. Instead of asking her to assume a statuesque pose, as she did for the Beaux-Arts artists, Picabia insisted instead that she be in constant motion.

"I posed for him for several days, but never in still position. He had me walk about the studio in different lights and taking different postures. He wanted to paint me in action, he said, not in repose," Audrey said. "The result was another collection of color areas, cubes, angles and blank

spaces on the canvas, vivid colors and mysterious lines and circles. When he had finished he professed great satisfaction. It was a true portrait of a woman walking, he declared."

Picabia was the very first modernist artist ever to come to America. The audacious thirty-four-year-old Parisian painter and poet acted as the unofficial spokesman of the Paris avant-garde when he was the only European modernist to attend the 1913 International Exhibition of Modern Art at the 69th Regiment Armory on Lexington Avenue in New York, where he had four large abstracts on display. "France is almost outplayed. It is in America that I believe the theories of the New Art will hold most tenaciously," he announced to the *New York Times*. "I have come here to appeal to the American people to accept the New Movement in Art."

The Armory Show, which included works by Paul Cézanne, Marcel Duchamp, and Pablo Picasso, is now celebrated as the moment when modern art arrived in an astonished United States.

Audrey, however, was not impressed by the modernist interloper. She had just finished several weeks of posing for the polished Russian prince Paul Troubetzkoy. "I have always preferred to pose for such delightful men as Prince Troubetzkoy," she said. "Somehow I seem to feel more of the beauty of art when it is being born in beautiful surroundings."

Picabia almost physically repelled her. He was too much of a genuine Bohemian. "Meeting and knowing Picabia one would think him to be one of those hangers-on at the fringe of art who failing to attract attention by any other means adopt long hair and unkempt grooming as a distinguishing mark," she said.

Picabia's conception of art was so radical that he even criticized the new cubists, whose geometric images had discombobulated critics. The *New York Times* said he was "outcubing the Cubists." He was trying to write music with his paintbrush.

"The Cubists made a great mistake. The Impressionists made a great mistake. Modern French art, in spite of its achievements, has made many mistakes," Picabia told the newspaper. "If you look at a painting of a landscape by Turner, by Constable, what do you see? An attempt to reproduce

Audrey thought Francis Picabia looked like
"one of those hangers-on at the fringe of art."

reality—the actual landscape as seen by the average man. Barring the fact that all painting is bound to reflect the personality of the artist, the artist of the old school, from early times to modern, has attempted, and has succeeded, in reproducing what any man of moderate intelligence could recognize as a copy of the original model."

He added, "But my idea is not the same. I do not produce the original. You will find no trace of the original in my pictures. Take a picture I painted recently, just the other day, while here in New York. I saw what you call your 'skyscrapers.' Did I paint the Flatiron Building, the Woolworth Building, when I painted my impressions of these 'skyscrapers' of your great city? No! I gave you the rush of upward movement, the feeling of those who attempted to build the Tower of Babel—man's desire to reach the heavens, to achieve infinity."

In America, Picabia found a natural ally in Alfred Stieglitz. Two days after the Armory Show closed, Stieglitz gave Picabia an exhibition at his tiny gallery at 291 Fifth Avenue, by then known simply as 291. Some 2,000 people came to view it, and Picabia himself dropped round almost every day. Picabia's wife, Gabrielle Buffet-Picabia, contributed to Stieglitz's *Camera Work*, which carried a caricature of Picabia the following year.

Picabia left New York after three months in April 1913 but was soon back, following the outbreak of the Great War in Europe. He had planned a trip to his father's homeland of Cuba to buy molasses for a friend in June 1915, but his stopover in New York lasted a year. This was the formative period of the New York avant-garde. Picabia renewed his friendship with Marcel Duchamp, whose cubist *Nude Descending a Staircase* had caused such sensation at the Armory Show that he had found himself already a celebrity when he arrived in New York in 1915. During his second stay, Picabia helped Stieglitz found a new journal titled *291*, which devoted a double issue to Picabia in July/August 1915.

Audrey said Picabia was painting "an incongruous collection of color splotches" when she visited his studio. Her description suggests that she posed for him during his first visit in 1913. By the time of his 1915 stay, he had moved on to much more mechanical images, such as the American

nude portrayed as an automobile spark plug in *Portrait of a Young American Girl in a State of Nudity* (1915), which was published in *291*.

On the transatlantic liner that brought him to America for the first time, Picabia had met the Polish-French dancer Stacia Napierkowska, who was on her way to perform at New York's Palace Theatre. Napierkowska caused an uproar on board by insisting on rehearsing in revealing costume. Once in New York, Picabia set about painting the vivid Napierkowska-inspired *Star Dancer and her School of Dance*. When it was displayed at his 1913 show at 291, one critic dismissed it as "a series of figures—cubes, triangles, disks, bed-slats and whatnots—of various colors, the combination of which undoubtedly suggests rhythmic motion. . . . It may bring satisfaction to the mind of Mr. Picabia to study the world in this way, but the wonder is why anyone else should be interested in a thing so purely subjective—in a conception so entirely incommunicable."

Star Dancer and Her School of Dance shows how Picabia was interested in figures in motion during the time of his first visit—though he generally did not use models. On his return from New York, he exhibited a new painting mysteriously titled *Udnie (Young American Girl, Dance)*, at that year's Salon d'Automne in Paris. He wrote to Stieglitz that the painting was based on studies he had exhibited at 291. *Udnie*—soon to be followed by another canvas titled *I See Again in Memory My Dear Udnie*—is usually described as being inspired by Napierkowska, without explaining the unusual name of Udnie, which is written on the canvas, or the fact that the subtitle explicitly refers to a "young American girl." Some have argued "Udnie" is an inaccurate anagram of the French "nudité"; others that it refers to the classical water sprite known as an "undine." Undine Spragg is the name of young woman from the Midwest who tries to scale New York society in Edith Wharton's novel *The Custom of the Country*, published in America on October 18, 1913. More recently, it has been suggested that "Udnie" is an accurate anagram of early modernist art theorist Jean d'Udine, whom Picabia met in 1909. D'Udine, whose real name was Albert Cozanet, compared visual arts to music. The first sentence of his 1910 treatise *L'Art et le geste* (*Art and Gesture*) is: "Vivre, c'est vibrer" ("To

live is to vibrate"). Picabia was strongly influenced by d'Udine to view painting as akin to music and motion. Until now, though, no one has put two and two together and asserted that Audrey is the "young American girl" of the subtitle. It is not fanciful to suggest that the mysterious name "Udnie" might be both an anagram of "Udine" and a pun on "Audrey."

Picabia's *Udnie (Young American Girl, Dance)*, now in the Centre Pompidou in Paris, would be the only major modernist masterpiece for which Audrey ever posed. It might have taken her life in a whole new direction. Audrey, however, did not think much of the outcome of her sessions with Picabia—or of modern art in general.

Modernism, and all its associated "isms"—cubism, fauvism, dadaism, futurism, expressionism, and surrealism—was breaking upon the unsuspecting world, Audrey's world. Apart from her encounter with Picabia, her artists came from the generation immediately prior to modernism, the generation that would be cast aside and forgotten in the face of its transformative cultural force. Audrey didn't work for isms.

Audrey was a child of the American Renaissance. The United States, after surviving the Civil War and celebrating its one hundredth birthday in 1876, felt it had come of age. It aspired, as many cultures have down the ages, to become the "new Rome." The young nation became an imperial power with the annexation of Cuba after the 1898 Spanish-American War and the Philippines after the 1899–1902 Philippine-American War. New York State became widely known as the Empire State. The United States took over from France the gargantuan project of cutting through an entire continent with the Panama Canal—a project that would soon have a big impact on Audrey's life.

Artists and architects of the time sought, like their Renaissance forebears, to emulate the classical forms of antiquity. Their civic pride provided the impetus for the City Beautiful movement that sought to combine the talents of sculptors, muralists, landscapers, and architects to construct grand neoclassical public buildings to uplift America's slum-ridden cities. The movement scored its first triumph in the World's Columbian Exposition in Chicago in 1893, when architects and sculptors

built the model White City in the Beaux-Arts style. Its central axis was dominated by a sixty-foot robed female figure of the Republic by Daniel Chester French. Sculptor Augustus Saint-Gaudens declared: "This is the greatest meeting of artists since the fifteenth century!" It was a visit to the Chicago World's Fair by the nineteen-year-old Evelyn Longman that persuaded her to become a sculptor. The success of the White City propelled a craze for public monument building across America until the outbreak of the Great War. Many of those monuments are still with us today, though sadly overlooked—and many of them feature Audrey.

Audrey became, in many ways, the face—and the hands and legs and breasts and dimples—of American Beaux-Arts. The movement drew on the academic tradition of the École des Beaux-Arts in Paris, which revolved around the study of classical art and architecture. The art world in America was still in thrall to Europe, Europe was in thrall to Paris, and Paris was in thrall to the École des Beaux-Arts, whose history dates back to 1648 and the reign of the Sun King Louis XIV. Many great artists had trained there: Degas, Delacroix, Fragonard, Ingres, Monet, Moreau, and Renoir. Rodin, on the other hand, who was seen as a radical, and shown by Stieglitz at his gallery, applied three times to the École des Beaux-Arts but was each time refused.

American alumni of the École des Beaux-Arts included Richard Morris Hunt, who designed the Tenth Street Studio Building and opened an architecture school there. His abundant contribution to American architecture includes the facade of the Metropolitan Museum of Art, the master plan for Columbia University, and the pedestal of the Statue of Liberty, as well as many of the extravagant mansions that America's great families built along Fifth Avenue in New York and along the oceanfront in Newport, Rhode Island. Other American sculptors and architects followed in his footsteps: Augustus Saint-Gaudens, who had a French father; Charles McKim of the architecture firm McKim, Mead & White; Frederick William MacMonnies, who was able to attend thanks to a fifty-dollar loan from McKim; and William de Leftwich Dodge. A group of American artists, painters, and architects, led by McKim, who had worked on the Chicago World's Fair, founded the American Academy in Rome to perpetuate the classical tradition.

Audrey's neoclassical looks were just what the Beaux-Arts style demanded. A rebellion was brewing, however, against its studied academicism. The first attack on the "academy" in America came from five almost-forgotten realist painters: Robert Henri, the oldest and the leader; George Luks; William Glackens; John Sloan; and Everett Shinn. Dubbed the Philadelphia Five, they all hailed originally from Philadelphia and had studied at the Pennsylvania Academy of Fine Arts. Every one of them except Henri was a former newspaper illustrator. Their journalistic work bred in them a love of the grit and dynamism of the streets, trash cans and all. They would eventually be dubbed the Ashcan School. From 1905 they allied with three quite different realist painters—Arthur B. Davies, Ernest Lawson, and Maurice Prendergast—to become known as the Eight. In a deliberate challenge to the conservative National Academy of Design, the Eight mounted a historic exhibit at Macbeth Gallery in New York in 1908. Their critics dismissed them as "Apostles of Ugliness."

The second offensive on the academic style came from the now-famous European modernists themselves. Stieglitz's 291 gallery began showing modernist art in New York with an exhibit of Auguste Rodin's drawings in January 1908, followed by shows of Henri Matisse, Paul Cèzanne, and Pablo Picasso. The 1913 Armory Show, marked a temporary alliance between the two groups of artistic insurgents. All of the Eight except Shinn were represented alongside Picabia, Picasso, and Duchamp. Davies had been the main organizer of the Armory Show, scouring Europe for avant-garde art, and served as the president. Stieglitz was named an honorary vice president but was not involved in selecting works for the show. Gertrude Vanderbilt Whitney, always an adventurous benefactor, donated $1,000.

Audrey's posing for Picabia marked the precise inflection point for modern art in America. Audrey said she first encountered the new form on a trip to Europe early in her career. "It was in Paris I first met artists seriously engaged in that strange phantasy of art—Cubism. Perhaps many of my readers have stood before a colorful painting in which there is a conglomeration of lights and shadows, with distorted landscapes

or human forms and faces drawn in angles, squares or straight lines or distorted curves, and pondered over the possible meaning of the artist's delineations. To be told that such a canvas, which seems to represent nothing at all but a meaningless mass of colors, is a 'portrait of a lady' or 'a man with a mustard pot' only adds to the mystery," she wrote.

Audrey said she modeled in Paris for drypoints for Maurice Millière and a painting for the presidential palace in Portugal by Camille Doucet—both very traditional artists. But the timing of her trip remains elusive. Shipping records suggest two possible dates. An unmarried woman identified only as A. Munson embarked aboard the liner *Tunisia* at Liverpool, England, bound for Montreal, in a cabin with a Miss E. Heede, on September 17, 1908. This could have been Audrey returning from a coming-of-age visit to Europe to see the English relatives—which she later said she had done. A second shipping record shows a "spinster" A. Munson traveling, this time in her own cabin, aboard the *Grampian* from Liverpool to Halifax, Canada, on November 16, 1911. This could have been her return from her modeling trip.

Audrey, once happy to be a humble "art worker," increasingly considered herself an "artist." After first listing herself as an artist in the 1916 New York City directory when she was living at 288 West Seventieth Street, she did so again in 1920 when she was residing at 601 West 239th. Five years later, she described herself as an artist for a census when she was living upstate. She eventually took up landscape painting in watercolor—though none of her works are known to have survived.

Audrey's verdict on modern art, though, was damning—and put her on the wrong side of history. "In America, as in France, Cubism, Futurism, Impressionism and other art isms have become quite a fad," she said. "Of course, I think these 'new' artists are just crazy persons capitalizing on their insanities." Given her own unfolding life story, her judgment would take on a flavor of irony.

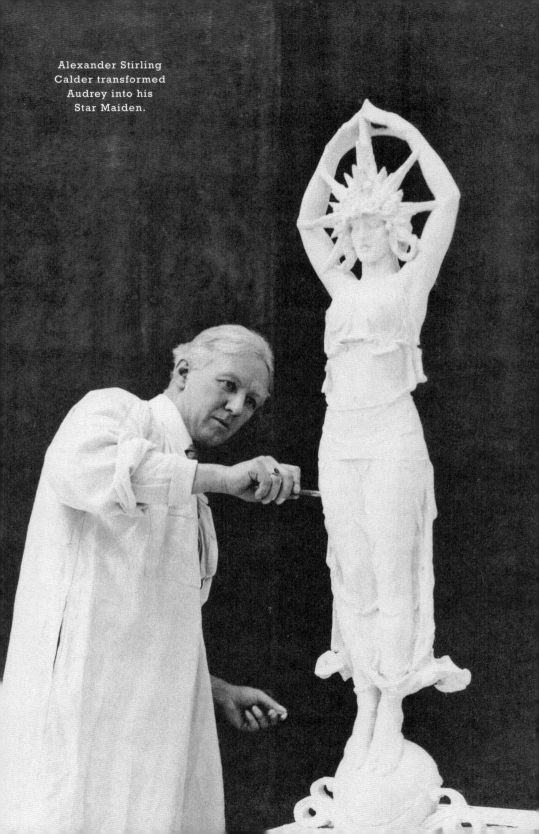

Alexander Stirling
Calder transformed
Audrey into his
Star Maiden.

9

THE EXPOSITION GIRL

Sparkling beside San Francisco Bay sat an extraordinary Jewel City built for the 1915 World's Fair. Millions thronged to the yearlong celebration, known as the Panama-Pacific International Exposition, but for Audrey it was a unique thrill. As she wandered through the crowds, she saw herself reproduced again and again in some of the most beautiful sculptures and paintings she had ever inspired. Three-quarters of the statuary and murals at the Expo used Audrey as the model. She was dubbed the Exposition Girl.

"Two exclamations are constantly rising to my lips as I wander through the courts of the exhibition," she said in awe. "'Can this be I?' and 'Did I help to make this thing of beauty?'"

The Jewel City was laid out on a symmetrical Beaux-Arts plan with ten palaces and courts grouped around the Court of the Universe with a forty-three-story Tower of Jewels in the middle. Everywhere Audrey turned, there was a surprise.

For the first time, she saw the completed statue of Adolph Weinman's *Descending Night*, which the sculptor had crafted from her bashful gesture the first time they met. It was on a spectacular scale. The finished figure now stood atop a column as *The Setting Sun*. Opposite it was a twin column topped by a male figure with upraised face and outstretched arms, representing *The Rising Sun*.

All around her, atop the colonnade, stood ninety striking Star Maidens modeled by Alexander Stirling Calder in her image. Each maiden stood erect, with her hands joined at the fingertips over her head. Audrey remembered the painful pose.

As she strolled down to the sunken gardens in a reverie, Audrey met Robert Aitken's four allegorical figures of her as the elements—Earth, Water, Air, and Fire.

"I see myself in the main figures as well as in the groups at the base," Audrey observed. "You will agree in this case that I am certainly a most

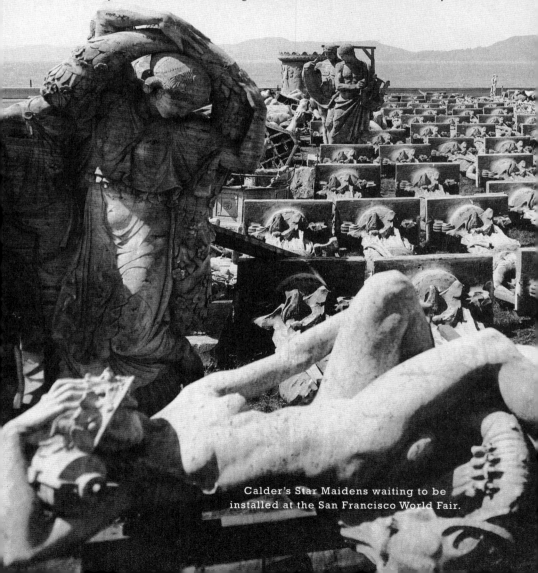

Calder's Star Maidens waiting to be installed at the San Francisco World Fair.

versatile creature—able to be, like the elements, at war with myself!"

Her proximity to the colossal sculptures provoked an extraordinary sensation. "In sun and rain my stone selves recline on their granite pedestals at the four corners of the court. Here I am larger than the largest elephant; naked, calm, indifferent to the crowds that surge about me and seem to grovel at my feet," she thought. "It is almost a shock to realize that I am myself merely a girl in that crowd. But for a moment I have felt the intoxication of brute power."

That strange feeling metamorphosed into a more tender emotion as

Ninety Star Maidens

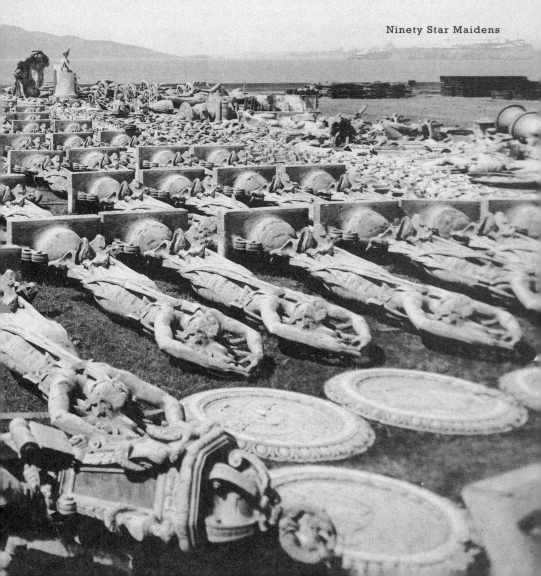

she moved into the Court of the Four Seasons, where Furio Piccirilli had carved her as *Spring*. After Aitken's muscular figures, she found Piccirilli's scale and subject more in keeping with her character.

"My hair is full of flowers and flows down my back. To my mind this is one of the loveliest statues in the fair grounds—far lovelier, I fear, than I can ever be," she said. "But I know that it is indeed my likeness, and I experience the joy that every woman must feel when the crowd applauds her beauty."

Audrey's personal favorite at the fair was the *Column of Progress* by Hermon MacNeil, because of the circumstances of its creation. It was topped by *The Adventurous Bowman* shooting his arrow at the sun, with a woman kneeling at his side. Audrey stopped to admire it, laughing to herself at the memory of its making.

"I am the woman urging on 'The Adventurous Bowman,'" she said. "In craning back my neck for this effort at close quarters I cannot help recalling the scene in the studio. There was no magnificent athlete to encourage me as I knelt in my pose for the sculptor, but an ordinary step-ladder—later, of course, replaced by the model for the male figure."

Much of Audrey's posing in New York for the previous two years—the late nights in the studio, all those aches and pains, the strained "nerves"—had been for sculptures to be displayed at the Expo. Her figure was interpreted there by more than a dozen artists: not just Weinman, Calder, Aitken, and MacNeil but also Daniel Chester French, Evelyn Longman, Gertrude Vanderbilt Whitney, William de Leftwich Dodge, Isidore Konti, Sherry Fry, Milton Bancroft, Albert Jaegers, and the brothers Furio and Attilio Piccirilli.

"America's greatest sculptors are ready to admit that she is the most perfectly formed woman who ever posed in an American studio," the *San Francisco Chronicle* gushed.

Audrey's form was even used on the Expo's official commemorative medal, designed by Aitken. She appeared as two female figures, representing the two hemispheres, on the coin's reverse side. "The reason I selected Miss Munson for this work is, as I said, because she is decidedly versatile," Aitken said. "She is very beautiful, in form and features,

typically American in delicacy, and yet holds enough of a Latin suggestion in her features to make her just the ideal for the work."

Audrey's starring role was the fruit of the trust and admiration she earned from America's leading sculptors. Karl Bitter, who would get run over several months later while making the Pulitzer Fountain, served as the "chief of sculpture" for the Expo in New York. Calder, who rented space in the Tenth Street Studio Building, acted as his assistant in San Francisco. The sculptures were conceived in New York, and maquettes were sent to San Francisco, where fifty men reconstructed them at full scale.

"These painters and sculptors will tell you that Audrey amply deserves some public notice in connection with the plaudits which their works receive," the *New York American* declared in a magazine cover story devoted to her. "Sitting to artists is tiresome work—meaning a strain upon every muscle, an ache upon every nerve. Beside having an almost perfect face and figure, Audrey revealed a remarkable talent for enduring these strains and aches. At different hours of the day and night, she could and did pose for a dozen artists. For two years, she posed until one or two o'clock in the morning. Some of these poses were very difficult. For example, standing on the tips of her toes, like a ballet dancer. Few models can hold a pose like this for more than a minute at a time."

World's Fairs had become integral to American life since the 1876 Centennial Exhibition held in Philadelphia to celebrate the nation's one hundredth birthday. As a child of ten, Audrey had visited the World's Fair in Buffalo, where her godparents lived. She kept a small red stained-glass beaker from the Expo inscribed with her name as a souvenir in her personal treasure chest. It was almost inconceivable to her that just fourteen years later she was being hailed as the star of another World's Fair.

The Panama-Pacific International Exposition celebrated the completion of the forty-eight-mile Panama Canal the previous year, an epic project that sliced through the American continent. The fair was also a symbol of the rebirth of the city devastated by the 1906 earthquake. It was a rip-roaring success. From opening day on February 20, 1915, until

it closed on December 4 of the same year, some 19 million people came to marvel. Among the celebrities who flocked to the fair were Audrey's old stage mate Al Jolson, as well as model-turned-movie-star Mabel Normand, who made a short film with her comedy screen partner Fatty Arbuckle titled *Mabel and Fatty Viewing the World's Fair at San Francisco.*

Fairgoers enjoyed a dizzying choice of entertainments. Americans curious about the country's new industries watched a Ford Model T automobile and saw a pair of Levi's Koveralls being assembled before their eyes. Visitors interested in radioactivity descended a fake mine and stared through a microscope at luminous specks of radium, which was being unwisely touted at the time as a source of safe and abundant power. The intrepid could even take a flight in one of the first seaplanes over Alcatraz Island. The fairground, stretching between Fort Mason and the Presidio, boasted a five-acre model of the Panama Canal with working locks and a six-acre replica of the Grand Canyon. The Liberty Bell made a guest appearance on its last-ever trip outside Philadelphia, and there was a reenactment of the Trojan War. The wife of a Pacific Telegraph and Telephone official became a "Human Telephone," handing guests a phone receiver they could use to call whomever they wished. The trick was that the receiver was wired to her metal-soled shoes, and she stood on special bolts in the floor to make the connection.

It was sobering for Americans to recall that the Expo, with its celebration of San Francisco's role as a Pacific trading power, took place while Europe was convulsed by the cataclysm of the Great War, with Germany using poison gas for the first time at Ypres, and Ottoman Turkey massacring its Armenian Christian population. Many exhibits and events were canceled, including one marking "One Hundred Years of Peace Among the English Speaking Peoples." President Woodrow Wilson was unable to come because of the war, but Franklin Delano Roosevelt, then a thirty-three-year-old assistant secretary of the navy, accompanied the vice president instead, and brought along his wife, Eleanor. "Did the world ever show a more massive and monumental contrast than this—the greatest war of history on one side, on the other the greatest exhibition ever seen of the triumphs

THE EXPOSITION STATUARY

AND THE GIRL WHO POSED FOR IT

By GILBERT K. HARRISON

As the 1915 "Flower"

"Harmony" group in Court of Four Seasons

"Genius of Creation," in Court of the Universe

Miss Audrey Munson in her favorite pose

"Descending Night" Decorating figure on Pinnacle of Setting Sun, Court of the Universe

As "The Exposition Girl"

Where the Little "Exposition Girl" Appears at P.P.I.E.

of peace and international intercourse?" asked *Current Opinion* magazine.

This was the first time Audrey had tasted true celebrity—and it opened new doors to her. She was cherished by the crowd, who delighted in her simplicity. "She loved to make friends and knew almost everybody who regularly attended the exposition," the *San Francisco Chronicle* said. "And, strangely enough, fame never turned her head. She was always unassumingly, childishly pleased with any kindness shown her; enthusiastic about everybody and everything."

The nudity on display, however, provoked a backlash from the National Christian League for the Promotion of Social Purity. Its founder and president, who would be reelected for twenty-nine consecutive years, was Elizabeth B. Grannis. She tried to persuade the infamous morality campaigner Anthony Comstock, founder of the New York Society for the Suppression of Vice, to come out to the West Coast to join her protest. But he apparently could not be bothered to make the long trip. Grannis advised Audrey to wrap up. "Maybe she has perfection, as the sculptors call it, of features and figure," Grannis said. "These are for her boudoir—not for the general public."

The scandal over the nude statuary may have shaken up Audrey's love life. The same *Washington Post* article about her breakup with "Robert Briggs" over his objection to a nude photograph in an art dealer's window also reported that she was to marry an Italian nobleman and musician named the Marquis Giuseppe Dinelli, an art lover who appreciated her posing for the Expo. "From having seen Ms. Munson as [Furio Piccirilli's] Winter, as Autumn, as one of the angels of Mrs. Whitney's group, a man will go back into the fray of life ennobled," the *Washington Post* quoted the Italian as saying. "His starving soul will have been fed by great beauty. It will have been as though the heavens had opened to him."

Audrey may have taken singing lessons from Dinelli. In 1914 he was advertising as an "opera coach" in the *New York Evening Telegram* from his studio on Eighth Avenue and Fifty-Fifth Street—an easy walk from Audrey's home. The *Musical Courier* described him as an "operatic coach, pianist and conductor" who had performed at Carnegie Hall. "Dinelli is

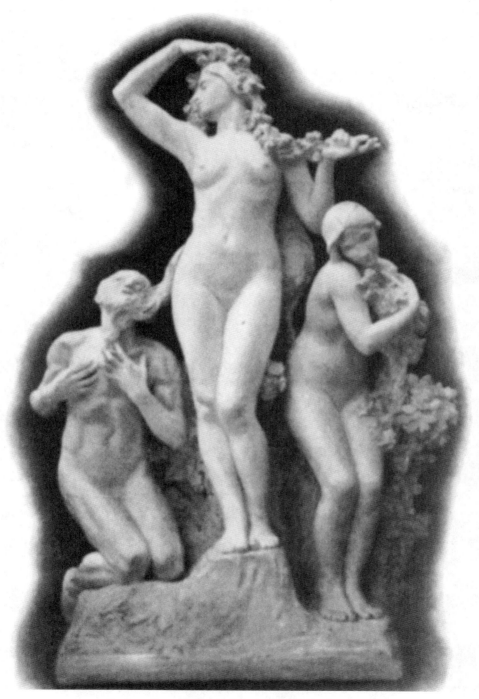

Audrey thought Furio Piccirilli's Spring to be
"one of the loveliest statues in the fair grounds."

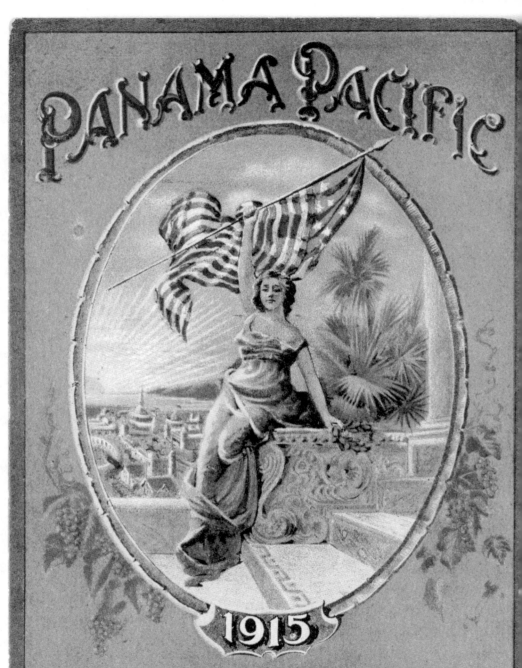

PANAMA PACIFIC

1915

INTERNATIONAL EXPOSITION
SAN FRANCISCO
CALIFORNIA

15·6

a son of the London vocal instructor of that name, was for some time connected with the Covent Garden Opera, conductor of various orchestras (notably the Ruth St. Denis), nine years one of the chief teachers in Toronto Conservatory, and at present associated with Lionel Robsarte, the New York voice specialist. He has also been organist and director of the First Presbyterian Church, Orange, New York, for twelve years," the journal said. The *Washington Post* reported that Dinelli introduced himself to Audrey while she was eyeing a hat in a store window—just as Herzog had done—and offered her free singing lessons. He invited Audrey and Kittie to one of his appearances at Carnegie Hall and then proposed. The marriage was apparently set for the fall of 1915, but it never took place. Audrey does not seem to have taken Dinelli seriously, for she never mentioned him.

The statuary for the San Francisco Expo was made from plaster and destroyed. The magnificent buildings were always meant to be temporary and were torn down. Only one structure survives to this day: the Palace of Fine Arts in what is now known as the Marina District.

Nevertheless, the Expo offered Audrey a glorious chance to break out of the fifty-cents-an-hour modeling business. She set her sights on a new career on stage and screen. It may have been an obvious and even necessary step, given her age, and it fulfilled Kittie's ambitions to see her daughter in the spotlight, but it would turn out to be a perilous move for Audrey. For now, though, the world was her oyster.

"When it was announced that Miss Munson had forsaken the studio there were many who feared that it was a direct result of the adverse criticism that had been heaped upon her nude models by the female Anthony Comstocks of the country, but this is not so," the *Boston Post* reported. "There was another and more material reason and most of us spell it M-O-N-E-Y."

America celebrated in San Francisco
while Europe was at war.

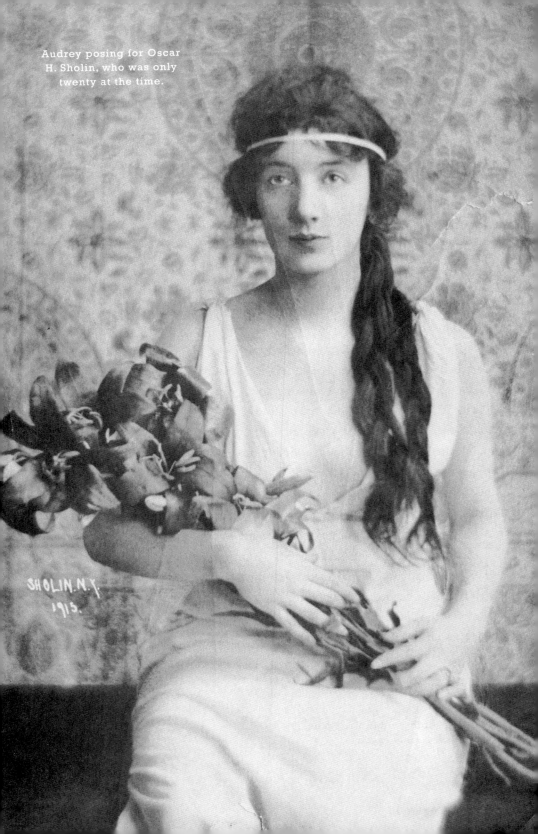

Audrey posing for Oscar H. Sholin, who was only twenty at the time.

SHOLIN. N.Y.
1913.

10

THE FASHION SHOW

The doors opened and Audrey sashayed onstage as "Eve," wearing just a negligee of lavender and salmon chiffon by Bonwit Teller & Co. It was her debut as a star on Broadway. After her success in statuary at the San Francisco World's Fair, the world wanted to see Audrey in the flesh. She was picked as the top model of *The Fashion Show*, which opened Monday afternoon, April 12, 1915, at the 1,800-seat Palace Theatre. "Twenty Handsomest Women in the World—and Audrey Munson," the ads proclaimed.

The Fashion Show inaugurated a new form of entertainment on the Great White Way. "The act is new and pretentious," the *New York Herald* declared. It had long been the case that the styles worn onstage had set fashion, but never before had the costumes been intended as the real star of the show. "Perfect Beauty and Perfect Art Combine to Glorify that Supreme Product of Civilization—The Fashionable Woman of New York," the ads said. The "matinee girls" who began going to the theater at the end of the previous century now wanted to catch up on the latest fashions. The plan was to stage *The Fashion Show* twice a year to help set the styles for the season.

"The much discussed problem of standardizing the fashion in women's wear has been solved," the *New York Tribune* announced. "It is now definitely decided that the fountain head of smart styles shall be the

Palace Theatre, and that this oracle will speak twice a year in the form of a Fashion Show like the display now current at this theater."

The mannequins paraded onstage in front of a giant *V* for *Vogue*, the small New York society magazine that Condé Nast had bought a decade earlier. Their *défilé* was interspersed with songs from Sam Ash, appearing as Beau Brummell, the famous British dandy.

Audrey was billed as "the Spirit of Fashion," a newly created goddess. This was her chance to reinvent herself and trade the life of an artist's model for a career on the stage. She had just finished modeling at a similar private event "displaying the newest dictates of Dame Fashion" at New York's Hotel McAlpin, organized by the society ladies Mrs. Robert Wright Hawkesworth and Mary Pace Groney. Audrey's starring role at the Palace Theatre was billed as her Broadway debut—ignoring her near-anonymous work as a chorus girl just four years earlier.

As well the Bonwit Teller negligee, Audrey modeled a yellow taffeta bathing suit with a Greek border done in lavender ribbons with a matching lavender taffeta parasol. Her final turn was in a body-hugging black-and-white-striped bathing suit.

In the audience was Djuna Barnes, there to describe the spectacle. A wiry woman with a narrow face and penetrating eyes, Barnes cut her hair short and wore blood-dark lipstick that gave her a distinctive personal style. She was known for her strong opinions. Just twenty-two, she was already the hottest young journalist in town.

Barnes was fated to be a maverick: born in a log cabin on New York's Storm King Mountain, her father, Wald, an unsuccessful painter and musician, was a polygamist—and so proud of it he wrote a book extolling the virtues of the practice. Starting out as a cub reporter on the *Brooklyn Daily Eagle*, Barnes displayed a sharp eye for the bizarreries of New York life—the Italian actress called the Wild Aguglia, who kept monkeys in her dressing room; the Indian snake dancer named Roshanara: The Reincarnation of the Ancient East, who was actually an overimaginative Englishwoman; and the "pain-free" dentist known as Twingeless Twitchell, who pulled teeth for free on a street corner in

Brooklyn and claimed, "I'm the man who put the 'dent' in 'dentist' and the 'ees' in 'teeth.'"

Barnes made a name for herself performing fearless journalistic stunts: she rode the Coney Island Steeplechase, climbed down a rope from the top of a building for an article on fire rescues, and became a dummy body for trainee firefighters. Most famously, she subjected herself to force-feeding to record the experience of hunger-striking British suffragettes. Some of her assignments were life-threatening. On one occasion, she was asked to go up in a homemade airplane as one of the first women to fly. Her worried lover matched the twenty-five-dollar freelance fee to persuade her to stay safely on the ground. The plane crashed and everybody died.

Barnes had always had literary ambitions. She wrote trenchant, amusing prose. Six months after *The Fashion Show* she was to publish her first book of poetry, titled *The Book of Repulsive Women*, which opened with a poem the censors overlooked about having sex with a woman. Barnes would become a fixture of Greenwich Village Bohemia and an integral part, with her sculptress lover Thelma Wood, of the expatriate arts scene in Paris between the World Wars. She published a celebrated modernist novella, *Nightwood*, with T. S. Eliot's backing in London in 1936. She spent her last decades in her Village hideaway on Patchin Place as a virtual recluse—dubbed the "Greta Garbo of American Letters."

During her colorful career, Barnes met a vast array of talent, from F. Scott Fitzgerald, who exclaimed, "My God, I should be interviewing you," to Coco Chanel, "world famous for two things, perfume and severe-tailored suits." She admitted letting her mind wander off during an interview with James Joyce. Today, it was Audrey who would suffer Barnes's mordant humor.

The *New York Press* had assigned Barnes to write a feature about *The Fashion Show*. After interviewing chorus girls and tango dancers, seal trainers in Brooklyn and even Dinah the baby gorilla at the Bronx Zoo, Barnes was about to come face to face with Audrey.

Watching the models parade, Barnes felt decidedly queasy. The whole

fashion show made her feel deeply unfashionable. "Surely we are becoming but the models to our gowns," she wrote in her review. "By the time—we say—each creation has been drawled before your senses, languished before your longing and hesitated upon your hopes, you feel so ultra ultra up your spine that your ninety-eight cent near-linen waist suddenly perceives that it is 'passe'. With a shock you appreciate that you are not 'a la mode,' that you do not Maison Maurice through life, you do not negligee a la Bonwit-Teller to bed. Ah, well! Life has never been all Redfern and skittles."

Backstage, the sarcastic poet-journalist snatched a short interview with the star model.

"What could you be but a chorus girl if you hadn't been picked to be a star in a beauty parade?" Barnes asked impertinently.

"What could I have been?" came the testy response. "Why, I am a model of course. That's what I am. I'm not a chorus girl at all, and never have been. You've bought my face a million times upon the current magazines."

"Not that picture of a girl trying on a joke bonnet?"

"Perhaps," said the model, "and perhaps not. Oh, dear, I know I'll be late. Don't I look beautiful?"

Barnes was seriously unimpressed. The girl was naive to say the least.

"Poor little ninny!" Barnes wrote.

To "play the Palace" was the pinnacle of a vaudeville actor's career. The Palace Theatre at Broadway and Forty-Seventh Street was the flagship of the Keith-Albee circuit, built by Benjamin Franklin Keith and Edward Franklin Albee into the dominant force in vaudeville from a single Boston freak show. The gilded age, with the growth and consolidation of American industry, had seen the creation of industry-wide "trusts"— and entertainment was no exception. Keith and Albee were inspired by the Theatrical Trust formed in 1896 by managers of legitimate theater chains, known simply as the Syndicate. The vaudeville monopoly Keith and Albee set up was called the United Booking Office. Like the major corporation it was, the United Booking Office opened headquarters on the top floor of the Putnam Building in Times Square, where the Paramount Building now stands. "It is probably the greatest consolidation of

Fashion Show Makes Girl Regret Life Isn't All Redfern and Skittles

Peggy Hopkins as "Milady of Fifth Avenue." — Betty Brown in a Silk Gown by Estelle Mershon. — Audrey Munson, the "Exposition Girl," in a Negligee by Bonwit-Teller. — Blanche Ring in a Gown by Harry Collins. — Andie Mellon as the Polo Girl, Costume by Nardi. — Kay Karoy as "Milady of the Hunt," Costume by Abercrombie and Fitch.

Girls Are So Perfect That One Longs for a Flaw by Way of Relief—Display Is Likely to Make One's $0.98 Shirtwaist Self-Conscious—Sam Ash Complains of Neglect.

By DJUNA BARNES

Thrillers and Comedies Offer Wide Diversity for Entertainment of Film Fans

Special Attention Paid to Improve Musical Programmes at Motion Picture Houses.

Betty Gray in "The Girl Who Might Have Been." Vitagraph — Grace Washburn in "When It Strikes Home." Hippodrome — Irene Fenwick in "The Commuters." Geo. Kleine — Alga Petrova with Popular Plays and Players—Metro

Audrey was reviewed in *Fashion Show* by the young Djuna Barnes.

money and power in the entertainment world and ranks with the most important of America's industrial corporations," the *New York Dramatic Mirror* wrote.

Keith and Albee had both begun their extraordinary careers by running away from home to join the circus. Keith sold "miracle gadgets" on circus grounds; Albee worked as a "tent boy," roustabout, and animal feeder. They joined forces when Keith hired Albee to work at his "dime museum," freak show, and theater in Boston.

The duo pioneered the "continuous performance plan" that would become synonymous with vaudeville. Spectators could enjoy ten or fifteen unrelated acts, ranging from acrobats and jugglers to singers and comedians and even trained animals playing nonstop from ten-thirty in the morning to ten-thirty at night. As much entertainment as you could possibly want, cost just ten cents—or fifteen cents if you actually wanted a seat.

Keith's Irish-born Catholic wife, Mary, ensured it was all good, family fun, winning the influential imprimatur of the Boston Archdiocese. Performers were required to sign pledges disavowing "all vulgar, double-meaning or profane words." The proscribed terms included: "Liar, son-of-a-gun, devil, sucker, damn, hell, spit and cockroach." The theaters remained dark on the Sabbath, earning them the nickname the Sunday School Circuit.

The formula proved a crowd-pleaser. Keith and Albee began repeating it elsewhere, first in Philadelphia, then in New York. It was at their Union Square Theatre in New York that movies were first seen in the United States, with the US debut of the Cinématographe Lumière on June 29, 1896. In 1906 when they set up the United Booking Office, which was dubbed the Octopus, it wielded control over one hundred vaudeville venues nationwide and 15,000 acts—including Audrey.

Keith retired in 1909 to a life of luxury and a trophy second wife, and died in 1914. But Albee—whose adopted grandson of the same name would become a Pulitzer Prize–winning playwright best known for *Who's Afraid of Virginia Woolf?*—continued to rule with an iron fist. He looked quite distinguished in his starched collar and splendid brush mustache. But Albee was regarded as a brute.

Groucho Marx, who started out in vaudeville, and "played the Palace," remembered Albee bitterly in his autobiography, *Groucho and Me* (1959). "Albee was the owner of a large cotton plantation and the actors were his slaves," Groucho wrote. If an actor had an appointment for eleven in the morning, he would consider himself lucky to get to see him by four in the afternoon. Albee simply dictated what the salary would be. Performers defied him at their peril. "Many an act was hounded out of show business by Albee's Gestapo," Groucho wrote, "or as he preferred to call it, the United Booking Office."

The United Booking Office guaranteed performers a thirty-week tour but took a five percent cut. Audrey appears to have been offered such a deal. She had caught Albee's eye. Three days after *The Fashion Show* opened, the *New York Herald* reported: "Albee believes that Miss Munson has exceptional talents as an actress and entertainer for Vaudeville." He planned to send her on the road as the star of a "beauty act" in variety theaters.

This was the future Audrey was searching for—but it all collapsed in a single incident backstage.

Audrey was in her dressing room. It had a dressing table with a mirror surrounded by electric bulbs and a hot-and-cold shower bath, a luxury at the time. There was a small curtained-off section where the star disrobed. Audrey was still wearing the bathing suit she had modeled onstage when a "man prominent in the theatrical world" entered.

The stranger put his arms around Audrey and sunk his burning lips onto her shoulder.

She tried to wriggle free and struck out at him.

"Get away from me!" she cried. "Don't touch me. I hate you. Your touch is repulsive to me. I would rather have a snake crawl over me than to feel your hand upon me."

The man released his hold.

"Do you mean what you have just said?" he asked.

"I do," Audrey replied defiantly.

She was already shaking, because even at the height of her fear she understood the consequences. This was not a man to be trifled with. He

was not used to having his advances to young actresses rebuffed.

"You will have cause to remember this!" the man warned, and walked out.

Audrey knew what he had done was wrong and had the conviction to resist him. Despite its name, she discovered that the Sunday School Circuit was a much more savage place than the artist's studio. After working so hard to become more than just a piece of flesh, she found herself treated as just that. The next day, it was announced that *The Fashion Show* was to be canceled at the end of the week despite the packed crowds—only one week into its three-week run.

Audrey defected to Albee's archrival in talent booking, William Morris, founder of the eponymous Hollywood talent agency of today. The month after she was dumped from *The Fashion Show*, she appeared at Morris's Jardin de Danse atop the New York Theater on Broadway striking "original statuesque poses." The "living pictures" included Audrey as a Water Nymph, a Sea Sprite, and the Fairy of the Waterfall. But even though she was working, Audrey feared the childhood curse had struck. She recalled how the fortune-teller had warned that her success would be a "Dead Sea fruit"—a fruit, the classical author Josephus wrote, of "a color as if they were fit to be eaten; but if you pluck them with your hands they dissolve into smoke and ashes."

Audrey never named the man who importuned her in the dressing room. He remained too influential. All she later said was: "You would know his name if I were to tell it to you." Others scoffed at her notion that a single man had power enough to banish her from the stage. But there was certainly one man: Edward Franklin Albee. We may never know for sure whether Albee was the prominent theatrical figure who grabbed Audrey in her bathing suit. But he fits the description of a "man prominent in the theatrical world." And Audrey despised him for many years. In a private letter she listed him as her number one enemy. And after *The Fashion Show* incident, Albee was the person she chose to sue.

Audrey's suit, against the United Booking Office, the B. F. Keith New York Theaters Operating Company, and Orpheum Operating Company,

complained that *The Fashion Show* had reopened at the Orpheum Theatre in Brooklyn with another woman in the lead role but was still using Audrey's photographs and name. The new star was Peggy Hopkins, a "Washington society belle" who had been a sidekick to Audrey in the original Palace Theatre production. It seems Audrey was not even warned that she would be replaced. "The plaintiff has been held up to ridicule and contempt and has been greatly damaged in her business and occupation and has suffered great anxiety of mind, humiliation and mortification," Audrey's lawyer told the court. Audrey claimed $20,000 in damages. It was the first time that Audrey had been substituted as the star—but it would not be the last.

Albee and his "Gestapo" were formidable opponents in both the court of law and the court of public opinion. On his side, Albee had arch-publicist Walter J. Kingsley, one of the first generation of modern PR men. Kingsley had been a foreign correspondent for the *Daily Express* of London covering the Boer War and the 1900 Boxer Rebellion in China before representing actress Sarah Bernhardt, singer-songwriter George M. Cohan, Florenz Ziegfeld, and even the German Kaiser before the outbreak of war.

Kingsley was entirely unscrupulous. He outlined his vision of the press agent in a unique collection of poetry by four of the top theatrical publicity men of the day, including Sigmund Freud's nephew Edward L. Bernays, considered the "Father of Public Relations." Kingsley's confessional poem "Lo, the Press Agent" included the following lines:

> *I hold a terrible power*
> *And sometimes my own moderation*
> *Amazes me*
> *For I can abase as well as elevate*
> *Tear down as well as build up*

Albee's side leaked to the press that naked PR photos of Audrey would be introduced as evidence if the case went to court. One of those photographs showed Audrey lounging nude on an artist's couch.

Albee's publicity men briefed that Audrey had been fired because she

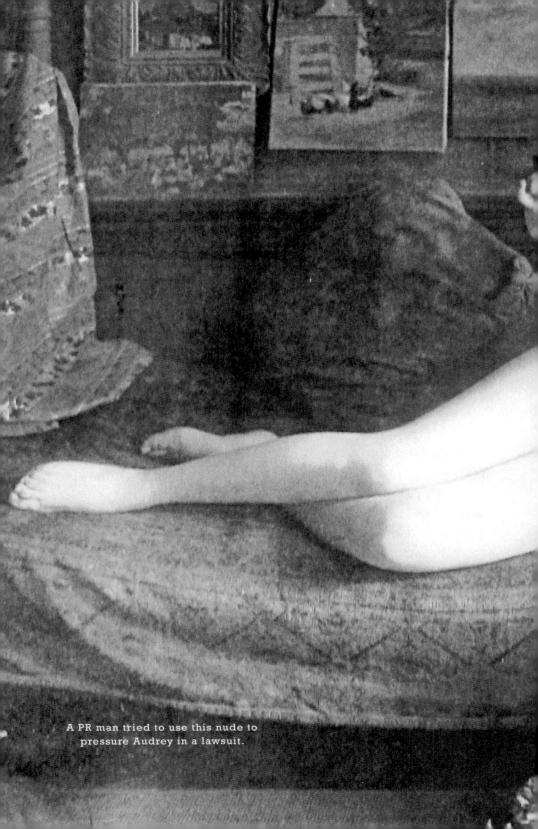

A PR man tried to use this nude to
pressure Audrey in a lawsuit.

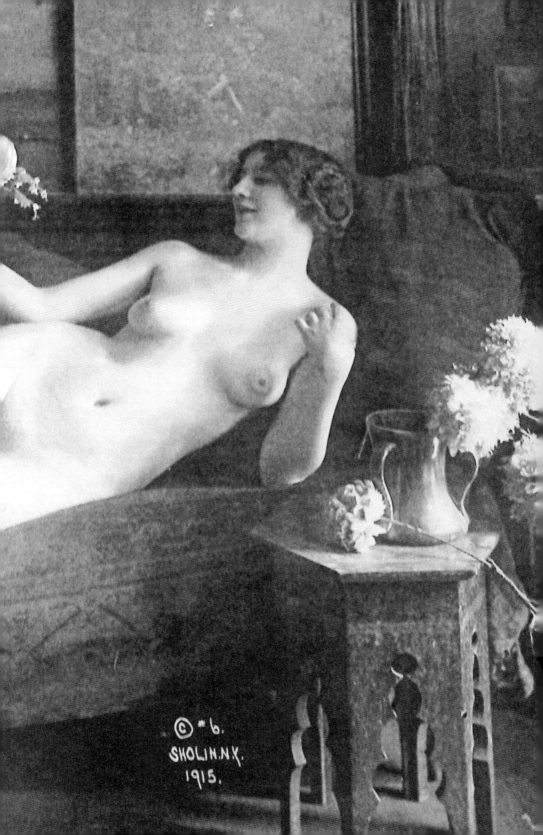

© #6.
SHOLIN.N.Y.
1915.

had not been satisfied with $100 a week and demanded a raise to $400 a week. "She felt she scored so heavily in the manikin parade that a heavy jump in salary was due," the *New York Dramatic Mirror* alleged.

From the court papers, it appears the case ended with an out-of-court settlement, but the details are not spelled out. Audrey must have been paid off in some way, or just dropped the suit. The case made her harder and more ambitious, but it meant her stage career was over before it had begun.

Audrey, who had just turned twenty-four, would never perform on Broadway again. But she still had her youth and her beauty. The obvious alternative was the "moving pictures."

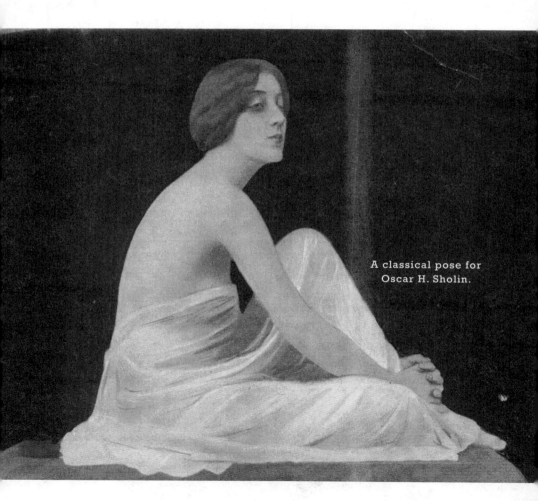

A classical pose for Oscar H. Sholin.

11

INSPIRATION

Audrey set aside her clothing and mounted a small stand in the center of the studio. A workman proceeded to paint her entire naked body with a mixture of oil and grease. This was the first step for her to be cast head to toe in plaster for a sculpture. Audrey just hated it, but she brazened it out, as she always had done.

Guided by the sculptor, Audrey assumed the desired pose. The casting began. Workmen mixed up small batches of plaster of paris until it was sticky and soft. Two casters then began wrapping the warm plaster around Audrey's feet. They applied layer after layer, patting the plaster firmly onto her flesh until she was rooted in a solidifying mass eight or ten inches thick.

The workmen had to work fast because the plaster dried quickly. Handful by handful, they worked their way up Audrey's body—up her legs, around her hips, over her torso and her breasts and her shoulders— until she was entombed up to her throat. Swaddled in the huge, sloppy mess, she felt like a large snowman beginning to melt.

The most unpleasant part came when the casters had to enclose Audrey's face and head. They stuffed her ears with cotton and slipped a silver tube between her lips for her to breathe. She closed her eyes so that an extra coat of oil and grease could be painted onto their delicate lids.

Although she knew what was coming, there was no way to be prepared. It was like a living death. The casters began smearing soft lumps of plaster onto her face and the back of her head. The final touch was for a workman to stand on the table beside her and pour the remaining plaster from the bucket over her head.

"Inside, the girl cannot move so much as a fraction of an inch. She is virtually part of the plaster itself. It is nothing less than a horrible sensation," Audrey later complained.

"I have tried to draw a full breath through my silver tube, only to find that I could not—there was no room inside of me for more than just the amount of air I had been breathing while the plaster was being put on. And once I was almost strangled because the workmen slapped the plaster onto my stomach and chest while I was exhaling a breath, and it hardened into place a moment later while I was again exhaling, giving me no room for expansion with the next intake of air. I had to breath[e] in little jerks till the mold was complete. Imprisoned in this way the model feels as if all the heaviness of the universe were pressed about her, slowly crushing her to death."

For the model, it was an excruciating process. For the voyeuristic public, on the other hand, the spectacle of a naked woman being slapped with wet plaster might prove rather more erotic.

The casting of Audrey in plaster was to be the centerpiece of her first movie, *Inspiration*. For this key scene, Audrey had to be entirely naked. It was a breakthrough in cinema history.

France, *naturellement*, had pioneered nudity in film. George Méliès's *After the Ball*, a one-minute scene of a servant bathing a woman, starring the director's future wife, is generally credited with featuring the first nude on camera. Already by 1907, there were underground pornographic films circulating in America. The first mainstream American film featuring nudity was probably *Hypocrites*, which opened at the Longacre Theatre in New York on January 20, 1915. The film was written, directed, and produced by Lois Weber, the first American woman to become a major movie director. In the film, the hypocrisy of a church

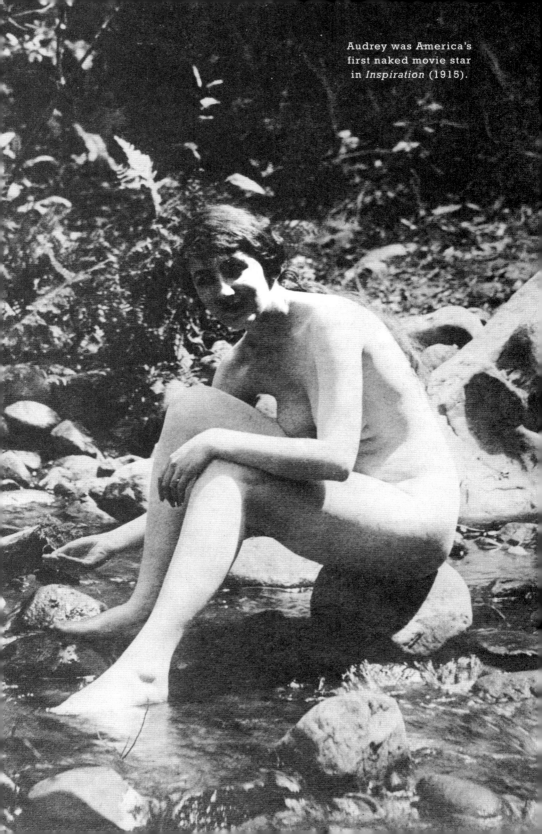

Audrey was America's first naked movie star in *Inspiration* (1915).

congregation is exposed by the nude figure of the uncredited Margaret Edwards as the allegorical character Truth. She was metaphorically and literally "the naked Truth."

Inspiration, released ten months later on November 18, 1915, made Audrey the first leading lady in America to appear nude in a film. She became America's first naked movie star.

The film industry at the time was split between the upstart independents and the would-be monopoly known as the Trust, organized by inventor Thomas Alva Edison, who falsely claimed to have invented the motion-picture camera and projector and controlled most of its patents. Motion-picture producers required licenses to make movies using the Trust's patented equipment. But feisty independents, largely Jews and Catholics, mounted a determined challenge, producing films that were both long and more zesty than the complacent product of the overwhelmingly WASP Trust. Several of these swashbuckling pioneers would go on to become the megaliths of today: Universal, Fox, and Paramount.

Inspiration was made by the Thanhouser Company, one of the independents. In all, it produced over 1,000 movies—though it never made the journey west like other independent producers to California, where Hollywood was born.

Edwin Thanhouser was the first American movie producer to come from a background in the theater. A former actor, like his wife, he had run his own stock companies before making a success of the Academy of Music in Milwaukee. He set up in the movie business in 1909, renting an old wooden skating rink in the New York suburb of New Rochelle. The town was a popular refuge for Broadway's theater people. Stars like Audrey could easily commute from Manhattan. *Tin Pan Alley* songwriter George M. Cohan, who grew up in Providence like Audrey, named a musical after the train ride from New York to New Rochelle: *Forty-Five Minutes from Broadway.*

Because of his thespian past, Thanhouser earned a reputation for luring fellow actors into the movie business. Hiring Audrey, however, was the first time he had pounced on a model from the art world. "Not

content with causing stage celebrities to migrate '45 minutes from Broadway,' he has now saddened the hearts of the Washington Square soft collar and flowing tie contingent by snatching from their midst 'Divine Audrey,' and he promises that in *Inspiration*, which is the title of her first release, he will give the pro- and con-ers of motion pictures something to talk about," *Moving Picture World* reported.

Inspiration opened new horizons for Audrey. She could now set aside her hopes of a stage career for a dream of the silver screen. Propelled by the power of movie advertising in local papers across America, Audrey suddenly became a household name.

Despite her clash with Albee, Audrey got a crucial helping hand from the man who had been penciled in to direct her "beauty act" on tour. Arthur Hopkins was just breaking into directing himself. One of nine children of a Welsh miner who died when he was young, Hopkins had started out as a newspaperman. As a young reporter for the *Cleveland Penny Press*, he got the scoop on the man who shot President McKinley at the Buffalo World's Fair. He rushed by horse-and-buggy to the Cleveland suburb of Newburgh, where the local priest told him that the assassin, Leon Czolgosz, was an anarchist.

Hopkins first got into show business as the press agent for Cleveland's new Colonial Theater, which he made so popular that the best seats were sold by auction. He moved on to New York to book acts ranging from bears to brass bands for the booming new amusement parks. Hopkins graduated to Broadway, where he worked first as a talent agent and director before producing his first big hit, *Poor Little Rich Girl* at the Hudson Theatre in 1913. At the time of *The Fashion Show*, he had a two-room office in the Putnam Building with the United Booking Office. He went on to become a playwright, director, and producer of some eighty plays, including John Barrymore's famous *Hamlet*. When Audrey was unceremoniously dumped by Albee, Hopkins stepped in and acted as her manager in negotiating her first movie deal with Thanhouser.

Loosely based on Audrey's own life story, *Inspiration* retells the timeless tale of the young girl who seeks her fortune in New York. In the press

agency's account, Audrey is not discovered by the middle-aged Herzog but by a group of young Greenwich Village gallants out for a drive.

"Like thousands of the girls, Miss Munson came to New York alone pursuing elusive opportunity. New York was not kind to her and her little pile of savings grew lower and lower. But just as in popular fiction the silver lining of the cloud appeared when the deluge threatened and in the most Bohemian sort of way imaginable the girl was struck by an automobile as she crossed a street near Washington Square, the rendezvous of artists," the press agent said. "In the machine were several men, one a sculptor in search of a model. When they learned the girl was not hurt and was looking for work the artist asked her to come and pose for him. Of course, he did not recognize what a find he had in this slim, hungry girl whom chance had thrown in his way. But when he came into the studio and saw the beauty and vivacity of the girl, he was amazed. That was the beginning of the brilliant career of Audrey Munson."

In the film, the Audrey character secretly falls for her sculptor savior as he sculpts his masterpiece, *Inspiration*. When the work is done, she disappears, leaving him a note, convinced that he has fallen for one of the rich young women who frequent his studio. Of course, the sculptor is secretly in love with her too. Heartsick, he searches the city until he finds her in a miserable heap at the base of the Maine Monument in Columbus Circle, where he has gone to gaze on her features again in the statue.

Moviegoers, not surprisingly, loved the sight of the naked Audrey getting caked in warm, wet plaster. Audrey's *poses plastiques*, in the form of her famous statues, also went over big—particularly the scene in which Daniel Chester French's Evangeline dissolves into her nude body. "When it comes to nude posing 'Inspiration' has anything in the line of picture entertainment beaten to a frazzle. 'Hypocrites' caused comment with its nude figure flitting here and there in a semi-seeable manner, but in this there is no doubt one is seeing the real thing," *Variety* declared. *Movie Weekly* ran a generally positive review, calling it "undeniably novel" and "a bit daring." It was followed by a footnote: "The preceding review completely overlooks the raison d'être for the film: the nude exhibition of Miss Munson's anatomy!"

Thanhouser was accused of trying to exploit Audrey's nudity on-screen. But he defended his artistic purpose. Firing off a letter of complaint to the *Morning Telegraph*, he insisted: "The impression that I advocate the nude in moving pictures is wrong and should be corrected."

Inspiration did gangbusters at the box office in Los Angeles, which was just emerging as the moviemaking capital of the world. The movie magazine *Reel Life*, the house organ of the film's distributor, did the math: *Inspiration* played to a full house for nine showings a day through the entire two-week run at the Garrick Theatre, capacity 1,000. That meant 126,000 people saw the film, or almost 40 percent of the city's 319,198 population. "For a film to create a furore in Los Angeles is unprecedented," *Reel Life* concluded.

It was the same success story elsewhere. "There is absolutely no chance of ever taking in more money in this house in one day than we did yesterday, for we played to absolute capacity from opening until closing time, and could not have played to another 50 people—all of which goes to show that a good picture, well advertised, will go over big," Herman Fichtenberg, owner of a chain of theaters in New Orleans, said.

Back in the film's hometown of New Rochelle, however, the nude Audrey ran into opposition. Before the opening, a committee of clergymen showed up at the North Avenue Theater and demanded a private screening. Charles Jahn, the theater manager, capitulated and let them in. As a result, the film was canceled. "Many of our residents have seen this picture at Loew's Circle Theater at 59th Street and can see nothing objectionable," Jahn complained. A letter from a Frank Egan to the *New York World* tartly observed: "It is difficult to understand New Rochelle morals when it permits motion pictures to be manufactured within its limits which it will not permit to be shown there because of the pictures being 'suggestive and likely to be harmful to young men and women.'"

The most severe reaction came in nearby Ossining, New York, where some of the wealthiest women in Westchester County had set up a censorship committee for the Civic League. Theater owner Louis Rosenberg was arrested at the league's behest and charged with corrupting

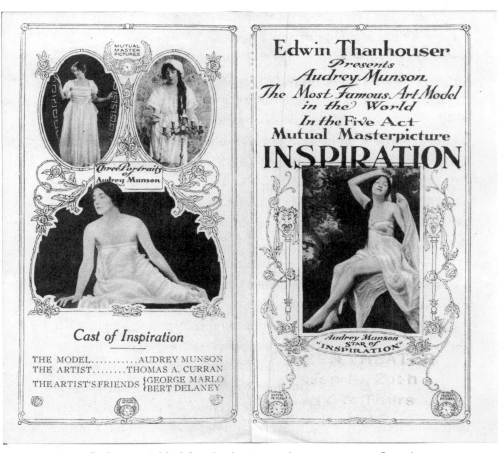

Audrey provided *Inspiration* to movie-goers across America.

the morals of a two-year-old boy who saw *Inspiration* on his mother's knee. The mother, Grace O'Neill, had walked out when the sculptor had wrapped Audrey in plaster only up to her knees. She admitted she did not know if her toddler, John, had been corrupted. The only visible ill effect, she said, was that he chewed off the leg of a red doll. When John was asked about the movie, he said only: "Me want more tandy, Ma-a-a!"

Sculptor Isidore Konti, shown in the film, was asked his reaction to the rumpus. As the man who first schooled Audrey about nudity in art, he stood strongly at her side. "To object to the nude is simply stupid. Nude pictures are found in all the noted art galleries," Konti said.

Audrey was always similarly dismissive of the puritans who would censor her work. Kittie may have had misgivings, but she had learned from Konti's lectures and stuck by her daughter. Movies were still new, and it was hard to understand why there should be a distinction between art forms. But Audrey and Kittie learned a bitter lesson about the finances of the nascent movie business. Despite *Inspiration*'s sensational success, and its historical importance as the first American film with a naked leading lady, Audrey complained she made only $450 from the picture—only a fraction of the box office take.

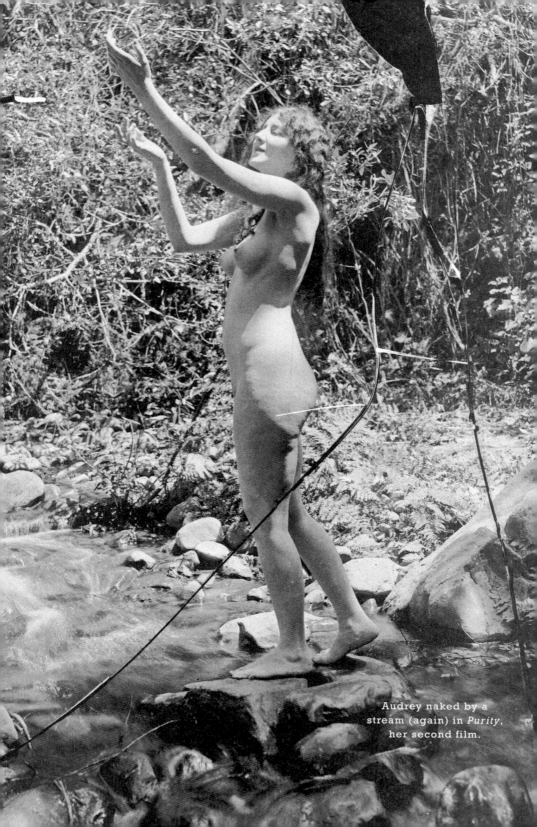

Audrey naked by a stream (again) in *Purity*, her second film.

12

PURITY

All of Audrey's motion pictures were lost. Then, in 1993, after many decades, her second film, *Purity* (1916), was rediscovered—a strange parallel to what would eventually happen to her too.

Purity only survived because it was found in a private collection of pornography in France. When the collector died, his heirs sold his archive of pornographic films, photographs, and other unmentionable items. France's national film archive, the Centre National du Cinéma et de l'Image Animée (CNC), acquired the 35mm print of *Purity*.

Even though Europe was roiled by the Great War when the movie was made, the sole surviving print of *Purity* was intended for distribution in France. The intertitles between the silent scenes are in French. The rediscovered *Purity* was first shown at the Pordenone Silent Film Festival in 1999. Since then, it has only been screened in public twice: at the University of California, Santa Barbara, in 2005, in the town where it was made, with live actors voicing a translation of the intertitles; and at the British Museum in 2015, with a traditional improvised piano accompaniment

Exactly one hundred years later, it is indeed mind-boggling to see Audrey posthumously wandering across the screen almost naked

for most of the movie's one and a half hours. Nothing can do more to bring Audrey back to life. Taller than the other women in the cast, she is wooden, as though she thinks she is still posing in an artist's studio. Her benevolent face suggests a sweet personality. Already, her slip of a figure has filled out with sizable haunches and hips. But it is still obvious from her upstanding breasts with their large areolae why so many artists and filmmakers—and the moviegoing public—prized her nudity so. In one scene she performs a nimble dance on an open-air stage, carefully pointing her toes, which hints back to her youth as one of Gerald Hampton's Dancin' Dolls. At times, however, her expression appears somewhat glazed, whether from boredom, a sense that she is imitating statuary, or from some deeper malaise it is impossible now to tell.

To watch it in plush armchairs in an air-conditioned theater is to miss a great deal of the fetid standing-room-only atmosphere in which it was originally shown on the road. Exhibitors were warned to make sure the police were in attendance on the last day of the run in case the crowd started a riot if the tickets ran out. "The announcement of the last screening should necessitate the calling out of the police reserves to keep the crowds from breaking down the doors of the theaters in their efforts to see it," warned *Variety*.

Purity tells two parallel stories in eight acts. The first story is an allegory set in a fantasized classical Greece where everyone is dressed in flowing robes. The second is a tale of present-day New York, in which a rather feeble and egotistical poet named Thomas Darcy is striving to get his poetry published.

Audrey plays two characters: a goddess and an artist's model. They were her archetypal roles. In the allegorical scenes, she is the goddess Virtue. In the real-life tale, she is the poet Darcy's aptly named fiancée Purity Worth. To get the $500 needed to publish Darcy's poems, Purity Worth agrees to pose secretly in the nude. Darcy's work is published to acclaim. The success goes to the poet's head as he is fêted by high society. When he discovers Purity has been posing nude, he breaks off their engagement. The crisis is resolved when the publisher lets slip that Purity's

earnings financed the printing of his poetry book. Darcy is overcome by remorse and begs Purity's forgiveness.

As a Greek goddess and an artist's model, Audrey could get away with respectable nudity in both roles. Despite their protestations as to the artistic merit of the movie, the producers were patently trying to maximize the amount of Audrey's skin they could put on view. The original synopsis specifies: "Virtue is represented in these scenes by a nude female figure, artlessly adorned with filmy drapery."

In the final product, Audrey's breasts are constantly bursting out of her Greek robes. And even when they are not, her nipples are visible through the gauzy cloth. In the surviving version of the film, however, there is only once scene of complete frontal nudity, as she poses for an artist. The fact that Audrey had removed her pubic hair renders her nudity perhaps less striking than it might otherwise have been.

Audrey had been approached to make movies on the West Coast after her starring role at the Panama-Pacific International Exposition in San Francisco. She began working for a new studio: the American Film Company, nicknamed the Flying A. The Chicago-based company moved production to Santa Barbara, California, in 1910 as filmmakers moved west in search of cheap labor, dramatic backdrops, and reliable sunshine. The Flying A leased an old ostrich farm that, in a sign of the times, had been abandoned because it was no longer fashionable to wear ostrich feathers. The company built a new state-of-the-art glass-topped stage known as the Glass House. In 1916 alone, the studio produced 242 titles.

The Flying A made two particularly controversial films. One was *Damaged Goods*, based on a 1901 French play, *Les Avaries*, by Eugène Brieux, which had been novelized by Upton Sinclair, about a couple who get syphilis, a serious social problem at the time. The 1914 film was directed by Thomas Ricketts, who would go on to direct Audrey next.

Audrey's *Purity* was the second controversial film. Its title is deeply ironic given that the National Christian League for the Promotion of Social Purity had so recently decried Audrey's naked poses for the San Francisco Expo. It seems to have been a deliberate provocation aimed at

the anti-vice campaigners. An archive copy of the synopsis had the original title, *Virtue*, crossed out and *Purity* penciled in. Censors really did not know whether *Purity* was art or smut. The critics were divided. But the theatergoing public did not seem to care much about the distinction.

In a landmark ruling the previous year in *Mutual Film Corp v. Industrial Commission of Ohio*, the Supreme Court had upheld the right of local and state bodies to censor movies, exempting them from the First Amendment protections of free speech. Justice McKenna wrote that motion pictures are "capable of evil, having power for it, the greater because of the attractiveness and manner of exhibition."

To try to overcome this patchwork of censorship, the film industry embraced the nonbinding recommendations of the National Board of Censorship, a nongovernmental outfit set up in 1909 by the People's Institute, a project of Cooper's Union in New York, to promote the cultural education of the poor. The board had shown its liberal leanings by approving *Hypocrites* and *Inspiration*. Just prior to *Purity*'s release, the body had changed its name to the less sinister National Board of Review of Motion Pictures. The board adopted new guidelines for nudity, stating: "All such representations of the NUDE or practically NUDE will in the future receive the most critical consideration and will be only favorably acted on when extraordinary reasons for the presentation of such figures appear to exist as an essential element of a drama the nature of which warrants such presentation."

To review *Purity*, the board invited a hand-picked audience of thirty-eight men and sixteen women to a screening at the Wurlitzer Fine Arts Hall, 120 West Forty-First Street, in New York on July 13, 1916—just nine days before the film's first scheduled screening in the city. The invitation said the question before them was "whether the artistic excellence of such a production warrants the exhibition of motion pictures of this type."

The invitees voted 32–20 against approving the movie for general release but 54–4 in favor of screening it for adult audiences. In addition, two women and one man voted for "modifications" before it could be shown.

Many of the artists for whom Audrey had posed—including Daniel

Publicity shot
for *Purity*.

Chester French, Adolph Weinman, and Augustus Lukeman—were among the audience at a second invitation-only screening on July 17. Not surprisingly, the artists reacted to the movie, and Audrey, with delight. Nevertheless, the National Review Board voted to recommend ten cuts—mostly shots of Munson dressing or undressing, or unclothed by a stream or in an artist's studio. The board also demanded that Mutual, the distributor, "eliminate all posed reproductions of masterpieces" in which Audrey herself struck the poses for famous statues.

The film, which cost $100,000–$150,000 to make, took in more on its opening night than *The Birth of a Nation*. The *Los Angeles Times* called it a "gasp arouser." In Ogden, Utah, some 2,000 people saw the movie at the Orpheum Theatre, with "ribald laughter and morbid curiosity." *Purity* was a box-office hit. The distributor was able to rent it to theaters for the hefty sum of $100 a day.

Some reports said *Purity* appeared minus 1,000 feet of film, equivalent to fourteen minutes of cuts. The National Review Board ducked a final decision on ordering nationwide censorship. In August it wrote to authorities around the country saying it would neither "pass" nor "deny" *Purity*. Instead, it asked for feedback to assess opinion across the nation.

Crafty exhibitors made a virtue of the controversy. James Q. Clemmer, who owned the Clemmer Theatre in Seattle, asked his patrons to vote on whether to screen *Purity*. He offered a ten-dollar prize for the best letter in favor and the best letter against, and said the best ten letters on each side would win free tickets—not a prize designed to appeal to those who felt the movie should be barred.

Of the thirty states or cities that wrote back to the National Review Board, ten reported they had allowed exhibition of the movie in some form while ten—including Dallas, Kansas City, and the District of Columbia—had banned it altogether. The opening at the Liberty Theatre in New York was delayed by a week, reportedly because the city's licensing commissioner considered the title *Purity* to be a "misnomer." The *New York Sun* said the licensing commissioner obtained the deletion

of 200 feet of film, almost three minutes, cut from the film in New York City. In Los Angeles, the film was seized at the Main Street Theater after allegedly being shown with censored scenes reinserted.

The publicity for *Purity* said of Audrey: "Her winning sweetness, her nobility of mien, her superb grace [and] finished acting are never to be forgotten optical delights." But the critics' verdicts on Audrey's performance were less than flattering. The *New York Tribune* wrote: "Although it is rather pretty, it is certainly very dull. As an actress, Miss Munson is quite incapable of registering an emotion." Given Audrey's ambitions for stardom, this was a serious problem, and it would recur.

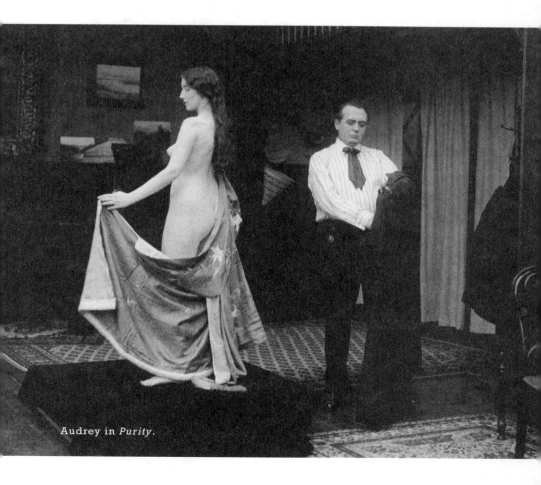

Audrey in *Purity*.

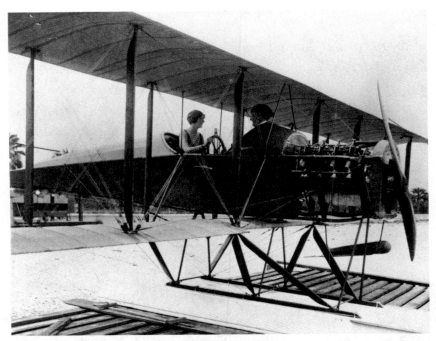

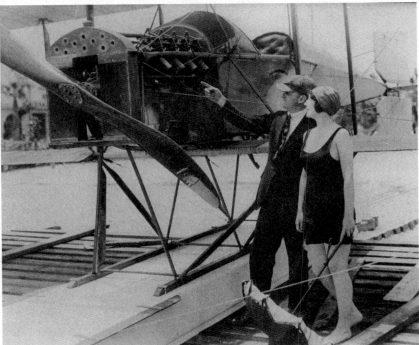

Audrey was the first movie star ever to fly to a movie set—
and her pilot was Allan Lockheed.

13

MR. LOUGHEAD'S HYDROPLANE

To shoot *Purity*, Audrey moved out West to the Flying A's new hometown of Santa Barbara. The first thing she did was secure a bungalow on the beach and begin going for a daily splash. One day two enormous man-eating sharks were spotted swimming in the waters off her home. Their appearance cut short her forays into the surf. "Don't know anything about these man-eaters hanging around the beach," she announced, "but I know a model who isn't going to be fed to them."

Even though Audrey was now a movie star, Kittie followed her to California. The balance of power between them had changed. There was no longer any doubt that Audrey was looking after her mother. They lived together on the ocean at 509 East Boulevard.

By now Audrey had become a beauty icon. She wrote occasional beauty columns for the newspapers, championing women's bodies as a source of beauty, not shame. The suffrage movement was in full swing, but women had not yet won the right to vote and could serve on juries in only six states. The elasticized girdle had begun to replace the ribbed corset, and a feminist had just been granted the first patent for the modern brassiere. But on the beach, women were still generally constrained to wear awkward Victorian dress-and-pantaloon combinations.

Audrey was photographed posing coyly in a one-piece bathing costume. The press reported that she believed in women wearing "the same kind of bathing suits that men wear." In this, she was joining a long-standing campaign by the Australian swimming-star–turned-actress Annette Kellerman, who had been arrested for indecency for wearing her snug one-piece on Revere Beach, Massachusetts, in 1907. Like Audrey, Kellerman had left vaudeville after falling out with Edward Albee, and she appeared naked in a movie herself the year after Audrey went nude in *Inspiration*. Her film *A Daughter of the Gods* (1916), an eight-month shoot partly in Jamaica, was the first production to cost $1 million, and Kellerman was dubbed the Million-Dollar Mermaid. Kellerman later set up her own company to produce one-piece swimsuits, which became known as Annette Kellermans.

Audrey seemed happy in sunny California, at least at first. "Pure air and water and sunlight are nature's great restoratives, and it would be an easier matter for more people to be beautiful if this were better understood. I'm sure if I did not keep the best of health I would soon lose my good looks and cheerful spirits. Health is certainly the first wealth and usually the means of every other wealth," she believed.

"Most healthy people if not actually beautiful are certainly good to see. I'm sure every girl who hopes to make the most of her appearance cannot do better than attain her greatest possibilities in the way of robust health. She can certainly learn to swim and enjoy it, because everybody can, and I'm sure it's the most healthful of the enjoyments."

On East Beach, opposite her home, Audrey saw something magical. Every so often, a hydroplane would skim across the waves and soar off into the skies. She was entranced and determined to fly. She found a truly extraordinary American to give her a ride.

The plane Audrey watched belonged to Allan Loughead, the son of a well-known female novelist who moved out West when she divorced. As a teenager, Allan was inspired by the Wright brothers' first flight in 1903. It gave him a lifelong passion for aviation. After just an hour and a half of flying time, Loughead became an early flight instructor and started

making exhibition flights at fairs for 25 percent of the gate. But when he crashed his rain-soaked canvas-winged biplane into some telegraph lines at an exhibition in Hoopeston, Illinois, Loughead decided he had better build a better plane for himself. Working with his brother Malcolm in a garage on the corner of Pacific and Polk Streets in San Francisco, he built the "Model G" hydroplane. The name was intended to give the impression it was not their first design—but it was.

The Model G that Audrey saw had made its first flight on June 15, 1913, when the brothers pushed it down the slipway at the end of Laguna Street into the San Francisco Bay. Allan had made a short first flight and then took his brother on a tour of Alcatraz and a pass down Market Street. Despite the novelty, however, there were only a limited number of people willing to risk their lives for a thrill ride at ten dollars a pop. The project had backing from the owner of the local Alco Cab Company, who impounded the plane until his $4,000 investment was paid off.

The Loughead brothers spent two years trying to find the money, even working as gold prospectors at one point. It was the Panama-Pacific International Exposition, where Audrey was the Star Maiden, that gave them their first big break. The Lougheads won the flying concession for the fair. For ten dollars, Allan would fly two passengers on a ten-minute flight around Alcatraz at 60 mph. They grossed $6,000 in fifty flying days. Not everyone was enchanted. Henry Ford refused to take a ride, declaring: "I would not take even a straightway flight four feet above the bay in anybody's aeroplane for all the money in California." Ford stuck to making cars.

After their success at the Expo, the Loughead brothers decided to take their hydroplane down the coast to Santa Barbara. To get there, the brothers had to dismantle the aircraft and pack it in crates because the Model G's fuel tank only carried eight gallons of gasoline—not enough to make the 300-mile-plus trip. The Model G was reassembled at the foot of Bath Street, creating great excitement among guests of the nearby Potter Hotel.

Just weeks after *Purity* was released, Audrey started work on her next

movie. *The Girl o' Dreams* was shot on location on Catalina Island, just off the California coast. Audrey wanted to fly to work.

Loughead was reluctant when first approached about flying all the way to Catalina Island. As soon as he saw Audrey in person, a newspaper noted, "he changed his mind with alacrity." Her producers had reservations about letting their star go up in the air in the newfangled contraption in the middle of filming. But after a month of negotiations, their star eventually won out.

Audrey had no idea what to wear for a flight in a hydroplane, so she did what any normal movie star would do: she turned up in her one-piece bathing suit, with a parasol to boot. Before placing her life in Loughead's hands, Audrey was invited by him to inspect the plane on dry land. She then climbed into the rear seat and the aircraft was pushed out on its floats to sea. As the plane lifted off, Audrey could see all along the California coast. "It was the most wonderful adventure of my life," she raved, declaring that she wanted to buy her own plane. The cast and crew were amazed when Audrey arrived by air. It was the first time a movie star had ever arrived on set by airplane.

Allan Loughead became one of America's most successful entrepreneurs. Tired of people mispronouncing his Scotch-Irish name as "Loghead," he followed his brother in changing it to Lockheed. His company eventually became Lockheed Martin, now the world's largest defense contractor.

The Girl o' Dreams was a shipwreck fantasy; its original working title was *Gem of the Western Seas*. A millionaire sculptor seeks solace after the death of his young wife by moving to an uncharted desert island. Meanwhile a cad who is pursuing a young convent-raised girl, Norma, played by Audrey, persuades her mother that she and Norma should both accompany him on a cruise. Their yacht catches fire and Norma is washed ashore on the millionaire's island refuge.

The reclusive millionaire sculptor uses Audrey's character as his model on the island. For her third movie in a row, Audrey was typecast as an artist's model—providing ample excuse for nude posing. In *The*

Girl o' Dreams, the reclusive sculptor sends a photograph of one of his works back to a friend in New York. It is seen by the cad, who recognizes the female form. The cad journeys to the desert island and tries to rape Audrey's character, Norma, but he is killed in the ensuing struggle.

The millionaire sculptor selflessly packs off Norma back to New York for her own good. Disconsolate, he returns to his hut to muse on one of his sculptures of her. As he is admiring her stone form, she steps out from behind it. She did not take the boat after all, and in a proto-Hollywood ending, they declare their love.

Audrey's acting skills in *Purity* had been panned. The print of *The Girl o' Dreams* has disappeared, so it is impossible to judge her performance. But there are signs that something much graver afflicted Audrey in the film than a lack of acting talent.

She is cast as a woman who becomes mentally damaged. The original synopsis, still among the papers of Flying A's co-owner John R. Freuler, describes how the trauma of the shipwreck has left Audrey's character with a childlike mind. "It is that of an innocent child of three," the synopsis says. At one point in the script, the sculptor describes Audrey's character as "deranged." When she is found on the beach, the intertitle reads: "Terror has torn the living present from her mind, and swept her back to childhood." By a "strange prank of fate," Audrey's character only recovers her memory when the cad plunges off the cliff near the end of the film.

The psychological problems of Norma, Audrey's female lead, seem an unnecessary plot point. The sculptor seems almost perverse ogling a naked woman with the mind of a child. Throughout her life, Audrey had been subjected to greater and greater exposure: first in an amusement park, then in a chorus line, then as a nude artists' model, and then in *The Fashion Show*. Moving to the West Coast to make movies seems to have pushed her too far. As she always had done, she tried to brazen it out. But the pressure was mounting, in sync with her fame. The studio's unusual decision to cast her as a woman with a childlike mind appears to have been a deliberate cover for her own growing psychological troubles.

The Girl o' Dreams was directed by Thomas Ricketts, the former

British stage actor who is credited with directing the first motion picture in Hollywood. *The Girl o' Dreams* was his 119th film for the Flying A. The film was reported to be "rapidly nearing completion" in July 1916, and was said to have been completed by the time the August 19, 1916, issue of the trade journal *Motography* hit the stands.

Audrey left a tantalizing hint about a possible affair with Ricketts, though he was married to movie star Josephine Ditt. Audrey later gave a highly embellished, indeed semifictional, account of her love life to the newspapers. In it, she said she had once had a much older movie director as a lover. Recounting her amorous life, she said: "Then I went into the movies. There I met my fifth love—Gordon, a motion picture director much older than I. Our romance was of the sedate kind and lasted only a few months. Though an able director, Gordon was far from rich and our romance went on the rocks at the first sign of financial storm. Gordon and I parted sadly."

While in California, she also fell in love with "an English Jew, 19 years old, a California fellow," according to one of her private letters. She gave no clue to his identity. Her semifictional newspaper account of her love life gave a rather different description of a young boyfriend from England: "Cecil was a titled Englishman who through financial troubles had been forced to become an automobile salesman in a California city. We took long drives together. I grew to love him," she said. "He told me that he was too poor to wed me. Then—difficulties over my motion picture contract arose. Several expensive trips to New York were necessary. One day I received news that Cecil's father in England had left him the family fortune on condition he wed his cousin, and that Cecil had complied and sailed for England."

This young English suitor may have been her companion on the "long drive" that Audrey took to try to cash in on her celebrity at the California State Fair in late August 1916. Audrey owned a racy Hudson Super-Six automobile. Outside Fairfield, California, she was stopped for speeding with a man she said was her manager as they raced to Sacramento from San Francisco with what the local newspaper called "visions

of rapidly acquired wealth." Audrey planned to demand a hefty fee of $1,500 for posing at the state fair. She had left Kittie at home. Her scheme came to nothing but a traffic ticket, however.

Audrey's West Coast adventure came to an abrupt end. She returned home to the East Coast by train as a conquering heroine—but that was not the real truth. She and Kittie stopped off at Syracuse on their way back to New York so she could see her father. Edgar Munson now saw his original fifty-dollar loan to Audrey to kick-start her chorus girl career amply repaid. When she stepped off the train clutching a fashionable bag, inside were bank statements showing a balance of $15,000. It made headline news. "Audrey Munson back home with $15,000 in bank book," the *Syracuse Post* screamed. "Think of it. This little girl of mine has made $10,000 in the last six months," Edgar exclaimed. "Any girl who can make that much more than her 'old man' is entitled to my respect." Audrey asked her father to help her buy a house in Syracuse. "I'm going to get the original $50 loan back in commissions," he quipped.

Audrey reveled in the welcome. Banners were strung across Salina Street, where Edgar and his second family lived. A chauffeur-driven car carried her through the streets, with little white dogs on her lap, to her hotel. She was curious about Syracuse, her father's adopted home. The last time she had visited was almost three years earlier, when she spent Edgar's money like water. Now she had money of her own. The reunion with her father, and seeing him so proud, came as a deep comfort to her fragile soul. "I cannot describe it, but this feels like home to me," she said. "Mother had quite a laugh at me because I thought Syracuse so much smaller than it is. But I hadn't been here in years. I like it—indeed I do."

Audrey was excitedly hatching plans for her future—a future in Syracuse. She said she would spend most of her time in the city, working on her music and languages. She was already an accomplished pianist but needed to improve her voice. "It isn't grand opera I'm looking forward to. I'm happy in my work. But I want to develop and grow so I'm taking up music." At the station, she even consulted a reporter about investing in a phonograph company.

Audrey was already a star in Syracuse from her role in *Inspiration* The local newspaper announced that *Purity* and *The Girl o' Dreams* would be arriving in theaters soon. Yet Audrey did not have any further films lined up for the Flying A.

Indeed, *The Girl o' Dreams* appears never to have been released in the United States. No reviews or advertisements for the film ever appeared in the trade press, and Audrey made no publicized appearances to promote it. Four years later, Audrey still said she had never seen it on-screen. It was the last movie that Ricketts ever directed for the Flying A. *Motion Picture News* reported: "Following the strenuous work on this and previous subjects, Mr. Ricketts has been granted a long vacation." Audrey's reference to "difficulties over my motion picture contract" seems accurate. The movie appears to have been killed. The University of California, Santa Barbara, which holds the Flying A's archive, calls *The Girl o' Dreams* "Perhaps the most mysterious project ever done by American Film Co."

The problem may have been a rival film, *The Girl o' My Dreams*, that came out around the same time, starring Billie Rhodes as a girl called the Weed. The two films were often confused in the press.

Freuler's archive does not give a reason why *The Girl o' Dreams* never came out, but it offers a clue. *The Girl o' Dreams* does not appear, as *Purity* does, on the company's list of "All Rights" films. That indicates that the Flying A did not control all the rights to *The Girl o' Dreams*. Audrey herself later said there was a second owner of her film. That man was press baron William Randolph Hearst—and Audrey came to bitterly regret it.

14

THE TRIUMVIRATE

The boarding houses in Providence, where Audrey grew up, stood only thirty-five miles from Theresa "Tessie" Oelrichs's magnificent oceanfront mansion in the summer colony of Newport. The true distance between the two worlds, however, was measured in millions of dollars, not miles.

Tessie Oelrichs, as heir to America's largest silver-mining fortune, could afford to emulate European royalty. Architect Stanford White modeled her mansion *Rosecliff* on the Grand Trianon built by the French Sun King Louis XIV for his mistress at Versailles. Gleaming white terracotta covered the facade, and the eighty-foot-high central ballroom with its gold-and-white organ was the largest ever built in the resort. Yet Tessie, like Newport's other superrich summer residents, referred to her palace simply as a "cottage."

Tessie's Bal Blanc (White Ball) on August 19, 1904, to celebrate the Astor Cup sailing race in Narragansett Sound, entered the annals of Newport history as the high-water mark of the Gilded Age. Tessie demanded that all the female guests powder their hair white in the style of the royal court at Versailles. She herself wore an elaborate white lace gown with strands of silver thread hinting at the source of her wealth, and three white ostrich feathers atop her head. Her sister, Virginia, nicknamed

Tessie Oelrichs called *Rosecliff* a "cottage."

Birdie, dressed as Marie "Let them eat cake" Antoinette in white crêpe de chine. Eager to offer a captivating view from her clifftop lawn, Tessie personally asked President Theodore Roosevelt to order the US Navy to anchor its Great White Fleet—then painted white—offshore. To her shock and dismay, the president refused, so instead she commissioned a fleet of mock vessels strung with white lights to be moored out at sea.

On her return east from California, Audrey's newfound fame bought her access to this dream world of privilege and riches. The glittering prize that had seemed so near but so out of reach in her youth in Providence was now within her grasp. Although she had become a movie star, she was now in way over her head. Her $15,000 bank balance would not even finance a decent costume ball, or a season's worth of gowns. Tessie Oelrichs once transported the whole Russian Ballet to Newport to entertain her dinner guests.

Kittie watched her daughter from afar—and there is a suggestion that she became temporarily estranged from Audrey for the first time. Instead

of stopping in Syracuse, Audrey had rented a large house at 601 West 239th Street in the smart Riverdale section of the Bronx. The new home was a short walk from the polo fields of Van Cortlandt Park, which had been requisitioned by the army for training exercises during the Great War. There is no listing for Kittie at the address, but even if she did live there, she was perhaps isolated in the Bronx from her daughter's life in Manhattan and Newport. Her information about her daughter appears not to have been entirely reliable. Whether because Audrey did not tell her the straight story or because Kittie embellished what Audrey said is not clear.

Until the end of her life, Kittie insisted that Audrey had married into the Oelrichs fortune in a secret wedding to Tessie's only son. In Kittie's eyes, the ostentatious multimillionaire became Audrey's mother-in-law. Indeed, Kittie listed her daughter as "Audrey M. Oelrich" (sic) in both the 1930 and 1940 US Censuses. Decades later, the phantom Oelrichs marriage even made it into Audrey's only obituary. It was, as even Kittie was forced to conclude, an unhappy union. Although there is no documentary evidence they ever married, there is proof, in Audrey and her mother's letter, that Audrey was involved with the young scion. The tangled and damaging relationship would leave her reeling.

Nowhere in America offers a more direct experience of the sheer extravagance of the Gilded Age than Newport. The European-style mansions that stretch along the Atlantic cliffs are a dictionary of the high-society families of the day: Tessie Oelrichs's *Rosecliff*; Mamie Fish's *Crossways*; Edwin Morgan's *Beacon Rock*—all designed by the soon-to-be-murdered Stanford White—and Cornelius Vanderbilt II's the *Breakers*; his brother William Kissam Vanderbilt's *Marble House*; O. H. P. Belmont's *Belcourt Castle*; and Ogden Goelet's *Ochre Court*—all by Richard Morris Hunt, architect of the Tenth Street Studio Building. Hunt also worked on *Beechwood*, the "cottage" of Caroline Schermerhorn Astor, for many years the reigning queen of high society. The competition between the leading families to build bigger and more lavish homes led to a new coinage: "Vanderbuilding."

The novelist Henry James, who spent happy summers in Newport in

his youth, called these enormous mansions "white elephants" after the legend that the kings of Siam would give such beasts to obnoxious courtiers to bankrupt them with the cost of their upkeep. "They look queer and conscious and lumpish—some of them, as with an air of the brandished proboscis, really grotesque—while their averted owners roused from a witless dream, wonder what in the world is to be done with them," James wrote in *Harper's* magazine in 1906. "The answer to which, I think, can only be that there is absolutely nothing to be done; nothing but to let them stand there always, vast and blank for reminder to those concerned of the prohibited degrees of witlessness, and the peculiarly awkward vengeances of affronted proportion and discretion." As James recommended, many of these misnamed "cottages," including Tessie's *Rosecliff*, are now museums run by the Preservation Society of Newport County. Their opulence is still dizzying today.

Tessie Oelrichs would become the first Catholic ever to reach the pinnacle of American "society." It was a formidable achievement and required immense ambition. To get to the top, she had to scheme like a medieval prince. She clinched her position by marrying off her sister to a Vanderbilt and teaming up with a blue blood of impeccable lineage. Eventually, she and two allies launched a palace coup to depose Mrs. Astor—"*the* Mrs. Astor"—from her throne.

Tessie, her niece said, "had been begotten and brought up in the racket of money-getting" and was "strongly addicted to Society as a business." A powerhouse of a woman with jet-black hair, Tessie's incessant struggles with her weight were chronicled by the society gossip columnists. In her later years, she got her male footmen to shoehorn her into restrictive corsets.

Her approach to life was uncompromising. When staying at *Rosecliff* for the summer season, she conducted an inspection of the property every morning at nine. All beds had to be changed daily, even if they were not slept in. In one inspection, she dislodged a carpenter's tack, which flew at her and left her blinded in one eye. She kept files on all her domestic servants. They were labeled: "Good," "Bad," and "Rotten."

Tessie Oelrichs was the first Catholic to reach
the pinnacle of American high society.

Tessie had the money to break into society but not the pedigree. She was one of three children of a poor, whiskey-loving Irish immigrant—James Graham Fair, once known as Slippery Jim—who married a widowed boardinghouse keeper in Virginia City, Nevada. Fair became an overnight millionaire when he gained control of the Comstock Lode, the first big silver find in the United States. The discovery was known as the Big Bonanza, and Fair and his three Irish partners were dubbed the Bonanza Kings. Fair went on to become a US senator from Nevada. But his wife divorced him for "habitual adultery" and brought up the children by herself—with the help of a then-record $5 million divorce settlement.

Tessie married in 1890 at the age of twenty-one in one of the grandest ceremonies ever seen in San Francisco. After the wedding, she and her groom traveled east aboard a private railway wagon nicknamed the Cupid to take up residence at their mansion at 1 East Fifty-Seventh Street, New York—across Fifth Avenue from Gertrude Vanderbilt Whitney's childhood home and kitty-corner across the junction from where

Harry Payne Whitney grew up. Gossips said Tessie's father did not even get an invitation to the nuptials and had to stay in his hotel suite. But the *San Francisco Call* newspaper reported that the "father of the bride" did indeed attend. His wedding present was a $1 million check. Tessie used the money to buy the eleven-acre *Rosecliff* site from George Bancroft, a historian and former US Navy secretary. Bancroft was an amateur horticulturist who bred the American Beauty rose in his clifftop garden. Hence, the property's name: *Rosecliff*.

Tessie's new husband was forty-year-old Hermann Oelrichs Sr., the wealthy son of a German émigré, whose firm Oelrichs & Co. acted as US agent for the North German Lloyd shipping line. The Bremen-based clan had been involved in shipping cargo for centuries. Born in Baltimore, Hermann Oelrichs Sr. became very active in Democratic Party politics but spurned an offer to run for New York mayor. The Yale alumnus was, above all, an avid sportsman who would go on to become the director of the New York Athletic Club. Tessie first met him playing tennis at the Stanford White–designed Newport Casino, site of the first-ever US Lawn Tennis Association championship in 1881 and now home to the International Tennis Hall of Fame.

As well as a tennis player, Hermann Oelrichs Sr. was a boxer, a wrestler, a horseman, a swimmer, a handball player, a hammer thrower, a baseball player, and a yachtsman. He founded the Lacrosse Association and served as its first president. Even more important, he is credited with being the person who first imported polo to America. In 1876 James Gordon Bennett, the publisher of the *New York Herald*, asked him to bring back mallets, balls, and polo shirts from England, which he did. The friends began playing indoors at Dickel's Riding Academy on Fifth Avenue at Thirty-Ninth Street in New York, scene of the first polo match on US soil. They then founded the Westchester Polo Club that played in Van Cortlandt Park in the Bronx.

In Newport, Hermann Oelrichs Sr. was known to spend hours at a time floating in the ocean off the exclusive Bailey's Beach, with a buoyant picnic hamper of cigars and other provisions. He sometimes drifted so

far that he posed a hazard to shipping. He was convinced that he faced no danger from sharks north of Cape Hatteras, North Carolina. In 1891, he offered a $500 reward in the *New York Sun* for "an authenticated case" of a man getting attacked by a shark in the temperate waters north of Cape Hatteras. His theory was disproved in a spate of shark attacks along the Jersey shore during a heat wave in July 1916, in which four people were killed and one injured.

"Slippery Jim" Fair died in 1894, leaving his $18 million estate equally to Tessie and her sister, Birdie, and their brother, Charley. James Fair had been estranged from Charley until they reconciled shortly before his death. In his will, Fair decreed that if either of the daughters died their money would go to their children, but if Charley passed away his money would go to his sisters instead.

Unluckily for Charley, while on honeymoon, he and his wife, Caroline, died in a car crash in France. While staying at the Paris Ritz, the newlyweds made frequent driving trips in their new 45-horsepower Mercedes Special, capable of 85 mph. Returning from Trouville on August 14, 1902, Charley accepted a fifty-dollar bet from his brother-in-law that he could not beat his record time of two and a half hours to the French capital. Charley took the wheel from the chauffeur, with his wife beside him. As the car hurtled toward the village of Pacy-sur-Eure about fifty miles from Paris, one of the left tires suffered a blowout and the Mercedes smashed into a tree. Charley and his wife both perished. The chauffeur, who had been in the backseat, was found writhing around in a ditch crying, "My poor masters! My poor masters!"

Charley and Caroline reportedly died instantly in the wreck, but Tessie and Birdie moved swiftly to assert that Caroline had passed away first—and that, as a result, she did not inherit Charley's $6 million one-third share of his father's estate, which went instead to his two sisters. If Charley Fair had died first, then Caroline would have inherited the $6 million, and it would have gone to her own aging mother when she died. To protect themselves, Tessie and Birdie had a representative pay Caroline's mother $125,000 in gold to sign away her rights, hinting

menacingly that there would be revelations about children born out of wedlock if she did not comply. Eventually, Caroline's mother did sue. A French eyewitness who was one of the first on the scene testified that he found Charley Fair dead but Caroline still in her dying throes. But he was then charged with perjury. The case was eventually settled with a finding that Charley survived his wife and that therefore his inheritance would pass to his sisters, Tessie and Birdie, but Caroline's mother was paid off with a sum reported to be $500,000. In tribute to their father, Tessie and Birdie built the Fairmont Hotel in San Francisco. They also inherited much of the land on the San Francisco waterfront that would be used for the 1915 Panama-Pacific International Exposition, where Audrey was the Exposition Girl.

Crucially for Audrey, Tessie and Hermann Oelrichs Sr. had one son, Hermann Oelrichs Jr., born the same year as her, on November 2, 1891. From his early childhood, his parents grew increasingly estranged. Hermann Sr. spent more and more time in Europe and San Francisco, while Tessie stayed in New York and Newport. When Tessie took Hermann Oelrichs Jr. to see his father in Carlsbad, Germany, she did not even meet her husband. Even the San Francisco earthquake in 1906 could not bring them back together. When Hermann Sr. was caught in the disaster, he hurried east. Tessie is said to have hoped for a reconciliation, and prepared a new wardrobe and a romantic supper to welcome him back in New York. When he arrived, however, he went first to his Fifth Avenue club rather than to his wife.

Tessie's niece Blanche Oelrichs, an actress and playwright who went by the name Michael Strange and later married actor John Barrymore, described the couple's domestic accommodation in her memoirs, *Who Tells Me True*: "Aunt Tessie, with her Irish beauty, classic nose and extraordinary humor too, had decided to remain amicably separated from her charming husband with his noticeably high blood pressure," she wrote. "And well do I remember the strain it was to sit at their luncheon table on one of my uncle's rare visits listening to their pretense of

intimacy. Eventually each adopted the other's edge of the continent, he living quietly in San Francisco, she lavishly in Newport and New York."

Hermann Sr. died in the mid-Atlantic as, suffering from illness, he tried to return to the United States from Europe for one final time, aboard the ocean liner SS *Kaiser Wilhelm der Grosse* on September 1, 1906. He left all his money to his brother and sister. In his will he reasoned that Tessie, a multimillionaire in her own right, had money enough for herself and the young Oelrichs. The determined Tessie went to court again to recover a half share under California law. This time, she was forced to settle for a mere $100,000, with little Oelrichs getting the $50,000 Cygnus Ranch in Sonoma County, California.

Ever ambitious, Tessie had made a project of making sure her younger sister, Birdie, married strategically. In 1894 she threw a coming-out ball in her honor for 300 guests at the Newport Casino. Her hard work paid off. In 1899 Tessie accomplished a brilliant social coup when she married off Birdie to William Kissam "Willie K" Vanderbilt II, the son of her friend Alva Vanderbilt. He dropped out of Harvard to marry the silver heiress.

"Willie K" was a speed-freak yachtsman and automobile racer who founded the "Vanderbilt Cup" car race. It was Willie K who made the fatal $50 bet that Charley Oelrichs could not beat his driving time from Trouville to Paris. Willie K was a first cousin of sculptor Gertrude Vanderbilt Whitney. But above all, he was the great-grandson of the founder of the family fortune, "Commodore" Cornelius Vanderbilt. The marriage meant the Fairs had joined the richest family in America. It was an alliance that was to transform New York and Newport society.

Following the turmoil of the Civil War, "new money" from railroads, oil, and steel had begun pressing for social recognition alongside the old Dutch families of the Knickerbocker elite. It fell to Mrs. Astor to redefine the social order. Born Caroline Webster Schermerhorn, she was well-placed to mediate because she was a product of both worlds: the Schermerhorns arrived from Holland in 1636, but she married William

Backhouse Astor Jr., the grandson of John Jacob Astor, the immigrant fur trader who became America's first multimillionaire. Conveniently, Mrs. Astor decreed that it took three generations for "new money" to "cool off"—meaning her husband just qualified. For decades, "society" was defined as "the Four Hundred"—the number of people who could fit into Mrs. Astor's ballroom in New York.

Mrs. Astor considered the Vanderbilts, who were busy "Vanderbuilding" mansions along Fifth Avenue, too nouveau riche. But Alva Vanderbilt outsmarted her. In 1883 Alva sent out invitations to a lavish costume ball to everyone who mattered—except the Astors. Mrs. Astor's youngest daughter, Carolina, or Carrie, was devastated to be left out. Alva let it be known that she could not invite the Astors because Mrs. Astor had never called on her. To appease her daughter, Mrs. Astor swallowed her pride and rode round to 660 Fifth Avenue in her carriage and had her footman leave her calling card. For Alva, it was the treasured imprimatur of Mrs. Astor. Carrie was invited. It was the most extravagant ball that had ever been held in New York—and the Vanderbilts had crashed New York society.

When Tessie arrived on the social scene, Mrs. Astor's reign was already in decline. The decisive challenge to Mrs. Astor's social supremacy came in 1898 when Tessie and Alva Vanderbilt and a third woman, Marion "Mamie" Anthon Fish, formed the Newport Social Strategy Board. The board burst onto the scene with a dinner picnic at Belmont's Gray Craig Farm in nearby Middletown. It had all the elements of a carnival: a merry-go-round, a shooting gallery, cowboy-and-Indian fights, fortune-tellers, an African juggler, a vaudeville show, a brass band, and fireworks.

The three women would henceforth dominate society as the Triumvirate.

"Their power is the power of the secret cabal," the *Washington Post* wrote. "They do not meet in council, they do not hold secret sessions, but the comparison holds good nevertheless. They have ruled Newport with a rod of iron. Woe be to any social aspirant who incurred their displeasure. One telepathic signal between members of the board and the unfortunate victim was sent to coventry."

Mamie, a lawyer's daughter who could barely read or write, was the most maverick of the three—and the one who most brought gilded age society into disrepute. Her husband, Stuyvesant Fish, was the son of the former US secretary of state and New York governor Hamilton Fish, and a descendant of Peter Stuyvesant, the last Dutch governor of the New York colonies. But Mamie was given to blunt, even insulting one-liners, and had a devil-may-care attitude to social conventions. "Make yourselves perfectly at home," she once told her guests. "And believe me, there is no one who wishes you were there more heartily than I do." One night, she reputedly served an eight-course feast in thirty minutes flat. Another time, she had to be talked out of instructing the band to play "Home! Sweet Home!" as the guests arrived.

Mamie hosted a string of outlandish extravaganzas at her cottage, *Crossways*. On one occasion, she gave a Dog's Dinner for a pet Pomeranian named Mighty Atom. Engraved invitations were sent out to seven dogs and their mistresses, and the canines feasted on stewed liver, fricassee of bones, and shredded dog biscuits. After-dinner entertainment was a hide-and-seek game with some cats. On another occasion, Mamie hosted a banquet for a visiting dignitary from Corsica known as the Prince del Drago—except that the prince was actually a chimpanzee in full evening dress.

"The hoarse laughter of Mamie Fish was never still. She had the elements of a true comedienne, but her harsh gaiety had the bitter overtone of a grotesque disillusionment with herself and everyone else," Tessie's niece Blanche Oelrichs recalled. "One knew as one looked and listened to her that she knew well the triviality in which she drowned her time, and that her brash mirth concealed an ever more exasperated cry at the impotence of the kind of life that went on around her."

It was into this social whirl that Audrey stepped.

Audrey's entry into the Newport social scene may have been through a new boyfriend, Bob Grosvenor. He lived in New York at 19 West Forty-Eighth Street, but he was, she said, the "owner of a lot of cotton mills, and his mother possessed of a social position at Newport."

Grosvenor, born a year after Audrey on April 8, 1892, came from the family that founded the Grosvenor Dale cotton mills in Thompson, Connecticut. He seemed like a good match for Audrey. He was born and brought up on Prospect Street in her former hometown of Providence. His mother owned the *Roslyn* mansion in Newport, a stone castle that is still there today. It is not clear how the two met, but it may be significant that the Grosvenor Private Boarding Stable at 50 West Tenth Street sat just across the street from the Tenth Street Studio Building in Greenwich Village where Audrey worked so much.

Grosvenor looked like a kind and engaging fellow—but he seems to have been interested in the medical powers of mind-altering drugs. He graduated from Harvard in 1914 and then completed Columbia College of Physicians and Surgeons in New York to become a doctor. "Immediately his genius became apparent to his intimates, as his great strides in neurology and chemistry, and finally an offer of an instructorship in neurology at the university, significantly testify," a Harvard alumni report said. Audrey eventually dumped him. "He was too fat and boyish," she declared.

Her next attachment was to Tessie's superrich but supercomplicated son, Hermann Oelrichs Jr.

15

THE RICHEST BACHELOR IN AMERICA

On September 30, 1913, Lucille Singleton, a chorus girl and music student in New York, dined at the fashionable Healy's restaurant at Sixty-Sixth Street and Columbus Avenue with a man she had met at a party four months before. She knew him as Billy Claghorn, a Columbia University student. After dinner, they went for a spin up Broadway in his Cadillac with another friend. As they drove, Singleton said she wished to go home because she had an appointment with another man. Furious, her date took his hands off the wheel and started stabbing her with a sharp object, variously reported to be an automobile tool or a needle. As she tried to fight him off, the car mounted the curb and crashed into a tree at 120th Street. Singleton was taken to the hospital, but her date and his friend fled the scene.

"I told the young man with me that I had an engagement to meet a friend, and that I wished to go home. He said, 'No,' that I must say in the car," Singleton said. "I refused to break my engagement, and told him to either take me home or stop the car so that I could get out. We argued for several blocks. Finally he grew enraged, and, before I could realize what was happening, I was being stabbed. There are ten wounds in my face

and body and arms. During the struggle the car swerved into the gutter, ousted the curb and struck a tree."

Police traced the Cadillac to Oelrichs, then a twenty-two-year-old freshman law student at Columbia. He claimed he had lent the car to his friend and fellow student D. Montgomery "Monts" Claghorn. But Monts was at home in Tacoma, Washington. So police laid a trap.

The day after the accident, a youth wearing glasses and posing as a detective had approached Singleton and offered her $400 to drop the charges. She demanded $5,000. Police asked Singleton to telephone the man calling himself "Claghorn" and ask him to come to her apartment at 606 West 115th Street. Officers hiding inside listened in on the conversation:

"How do you do, Claghorn?" Singleton said.

"You know my name isn't Claghorn," Oelrichs replied. "You know my name is Oelrichs."

The police arrested him.

The young Oelrichs was charged with felonious assault. Humiliatingly, his mother, Tessie, was forced to post her $100,000 home at 1 East Fifty-Seventh Street to satisfy the $5,000 bond to get her son out of a holding cell at police headquarters. The dean of Columbia Law School warned Oelrichs would be expelled if found guilty.

The family money appears to have resolved the problem. Negotiations reportedly took place between Oelrichs and Singleton on an appropriate amount of money to settle the claim—although the judge who dropped the case said he had been assured no payment was made. Nonetheless, Oelrichs's counsel underlined that appropriate compensation for Singleton's injury would be paid. When the time came for Oelrichs's first court appearance, Singleton said she was too ill to attend. Three days after the accident, she signed an affidavit affirming that all her injuries were the result of cuts from the car's shattered windshield. "I do not know why I said I was stabbed unless it was because I was so excited," the affidavit stated. "It was not because I want money."

From birth, Oelrichs inhabited the most exclusive salons of high

" HERMANN OELRICHS, JR., CLEARED BY
CONFESSION OF GIRL HE DID NOT STAB HER

Hermann Oelrichs
Jr. denied he paid
off the young woman
who had claimed he
stabbed her.

society. At the age of eight, he served as a page at his Aunt Birdie's lavish wedding to Willie K. Vanderbilt II. Blanche Oelrichs wrote in her memoir: "My round-faced cousin, Herman Oelrichs . . . was my favorite cousin, for he had a great sense of humor, which I thought he needed, dressed as he always was in ringlets and long-trousered sailor suits." The two won the Children's Flower Parade at Newport one year in a hansom carriage bedecked with blooms.

Oelrichs was something of a "wild child." Two years before the stabbing of Lucille Singleton, when he was just nineteen, Birdie made a remarkable bet with him to make sure he stayed sober. She offered him $500,000 if he could abstain from tobacco and intoxicating liquors until the age of twenty-one. If he failed to do so, he was to pay his aunt $500,000. Newspapers reported he won the bet.

Oelrichs's great pal was that other society scion, Vincent Astor, grandson of *the* Mrs.. Astor. He had inherited a vast fortune and dropped out of Harvard when his father, Jack, went down with the *Titanic*. Oelrichs and Vincent Astor both loved fast cars and fast boats. They would race their automobiles and motorboats against each other in Newport.

They once even issued a joint challenge to a Spanish countess renowned for her boating skills. On May 1, 1914, Oelrichs served as the best man at Vincent Astor's wedding. Vincent Astor had been the richest bachelor in America. Once he married, Oelrichs assumed the title.

It is not surprising that one of America's most eligible bachelors should be linked to a young model-actress who was considered the beauty of her day. Indeed, there is little doubt that Oelrichs enjoyed a close relationship with Audrey. Audrey herself, in a letter, mentions him going freely in and out of her home. But they never made the gossip columns together.

In different letters, Kittie gave two different dates for their supposed marriage. The first, December 1914, might be the time they first met, but Audrey's own accounts suggest she had no romance with him that early. The second, 1917, corresponds to Audrey's own chronology of the relationship.

Possibly Kittie's first known mention of him as her supposed son-in-law is her handwritten inscription on a photograph of Evelyn Longman's *Fountain of Ceres* at the 1915 San Francisco Exposition. She wrote her daughter's name as Audrey Marie Munson Oelrich. Uneducated herself, Kittie always misspelled the name of her supposed son-in-law like that, by leaving off the final *s*. That makes it easy to recognize when she is the source, rather than Audrey herself. It was Kittie who listed her daughter as Audrey M. Oelrich, *M* for "married," in both the 1930 and the 1940 federal censuses, saying Audrey married Oelrichs when she was twenty-one, which was obviously false; and Kittie was the source of the claim in Audrey's obituary that said: "She married Hermon Oelrich in 1914, until their divorce."

In later life, Kittie would become bitterly resentful of the Oelrichs' treatment of Audrey, and envious of their great wealth. "Her husband was jealous of her race as he was Irish Catholic on his mother's side and German on his father's side yet his grandfather was Sen. Fair of Cal— born Ireland, worth fifty million when he died," Kittie wrote in a letter dated October 30, 1934. "He left Audrey's mother-in-law fifteen million, the same to Mrs. Vanderbilt and the same to a son, now dead. The rest to

his widow now dead. So they have it all now, but Mrs. Oelrichs is dead so Audrey's husband is heir to all and see where she is."

The problem, Kittie believed, was another woman.

In a letter about her daughter dated August 17, 1939, Kittie lamented: "She knew nothing about her husband going with this other girl at all until they began to crush her." The other woman's family retaliated for Audrey derailing the marriage, Kittie believed, by destroying Audrey's career.

That other woman was Edith Mortimer, an adventurous Newport society belle who was a fellow member of the "millionaires set." Her father, Stanley Mortimer, was an art-collecting, polo-playing intimate of the Vanderbilts and a descendant of John Jay, one of the founding fathers of the United States and the first chief justice of the Supreme Court. Edith's mother, the former Elizabeth Livingston Hall, was an aunt of Eleanor Roosevelt. The Mortimers were among the founders of the wealthy enclave of Tuxedo Park, New York, and had a mansion named *Roslyn House* in Old Westbury, Long Island. When in Newport, they rented the huge timber-framed Cadwalader Cottage at the southern end of Bellevue Avenue, not far from *Rosecliff*. The Mortimers were naturally listed as members of the Four Hundred by the 1904 publication *The Ultra-Fashionable Peerage of America: An Official List of Those Who Can Properly Be Called Ultra-Fashionable in the United States*. The style guide named Stanley Mortimer as one of its "noticeably well-dressed men."

The Mortimers, as a family, were so skilled at marrying well that they are still known today as the Marrying Mortimers. The tenor of the family debate over Edith's future was caught in a newspaper feature in 1920. Her mother wanted Edith to follow other "dollar princesses" and marry into the European aristocracy; her father preferred an American multimillionaire groom—namely, Hermann Oelrichs Jr.

"Mrs. Mortimer sang of the delightful manners and the distinguished charms of Russian princes and French marquises and the stor[ied] good sense of English dukes, combined with their great landed properties. Mr. Mortimer expatiated on the hollowness of European and English titles after this war would be over, and explained carefully that ducal estates

and continental chateaux would have to be sold to pay the expenses of the war and the consequent reconstruction," a Hearst-syndicated article reported.

"Things were becoming difficult for Mrs. Mortimer because, of course, she was forced to stay in American atmosphere. She found that young Oelrichs, 'handsome as a young god,' to quote a gushing debutante,

Hermann Oelrichs Jr. with his mother Tessie, seated, and two Vanderbilt relatives.

was in the house every day and almost all day. She knew that her husband favored the heir of the Fair fortune, and while she liked him—well, he was not a continental nobleman.

"'He can't give you mellow chateaux in France and children who will wear proud titles,' she lamented to her daughter.

"'He can give you a splendid house in Fifth Avenue, one of the most beautiful show places in Newport, several blocks of San Francisco real estate, and children who will be Americans of the purest strain,' was Stanley Mortimer's response to his only girl."

According to Kittie's account, it was Oelrichs's relationship with Audrey that prevented the grand union of the Oelrichs and Mortimer families. By the time this letter was written in the early 1930s, Kittie had become violently anti-Semitic, as had so much of the world. She wrongly identified the Mortimers as Jews, when they were Episcopalians, and the Oelrichs were Catholic. Oelrichs, she complained, tried "to cover up his dirt in not marrying a German Jew that he went with for a long time. He used Audrey to protect himself from the Jews when they tried to make him marry the Jew."

Edith Mortimer did eventually end up marrying a European aristocrat, as her mother desired—but not before a mini-scandal erupted that once again involved a car. Stanley Mortimer, in an attempt to cure his daughter of a love of winter sports at the exclusive French ski resort of San Moritz, had taught her to drive. Every time she despaired of the emptiness of American life, and pined for the ski slopes, daddy bought her a bigger and faster car. At around 5:00 PM on November 27, 1918, Edith was driving her yellow two-seat roadster toward Manhattan down Broadway in Flushing, Queens, near Linden Avenue. In the car with her was a French military attaché, Captain Mercier Pore, who had become "attached" to her. She smashed her roadster into the back of another car, which had stopped on the road to change a lamp. The two men in the other car—Nathan Wasserberger and Morris De Mato—died. It was Edith's second fatal automobile accident in the space of a month. On September 18 she had run down and killed a five-year-old while on

vacation in Southampton, Long Island, but was exonerated after she paid $500 compensation.

This time, Edith was arrested, indicted for manslaughter, and stood trial. The prosecutor railed against the impunity enjoyed by the super-rich. "She by her actions said, 'If you are in the way, get out. The law was made for you to obey, not me.'" he said. "It is this attitude on the part of persons like Miss Mortimer which creates Bolshevism." Edith insisted she was traveling at only 25 mph when a truck emerged from a side street and hit her, forcing her to swerve into the stalled vehicle. The Mortimer family reportedly offered the families of the dead men $10,000 and $12,000 each. After deliberating for two and a half hours, the jury acquitted her.

Within weeks of being acquitted of homicide, Edith announced her engagement to Count Mario di Zoppola. He was a double prize. Not only was he an Italian aristocrat but a dashing pilot to boot, having served in his country's aviation corps in the recently ended Great War. Pilots were exciting pioneers for young American women in the early days of flight. At a wedding at her parents' *Roslyn House* on June 28, 1919, the very American Edith Mortimer became Italy's Countess di Zoppola, another "dollar princess."

Tessie Oelrichs aspired for her son to eventually become the United States ambassador to the Court of St. James in England, the country's top diplomatic posting. She now sought prestige. Her son certainly did not need money. Oelrichs's diplomatic career proved, however, short-lived. After narrowly avoiding expulsion over the Lucille Singleton stabbing, he graduated with a law degree from Columbia in 1914 and pursued further studies in international law. On December 5, 1916, when Audrey had just moved back east from California, Oelrichs sailed to Europe aboard the ocean liner *Frederik VIII* to take up a new post as private secretary of the US ambassador in Berlin, James W. Gerard. For his work, he frequently visited American internees at the Ruhleben prison camp on the outskirts of Berlin. Yet his assignment was quickly cut short by the United States' entry into the Great War. By early March 1917, he was

back in America after the two countries severed diplomatic ties. In April he was assigned by the US military with the rank of lieutenant to the rather privileged role of protecting Block Island, Connecticut, just off the coast of Newport.

Oelrichs struck those who knew him later in life as a thoughtful intellectual who cared little for his position in society. He was a good friend of songwriter Cole Porter, himself the scion of a wealthy family whose grandfather was a coal and timber speculator reputed to be "the richest man in Indiana." Porter would stay in Oelrichs's childhood room on the second floor at *Rosecliff*. It is in the adjacent study that he is said to have written his classic song "Anything Goes" for the musical of that name, with a book by P. G. Wodehouse and Guy Bolton, the duo who mistook the naked Audrey for a visiting sofa repairwoman.

Porter was also a good friend of Edith Mortimer, Countess di Zoppola. It was while riding at her estate on Long Island in 1937 that his horse bolted and fell on top of him, crushing both his legs. He narrowly escaped having his legs amputated, but the injury left him in pain for the rest of his life. "It just goes to show that fifty million Frenchmen can't be wrong," he quipped. "They eat horses instead of riding them."

Hermann Oelrichs Jr. struck many who knew him as an odd fish. The gossip columnist Elsa Maxwell, who grew up across the road from his grandfather James Fair in San Francisco, wrote: "Hermann is an amazing product—being a man who, though inheriting a great wealth and position, became an intellectual—an unusual antic for the grandson of a miner. He is an authority on philosophy and follows many other scholarly pursuits." She noted his talent for sleight of hand, saying he "rivaled Houdini." At one party, she recalled, the lights were dimmed and one pompous guest felt a "clammy cold lizard crawling out of his cuff—one of Hermann Oelrichs Jr.'s tricks.

The *New Yorker* magazine wrote an impressionistic profile of Oelrichs in 1927, listing his likes and dislikes. "He is interested in all philosophies, though his leaning is distinctly toward the Teutonic. He never, under any circumstances, reads the tabloids," the magazine wrote. "His chief

abominations are: supper restaurants, Pullman smoking compartments, moving-picture comedies, professional baseball, puns, kümmel, musical revues, old English inns, French telephones, and Japanese champagne." He always wears double-breasted suits and shoes from Lobb's in London, loaths early rising, never dances, and "cannot abide flappers," the magazine reported. Perhaps the magazine's pithiest insight into his paradoxical personality was: "He always tips the doorman not to open the door for him."

The British journalist Ivor Brown, in his memoir *The Way of My World*, described Hermann Jr. succinctly as "one of the most gifted, delightful, and yet repressed men I have ever met."

In a 1921 letter, Audrey appeared to blame Oelrichs for the breakdown of their relationship. By then, like her mother, she had started using "Jew" as a term of abuse. In the letter, she seems to be referring to Oelrichs when she writes: "The last one that nearly put a dent in my heart was a German-Jew and he was in love with a cross-eyed woman."

There was one aspect of Oelrichs's personality, however, that appears to have escaped Audrey altogether. It may have been too much for a former Catholic schoolgirl to comprehend. Oelrichs was, like his friend Cole Porter, a closet homosexual.

Oelrichs's homosexuality emerges clearly in two handwritten love letters, now in the National Library of France, that he wrote to the Russian ballet dancer Boris Kochno. Also a poet, Kochno had been Sergei Diaghilev's lover, private secretary, and main collaborator at the Ballets Russes in Paris. Kochno also had a passionate affair with Cole Porter in 1925 at around the same time as he did with Oelrichs.

Oelrichs's love letters to the much younger Kochno leave no doubt that the two had a sexual relationship. They give a unique, unfiltered insight into Oelrichs's intimate life—probably more than Audrey ever knew.

The first letter, written from the Italian resort of Rimini on September 19, 1925, reveals Oelrichs's despair at being separated from Kochno, who had not even written to him since the two were apparently together in Venice, where Porter and his wife had rented the magnificent

Ca' Rezzonico for the summer. Oelrichs communicated with the ballet dancer in impassioned but imperfect French. "I know that I write you too much. But I love you too much, my angel. I think of you too much. I want to see you too much and that is going to end badly. Because you will soon say—'Enough! I've had enough.' But all the same I want to risk that."

Oelrichs is explicit about their physical love, and voices his own otherwise unexpressed inner melancholy. "The beginning was too beautiful and I can't believe it can last so. I was poisoned by life until the moment I found you. . . . And my sadness this evening makes me think of my habitual sadness, which disappeared for the first time when I was seeing you on those beautiful evenings before your departure. Oh I need to have you in my arms again, Boris, and so alone. Otherwise, I will be too unhappy."

It is abundantly clear from the letters that Oelrichs probably never loved Audrey—and quite possibly was incapable of falling in love with any woman. The love letters to Kochno date from six or seven years after Audrey knew Oelrichs, but they completely upend Kittie's claim that Audrey and he fell in love and married. Indeed, the real reason why Oelrichs did not want to marry Edith Mortimer may not have been because he loved Audrey instead but because he really was gay and did not want to marry a woman at all. Maybe Audrey, a famous sex symbol, was simply his beard.

It is difficult to divine how much Audrey knew about Oelrichs's homosexuality. Unlike her mother, she never described him as her husband. Just as Audrey may have been Oelrichs's "beard," so he may have fulfilled a similar role for her. She may have boasted to her mother of her relationship with the richest bachelor in America, and even claimed to have married him, even if the two may not have actually been lovers.

On the one occasion she does mention Oelrichs in her surviving correspondence it is as an unfaithful, indeed malicious acquaintance or ex-friend. Audrey retained her innocence well into adulthood. It must have been hard for her to comprehend the mind games involved in Oelrichs keeping his homosexuality secret. And if she indeed fell for him herself,

it must have been particularly shocking. The inescapable conclusion is that the young, secretly gay plutocrat who liked to perform magic tricks manipulated Audrey to save himself from marrying Edith Mortimer.

Years after his relationship with Audrey was over, Oelrichs did eventually marry in the French resort of Biarritz in the first half of September 1925. Many American homosexuals of the era felt compelled to marry to mask their sexual preference. Cole Porter did so himself. Homosexuality was still illegal under state "sodomy laws" across the United States.

Oelrichs's marriage in France was reported to have "surprised friends" who thought the engagement had been broken off. His mother was not even present, remaining at *Rosecliff* in Newport for the summer. His bride was the actress Dorothy Haydel, who had once appeared with Douglas Fairbanks in the film *Flirting with Fate* (1916). Haydel also made *The Great Secret* (1917) and *The Slacker* (1917) before going to work in a New York publishing house. By the time she wed Oelrichs, she was thirty-two years old and unflatteringly nicknamed Dumpy. She and Oelrichs never had children.

Just weeks after his marriage, a lovesick Oelrichs wrote another letter to Kochno. Dated October 8, 1925, it is written on the headed notepaper of his home address at 10 East Forty-Fifth Street, New York, but has a Paris postmark. The newly wed Oelrichs is clearly distraught. This is the letter of a man who recognizes that his affair with the ballet dancer is over forever and that his marriage is the crown on the lie that his life has become. In his letter, Oelrichs reports that he has just left the hospital after two operations and is considering going into self-exile in Europe forever. Without ever mentioning the enormous fact that he has just got married, Oelrichs pours out his existential sadness to his lost boyfriend: "In any case I am unhappy and will be forever."

Oelrichs addresses Kochno by the French gay term of endearment "ma tante" ("my aunt"). In an apparently vain attempt to keep his former lover interested, he gamely tries to update Kochno about the current New York performances by conductor Arturo Toscanini and by the "Moscow Art Studio." But the letter ends with a pained finality—and a

hint at the unspoken changes in his life: "I would like so much to see you and to explain things but there are so many inexplicable things to explain that I will never have the courage. Goodbye Boris, and believe me that life is not worth the pain. I kiss you."

As her personal troubles mounted, Audrey almost completely disappeared from the newspapers in 1917 and 1918. The Exposition officials, the theater publicists, and the movie PR men had stopped promoting her. A rare mention in the *New York Times* on Christmas Day 1917 places her at a seasonal celebration at the nearby Kingsbridge police station in Riverdale, where she entertained the local precinct by striking the poses of several of her well-known monuments in the city. Then she disappeared from public view again.

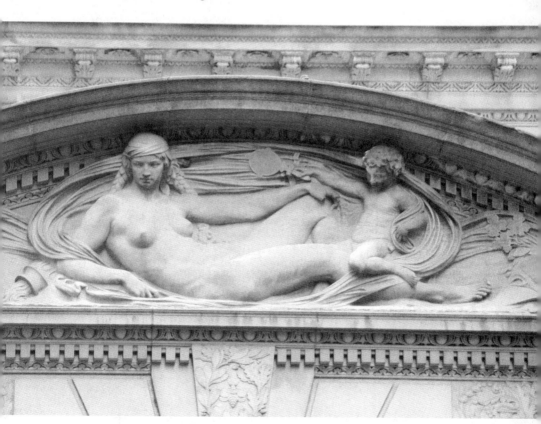

Audrey over the entrance to the Frick House in New York.

Audrey was always really an
animal lover.

16

AGENTS OF THE KAISER

Audrey and Kittie retreated back to a boardinghouse in their old neighborhood around Lincoln Square, just across the street from the Arcade Building, where Herzog had his studio. It was a temporary step. Kittie was looking after her, and she was under a doctor's care. She told people she had caught influenza in the epidemic that was sweeping the world at the end of the Great War. But her problems went far deeper.

The Girl o' Dreams had never reached theaters and she had not worked in movies for two years. Her bank balance was running low. She had apparently provoked the ire of the powerful Mortimer family and been rejected by Oelrichs. Any fantasy of marrying America's richest bachelor was at an end. She was angry and frustrated and lost. And she wanted revenge—revenge against Oelrichs and Edith Mortimer, revenge against the moviemakers, revenge against all the men who had tormented and harassed her because of her outstanding beauty.

On January 29, 1919, she sat down at her typewriter in New York and typed:

Department of State,
Washington.

Dear Sir:

I am sailing for Europe sometime in March but leave for Canada
Feb. 1, 1919. As you know the Kaisers $25,000,000 in the Motion
Picture Industry has thrown me out of work as I am an American
of English blood dating back to the Mayflower days.

This was to be her farewell missive to America. It was the start of a
desperate three-page poison-pen letter, since hidden in the FBI archives,
that accused a long list of all Audrey's enemies, including both Oelrichs
and Mortimer, of being agents of the Kaiser—even though the last Ger-
man emperor, Wilhelm II, had been forced to abdicate two months ear-
lier at the end of the Great War. In her apparent delirium, she typed on.

I find it impossible to obtain employment in my own country
through this German and German-Jew tie-up—I understand that
the English and English Jew is the one to help me.

Audrey was furious that, while she lacked for work, other models
were being sent out to theaters impersonating her in order to promote
her pictures—including the rereleased *Inspiration*, which had been re-
named *The Perfect Model*. Incredibly for someone who described herself
as an artist and whose nudity had broken through social taboos, Audrey
requested in writing that the US government censor her own films.

I am going to ask you to pull my films off the market through
Censorship and place them in American or English hands or keep
them from appearing at all as they are Nude—Art—Films and
hundreds of girls have traveled about the U.S. as me which is not
different from a White Slave Traffic.

To help the would-be government censors, Audrey identified her three films up to that point and the owners who were to be targeted: *Inspiration,* or *The Perfect Model,* owned by Edwin Thanhouser, his partner William Shallenberger, the Arrow Film Co., which handled the rerelease, and Harry Samwick of Producers Features Service; *Purity,* owned by John R. Freuler and Samuel Hutchinson of the American Film Co.; and *The Girl o' Dreams,* owned by Mutual, William Randolph Hearst, and John R. Freuler.

> *They cannot claim they have not had their money out of them as they have also had girls appearing at Army camps as me and collecting money for pretended Liberty Bonds.*

As an incentive for the censors to act, Audrey promised to give the government the $200,000 in unpaid royalties she said she was owed on her film contracts. It should be spent, she said, on the American troops just then returning from the European battlefield.

> *The U.S. government can collect this money as I will make the Department accept them as a gift, so turn [over] the money for benefit of our boys.*

Audrey displayed a debilitating paranoia in describing a fantastical German-inspired conspiracy against her. She was talking about some of the richest and most established families in the United States. Although the Great War has ended, she was effectively leveling an accusation of treason.

> *Although these people profess to be American I find them pro-German. These same people attack the clergy and people who are trying to accomplis better. . . . There is the cleverest-system going on . . . to play all business back and forth in German-Jew and German hands.*

In her fury and confusion, Audrey was not shy to name names. Her goal was a shameless smear. She felt set upon and wanted her government to take her side against those whom she felt had misused her. She found it satisfying to catalog them one by one:

> *E.N. Albee [sic] of Palace Theatre, Hermann Oerichs [sic], Wm. R. Hearst, Robt. Barbour Patterson [sic] N.J. whose brother was named after Kruppe, Robt. Grosvenor, a German-American but pro-German son of Mrs. Wm. Grosvenor of Newport and Edith Mortimer daughter of Stanle Mortimer of Wall Street.*

It is a motley list of men, some ex-boyfriends, who had bothered her—and the one woman whom Audrey blamed for her woes. The names burst into Audrey's burning head in order of priority.

E. F. Albee evidently gets pride of place because of the row over the cancelation of *The Fashion Show* at the Palace Theatre in 1915. The fact that no other "man prominent in the theatrical world" makes Audrey's list reinforces the suspicion that it was indeed the domineering Albee who grabbed her in her dressing room in her bathing suit and, when repelled, threatened, "You will have cause to remember this."

Also a target for Audrey's ire was William Randolph Hearst, the dominant press baron of the era, later portrayed by Orson Welles in *Citizen Kane*. Born in San Francisco, Hearst would have been very aware of Audrey's leading role at the Panama-Pacific International Exposition, and eventually furnished Hearst Castle with a cast of Adolph Weinman's *Descending Night*. Hearst would later play an important part in publicizing Audrey, and his newspapers would also report her personal problems, but at the time this poison-pen letter was written in 1919, his newspapers had only given her positive coverage.

Hearst's inclusion on the list raises the unanswered question of whether Audrey ever had a personal relationship with him. Hearst was a dashing man around New York with a taste for chorus girls. Jane Ardmore in *The Self-Enchanted*, written with movie star Mae Murray, recalls:

"Tall, distinguished Mr. Hearst, with his deep-set eyes, hair parted at the center, was an excellent dancer with vitality and zest. Often he'd come backstage to say he'd engaged a ballroom and he'd send a car and his secretary for Mae [Murray] and Olive [Thomas], for Ann Pennington and Marion Davies who was working upstairs on the roof."

The fact that Audrey also names Hearst as a co-owner of her film *The Girl o' Dreams* suggests that, rather than a romantic motive, the real reason for his inclusion was that she blamed him for her movie never being released.

None of Audrey's attacks landed wider of the mark than the shot she took at Robert Grosvenor. Though his father, William, was born in Providence and his mother, Rose Dimond Phinney Grosvenor, in nearby Bristol, Rhode Island, she describes her former fiancé as a "German-American." After breaking up with Audrey, Grosvenor had married Aerielle P. Frost of Chicago in May 1918, but he died from pneumonia following influenza just five months later, on October 27, in the Waldorf Astoria Hotel—another victim of the flu epidemic. By the time Audrey wrote the letter, Grosvenor was already dead.

She denounced the Irish American Robert Barbour of Paterson, New Jersey, on the equally flimsy pretext that his youngest brother was named Fritz—apparently after Fritz Krupp, the philanthropist son of the founder of the German armaments giant Friedrich Krupp AG, which made weapons for the Kaiser. "Fritz" was a diminutive of the common German name "Friedrich" that the British "Tommies" had called the German soldiers across the trenches. At the time Audrey wrote the letter, Barbour was still single, though he later married and quickly divorced. It seems likely Audrey's grievance against Barbour sprang from spurned love.

Audrey singled out Oelrichs for a more detailed denunciation. Despite her mother's claims that they had married, Audrey does not so much as hint that he was ever her husband, or even an ex. Her fingers rattled off an improbable scenario:

Hermann Orlrichs [sic] sets German up in work by stealing my photographs coming into my home taking photos of my paintings

and art work and establishing lithographing places, my Birth-certificate which I had sent to Rochester, N.Y., for, was stolen out of my trunk and I would like you to make sure that no one is passed into Germany as me.

Her rage was reaching a crescendo. The climax of the letter is per-haps the real point of her hurt and confusion. Audrey believed Oelrichs was putting it around that she was pregnant and that was her real reason for leaving the United States. She was almost howling as she wrote:

You will see how pro-German Hermann Oelrichs is when he tried to frame me up with an Irish Doctor I called upon for an errand. The Doctor had witnesses in the Anti-Room and tried to make out because I was going to England that I was about to become a mother. I have heard this openly discussed in street-cars and one the street by women who were this mans [sic] agents.

These are the words of a deeply wounded woman. Whether Audrey actually was pregnant and suffered a miscarriage or had an abortion or gave up her child for adoption when she got to Canada is an abiding mys-tery. Kittie once said that Audrey's relationship with Oelrichs was child-less. Later in life, as we will see, even Audrey herself appeared unsure.

Audrey's diatribe came to an end with a final appeal to the govern-ment to take on her perceived enemies.

It is about time you surveyed some of these Motion Picture houses and investigated this German crowd in the Moving-Picture busi-ness.

<div align="right">

Sincerely,

MISS AUDREY MUNSON

</div>

The State Department official who received Audrey's letter seemed nonplussed. L. Lanier Winslow forwarded it for follow-up to William E.

Allen, the acting chief of the Bureau of Investigation, the predecessor of the FBI. "The letter is involved and illiterate and it is rather difficult to see what the lady is driving at," Winslow wrote. "However, I send it to you for your information and should be glad if you will cause an investigation to be made and let me know something about this lady and her curious activities." Allen instructed the Bureau's city hall station in New York to investigate.

Sidney B. Pfeifer, the investigating officer, quickly dismissed Audrey's extravagant claims. "By consulting our files and noting the character of the information previously given by Miss Munson," he reported, "I am inclined to believe there is nothing in her statements and that she is merely afflicted with the spy mania which was so prevalent in the days of the war."

Ever since *The Girl o' Dreams*, Audrey's mental health had seemed to ebb and flow. At times, she became convinced the world was out to get her, she spun incredible conspiracy theories, and lost her reason. She looked for culprits, whether secretly funded by the Kaiser, or part of some other imagined plot. At other times, she was again her bright and charming self, childishly enthusiastic, friendly, and disarmingly funny. She seemed to lack control over her moods, and there is some suggestion that she tried to self-medicate with drugs—although her mother always vehemently denied it. Audrey was at war with herself.

SCULPTORS' "PERFECT WOMAN" FIGURES IN WILKINS MURDER MYSTERY

Audrey Munson Has Been Immortalized in Bronze, Stone and Silver

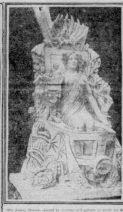

A full face view of Miss Munson, who posed for some of the cleverest sculptural pieces that were shown at the Panama expositions.

Miss Audrey Munson, selected by sculptors as a model for the wonderful art of the world's fair, has been acclaimed by many women as the most beautiful woman in America.

Audrey Munson is just now in the public eye as a witness in the mysterious case of Dr. Wilkins, who is accused of poisoning his wife at their home last February at their Long Beach home. Miss Munson and her mother occupied an apartment near Dr. Wilkins' New York home at Sixty-fifth street.

PASTEBOARD KINGS AND PARLOR BOLSHEVIKI ARE FAIR GAME FOR HARVARD JUNIORS

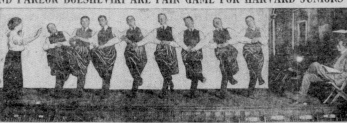

The Hasty Pudding Club chorus, which is to appear in "Cousin Lucy."

How Marion Crawford Escaped a Musical Career

17

THE HAMMER MURDER

What took place on the brick walkway outside the Wilkins' cottage on East Olive Street in Long Beach, New York, at exactly "9:28 ½ pm" on Thursday, February 27, 1919, changed Audrey's life forever—irredeemably for the worse.

And she was not even there.

The white-whiskered Dr. Walter Keene Wilkins, sixty-five, noted as a "society man and physician to many wealthy families," had just returned home on the last train from a visit to friends in Manhattan with his stout and strong-minded third wife, Julia. Alighting at Long Beach, a summer "water resort" on Long Island, the couple ran into Police Sgt. Harry H. Schneider on patrol. Sgt. Schneider knew the worthy Wilkins couple because they were among the few residents who had spent all winter at the beach. He made small talk, remarking on the strong February wind, as he walked the couple to within a block of their home.

Dr. Wilkins told police what happened when they arrived at the cottage:

> I was about to walk up the steps when I noticed the door of the garage was open, and becoming suspicious I told my wife to wait at the door while I made an investigation. Just as I entered the

hallway I was hit on the head with a blackjack by some man who said he would not strike again if he was handed over all that I had in my pockets. While I was being searched, I heard my wife moaning and calling for help. The man who had taken the contents of my pockets ran out and down the road. I then went inside and found my wife lying in a pool of blood.

Dr. Wilkins ran to his neighbor's to call for help. His coat was ripped from the breast pocket and his derby hat smashed. Together, he and his neighbor rushed to another nearby house to telephone the police. The call arrived at 9:52 PM. The police summoned a doctor from the wartime army hospital that had taken over the Hotel Nassau, just down the block.

The first policeman on the scene was the very same Sgt. Schneider who had just chatted with the Wilkinses as they strolled home from the railroad station. "I knelt beside Mrs. Wilkins," he said, "and asked her, 'Who did this?' She did not answer the question but put her hands to her head and said, 'Oh! Oh! Oh!'"

A machinist's hammer, with paper wrapped around its head and handle with twine, was found beside the prostrate Mrs. Wilkins. Dr. Wilkins told Sgt. Schneider two short men in gray caps attacked him and stole forty dollars along with his watch and a love-knot pin. He shouted to warn his wife not to come inside, but she screamed. A third, taller man was ordered to go outside to silence her. "Better go out, Dick, and quiet that noise," one of the gang said. "This is a mussy job." Dr. Wilkins showed the police his crumpled derby hat, torn coat, and his linen collar, which he said had been ripped from his neck. The officers noticed, however, there was not a single scratch on his balding head.

Later that evening, Dr. Wilkins was spotted by a neighbor walking on Olive Street. She told him to hurry to the hospital to see his wife. Instead he returned home to feed the dogs, one of which, Duke, had been stabbed in the fracas. Dr. Wilkins arrived at the hospital fifteen minutes after his wife died. He shed no tear, and his one question was: "Did she name anybody—did she say she recognized anybody?"

It had been a long and tortuous journey for Dr. Wilkins to that fateful Long Beach cottage. Born in Concord, New Hampshire, he began his working life as a hotel clerk before going west to seek his fortune. He found work as a property clerk running the men's clothing storeroom in the Kalamazoo insane asylum. One of his tasks was to provide clean clothes held over from dead inmates to patients who suddenly soiled themselves—and, he said, "there are a great many who do," some two or three times a day. It was an unglamorous job, and he came under investigation for taking kickbacks on the clothes the storeroom sold the inmates as part of a wide-ranging state inquiry into "carelessness, cruelty and abuse" at the asylum. Nevertheless, the lowly position spurred his interest in medicine. He set his mind on becoming a physician.

He moved to California to study medicine at the Napa State Hospital. In Napa, he met his first wife, Grace Mansfield. The two moved to New York and had a daughter, Florence, who died at ten months. Wilkins matriculated at the Bellevue Hospital Medical College in 1886 and got posts first in San Diego and then in Seattle. His in-laws insisted, however, that their only daughter live closer to home. He divorced her for "desertion," only to return to New York shortly afterward himself.

Wilkins next took a post at the New York City Asylum for the Insane on Wards Island, sitting just off Manhattan at the confluence of the East River and Harlem River. The asylum, connected to Queens in 1916 by what became known as the Hell Gate Bridge, lives on today as the Manhattan Psychiatric Center. Like many of the old insane asylums, it had, over the years, had some notable and notorious patients. The most famous was the great African-American ragtime composer Scott Joplin. Dr. Wilkins, however, had already left the institution by the time the composer of the "Maple Leaf Rag" was committed with schizophrenia resulting from tertiary syphilis and died there on April 1, 1917.

From 1899, Dr. Wilkins had maintained an office in the Theater District at 237 West Thirty-Eighth Street, a block and a half from Broadway. He married Susan Ann Hardee, the divorced wife of a Confederate general who was shot in the thigh at the Battle of Gettysburg. In marrying

Hardee, Wilkins acquired as a stepdaughter an actress named Odette Tyler, whose talent was once praised by Queen Victoria at a command performance in London. Tyler, the daughter of Confederate brigadier general William Whedbee Kirkland, was the goddaughter of Gen. Robert E. Lee. She married a fellow thespian, the Shakespearean actor named R. D. MacLean, known onstage as R. D. Shepherd, and the couple played Romeo and Juliet together.

The family connection helped Dr. Wilkins develop a theatrical clientele. His specialty was listed by the American Medical Association as "allopathy." The term, coined by the German founder of homeopathy Samuel Hahnemann in 1810, was often used derogatorily. It brought together the Greek prefix ἄλλος, állos, meaning "other" or "different," with the suffix πάθος, páthos, which meant "suffering." It was a deliberate contrast to "homeopathy," from the Greek ὅμοιος, hómoios, meaning "same" or "like." While homeopaths treated patients with substances that were related to the disease, allopaths administered unrelated agents that produced contrasting effects. In Dr. Wilkins's case, it appears, he specialized in one particular drug known for its soothing effects: morphine.

When his second wife died of cerebral apoplexy, Dr. Wilkins married again, on July 21, 1906. His third wife was another divorcée, Julia Krauss, who had already lost her adult son Otto. The doctor complained of Julia's violent temper but prided himself that he had been able to master her. Though not rich, she had accumulated enough real estate for the couple to be able to live comfortably. Three years earlier, Julia had suggested her husband abandon his medical practice and manage her properties instead. They had moved to their beach cottage and let out rooms at their house at 164 West Sixty-Fifth Street on Manhattan's Upper West Side. They were not, however, an entirely conventional couple: Julia kept a menagerie at home that included two pet collies named Duke and Duchess, a caged monkey, and a parrot that squawked "Poor old man! Poor old man!"

Long Beach is a barrier island that lies off the south of the much larger Long Island. At the time, it was connected by just one drawbridge,

which was constantly manned. The water provided a natural barrier, a moat. In the hours after the murder, police had no difficulty setting up a cordon to try to catch the assailants, but none were apprehended. Doubts began to grow about Dr. Wilkins's story. A neighbor and close friend of Mrs. Wilkins named Sophia Bentz called the Wilkins residence the day after the murder to speak to the doctor. The housekeeper told her: "Dr. Wilkins is not at home. He murdered his wife last night."

When Mrs. Wilkins's clothes were hastily burnt before an investigation because of the stench of blood, the Nassau County district attorney called in the William J. Burns Detective Agency for help. Burns, a former Secret Service agent, was renowned as "America's Sherlock Holmes." He went on to head the Bureau of Investigation from 1921 to 1924, with future FBI chief J. Edgar Hoover as his deputy.

Funeral etiquette for a private detective is not the same as for your average mourner. As Mrs. Wilkins was being interred at the Lutheran Cemetery in Middle Village Queens on March 3, Burns sidled up graveside to the grieving Dr. Wilkins. "At that time Dr. Wilkins evidently had not thought that he was suspected. He didn't know who I was, but when I told him he would have 'a lot of explaining to do' he blanched and was never the same mannered person after that," Burns said. "I asked him why, when his wife lay dying at the hospital, he thought more about seeing that his dogs were fed than arriving at his wife's side fifteen minutes after she had died. His answers were very hazy."

A month after the murder, police exhumed Mrs. Wilkins's body and an autopsy was performed in a burial vault at the cemetery, in Dr. Wilkins's presence. As might perhaps be expected of a doctor, he showed no emotion at the gruesome procedure—even though it was his wife. The medical examiner determined that Mrs. Wilkins had suffered seventeen blows, all above the brow line apart from one to the left hand.

Quickly, Dr. Wilkins's story began to unravel. Burns and two other detectives questioned him in the presence of his lawyer at the Long Beach cottage. Burns left the house carrying a paintbrush, found in the bathroom, with spatters of green paint on the handle. The brush was being

used to paint the picket fence at the back of the house. The hammer that killed Mrs. Wilkins was also splashed with green paint. To fuel suspicion, the hammer also had a parrot feather stuck to it.

Dr. Wilkins turned in a new will to his lawyer, apparently written by his wife in 1915. In it, she bequeathed the bulk of her $65,000 estate to him—including the West Sixty-Fifth Street building and her share of their Long Beach home. This will, kept in a safe-deposit box in Manhattan, superseded an earlier June 26, 1903, document found at their Long Beach home, which was written before their marriage and therefore left nothing to Dr. Wilkins. The 1915 will was unwitnessed—and Dr. Wilkins said that was why he had not produced it before. Detectives later found the typewriter used to type the second will in an office Dr. Wilkins often visited.

The doctor made an appointment to turn the new will over to police. But he never arrived. The last person to see him was a friend and local justice of the peace named Edward T. Neu, at Lynbrook station on Sunday morning as he took a train into New York City. "He said it was a terrible thing to be suspected of murdering the wife to whom he was devoted," Mr. Neu said. "He said that she had nursed him when he was ill and that it was almost more than he could bear to be under suspicion of slaying her."

On Sunday, March 16, 1919, the Nassau County district attorney, Charles R. Weeks, issued an arrest warrant.

"Wanted for Murder. . . . Fugitive is 64 years old, 5 feet 8 inches tall, had florid complexion, gray side whiskers, closely trimmed, gray hair and when last seen wore dark clothes with a black derby with a mourning band." Officers added, correctly as it turned out, that he would probably take the first opportunity to shave off his whiskers. Silently, they also feared he might kill himself.

New clues began flooding in: detectives ransacked the Long Beach cottage. Inside a length of lead pipe, they found a piece of newspaper from the *Lynbrook New Era*, to which Dr. Wilkins subscribed. It was the same publication that had been used to wrap the handle of the hammer.

**He Faces Charge
of Wife Murder**

DR.
WALTER K
WILKINS

This is the latest picture of Dr.
Walter K. Wilkins of Mineola, N.
Y., who is on trial for the murder
of his wife, but who says she was
slain by burglars. The beautiful
Audrey Munson, who lived in a
house belonging to the doctor's
nesses in the case.

Detectives found matching scraps of the newspaper in the pockets of a pair of Dr. Wilkins's trousers hanging in his bedroom. In a toolbox, officers found a sixteen-twine string similar to that used to bind the hammer handle. They also found three bloody knives in a desk drawer they suspected were used to wound Duke. Police concluded that the hatpins in Mrs. Wilkins's crushed purple hat had been crossed as they would have been before she went to bed, suggesting she had entered her room and taken off her hat before being battered to death. Two witnesses reported they had overheard the Wilkinses arguing over property at the Jamaica station of the Long Island Rail Road on the night of the murder. Dr. Wilkins, they said, told his wife, "I must have ready cash."

On the Wednesday four days after going on the run, Dr. Wilkins contacted the Nassau County district attorney from Baltimore. He was

staying at the city's well-appointed Joyce Hotel under the false name of Randolph C. Howe. He claimed he did not know there was a murder charge against him until he read it in the newspapers. "Morning papers say my case to be presented by you today," the doctor telegrammed. "Would like to appear. Am returning to place myself in your hands."

Police immediately mounted watch at every possible railroad station he might use to return from Baltimore. It was only in the evening, however, that Det. Burns received a call from Dr. Wilkins's lawyer saying that he was to meet the suspect at Pennsylvania Station and take the 9:06 PM train with him to Long Beach—the very same train Dr. Wilkins had taken with his wife on the night of the murder.

Dr. Wilkins got no further than Penn Station. Identified by a reporter on the platform, he was arrested by the NYPD. "The change that has transformed him into a feeble old man came almost as a shock. His pale cheeks, shorn of the protection of his whiskers and mustache, were sunken," the *New York Tribune* said. Asked why he disappeared, Wilkins said: "I got the idea that they were making a case against me even though I was innocent. I made up my mind to rest for a few days and consult with my step-daughter in Washington. On the way I decided it wasn't fair to burden her and drag her into the matter so I stopped off in Baltimore. After a few days, I thought I was attracting a lot of attention so I shaved."

Odette Tyler's husband had inherited a large estate with sixty horses outside Washington in Shepherdstown, West Virginia. Investigators discovered, however, that she was not there. Although Dr. Wilkins said he was going to see her, she had been in Los Angeles for the last eight weeks.

The arresting officers searched Dr. Wilkins to remove items that he might use to harm himself. The first thing police found was a box containing a hypodermic needle and numerous light-colored tablets of morphine sulfate, as well as some strychnine pills. "I-I'd like to keep . . ." he stammered, gesturing to the box. In his holding cell, Dr. Wilkins admitted he used morphine regularly—but in moderation. He said he took the strychnine daily as a stimulant for his heart. His request to keep his drugs was denied.

A tip from an unidentified woman alerted police to Dr. Wilkins's "telephone practice". The information prompted an investigation. Police suspected he was using his physician's license to prescribe narcotic substances—that he was, in effect, a drug dealer. The inquiry located another apartment building owned by Mrs. Wilkins at 8 West Sixty-Fifth Street. At the address Dr. Wilkins, despite having given up medical practice three years before, maintained a furnished apartment, another office, and a "night call bell." He was a daily visitor to the building, even though police said he had not received patients there for some time. Police had recently responded to a report of a woman's scream in the building at night.

"Friends of the late Mrs. Wilkins are said to be coming to the aid of the prosecutor Mr. Charles R. Weeks in connection with this phase of the case," the International News Service reported. "They say that relations between Dr. Wilkins and a certain young woman are very well known to a certain coterie and that Mrs. Wilkins had been waging a valiant but losing battle against the situation for two years."

Detectives told the press they were seeking an actress as "the other woman" in a love triangle to explain why the normally amiable Dr. Wilkins hammered his wife to death. Two days after Dr. Wilkins was arrested, the *Washington Times* reported: "A definite clew indicating that a pretty young woman may prove to be an important factor in the solution of the murder of Mrs. Julia Wilkins whose husband Dr. Walter K. Wilkins, who was indicted for murder in the first degree, has been found, according to detectives working on the case. The eternal triangle is on the verge of being revealed, these detectives assert, and sensational disclosures which will dwarf others so far unearthed, are soon to be made."

That clue was a postcard-sized advertising photograph of a beautiful model posing on a pedestal in just her swimsuit. It was Audrey.

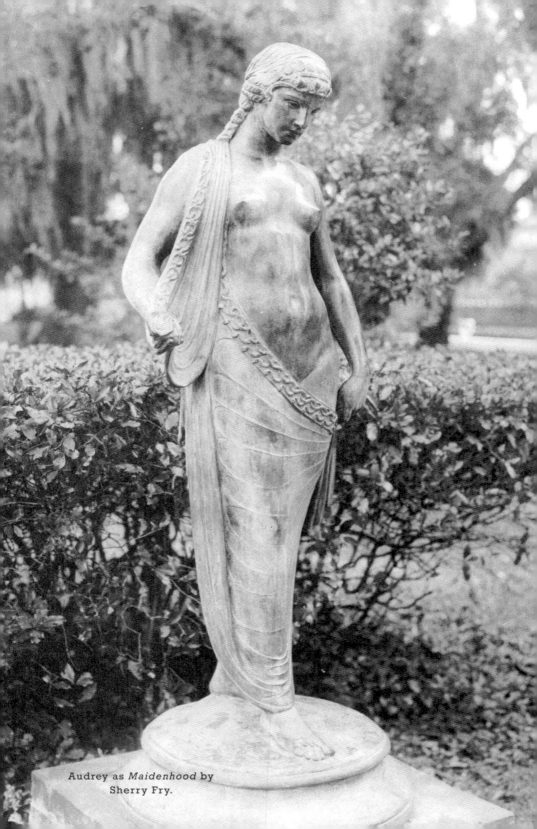

Audrey as *Maidenhood* by
Sherry Fry.

18

THE ETERNAL TRIANGLE

Audrey's landlord at her boardinghouse was also her doctor: Dr. Wilkins. She and Kittie had moved into the property at 164 West Sixty-Fifth Street several months before the murder, and lived there until several weeks before Mrs. Wilkins was battered to death. Now Audrey was nowhere to be found. Police launched a nationwide manhunt.

If the detectives were right, it would be a love triangle of a beautiful starlet whose famous nudity had driven movie audiences to distraction; an elderly doctor who serviced theater folk; and the doctor's unglamorous and even older wife. The case grew even murkier when investigators took into account that the showbiz doctor was himself an admitted morphine user and was able to prescribe the opiate to patients through his "night bell" and "telephone service."

From his jail cell, Dr. Wilkins insisted he only had a "bowing acquaintance" with Audrey and the only time he ever spoke to her at length was when he objected to her cooking in her room. He believed that his complaint was what had prompted her to leave. Dr. Wilkins adamantly denied he had been unfaithful to his wife. But investigators found that the doctor had greatly upset Mrs. Wilkins by flirting with Audrey in her presence.

"Don't you ever get married because if you do you'll lose your symmetrical figure," he had told Audrey suggestively, according to Mrs. Wilkins's daughter.

Unable to locate the missing movie star, the district attorney turned to the press for help. On March 25, 1919, the *New York Times* reported: "Audrey Munson, said to be a motion picture actress and artists' model, and her mother are being sought by District Attorney Weeks in the hope they may be able to give valuable information concerning Dr. Walter Wilkins, according to county officials today." Weeks told journalists he was seeking information from Audrey about Dr. Wilkins's "domestic relations" before the killing to determine "just how much interest he displayed towards her and whether and to what extent it was resented by Mrs. Wilkins."

Movie exhibitors, following the old maxim that "any publicity is good publicity," jumped on the scandal shamelessly to promote the reissue of *Inspiration* under its new name, *The Perfect Model*. One local newspaper ad for a screening at the Hippodrome in Oswego, uncomfortably close to her father's hometown, proclaimed Audrey "The Most Talked Of/Looked For/Wanted/Perfect Woman of the Present Day . . . Star Witness in the Wilkins Murder Trial." "WHERE IS SHE?????" the ad screamed. "See her in The Perfect Model."

The first port of call for detectives and reporters alike was Audrey's father, Edgar, in Syracuse. The evening *Syracuse Journal* reached Edgar's second wife, Cora, on Tuesday morning, March 24. Cora said Audrey had not been to her father's home at 2426 North Salina Street for two years. Audrey and her mother, she said, had been living with Dr. Wilkins in New York, where Audrey received all her mail "in his care." She said Audrey and her mother had left New York shortly before the murder without telling Edgar Munson where they were going. Their last contact was a letter from Audrey about a month before, announcing she was going to leave New York. Cora, who now had five children with Edgar, was not, it seems, being told everything by her husband about her stepdaughter.

Later that day, the *Syracuse Post-Standard* reached Edgar himself. The next morning's paper quoted Edgar saying that Audrey had gone to Toronto on movie-related business. "Audrey is not in hiding nor running away from any district attorney," Edgar insisted. "It is perfectly preposterous to suggest she ran away. It is no secret that Audrey has been in Toronto and was there three weeks ago when I heard from her last. On her way to Canada, on the night of January 11, in answer to a telegram I met her at the [Syracuse] Central Station and on the train I kissed her goodbye." Edgar's statement is open to question, because Audrey had signed her poison-pen letter to the State Department from New York City on January 29. But it is possible she went up to Syracuse to say farewell to her father because she was leaving America for good and then returned to New York.

Edgar Munson said he had received five letters from Audrey and answered them at the address in Toronto that she gave: No. 10, Alexander St, % Mrs. H. East. (The federal Bureau of Investigation eventually came up with a slightly different address: No. 30, Alexander Street.) The address was that of a Mrs. Frances East, the wife of Herbert East, a gardener. Her connection to Audrey is not clear, but perhaps she was an old friend of Kittie's. As always, Audrey's father was at pains to stress his firstborn's love for his second family. She had, he said, recently sent a box of clothing and books as belated Christmas gifts to be distributed among her half-siblings. Edgar's account, however, included a telling discrepancy from that of his second wife. For about three months Audrey and Kittie had lived at the Wilkins rooming house, but Edgar insisted Audrey's mail was addressed in care of Mrs. Wilkins, not in Dr. Wilkins's care, as Cora said.

Private detectives from the Burns Agency were dispatched to Toronto, where Audrey was beyond US jurisdiction. She was adamant she would not return to New York to testify against her kindly former landlord.

"I had only the slightest acquaintance with Dr. Wilkins. I saw him passing in or out of the house and said good morning or good evening. Nothing more," she said. "I knew Mrs. Wilkins much better and she was a good friend of mine."

Audrey confirmed that Dr. Wilkins had been her "medical adviser." That could well have been the case, and the reason she moved with her mother into his boardinghouse. Dr. Wilkins's own morphine habit and his theatrical clientele suggest he may have been supplying drugs to Audrey. If her complaint about others saying she was pregnant was actually true, it is also possible that she turned to him for an abortion. Audrey, however, gave a much more innocent explanation. While staying at the Wilkins house, she had been very ill with influenza. Mrs. Wilkins had very kindly not asked her to move out to the hospital, she said.

Audrey said it had originally been her intention to go to England on December 1 to take up an offer from the "Thirty-Six Film Company." However, she had been first required to travel to Canada to help her film *Purity* pass the censors board. The movie, she complained, "seemed to be conspired against and delayed my royalties." But she added: "The picture is passed and everybody is happy." She complained that she had been due to depart for England by liner from Montreal on March 1, but the US government had denied her a passport. Now, she said, she might be forced to set up her own production company in Toronto and make her films in Canada.

Flashing the arrogance and temper of the star she was, Audrey wrote to Mr. Weeks, the Nassau County DA, refusing his request to come back to New York. He leaked the imperious letter to the press:

Dear Mr. Weeks,

I have been much annoyed by statements in the newspapers that you were looking for me as a witness in the Wilkins murder trial. The Toronto authorities recently told me I was wanted in Mineola because it was believed I could tell them something of the private life of Dr. Wilkins, whom I know as a refined, cultured old gentleman. I resent the statements attributed to you that I left the Wilkins home in New York on account of remarks the doctor is supposed to have made about me. I told Mrs. Wilkins early in December that mother and I intended to go to England, where I have

numerous relatives that we have not seen for several years. And let me say right here that I am not going to be cajoled to coming to Mineola to testify against old Dr. Wilkins, because mother and I believe him to be innocent of any crime, as we know him to be a gentleman, incapable of such an offense as charged against him. The relations between Dr. and Mrs. Wilkins were ideal, and during the time mother and I lived with them we never knew them to have a fight. Instead of sailing to England on March 1, as we had intended, the first part of February I received notice that there was trouble about my films in Canada, and my mother and I immediately went to Toronto. We stopped at Syracuse to see my father and there has been no secret about our movements. We are going to England soon. In March we read of the murder and I was astonished to learn that I was being hunted by the district attorney of Nassau County. There was never anything wrong between Dr. Wilkins and myself. On several occasions, he acted as my medical adviser.

<div align="center">

Very truly yours,

Audrey Munson.

</div>

Refusing to return to the United States, Audrey and her mother agreed to send sworn statements from Toronto via the Burns Detective Agency. The content of those affidavits has never been revealed—and the entire court file has gone missing from the Nassau County Courthouse despite the enormous gravity of a capital murder case. The press described the affidavits as "sensational." An unnamed Burns Agency detective told the press: "The contents could prove very damaging to the defendant." Yet they were never used in open court.

In an interview the following year, Audrey said: "I told the District Attorney all I could with regard to the people who were in the habit of calling at the Sixty-Fifth Street house, the servants etc. I don't think the affidavit which I signed was ever produced or used in any way."

tion

ockade

rding to
oritative
Germany
e powers
e Peace

er, that
fication
e powers
nt Wil-
regarded
at of the

OSE

HOOL

s Steps
adical
ter.

PRISING

Commit-

DR. WILKINS GUILTY OF FIRST DEGREE MURDER, MUST DIE

Jury Recommends Mercy, but Court Announces That Only Governor Can Intervene.

VERDICT STUNS PRISONER

"Only Love in Our Home," He Declares in Statement Protesting His Innocence.

JURY OUT FOR 22 HOURS

First Ballot Six to Five for Conviction—One Man Held His Ground Alone for Seven Hours.

Special to The New York Times.

MINEOLA, L. I., June 27.—Dr. Walter

Revolu
with

COPE
sociated
and Au
confere
days ag
ing for
a dispat
The n
middle

REDS

G

Noske
to

ARMY

Many
Lea

19

THE ELECTRIC CHAIR

Dr. Wilkins sat impassively at the defense table at the Nassau County courthouse in Mineola. While on the run, he had shaved off his whiskers, but to go before the jury he had grown a white "grandfather beard." As proceedings got under way, a court reporter noted that the defendant displayed two nervous ticks: sucking the tip of his forefinger, like a child, and swinging his eyeglasses on their string, like a doctor.

Dr. Wilkins knew he faced the prospect of the electric chair, and it weighed on him terribly. The district attorney had concluded that Wilkins had been planning to kill his wife for months. He was charged with murder in the first degree, with a mandatory death sentence.

It was a sensational capital murder trial and attracted a crowd of ghoulish onlookers. So keen were they to see Dr. Wilkins face justice that some turned up to court a week early because of confusion over the start date. They packed the public gallery.

Charles Weeks, the district attorney, and son of a local lobsterman, rose to outline the prosecution's case. Dr. Wilkins, he told the jury, only married Julia Krauss for her money. "Dr. Wilkins was not endowed with any real or personal property, so far as we can find, and he did not practice in the medical profession, but lived on his wife's money," he explained.

"His wife was short, stout, unprepossessing in appearance, of a stubborn disposition and close in money matters."

Only an old man, Weeks argued, would have needed seventeen hammer blows to fell an elderly woman. He scoffed at his claim that he entered the house alone to tackle the burglars. The evidence, the prosecution argued, suggested that Mrs. Wilkins went into the house, took off her hat and gloves, and went back outside to feed her dogs, where she was attacked.

"This case is not entirely circumstantial, for it involves the credibility and truthfulness of the defense, for he told to various persons a tale that burglars who were in the house killed his wife," Mr. Weeks declared. "The tale varies with various tellings, and if this story is true, then he is innocent of this crime. If it is not true, then there is no escape from the logical sequence that he killed his wife."

Everyone in the courtroom, especially the wizened crime reporters on the press bench, recognized that something, or rather somebody, was missing: That somebody was Audrey.

KNOWLEDGE OF MUNSON GIRL MISSED AT TRIAL, the *Syracuse Herald* headlined its report on the opening day. "District Attorney Charles B. Weeks of Nassau County exhausted every means to find a woman in the case of Dr. Walter Keene Wilkins on trial today for murder—and failed. The sextuagenarian physician's lawyers are elated over the failure for now they are confident that no light of love will flicker through the proceedings in the Mineola Court House: no beautiful face will appear to be contrasted, to their client's disadvantage, with the cold body of his dead wife. This they believe will be a murder with the only feminine character in it the woman who was slain. The prosecution did think almost up to the minute of the trial that they had a woman witness who would be of extreme importance, but what she was expected to testify to was, and still is, a great mystery. The woman was Miss Audrey Munson, actress, model and film favorite, young and very fair to look upon."

Weeks, however, had hard evidence up his sleeve.

Dr. Wilkins's face blanched and a look of panic flashed in his eyes

when he heard that the Swiss watch and the "love-knot pin" he told police had been stolen by the burglars had been recovered. The pin was discovered by chance inside the lining of his overcoat, which was in the possession of police. The shattered Swiss watch was discovered at the cottage inside a bloody napkin stuffed into the sofa. It was stopped at 9:28 ½ p.m., unwittingly recording the exact time of the murder.

Armed with this proof, Weeks turned to the defendant and looked him in the eyes and called him "Murderer!"

Dr. Wilkins's face muscles "twitched convulsively," one court reporter noted, and his face "turned from deep pink to ashen gray and back again several times." He clutched his fleshy thigh anxiously.

Relentlessly, Weeks spelt out the litany of proof.

The day after his arrest at New York's Pennsylvania Station, he was driven back to Long Beach by escorts from the Burns Detective Agency. When the haggard doctor complained of being hungry, they stopped at a hotel to allow him a breakfast of coffee, rolls, and eggs. Before delivering him to his arraignment hearing, they drove him round to his cottage on East Olive Street for a change of clothes. When Dr. Wilkins entered his home, his collie Duchess greeted him eagerly, but the injured dog Duke shied away. The encounter left the doctor visibly disturbed. Supersleuth William J. Burns later earned his reputation as "America's Sherlock Holmes" by declaring that it was this moment when he confronted the doctor with his dogs that he became certain Dr. Wilkins was the killer.

Incriminating evidence, Weeks explained, had continued to pile up: Joseph Jacobson, who had a valet shop on Sixty-Sixth and Broadway, around the corner from the Wilkinses' New York rooming house, said Dr. Wilkins had given him a bloodstained suit and an extra pair of gray worsted trousers. The cleaner thought nothing of the stains on the waistcoat and around the right suit trouser pocket because he assumed the doctor got them while performing surgery. Dr. Wilkins denied he owned such a suit, but he was forced to remove his pants in his prison cell so Mr. Jacobson could point to the secret mark he leaves on clothes he has cleaned. His housekeeper confirmed he owned the salt-and-pepper suit.

The district attorney entered into evidence the hypodermic needle and the tablets of morphine sulfate that had been seized from Dr. Wilkins on his return from Baltimore. Though the doctor's drug use or even drug-pushing were not germane to the trial, they provided the subtext of the case. The *Brooklyn Daily Eagle* suggested the drugs offered "a mute explanation" for Dr. Wilkins's crime.

Dr. Wilkins took the stand as the first witness in his own defense. He sobbed as he described the moment he learned his beloved wife had died. But the twelve-man jury, six of them older than fifty, and all but one married, remained unmoved. The judge cut short Dr. Wilkins's heart-warming anecdotes about his domestic life, admonishing him to cut out the "conversational adornments."

"Just tell us the facts. The jury will then be more interested," the judge advised. "They want to know about your actions."

Dr. Wilkins accused the police of a "frame-up" to cover up their failure to catch the real killers. His attorney, Charles N. Wysong, in a pre-agreed routine, asked in a final flourish: "Did you kill your wife?"

"I did not," Dr. Wilkins swore.

In his closing arguments, Wysong faced the jurors and asked them squarely: "Who said Dr. Wilkins killed his wife? Nobody, yet you are asked to deduce from this mass of testimony that he is Jekyll and Hyde and up to ten minutes before the murder he was kind and loving and devoted. And now they tell you he murdered foully and in cold blood."

Before making their life-and-death decision, the jurors paid a visit to the Wilkins cottage on East Olive Street. They stayed half an hour. Their verdict was delivered at 3:34 PM on the following day, Friday, June 27, 1919, after twenty-three hours of deliberation.

Foreman Oscar W. Paries read out their decision to the court.

"We find the defendant guilty as charged," he began.

Another juror sought to interrupt, but Paries continued. Addressing the judge, he added: "We recommend the mercy of the court."

Dr. Wilkins showed no reaction to the guilty verdict, with its mandatory sentence of death in the electric chair—even when the judge told the jury it was up to the governor not the court to extend any clemency. In a statement to reporters through his lawyer, Dr. Wilkins insisted: "I am absolutely innocent. I never injured a hair in my wife's head. I never could have injured a woman who was universally so generous to me. We never had a steak that she did not insist that I have the tenderloin." As soon as he got downstairs to his cell, however, he broke down in tears.

Dr. Wilkins was placed in Cell No. 1, inside a caged corridor that had a total of eight cells. At the end of the corridor was a bathroom and WC. The other inmates in the section were so-called "trusties," prisoners who had earned the trust of the prison warden. The Nassau County jail was

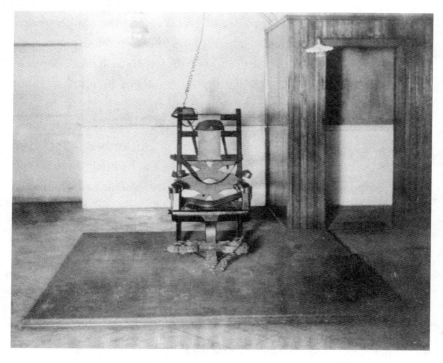

Dr. Wilkins hanged himself to avoid the electric chair.

notoriously lax, and the trusties were allowed to wander around the jail. One even used to run errands to the post office for the staff.

On Sunday, the day before his transfer for execution to Sing Sing prison in Upstate New York, Dr. Wilkins received only one visitor in his cell: Rev. August Deppisch, an old friend who now ran a stationery business in Manhattan. As a spiritual adviser, he was not searched. That evening, Dr. Wilkins's cell door was left open, although the gate closing the corridor was locked. All the "trusties" were still out at visiting time, even though it had ended hours ago. At 7:45 PM, warders discovered Dr. Wilkins hanging from a rope the thickness of a clothesline tied to a pipe in the bathroom at the end of the corridor.

According to a report ordered afterward by New York Governor Alfred E. Smith: "Dr. Wilkins was fully dressed at the time in a cutaway coat and vest, dark trousers, his shoes were polished, his collar and necktie on, and there was every appearance of personal neatness. In his pocket were found strips of his bedsheet which had been knotted together as a rope. This, however, was not the rope with which he hanged himself, that being a piece of what may be termed manila or hemp rope about one-quarter inch in thickness and six feet in length."

He was still breathing when the warders cut him down, but his neck was broken at the first vertebra. The prison doctor rushed to the scene and tried to resuscitate him for fifteen minutes, but he died. "Rather than be driven across the State of New York by Carman Plant and delivered up to Sing Sing prison I prefer to be my own executioner," he wrote in a suicide note. "I am absolutely innocent of this crime."

Dr. Wilkins left five notes: one to his lawyer, one to a clergyman, one to a friend, one to a neighbor asking him to take care of his pets, and one asking the sheriff to use the sixty dollars in his clothes to cremate him.

William von Welsen, one of the jurors, reacted with satisfaction: "He is guilty, all right. He saved the county some money. I have slept well ever since we did what we did. I think we have done justice." Wysong, his lawyer, said he knew Dr. Wilkins had thought of taking his own life. "He told me that he was prepared, when he went to Baltimore, to write to an

undertaker to take charge of his body and have it cremated. He then told me he decided not to kill himself because he did not want to die under a cloud."

A State Commission of Prisons investigation found: "The Nassau County Jail has been conducted with a looseness and laxity that is without parallel. Indeed, it is difficult to retain the fact that it is a jail. The superintendent of an institution for the blind or a home for aged and infirm exercises more care and supervision." The man in charge of the prison, Sheriff Phineas A. Seaman, was fired.

Audrey, in self-exile in Toronto, made no comment on the verdict or Dr. Wilkins's suicide.

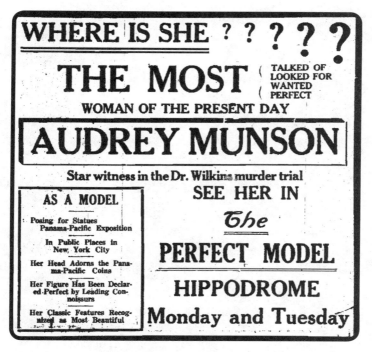

Theater-owners cashed in on the manhunt for Audrey.

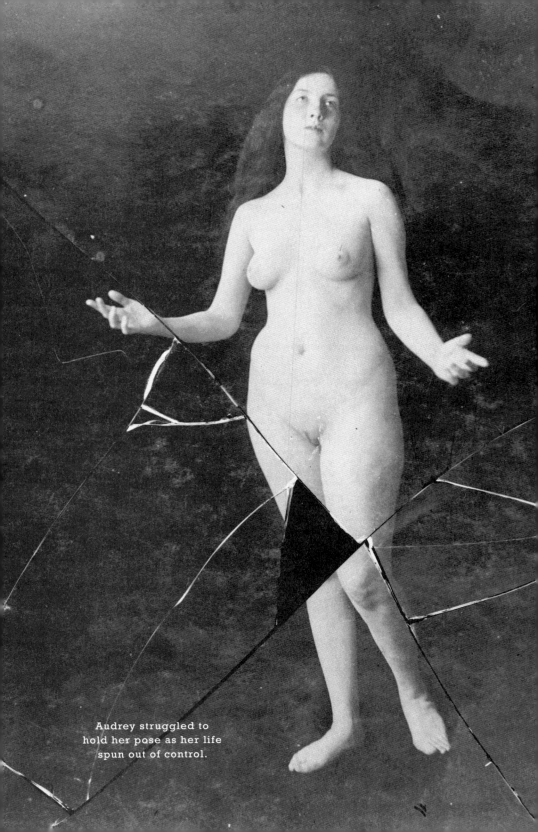

Audrey struggled to
hold her pose as her life
spun out of control.

20

SHATTERED

A year after the Wilkins murder-suicide, a "bent, broken, hollow-cheeked, prematurely-old woman" walked into a newspaper office in Syracuse, New York, with a startling request: she asked the clerk to place a notice announcing the death of Audrey Munson.

The clerk eyed the woman suspiciously—and then incredulously. "Audrey Munson!" he exclaimed. "Dead? Why what are you doing, putting over a press agent stunt? I know you Miss Munson."

Audrey's bid to start a new life under a new name failed there and then. Like so many men, the clerk recognized her all too well. She left the office sobbing and returned to her mother's arms. "I thought that if poor Audrey Munson were out of the way some of those who had cared for her and for her work in the past might remember her and be sorry and that her old self, under another name, might have a chance to work and to be happy again," she said.

Spurned by the in-crowd in Newport and New York, reviled by the press as the "other woman" in the Wilkins case, Audrey found herself shunned by her former employers. The American Film Co., which had made *Purity* and *The Girl o' Dreams*, released her from her contract and told her she was not needed for another film "right now." For the first

time in years, she found herself in want of money. She became a member of what she called the "'Down and Out' club."

Audrey had planned to escape from America even before Mrs. Wilkins's murder. Perhaps because of her failure to get a US passport for the crossing from Montreal, she blamed the scandal for destroying her plans in England too. As she had discussed with the reporter in Syracuse on her return from California, she had hoped to break into the music world. Shortly after Mrs. Wilkins's murder, she told the *Watertown Daily Times*, near her mother's hometown of Belleville: "I have composed a song which is both educational and classical, words and music by me, which the people of Watertown and Belleville will soon hear on the phonograph records." On her return from Toronto, however, she found herself rejected and despised by everyone in New York. "Wherever I went I felt cold, curious eyes upon me," she later complained.

One day, she attended a matinee and someone addressed her as "Audrey." The woman in the next seat leaned forward and said to her: "I thought I was not mistaken. Aren't you Audrey Munson, who was in that murder case in Long Island?"

"I am Audrey Munson," Audrey replied.

The woman and her friend picked up their wraps and left their seats. Audrey saw the usher show them to places in another part of the house.

Waiting for a downtown stagecoach near St. Patrick's Cathedral on Fifth Avenue, Audrey suffered another humiliation. A young woman pointed Audrey out to her friend. "Look here!" the woman said. "That girl in brown is Audrey Munson that the old man who hanged himself killed his wife for."

"I had letters by the score," Audrey complained. "Some of them purported to be from women who said their husbands had become infatuated with me and were trying to get rid of them and warning me against accepting the advances of people I'd never heard of," she said. "Some were from miserable old wretches of men, asking me whether it wasn't a happy life to be an old man's darling."

Audrey was already fragile. She saw the world conspiring against her—

the movie men, the millionaires. But the public had always loved her—at the Panama-Pacific International Expo, on the silver screen. The scorn that now fell upon her exacted a heavy psychological toll.

"I suppose that the whole wretched business had shattered my nerves. But you have no idea of the hell on earth I have endured," she said. "I suppose some people think that to be mixed up in a famous murder case would be good advertising for a movie star, but they are making a great mistake. You see, the circumstances surrounding the crime were so perfectly hideous. An old woman, beaten to death with a piece of lead pipe, her husband convicted of her murder and hanging himself in his cell, and an artist's model and screen star tacitly, if not actually, alleged to have been the vampire on whose account the horrible deed was committed."

Trying to turn back the clock, Audrey made the rounds of the artists' studios just as she had done as a girl. Her old artist friends voiced sympathy in private but offered no work. Patrons were unlikely to want statues of Beauty or Virtue modeled on a woman considered a virtual murderess. Their new, younger models were cruel. "It surely seemed as if fate, wielding a mighty hammer, had brought down upon this model a blow that shattered," the *Washington Post* said.

After her legal battle with E. F. Albee and the United Booking Office five years earlier, the New York theater world had no use for her either. The rejection fed her growing paranoia. She became convinced she was followed by the curse the Gypsy had laid on her when she was just a girl.

"It was no bitter mouthed, flaming eyed prophet wandering in the desert three thousand years ago who cried a curse on Audrey Munson. It was no stern high priest of Judah thrusting the sinner away from the gate of the temple. Nor any city of righteousness where the wicked were crucified. It was easy New York," the *Buffalo Courier* declared. "It was not the respectables of the New York middle class who turned away from Audrey Munson, nor the Church folk. Here is the marvel. The world in which Audrey Munson lived, and which cast her out of it for the sin of which she was accused, was the bohemian world of artists and the equally bohemian world of the theater."

Shunned, Audrey headed to the Midwest. She received an offer from William Fox's Fox Studios to make personal appearances at several theaters to pose alongside one of her films. The pay was to be $250 a week. It was Audrey's first time back on the road since touring with *Marrying Mary* when she was seventeen. She went first to Chicago and then to Detroit, the newly nicknamed Motor City. In mid-November 1919, she posed at the William Fox Washington Theatre in Detroit during screenings of *Purity*. Her body still had its drawing power. "Seldom before have such long lines waited in front of the box office at this house to gain admittance," the *Detroit Free Press* observed. Her popularity generated its own problems, however. According to her family, fans eager to see her overwhelmed the city's grand Temple Theater and the show had to be shut down because of the violation of the fire code.

Audrey was finding it increasingly difficult to manage her own life. Kittie had remained back in Syracuse, where she had gone after returning from Canada so Audrey could be near her father. Due to "misunderstandings with her manager" Audrey found herself stranded in Detroit. She was forced to make a living giving dance classes to "a select group of society children"—using the skills she had learned in the Dancin' Dolls as a teen.

While stuck in the city, Audrey worked to maintain her public profile. Some years earlier, she had posed for C. S. Pietro's memorial to Salvation Army founder William Booth, titled *Suffering Humanity*—although the first maquette was destroyed by a fire in Pietro's Fifth Avenue studio in 1916. Now, she showed her loyalty to the Salvation Army by volunteering to help with their pre-Christmas sale at a booth in Detroit's luxurious Hotel Pontchartrain.

In January 1920 she volunteered again for a more secular cause. She agreed to appear in a series of poses for the Scarab Club's "Oriental"-themed costume ball, also in the Hotel Pontchartrain. She said she was appearing "as a courtesy to Detroit artist members of the Scarab Club."

Audrey still harbored hopes of a film comeback. Planning to press on to Los Angeles to seek movie work, Audrey pawned her jewelry. But the hint of a job prospect in New York persuaded her to go back east. She

fell sick with what she described as a "serious illness." The role did not materialize. Audrey was forced to accept "charity" from her cousin Harriet's wealthy father, Samuel Lyman Munson, to be able to get back to her mother in Syracuse. "I was brought up in Syracuse," Audrey said. "There I thought I might get rid of this terrible bugbear of suspicion."

When Audrey moved back in with her, Kittie was eking out a living selling kitchen utensils door-to-door. They shared a single shabby furnished room at 621 East Fayette Street, cooking on a single gas burner as they had done in the Wilkins's house. Kittie was really struggling, and Audrey's notoriety made matters worse. "My mother and I have always lived in rooms in private homes instead of in hotels. Half a dozen different times we have been told by the landlady or agent that we were no longer acceptable as tenants," Audrey complained. "More than once my mother and I have been hungry. She has taken work of any kind she could get—canvassing, nursing—anything."

A visiting reporter from the *New York World* found Audrey working with needle and thread to repair her scant remaining wardrobe. Her appearance shocked him. "The gloriously beautiful Audrey Munson," he wrote, "is now a girl who shrinks if you look at her; who speaks in a low, hesitating voice as though she were not certain you would think what she had to say worth hearing; who is thin almost to emaciation; the hollows in her cheeks and in her throat are visible evidences of the material hardships she has endured and is enduring."

Desperate, Audrey applied to become an apprentice at the Syracuse Public Library for fifteen cents an hour. She did not get the position. She did the rounds of every department store asking for a job—also with no result. She said she applied unsuccessfully for 200 jobs.

"I have been turned down in an application for the job of addressing circular letters. Four stores which advertised for a girl to act as cashier, with nothing more to do than to drop coins in a cash register and ring a bell, have refused to employ me. The excuses they give are worse than if they would come out flatly and say that they do not wish their customers to approach such a woman as Audrey Munson," she said.

She still had the marble bust of herself that Daniel Chester French had given her and the bronze statue by Ulysses Ricci. She loaned them to the Syracuse Museum and thought she could make money posing next to them. It was a bizarre notion. The museum rejected her request for a cut of the ticket price. "She loaned them to the Syracuse Museum. They kept them for a year but they would not pay her anything for exhibiting them. She said she should have had at least twenty percent of door receipts," Kittie wrote later in a letter. "Poor girl was cheated out of all."

According to one story, some old theatrical friends came upon her working as a waitress at a "hashhouse," or diner. Audrey did indeed wait tables. "Two weeks ago I happened into a restaurant where the proprietor was short of help and he gave me work as a waitress," she told a reporter. "He knows who I am and has been very kind, but the work is hard and exacting. I will not tell you the name or location of the restaurant because I fear that the public might flock there to see the one-time screen star in the role of a menial."

The Syracuse newspapers began to champion Audrey's cause, seeing her humiliation as a cause of shame for the city. "It is menial employment at the lowest wages that the home city of Miss Munson holds out to her in the day of her adversity," the *Syracuse Journal* lamented. "And even such offers did not come until the woman whose curves were acclaimed by art critics as classical, had made known her plight, after her appeals for work had gone unanswered by prospective employer after employer. Not one position as tutor or companion had come to Miss Munson since the fact that she is penniless here became known. By birth and by education, Miss Munson is fitted for either."

"Society, apparently," Audrey concluded, "has no use for a member of the 'Down and Out' club."

The news coverage won Audrey widespread sympathy. One generous plumber sent her a check for fifteen dollars pinned to a note saying it wasn't charity but a loan she could pay back whenever she wanted. A woman artist in nearby Baldwinsville organized a benefit for her at the Orpheum Theatre in which she would pose along with a showing of

Purity. The event was advertised as her "first time onstage outside the big cities."

The publicity began to generate job offers. At least some movie men judged there was still money to be made off Audrey. The first new business proposition came from a new production company in Boston called the Metropolitan Picture Corp set up just weeks earlier. The company listed a capitalization of $100,000 and planned to recruit Audrey for a major motion picture called *A Thousand Faces*. A small ad placed in a Boston newspaper did not inspire confidence in the project, however. "Wanted, A Thousand Faces. 10 reels. Boston's greatest film production. Metropolitan Pictures Corp 168 Dartmouth St, Boston. Call and Register Day or Evening. All Types Wanted." The defunct company was wound up two years later by a state law that shut down inactive and insolvent companies.

Finally, a genuine offer arrived. Audrey saw the first light at the end of the tunnel. On Tuesday, October 26, 1920, she packed up her bags and boarded the train for New York City. The proximity to her father in Syracuse had brought her closer to her father's second family. She took two of her half-sisters along for sightseeing. Five years earlier, she had written: "Children should be shown beautiful pictures and should be taken to see lovely statuary." True to her belief, she took her half-sisters Vivian, aged fourteen, and Gertrude, nine, to see the images and sculptures inspired by her in the Metropolitan Museum of Art. She counted about forty in all. The girls were most impressed, however, that the museum was selling photographs of Audrey in the lobby.

The real purpose of Audrey's trip, the *Watertown Daily Times* reported, was to "relate her story to a newspaper syndicate." She was to meet an agent and a talented newspaperman who wanted to tell her life story. The meetings went well. They discussed a newspaper series written under Audrey's name, and even a spin-off film.

Audrey returned back upstate for more small-town and small-time "living picture" appearances. She posed at the Fowler's Hall in Manlius on November 13 and the Dellinger Theater in Batavia on Thanksgiving

Day, November 26. Soon, however, news became public of her new project. She was to star in yet another autobiographical film. Audrey was once again, of course, cast as a nude model. It was to be a cautionary tale about the perils that faced young women who took off their clothes for art and, like moths, flew into the flame of Bohemia. Audrey was too desperate to heed its message. It was to be called *Heedless Moths*.

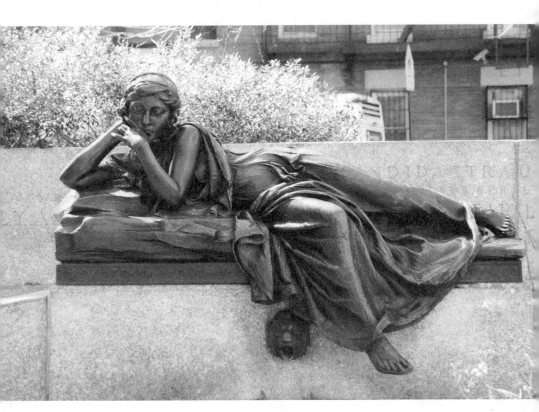

The Isador and Ida Straus Memorial was built in memory of a woman who would not leave her husband on the sinking *Titanic*.

21

HEEDLESS MOTHS

On December 3, 1920, a desperate telegram arrived at the Buffalo State Hospital for the Insane. "Looking for you all over state," the message read. "Have $2000 and good news awaiting you." It was signed "Yates."

According to the *Buffalo Courier*, the telegram was addressed to Audrey Munson in care of Anna Lyman, a "special attendant" at the asylum. Mrs. Lyman and her husband, Michael, also an attendant at the hospital, were friends of Audrey's parents from Rochester. Michael Lyman had been employed as a motorman when Edgar Munson was working in the city as a coachman and driver. When Audrey was baptized as a baby at Rochester's St. Patrick's Cathedral, Anna and Michael Lyman were listed in the parish register. The couple were Audrey's godparents.

Audrey's wan appearance and broken spirit had spurred concern over her health. Her temporary disappearance provoked a flurry of rumors that she had been confined for treatment in a sanitarium. "Are the doors of the Buffalo state hospital for the insane about to clang shut behind Audrey Munson? Is the one-time beautiful idol of America's millions about to enter a refuge for the demented and helpless? Indications point to an affirmative answer," the *Buffalo Courier* reported. The Lymans reportedly scoured the wards to see if their goddaughter had been admitted under a false name—and found nobody. Or at least that is what they said.

The public explanation of Audrey's absence was that she was "in seclusion" rehearsing for an appearance she was to give two weeks later at the Regent Theatre in Lyons, New York, where she would perform statuesque poses alongside the rereleased *Inspiration*, since retitled *The Perfect Model*. But she had posed for the film many times. She did not need two weeks of rehearsals for that.

Then news broke that she had struck a new movie deal, and she reappeared. "Audrey Munson is again on her way to fame and fortune," the *Syracuse Journal* trumpeted. "When she left here a few weeks ago she was pale and emaciated. She is now her former self, however." The deal had lifted her spirits, or perhaps the treatment had worked. Or both.

At first, Audrey refused to divulge the identity of her new producers. "I finally found an influential friend," she said. "It was a company that couldn't offer me employment itself, but interceded on my behalf with a film concern—which one I must not tell. I've been given an advantageous contract and an opportunity to come back. I'm only twenty-seven— think of it!—and I've time to build a new career. We'll succeed, won't we mother?" In the furnished room they shared in Syracuse, Kittie smiled gently at her damaged angel and replied reassuringly: "We'll try real hard."

A large advertisement suddenly appeared in newspapers and the movie trade press. It showed a check for $27,500 dollars drawn on the Pacific Bank on Forty-Ninth Street at Seventh Avenue in New York, dated December 14, 1920. Written on the face was the note: "Initial payment on contract Dec. 14, 1920." It was made out to Audrey Munson.

"To Every Production, Distributor, Exhibitor, Promoter, Operator, and Agent in the Motion Picture Industry—You are hereby informed that the full and complete motion picture, book and dramatic rights to THE STORY OF AUDREY MUNSON have been secured and are now exclusively owned and controlled by Perry Play Films Inc 220 West 42nd Street, New York, by arrangement with Allen Rock," the ad proclaimed.

Miss Munson is the most famous of all artists models whose beauty has inspired the greatest modern masterpieces. Her intimate story

LEGAL NOTICE

No. 131

NEW YORK, December 14 — 1920

1-28　　**THE PACIFIC BANK**　　49

49TH ST. AT SEVENTH AVENUE.

PAY TO THE ORDER OF _Audrey Munson_ —————— $27,500 00/100

Twenty Seven Thousand Five Hundred DOLLARS

Initial payment on contract Dec 14, 1920　　_Allan Rock_

TO EVERY PRODUCER, DISTRIBUTOR, EXHIBITOR, PROMOTER, OPERATOR AND AGENT IN THE MOTION PICTURE INDUSTRY—

You are hereby informed that full and complete motion picture, book and dramatic rights to

The Story of Audrey Munson

Have been secured and are now exclusively owned and controlled by

PERRY PLAYS INCORPORATED
220 West 42nd Street, New York
By arrangement with Allen Rock

Miss Munson is the most famous of all artists' models whose beauty has inspired the greatest modern masterpieces.

Her intimate story is the tremendous drama now appearing in smashing two-page spreads, every Sunday, in all the Hearst Sunday Newspapers and in more than fifty other big Sunday newspapers throughout the country.

PERRY PLAYS INCORPORATED has also secured the exclusive services of Miss Munson herself, including all photographic rights originating with her for a period of time fixed by contract.

In view of the extraordinary value of the above rights—plus the value of the newspaper cooperation in the resultant publicity and promotion campaign,

PERRY PLAYS INCORPORATED
Notifies the trade in general that it will promptly protect each and every right thus possessed by it and punish infringements to the full extent of the law.

Audrey should have become rich—but later called the check a forgery.

is the tremendous drama now appearing in smashing two-page spreads, every Sunday, in all the Hearst newspapers and in more than fifty other big Sunday newspapers throughout the country.

The $27,500 check was signed in the looping handwriting of Allen Rock, a PR man who had made millions revolutionizing movie publicity. A consummate wheeler-dealer, Rock began in the motion-picture industry in 1913 with the organization of Jesse L. Lasky Feature Play Company, before joining Paramount Pictures Corp., and then representing the Famous Players-Lasky Corp. On January 1, 1918, he struck out on his own with the Press Service Bureau at 1402 Broadway.

Rock understood the value of celebrity in the nascent movie business. When the tomb of the ancient Egyptian "boy king" Tutankhamun was discovered in 1922, he quipped: "I don't know whether or not anyone has signed up King Tut-Ankh-Amen for the screen, but he sure would be a big attraction. And oh, baby, what a press agent that guy has." Rock had decided he would make Audrey a star again.

When Audrey walked into Rock's office to sign her deal, she came face to face with the Blonde Vampire. She had a very chubby, friendly countenance for a vampire and a head of blond curls, but she had a mischievous look in her eye. Her real name was De Sacia Mooers, whose husband owned the Yellow Aster gold mine in Randsburg, California—the richest in America. Rock was working at the time on a movie starring Mooers as the heroine of her own novel, *The Blonde Vampire*. To promote the movie, Rock got the novel republished, a phonograph record produced of the title song by Walter Scanlan, and commissioned a portrait of Mooers by painter Henry Clive. In return, Rock was to get a 35 percent cut of the movie. When the moviemaker Vitagraph stalled, Rock sued to force release of the film, saying Mooers had invested in an expensive wardrobe and feared that "style of vamp" would be out of date by the time the picture hit theaters. The film eventually came out as *The Blonde Vampire* in 1922 as an "Allen Rock Presents" production. Rock later married Mooers in 1924.

Because "The Blonde Vampire" Mooers was in the office that day, she

served as a witness to Audrey's agreement. De Sacia Mooers was one of two people—along with Rock's manager Albert W. Lee—who attested to the contract Audrey signed with Rock on December 14, 1920. That was the same date as that written on the $27,500 check, but Audrey never got that money. She later derided the check as publicity "bunk."

The contract stated that Rock "is about to cause the production of a motion picture exploiting Audrey Munson." Audrey read through it, but paid no attention to the word "exploit." She put her name on the dotted line.

In the document, Audrey agreed to "exclusively render her services as an actress before the camera and in theaters" for forty weeks, with a twenty-week option after that. She was to receive a $2,000 signing fee on December 30, 1920. Once shooting began, she was to get $250 a week for the first ten weeks, and $100 a week for the next thirty weeks—supplemented by an extra $200 payment per week for personal appearances at screenings. Audrey was also to get 5 percent of the box office, after expenses were deducted. Those were what Hollywood now calls "net points"—and are not nearly as good as "gross points" before accountants get to work on deducting (and inflating) expenses.

Upstart producers, like Rock, knew that sex sells. *America* magazine noted that the economics of the motion picture business were that a "decent drama" grossed $75,000–$100,000 while a "successful sex-play" brought in $250,000 to $2.5 million. Audrey's naked body was again to be the star attraction.

While in New York, Audrey stayed at the ten-year-old Great Northern Hotel at 118 West Fifty-Seventh Street, which offered rooms and suites for monthly rental. One day in her room she sat down to write a sincere "Letter of Thanks" to the *Syracuse Herald* for the newspaper's help in her comeback. "She is not forgetful, it is indicated, of the dark days through which she and her mother went after the jinx of unwarranted mention in a murder case fell upon them and hounded them so that the girl who was only a few months before the toast of internationally famous artists could not get work in her own hometown even as a waitress, and her mother had to mend her stockings," the newspaper wrote.

Rock's PR innovation was to boost movie sales through the use of newspapers—particularly with the "novelization" of movies. To warm up the public for Audrey's new film, her life story was to be serialized in newspapers across the country. The twenty-part series was published in what was disparagingly known as the "slush" section of the Sunday edition of the *New York American*. It was syndicated in Hearst papers around the country with a total readership of 30 million—worth an estimated $1 million in advance publicity. Hearst received a $20,000 advance from producer Perry Plays Inc. against a royalty on the box office.

The newspaper series offered Audrey a colossal amount of positive publicity just two years after the Wilkins murder—which it totally ignored. The articles recounted her funny, heartbreaking, embarrassing, and lurid experiences as an artists' model. She told personal tales of famous artists, their models, and the artists' jealous wives. Despite the thousands of words, her earlier films were never even mentioned. Her unhappy movie career on the West Coast she could now put behind her. Audrey was able to present the self she liked best: the artist's muse. Week after week, as the newspaper landed on the Sunday breakfast tables of families across America, the series ran under the title: "The Queen of the Artists' Studios."

"Audrey Munson has written the story of her own life, the incidents and episodes behind the scenes in the studios, the unknown history of the inspiration of many masterpieces in public and private art collections, the strange eccentricities and methods of the artists—and the distressing tragedies of the pretty models who lacked the moral balance to safeguard them from the perils of the intimate atmosphere of the studios," the newspaper declared.

The piece carried Audrey's own byline—improbable as it was that she could craft twenty lengthy pieces in the breathless style of the yellow press. In fact, it was not Audrey herself who put pen to paper. It was an "As told to." She had a ghostwriter, but his identity was kept secret—until now.

Audrey told her millions of readers: "I learned and saw some of the

tragedies that come to women whose beauty is their misfortune.'"

When first mentioned in the trade press, the film of Audrey's life bore the unexciting title *The Audrey Munson Story*. It then became, in advance publicity, *The Soul Within*. Later ads called it *Body and Soul*. Finally, the film was released as *Heedless Moths*—about the young models who flock to the dangerous flame of Bohemia.

In the movie, the character of Audrey Munson is asked by a dilettante Greenwich Village painter to pose for him. She discovers that his intentions are not altogether honorable and flees. She is found wandering in a storm by a kindly old artist who introduces her to a renowned young sculptor. Inspired, he asks Audrey to pose in the nude for a sculpture to be titled *Body and Soul* that is to become his masterpiece. The Sculptor's jealous wife falls for the dilettante. Audrey falls for the sculptor and wants to spare him from discovering his wife's betrayal. She breaks into the dilettante's studio, hides the wife, and pretends to be a reveler herself. Appalled to find Audrey there, the sculptor destroys his masterpiece of the woman he idolized—and the selfless Audrey engineers a reconciliation between the sculptor and his wife.

In the final installment of her "The Queen of the Artists' Studios" series on May 22, 1921—timed to come out just the week before the movie premiere—Audrey, or, rather, her ghostwriter, gave the movie a shameless plug: "One of these real experiences of an artist's model has just recently been made the subject of a very beautiful motion picture, and, although it was a bit of real life—just an incident in the career of a model—it made as thrilling and pulsing a movie drama as was ever seen."

The movie caused a mini-uprising on its native Bohemian soil, however. It opened at the Greenwich Village Theatre with a top ticket price of $2.75, the highest ever for an independent film. A 20'x 20' poster plastered above the theater at 320 West Fourth Street showed Audrey clad only in a thin veil around her waist, mimicking her pose for Weinman's *Descending Night*. At the time, authorities—under pressure from old-time residents of the Ninth Ward—were cracking down on the teahouses, such as the Black Cat, for allowing unlicensed dancing. Audrey's display

of nakedness provoked the Village old-timers to hurl stones at the movie theater in protest. Chief Magistrate William McAdoo ordered the poster removed from the public gaze. He pronounced it "obviously and flagrantly indecent and disgusting."

The notices were not just poor, but sarcastic. "Two spots in Greenwich Village last night attracted unusual attention. One of these was a dimple on the right side of Audrey Munson's back. The other a dimple on the left side of Audrey Munson's back," the *New York World* reported.

Photoplay magazine fulminated: "Heedless Moths, despite whatever claims it may make as a story or a dramatic photoplay, is nothing but a bold bid to indecency. . . . It is a tiresome play. And let us hasten to add, in order that no craven pulse may quicken with anticipation, it does not even purvey the prurient thrill which is its thinly veiled pretense. No one knew better than its producers that downright uncleanliness could not be shown at all. So that all we have left is mock sentimentality, lachrymose titling, a considerable extent of unnecessary and unstimulating epidermis, and boredom."

The dilettante was played by Ward Crane, who went on to play Count Ruboff in the classic 1925 *The Phantom of the Opera* before dying at the age of just thirty-seven. The sculptor was portrayed by British actor Holmes Herbert, who chose his stage name in tribute to Sherlock Holmes. Hedda Hopper played the sculptor's wife. When her film roles began to dry up in the 1930s, she started a more successful and long-lasting second career as a feared Hollywood gossip columnist.

The director, Robert Zigler Leonard, had been a film pioneer. He was married to former Ziegfeld Girl–cum–leading lady Mae Murray, dubbed the Girl with the Bee-Stung Lips. The couple held court at their apartment in the new Hotel des Artistes in the "Sixty-Seventh Street Studio District," not far from the rooms Audrey and her mother had rented from Dr. Wilkins. Not long before *Heedless Moths*, Leonard had directed *April Folly* and *The Restless Sex* with another former Ziegfeld Girl, Marion Davies—the lifetime mistress of William Randolph Hearst, whose newspapers were serializing Audrey's "The Queen of the Artists' Studios."

Leonard went on to make the 1936 Best Picture Academy Award winner *The Great Ziegfeld* (1936) about Florenz Ziegfeld.

Leonard would soon find himself locked in litigation with the very same characters Audrey battled. When *Heedless Moths* was released, he placed ads in the trade press pleading that "the fair-minded, square-dealing gentlemen of the distributing companies" be given a producer's credit as well, while admitting he had no legal claim on the title. Leonard has sometimes been given a writing credit for *Heedless Moths*, but he does not deserve it.

The real surprise in *Heedless Moths* was the star. Despite the blizzard of movie posters, newspaper ads, the controversial poster above the Greenwich Village Theatre, and a section reportedly featuring her and director Leonard on the movie newsreel *Screen Snapshots*, the leading lady was obviously not Audrey. It was another woman. "I found out I was to be a star in name only," Audrey howled. "Some scenes were shot in which I posed. Another girl took my place and acted the scenes for which I had been engaged, and I was told she resembled me in the days when I first began posing."

Audrey's role was played by newcomer Jane Thomas. In the midst of filming, the producers had put out an urgent casting call for young actresses who resembled Audrey. Hundreds of young women had answered the casting call, but it was only Jane Thomas who was judged to be the "perfect double." "Why did not Audrey Munson play the role she was supposed to play?" *Movie Weekly* later asked in what it billed as the inside story of the production. "Perhaps it was because she fell down as an emotional actress? Perhaps her physique had rounded out to proportions making it impossible. Audrey Munson herself, we were told, proved unable to portray the role originally written for her. A capable double, in Jane Thomas, was found to do the emoting. But the producers did fair play to all concerned in this respect: The scenes in which Miss Munson did her famous poses were, for the most part, her actual self."

Until the last day, the film crew thought Jane Thomas actually was Audrey. The few scenes featuring Audrey posing were shot at night.

"Audrey was Heart Interest, Yellow-journal Feature Stuff, and Box Office Belle Extraordinaire at that time. So when it was discovered that she was totally unable to do acceptable work before the camera, the impresarios, loath to part with the valuable 'name' they had signed, said to themselves: 'We'll use Munson for a few [scenes of] posing work some distance from the camera, and hire a double for her throughout the rest of the picture,'" *Picture Play* magazine reported. Even when Audrey was billed to make a public appearance, it was Jane Thomas who did it in her place. "This is one of the strangest of strange stories that unfold now and then in motion picture circles," *Movie Weekly* noted. "Perhaps it is the histrionic, the artistic highlight, in the strange story of Audrey Munson's tragic life."

Once again, Audrey retreated back up to Syracuse, moving into her mother's room at 540 South Warren Street. Despite the much-publicized $27,500 check from Rock, she again began making small-town appearances to raise cash. She posed for villagers and folk from the surrounding farms at Manlius. On May 6, 1921, she was booked for a return engagement at the Orpheum Theatre in Baldwinsville, organized by local artist Mrs. Way. "Miss Munson feels very grateful for the assistance she received on the occasion of her former visit here and would like, as best she can, to express her gratitude," the *Baldwinsville Gazette & Farmers' Journal* reported. This was meant to be her big comeback, but it was a bust. The *Syracuse Journal* concluded: "Her heralded return to the silent drama as a star apparently is a flivver."

The answer came in court papers issued by Audrey's Syracuse attorney, George H. Cole. Audrey sued Rock for her full $15,000 deal. Calling her mother as a witness, Audrey complained Rock had never paid her the $2,000 signing fee, and only a few of the promised weekly payments. "The plaintiff performed and offered to perform, and was ready, able and willing to perform all of the services specified in such contract, and that the said defendant failed and neglected to pay the weekly payment which he agreed to make in said contract," the suit states.

Audrey called the $27,500 check a "forgery." At first, she thought it was just harmless movie puff. But it had done her real damage. "That

check has caused me a world of trouble. They called me a hypocrite—when I was giving benefit performances. I was supposed to get $250 a week on this contract I signed. It gave me an almost endless amount of publicity but nothing tangible to pay the bills, and a woman can't live on her press notices. I never had that check or any part of it."

Rock countered that he had been forced to find a substitute actress. In his legal response, he put the blame squarely on Audrey: "A scenario had been prepared which included a role to be enacted by the plaintiff. In conformity with the scenes to be enacted by the plaintiff, a studio had been rented, costly settings and scenery had been constructed; actors, actresses, studio equipment and help had been engaged for the work of systematically photographing according to the usual labor-time-material-saving schedule—and the plaintiff failed and neglected and refused to appear when called for one of the most important scenes of the role assigned to her, although duly notified to appear by defendant, and subsequently and from time to time failed, neglected and refused to appear when called for one of the most important scenes of the role assigned to her." He insisted he had paid the $2,000 signing fee and the weekly installments until May 30, 1921, when Audrey failed to appear for a scheduled "personal appearance" for the big New York City opening at the Greenwich Village Theatre.

By the "Queen of the Artists' Studios"

The Story of Audrey Munson—Intimate Secrets of Studio Life Revealed by the Most Perfect, Most Versatile, Most Famous of American Models, Whose Face and Figure Have Inspired Thousands of Modern Masterpieces of Sculpture and Painting

Miss Mabel Normand, Showing the Face Which Sculptor Piccirilli Rejected in Making His Combination Statue Because It Was "Too Merry."

W HAT is it that has made Miss Audrey Munson the undisputed "Queen of the Studios" for more than ten years?

Of the two hundred and more of the foremost artists and sculptors of the United States for whose masterpieces she has been the inspiration probably each one would give a different answer to the question.

Francis Jones found in her face the purity and sweetness he needed for the stained glass angels in the Church of the Ascension in New York; and the great MacMonnies found in her the inspiration for his voluptuous bacchanalian figurite. William Dodge used her budding vivacity for the "Spirit of Play" in the Amsterdam Theatre frescoes, and yet her serious dignity won for Adolph Weinman the prize in the competitive statues to adorn the top of the great New York Municipal Building—and there Audrey Munson stands as "Civic Fame," cast in copper, a gigantic figure twenty feet tall.

Throughout the length and breadth of the United States, in libraries, museums, private galleries, town and country residences, public buildings, fountains, churches, bridges, public squares and parks and private lawns and estates the most famous of all American artists' models is seen in endless variety.

Audrey Munson has written the story of her life, the incidents and episodes behind the scenes in the studios, the unknown history of the inspiration of many masterpieces in public and private art collections, the strange eccentricities and methods of the artists—and the distressing tragedies of the pretty models who have lacked moral balance to safeguard them from the perils of the intimate atmosphere of the studios. Audrey Munson's fascinating story will be told from week to week on this page.

CHAPTER V.
By Audrey Munson
(Continued from Last Sunday)
Copyright, 1921, by International Feature Service, Inc.

THE lure of the studios is an intangible glamor which few workaday people of an everyday world can understand. It is something, too, which even I, who have lived all my life so far among the paints and pastels and clays of the studio workshops, have never quite measured.

I have never met a beautiful woman, of society environments or working class, who did not want to be either painted or sculptured. I have met thousands who thought it their duty to take the place of professional models and thus make masterpieces more masterful because they thought their own charms excelled those of the models whose charms were their stock in trade.

I think one of the most interesting examples of this that I know of was the famous Lady Constance Richardson, daughter of the Earl of Cromartie, granddaughter of the haughty Duke of Sutherland, and, when she was a debutante, the favorite "youngster" in London society of King Edward.

It was in the great rambling studio building at No. 51 West Tenth street I first saw the distinguished Lady Constance. At that time all the world was bursting with its gossip about her, for she had shocked the mobility of all Europe and the more conservative families in America by appearing at public gatherings in scantily draped interpretive dances.

Then, in America, at a fashionable gathering at one of the exclusive hotels, she first amazed her audience and then aroused a laugh. It was Mrs. Cornelius Vanderbilt who laughed, and, of course, when fashionable Mrs. Cornelius laughed all fashionable New York society had to laugh, too. This laugh was occasioned by Lady Constance's appearance before her audience with only a Grecian drapery clasped rather loosely around her.

One morning Adolph Weinman, the famous sculptor, who carved me into more marble perhaps than any other artist, met me with a smile when I appeared at his studio in the Tenth street building to continue a pose.

"Did you see the young woman who must have passed you in the hall?" he asked.

"That was Lady Constance Richardson. She wanted me to pose her legs. She believes them to be the most shapely limbs in the world."

"Are you going to do it?" I asked.

"I don't know; I did not enthuse, and she promised to come back again to persuade me." He eventually agreed, however, to make a bronze figure of her.

She came to the studio a few mornings later. Perhaps as great statues might have jeen the result, for Mr. Weinman never did anything that did not become great, if it hadn't been for an incident of that morning.

She came well toward noon. Her secretary and her maid accompanied her, one artist who worked out alone for the fees. He worked from inspiration only.

He was then doing an important work, his wonderful "Daphnis and Chloe," which now graces the halls of Devonshire House, the seat of the Duke of Devonshire. I was posing for Chloe. He was not at all keen carrying various costumes in handbags, the other various articles of the feminine toilette. Mr. Weinman's studio was at the end of a long stretch of narrow hallway; it only by flickering gas lights and with barren floor. At a turn of this hallway Lady Constance and her party passed into a young woman. As they bumped into each other both the strangely clad women and Lady Constance gasped. But Lady Constance gasped in surprise, while the other—well, she just gasped because she was out of breath.

The noblewoman's surprise was occa-

sioned by the appearance of the unknown girl—who was wholly nude, just some slippers on. Lady Constance drew back; her secretary screamed, horrified; her maid gaped open-eyed.

Lady Constance looked after her until she turned the corner of the hallway and was out of sight. She then flounced into Mr. Weinman's studio and very haughtily asked, "What sort of place is this in which naked girls run about the hallways?"

When Mr. Weinman asked what she meant she explained the meeting in the hall. "Oh, that young woman," said Mr. Weinman lightly, "that was one of our best models—she usually checks her clothes at the door when she comes in in the mornings, and runs from studio to studio, without them. She likes to be ready, you know, when an artist wants her to pose."

Lady Constance said after that she did not believe in mortals less than nudeswomen affecting the nicest of drapery. She said something about it being shocking shocking vulgarity for a young person with no pretense to refinement being so bold." This made Mr. Weinman angry—he was always loyal to his models, and believed we were worthy of more praise than some of the society won on who frequented his studio. He said some very exciting things to Lady Constance and virtually dismissed her from the studio.

In her audience at a fashionable gathering in a Fifth avenue home one afternoon there was a sculptor who had earned honors around the world as an artist of unusual attainments—Troubetskoy, the Russian prince who had won and married the beautiful Amelie Rives, the famous novelist. One of the movements in the titled lady's dance suggested a pose to the prince. When Lady Constance was presented to him he asked her to come to his studio for tea. There he asked the question to pose for him that was eagerly given.

The result was one of the most beautiful figures in bronze modern artists have accomplished. It is called "The Dancer," and has been exhibited around the world as a marvellous achievement of arrested action.

When Lady Constance appeared for her pose Prince Troubetskoy very abruptly asked her to disrobe.

"Now, then, dance—just as if you were before an audience," the Prince commanded when she had removed her clothes. The studio is large and roomy. Prince Troubetskoy himself strummed the piano in the corner, giving her the rhythm. Lady Constance gradually lost the shyness that had come over her in the presence of this man, and finally was dancing; perhaps as she never had danced before, completely forgetful of her lack of covering. The Prince watched sharply, his experienced eye catching every movement of the shellpink body as it pirouetted in constant silhouette against the heavy velvet studio hangings.

Suddenly he stopped playing and both shouted and clasped his hands at the same instant. "There—that—on the toes, with the leg out. Do that again!" he cried. He had caught with his eye a posture that fascinated him. The dancer had raised herself on one foot, balancing on her bare toes, and had swung her other leg back until it reached out straight behind her, level with her back and shoulders, which bent forward—making a perfect horizontal line from neck to and along the leg on which she balanced. It was Lady Constance's most difficult as well as her most graceful movement.

Again and again the dancer repeated this movement—each time having to precede it with the figures of the dance that led up to it, as it was a position she could not

take abruptly or hold more than a few seconds at a time. When she tired the Prince told her to come again the next day and that he would be ready to begin work.

Prince Troubetskoy saw in the figure of Lady Constance just the ideal the sculptor admires—slenderness, delicacy, yet the fulness of muscle and line which reveals the feminine without exaggerating it. But he wanted more than a portrait, he wanted to embody a thought and its into bronze a message—the ambition of every conscientious artist. To snatch an opportunity to portray the spiritual, the abstract; not the external of the body alone, but the body animated by the spirit within.

When Lady Constance appeared the next day the Prince had already set up the little mound of clay on which he worked in miniature, later making the title-size model from the smaller one. He explained what he wanted to do, to catch her in the movement that had caught his fancy. But he did not want the completed posture—the leg thrown back and balanced by the head and torso thrown forward. He wanted to catch her at the exact instant the leg raised in front of her to a right angle with her body preparatory for its sweep backward. Lady Constance declared she could not give him such a pose. The balance of her body would not permit her to hold her leg forward, stretched straight out, while she posed on her other foot, her torso upright, for even a second. She would hold it the attempted it.

"But that is just what we will get," said the sculptor.

Lady Constance, unhindered by clothing, so that the sculptor could detect the play of every muscle in her body, danced the movement again and again. As she had said, there was not an instant's pause when her foot swung forward preparatory to the sweep back, it reached the summit of its upward curve, described a half circle and swept down and back without pause. Yet the instant of its reaching its upward climax was the impression the artist sought to fix in bronze.

A stand was fixed for Lady Constance to lean against. She held her leg outward to approximately the position of the dance. The Prince moulded his clay into a sketch of the figure thus posed. This took several weeks. When he had completed his rough sketch he then had her dance for hours at a time every day, going through the preliminary movements to the position he sought to catch over and over again, each time trying to catch with his eye see a new strain of a muscle, a new bend of the toes, the exact tension of the tendon of Achilles, which is only brought into action when the heel is thrown and

(C) 1921, International Feature Service, Inc.

Piccirilli's Statue of "Rain," in Making Which He Modelled from the Figure of Mabel Normand, Now a Motion Picture Star, but Used Audrey Munson's Face to "Tone Down" the Total Effect.

A Remarkable Photograph of Lady Constance Richardson, Posing for Prince Pierre Troubetskoy, the Distinguished Russian Sculptor. Note the Statue Which He Is Modelling in Miniature, and Which Later He Enlarged Into His Famous "The Dancer."

and the thigh muscles accordingly drawn. No sculptor ever had attempted such a study before.

At last the statue was completed. Lady Constance in bronze looked as if a miracle had transfixed her in the flesh in the most difficult part of her dance—a daring conception, beautifully done, pure in its outlines, delicate in its suggestion of grace, youth, vivacity and inspired strength. No statue of recent years created such a furore. Whatever Lady Constance had lost in dignity as a dancer in nearly clothing, she regained in the model and the inspiration for "The Dancer." She took the statue back to England with her. There it attracted the same attention it drew over here, and is generally admitted to be the world's foremost piece of "arrested motion" in statuary. Millions of replicas of it were sold for the benefit of war sufferers.

There are occasions, however, when the sculptor, in putting his inspiration into form, wishes to convey something of the fleshly beauty which appeals to the senses. Even at such a time he must, however, avoid the imputation of a purely emotional appeal.

When Piccirilli conceived his famous "Rain" for the Exposition at San Francisco he wished to make his feminine figure representative of the cross-combining quality of a steady, gentle downpour from the heavens. Rain is not delicate, nor dainty, nor does it suggest firm, reserved lines. Rather it suggests fulness, soft curves, beauty that is enticing. Lady Constance, with her slender lines and taut muscles, would not have done for his model; nor Mabel Normand, whose figure was slighter to the "perfect thirty-six" of the cloak and suit makers, and who might have been a modern Venus, was just the type he wanted.

So Mabel Normand was chosen by Piccirilli for his model. In those days Miss Normand was earning but fifty cents an hour, and, while she was very modest and conscientious as a model, was not used as often as others whose figures were more of the ideal.

Where, in modelling Lady Constance, Prince Troubetskoy wished to avoid any suggestion of flesh, Piccirilli, in doing "Rain," wished to suggest it frankly—almost to exaggerate it. "Mabel Normand's body was done in the sketching clay into that of a siren, a beautifully, rounded figure that seemed to glow with life and vitality. She has Spanish blood and her entire physical personality glows with Latin warmth of impulse and emotion.

But when the figure was completed Piccirilli was not satisfied. He had fixed an impression of voluptuousness—such as he believed a miniature created—yet the spiritual, the inner expression of noble thought and purpose seemed to be lacking. The face he had modelled seemed too merry. He went for me, and destroying the clay sketch of the head and face, made a sketch of my face. This completed statue was made of two models—Miss Normand for the body, me for the face. He professed to find in my features that which he wanted to elevate and purify his statue. When I took the pose he wished he asked me to think of myself as being in a rainstorm, saddened by the damp caress because it suggested tears to me, yet held fast by the inexplicable spell which the rain threw about me. My interpretation of this commend is what is pictured on this page in Piccirilli's statue.

The completed work won much favorable comment at San Francisco. The artist's conception was widely discussed and his interpretation of rain as a siren in body but of noble soul was considered daring but correct.

I do not mean to be understood that Miss Normand was unable to portray to artists the nobler character which the real artists always want to put into their works. Some sculptors found in her face, in the droop of

her eyelids or the curves of her mouth features which were especially attractive to them. Her chief asset as a model was her ability to catch the mood of the artist and translate it for him, but it had to be a merry mood. Miss Normand could only "posi" when she should be sad and thoughtful. Her "posi" on the movie screen has earned her a million dollars or so; as a model it cancelled many poor engagements for her.

But in her merriment Miss Normand was typical of those models, many of whom later became famous as movie stars or stage beauties, who frequented the Tenth street studios of which I have spoken—studios occupied by such men as William De Leftwich Dodge, Gutzon Borglum, MacMonnies, Scotti, Weinman, Daniel French and Robert Aitken.

There is a famous sculptor, now dead, whose name, through sympathy for his widow, I will not reveal. This artist's wife, who never was reconciled to studio life, was frequently distressed at the thought of her husband using models to assist conjures, or without them altogether. It was often repeated among his friends that the sculptor's greatest difficulty was to persuade his wife an artist could work from a model and think only of his work. There are many artists whose wives have the same failing.

When I posed for him this man always warned me to leave my clothes in a neighbor's studio dressing room, and to make a hasty escape from the studio through a back door, if his wife should appear in the reception hall.

I sympathized with the sculptor very deeply. He was a conscientious worker, and few artists ever so completely forgot the feminine presence of their models while at work as he did.

One of his models twice had gone through the experience of posing in the studio during when the wife unexpectedly called upon her husband. Each time she skipped through the rear door of the studio and out into the neighbor's dressing room until recalled. She also never complained about the rainthird with the wife, and often declared she "missed her laugh" and they proceeded to do it.

She was posing then for a fountain. The wife had decided, after her husband left home early in the morning, to come from town for an afternoon of shopping, to have a had sad two social acquaintances and had

entertained them at dinner at Delmonico's. Proud always of her husband and his work, she delighted her friends by accepting their bid, that they would enjoy a casual visit to his studio.

Without telephoning she brought her friends to the studio and entered her husband's reception room. The opening of the outer door jangled a bell. The sculptor heard his wife's voice. "The model, who was in position, heard also. She skipped down from the pedestal and disappeared into the passageway leading to the rear door. The sculptor, a little confused but self-poised, met his wife and her friends smilingly, acknowledged the presentations and began to show the party about the studio, explaining the works in the color room and then leading the way to the big room flooded with the precious north light.

The clay sketch of the fountain was taking shape—a beautiful nude girl poised on the brink of a basin, holding a large vase out of which the water was to pour.

"My husband works without models, you know; it is one of his especial talents, being able to create such charming yet purely things without submitting to association with those terrible creatures who appear in the studios before men without their clothing."

"Oh, that is so splendid!" one of the women responded, "for I am sure you have given most dissatisfaction in the art that the artists who must continually think of their husbands vis-a-vis with these horrible girls!"

"Yes, indeed," the wife began, her voice expressing her delight at this admiration her art understood, but before she could say more the door leading to the back passage opened, there was a vivery laugh, and the model, as she sketched on where the rain from the studio, confronted the party. While the woman gasped and the sculptor swore beneath his breath, the model exclaimed, her eyes twinkling merrily:

"Oh, excuse me! I thought your visitors had gone. I'll go back and wait till you call me then I'm really not a horrible girl—just your regular model!"

One can imagine the scene that followed the closing of the door behind that girl! The wife was too well bred to make a quarrel before her guests, but the looks she must have given her husband must have been knife thrusts. She closed the visit abruptly and departed with her friends.

(To Be Continued Next Sunday.)

22

AUCTION OF SOULS

It is one of the classic Hollywood scenes of all time—the mass crucifixion of a dozen naked maidens in the California desert. One of the young models, Audrey wrote in "The Queen of the Artists' Studios" series, actually died.

The sensational recreation of the crucifixion of Christian girls by the Ottoman Turks, so affronting to America's overwhelmingly Christian audience, was shot for *Auction of Souls* (1918), also known as *Ravished Armenia*, the epic film of the then-recent Armenian genocide. To film the scene, the cast and crew had to ride the train far into the desert so there were no telegraph poles visible to the camera. The models were selected for their long hair so that their flowing locks might mitigate their nudity on the cross.

"When the desert was reached it was very cold. It was the time of the influenza epidemic in the West. Each young woman who disrobed and bared herself to the cutting wind for the many hours necessary to the tests and the correct arrangement of their poses exposed herself to the dangers of pneumonia. But not one of them hesitated," Audrey wrote in her newspaper series.

"When each had been assigned to her cross, she disrobed behind it, and, while the thousand extra people gazed curiously, each girl was lifted to the position of her 'crucifixion' and fastened in place with concealed ropes. Until sundown, there were rehearsals, false moves, re-arrangements, and mishaps—until just before the light faded the scene

was finally taken. And not until then could any of the young women replace her clothing."

The arduous shoot claimed its first casualty shortly afterward. Audrey was the only person ever to write this—yet there is good reason to believe her. "One of the models, the prettiest and youngest of them . . . was stricken with influenza two days later as a result of the day's exposure and died in a few days," she wrote. "Another was stricken and suffered a long siege of pneumonia." Audrey's article, published in newspapers across America on March 20, 1921, identified that dead model, with a photo of her on the cross, as Corinne Gray.

The film was produced by movie pioneer William M. Selig for the American Committee for Armenian and Syrian Relief, which sold ten-dollar seats to raise money for Christians suffering at the hands of the Ottomans. The Turks, and their Muslim allies the Kurds and the Chechens, set out to kill or deport the Armenians in 1915 when Christian Russia entered the Great War and invaded. Half of the two million Armenians living in the Ottoman Empire were massacred and another quarter escaped to Russia, with many who were stuck behind being forced to convert to Islam. In the absence of real footage, the crucifixion scene has become one of the best-known images of the Armenian genocide. Canadian-Armenian director Atom Egoyan says of the movie: "In a century that would be marked by many films about genocide and the Holocaust, it is certainly the first film to depict scenes of mass murder and racial hatred."

The story was adapted for the screen from the story of an Armenian Christian girl who escaped the slaughter of her people by the Ottoman Turks during the Great War. Shortly before Audrey's "The Queen of the Artists' Studios" was serialized in the *New York American*, Aurora Mardiganian's eyewitness account of the massacres ran week by week in the same paper and was released as a book. With typical Hollywood hype, some ads for the movie called Mardiganian "the only Christian girl to survive."

Mardiganian saw her entire family murdered by the Turks except for one elder brother and a sister. Her mother was horsewhipped to death as she clung to her feet. Her oldest sister, then sixteen, was stabbed to death

by a Turkish soldier. Her fifteen-year-old brother and her seven-year-old sister were clubbed to death with a whip handle. Her youngest sister was hurled from a cliff.

Mardiganian herself was sold into slavery for eighty-five cents, kidnapped by Kurds, seized by Chechens from a monastery, and forced into a harem before being rescued by a friendly shepherd who paid with his life.

In her horrifying book, she described one scene outside Malatya where vultures were feasting on the carcasses of sixteen Christian girls who had been crucified by the Turks on rough wooden crosses.

She later insisted that the movie's depiction of the crucifixions was sanitized for the moviegoing public. "The Turks didn't make their crosses like that. The Turks made little pointed crosses. They took the clothes off the girls. They made them bend down. And after raping them, they made them sit on the pointed wood, through the vagina. That's the way they killed—the Turks," she said before she died. "Americans have made it a more civilized way. They can't show such terrible things."

Mardiganian was just sixteen when she escaped to the United States via Russia and Norway on November 5, 1917, after reaching the sanctuary of an American Christian mission. Pro-Armenian feeling was running high in America. The United States had recently entered the Great War against Turkey's ally Germany. The American Committee for Armenian and Syrian Relief was raising millions of dollars and caring for 130,000 Armenian orphans. Henry Morgenthau, the US ambassador to the Ottoman court, had just published his account of "the greatest crime in modern history" in *Ambassador Morgenthau's Story*.

Mardiganian—whose original Armenian name was Arshalouys Mardigian—came to America hoping to find her last surviving brother. She was met on arrival at New York's Ellis Island and taken in by an Armenian couple who placed newspaper advertisements seeking to locate the boy. Because of the advertisements, she came to the attention of the New York press. Mardiganian was placed under the supervision of Nora Waln, a Quaker who dropped out of Swarthmore College as a sophomore in 1917 to become the publicity secretary for the American Committee

for Armenian and Syrian Relief. Describing her first encounter with Mardiganian in a foreword to her book, Waln wrote that the original plan had been to send her to boarding school in Boston. "We talked about education that afternoon, through her interpreter, but she shook her head sadly. She would like to go to school, and study music as her father had planned she should before the massacres, but now she had a message to deliver—a message from her suffering nation to the mothers and fathers of the United States." Waln went on to become a journalist and best-selling author with *The House of Exile* (1933), about her life in China, and her exposé of living in Nazi Germany in the 1930s, *Reaching for the Stars* (1938), since reissued as *The Approaching Storm: One Woman's Story of Germany 1934–1938*.

The man chosen to tell Mardiganian's story was Henry Leyford Gates, an extraordinarily talented hack journalist, if that is not an oxymoron, and sometime *New York Times* feature writer, who was now associate Sunday editor of Hearst's *New York American*. He lived just steps from Times Square at 109 West Forty-Fifth Street. It was Gates's much younger novelist wife, Eleanor Brown Gates, who became Mardiganian's legal guardian. The literary pair changed her first name from Arshalouys—meaning "light of early morning" in Armenian—to the English equivalent, Aurora.

The newly arrived Mardiganian initially planned to work in a dress-making factory, but the Gateses promised to take care of her. Setting up camp at the Latham Hotel in New York, the Gateses debriefed Mardiganian on her almost-three-year ordeal with the Armenian family she was staying with acting as interpreters. Eleanor Brown asked her to sign some papers so she could go to Los Angeles to have her picture taken. Mardiganian wanted to go to California because she had an uncle in Fresno. She knew nothing of motion pictures and assumed Brown meant a still photograph. She signed the papers, giving her just fifteen dollars a week to star in the film that became *Auction of Souls*.

The filming conditions in early Hollywood were harsh. One scene called for her to jump from one roof to another to escape from a Turkish harem. She fell and broke her ankle. The director insisted on continuing the shoot, with the female lead being carried from scene to scene.

The bandages visible on her leg, which audiences assumed to be from wounds inflicted by the Turks.

Mardiganian suffered more than a broken ankle in the project. For a genocide survivor, the filming was also psychologically traumatic. "The first time I came out of my dressing room, I saw all the people with the red fezzes and tassels. I got a shock. I thought, they fooled me. I thought they were going to give me to those Turks and finish my life," she said. "So I cry very bitterly. And Mrs. Gates say, 'Honey, they are not Turks. They are taking the part of those barbarics. They are Americans.'"

Although it was H. L. Gates who insisted on the long hair to mask the maidens' nudity in the crucifixion scene, the film fully exploited the sexual atrocities of the Ottoman troops. The trade press suggested the movie be promoted as a "Sensational Story of Turkish Depravity." The accompanying press book suggested the following publicity pitches: "'Ravished Armenia' to show real harem;" "Girls impaled on soldiers' swords," "With other naked girls, pretty Aurora Mardiganian was sold for eighty-five cents."

Mardiganian was hosted by the Los Angeles mayor before the January 1919 premiere, and toasted by New York high society at the New York opening, with Mrs. Oliver Harriman and Mrs. George W. Vanderbilt serving as cohostesses on behalf of the American Committee for Armenian and Syrian Relief. The charity advertised that: "Ten million Americans MUST see this movie"—and it is possible that ten million did. Mardiganian became a cover girl on the January 12, 1919, issue of Hearst's *America* Sunday magazine with a full-page color portrait by illustrator Howard Chandler Christy.

Required to make personal appearances at screenings and facing the prospect of having to go to London to drum up publicity, the sudden attention overwhelmed Mardiganian. The Gateses sent her off to a convent school and hired seven look-alikes to appear at future screenings. But Gates underestimated Mardiganian's survival instincts. She escaped back to New York and sought help from Mrs. Harriman.

In February 1921, just as Audrey's "The Queen of the Artists' Studios" series was appearing in newspapers across the country, Mardiganian sued her

guardian Brown for an accounting of her earnings. In New York Surrogate's Court it emerged that, in addition to her fifteen-dollar-a-week salary, Mardiganian had been paid $7,000 for the film—but Brown had been able to save just $195. Brown complained that her ward had "become incorrigible" and missed business appointments. Then Brown fainted on the witness stand.

Henry Gates testified that Mardiganian had been surrounded by every luxury during monthlong filming in Los Angeles, including a chauffeur, nurse, housemaid, and messenger. He admitted that seven Mardiganian imposters had been hired in order to keep contracts for "personal appearances" in various cities and said he had spent $6,000 from his own pocket. Her book had been purchased from her for fifty dollars and sold to the International Copyright Bureau in New York for $700, although she was entitled to a 10 percent royalty on sales. Mardiganian eventually won $5,000, but she learnt a bitter lesson. After narrowly escaping the marauding Turks with her life, she got badly mauled by the New York sharks.

The Mardiganian case was a warning—but Audrey remained a "heedless moth." For it was the very same H. L. Gates who "exploited" Audrey's story and committed her twenty-part "The Queen of the Artists' Studios" series to newsprint for the Sunday edition of the *New York American*. He performed in-depth interviews with her while she was staying at the Great Northern Hotel, ranging from her first nude posing for Isidore Konti to her discovery of "dimples." When she did not want to use a correct name, as in the case of photographer Felix Benedict Herzog, he made one up. When he thought one of Audrey's stories did not measure up, he embellished it—or told his own.

Audrey herself had no direct knowledge of the fatal crucifixion scene in *Auction of Souls* that she described with such detail in her newspaper series. That was included by the ghostwriter Gates, who was almost certainly there with Mardiganian because, as well as his wife being her guardian, he was the listed scriptwriter on the film.

Gates's identity as Audrey's ghostwriter and the real screenwriter of *Heedless Moths* emerged from a lawsuit filed by the litigious Allen Rock, whom Audrey herself had sued. After Audrey's *Heedless Moths* was made,

Rock sued the producers Perry Plays Inc.; its financier Herbert Cronen-weth, a music-loving Detroit millionaire; and the former vaudeville actor who founded it, George Perry. In the suit, Rock complained that he had been forced to cancel his 50–50 deal with Perry Plays Inc. to make room for Gates's 33 ⅓—33 ⅓—33 ⅓ cut.

Gates's novelist wife was a close friend of Allen Rock's client De Sacia Mooers. Indeed, Mooers dedicated *The Blonde Vampire* novel "To My Friend Eleanore [sic] Brown Gates, who inspired me to tell my story."

Rock's suit was just part of a tangle of litigation that engulfed the group: Audrey sued Rock for not paying her, Rock sued Cronenweth and Perry for not paying him, Cronenweth and Perry charged that Rock had defrauded them by claiming he had exclusive rights to the "motion pic-turization" of Hearst material when he did not. In the contract between Rock and Perry Plays Inc., Gates is identified only as "the writer"— suggesting that though he was the actual screenwriter of *Heedless Moths* he could not claim credit publicly because of his day job for Hearst's *New York American*. Rock's complaint identifies "the writer" as Gates.

The litigation between this quarrelsome band rumbled on for a decade. After their spat with Rock, Cronenweth and Perry set up a new company, Globe Production Co., with Gates as general manager. It was to produce *Peacock Alley* with movie star Mae Murray, directed by her husband Rob-ert Z. Leonard, who had directed *Heedless Moths*. Gates, however, soon ended up going to court himself when Cronenweth and Perry set up yet another company, Tiffany Productions, to produce Murray-Leonard movies without him. Gates sued for $50,000, claiming the couple stole his planned production *Peacock Alley*, the couple's first Tiffany film, the story of a French dancer played by Murray who marries into a New England family that rejects her. Perhaps not surprisingly, given the group's sharp business practices, Murray herself eventually sued Cronenweth in 1931, seeking $300,000 for eight films she made with Tiffany, alleging he hid the $2 million profits from her. Murray lost the case but got the minor satis-faction of slapping Cronenweth's attorney on the face in court.

Audrey realized much too late that these were the wrong people to

be mixed up with. She blamed Rock for not paying her, when in fact Rock himself did not get paid what he claimed he was owed.

After "The Queen of the Artists' Studios," Gates went on to make a successful career penning sexually charged "novelizations" about other young women. His next subject was actress May Yohé, the former wife of Lord Henry Francis Hope, the last member of the Hope family to own the allegedly cursed 45-carat blue-tinted Hope Diamond, now in the National Museum of Natural History in Washington, DC. Based on her brief ownership of the notorious gem, Gates wrote a fifteen-part movie serialization titled *Mystery of the Hope Diamond*.

His later newspaper serials included *Joanna* (1925), about a salesgirl who gets a million dollars to spend, and *Vivian* (1927), about a "modern woman" who plans to become a wife. "Vivian has the mentality of a moron and the loyalty of a rabbit," the *New York Times* opined in a no-holds-barred review.

Gates wrote a bestselling novel *Here Comes the Bandwagon*, about a trapeze artist who faces retaliation after falling in love with another member of the circus troupe, It became the 1929 Charles "Buddy" Rogers and Jean Arthur film *Halfway to Heaven*. Gates and his wife also cowrote a novel about a revolutionary peasant girl who falls in love with a nobleman in Russia, which also became a film the same year, titled *The Red Dance*, starring Dolores del Rio.

In 1934 Gates penned *Even the Rich Girl*, about three people stranded on a South Sea island after a liner wreck—with the catchy tagline: "Two men . . . and Diane." By the time of his death at age fifty-nine in 1937, he had penned more than fifty popular novels, including *Lipstick* (1929), *The House of Murder* (1930), *Easy Lady* (1932), *The Laughing Peril* (1933), and *Thunder on the Range* (1935). Audrey was just one of his sensational tales.

Audrey had trusted Gates. He was surely the "influential friend" who had intervened to get her a new film contract. Which makes it likely that the man who sent the mysterious telegram seeking Audrey at the Buffalo State Hospital for the Insane a month earlier, promising her the $2,000 signing fee she never received, was not "Yates," as the Buffalo Courier typesetters said, but her ghostwriter Gates.

23

"PERSECUTED BY HEBREWS"

Audrey won a court ruling to keep her lawsuit against Allen Rock in Syracuse, rather than moving it down to New York. But her local lawyer, George H. Cole, dropped her as a client. From then on, she struggled to get legal representation. Her mother felt sure she knew why.

"The Jews and Hearst have cheated her out of all [that] belongs to her, more than two million dollars. We can't get a lawyer to fight against them, as Mr. Oelrich [sic] is with them to cover up his dirt in not marrying a German Jew that he went with for a long time," Kittie wrote in a letter. "We are helpless as we have no money. Oelrich and the Jews— Hearst has it all."

At a sit-down with one local lawyer, Audrey and Kittie explained their claims. John Mowry, the attorney, later told one of Audrey's cousins that they came to see if he would "represent them against the damn Jews in New York who stole all her money."

Anti-Semitism, a seemingly perennial failing of humanity, was making a vicious resurgence in the wake of the Great War and the Karl Marx–inspired Bolshevik Revolution in Russia. Adolf Hitler had organized the Nazi Party in Germany and would shortly start dictating *Mein Kampf* in jail. Hitler would be inspired by a famous American: carmaker Henry Ford.

In America, nativism was on the march. In 1915 a Jewish factory

owner in Texas, Leo Frank, who had been jailed for the murder of thirteen-year-old employee Mary Phagan, was seized from prison and lynched by a mob. That same year, the Ku Klux Klan had been reconstituted and by the early 1920s was growing into a powerful racist force across the country. A jury in Hammond, Indiana, acquitted a man who killed a foreigner who said "To hell with the United States." In the Great Red Raid of 1920, more than 2,000 people, many Russian immigrants, were arrested in thirty-three cities in two days because of fear over the spread of Bolshevism. The same year, two Italian-born anarchists, Nicola Sacco and Bartolomeo Vanzetti, were controversially convicted and condemned to death for shooting dead a guard transporting the payroll from a shoe factory in South Braintree, Massachusetts. There were KKK cross burnings on hills around Audrey's home.

Nativists turned their sights on what they denounced as "Jewish Hollywood." Many of the impresarios who built the movie industry were Eastern European Jews: Paramount boss Adolph Zukor and William Fox, whose company became 21st Century Fox, both from Hungary; Carl Laemmle of Universal, from Germany; Louis B. Mayer of what would become Metro-Goldwyn-Mayer, from Russia; and the Warner Brothers, whose father came from Poland. By late 1921, Ford's anti-Semitic *Dearborn Independent* newspaper was running a series titled: "Baring the Heart of Hollywood: The Truth about Motion Pictures." "Many . . . don't know how filthy their stuff is—it is so natural to them," the newspaper declared. Methodist Darryl F. Zanuck was initially blackballed by the Los Angeles Athletic Club because it mistakenly thought he was Jewish—a snub he later turned into the 1948 Best Picture *Gentleman's Agreement*, with Gregory Peck playing a journalist passing himself off as a Jew to report on anti-Semitism.

Audrey's inability to pursue the lawsuit and her growing money problems, drove her into a new episode of psychological crisis. Increasingly paranoid, and increasingly anti-Semitic, Audrey took her anti-Jewish complaints to absurd lengths. In February 1922, she petitioned the House of Representatives to pass a bill "to protect her from being

persecuted by Hebrews." She vowed to bring the matter up with President Warren Harding in person.

The *Syracuse Herald*, reporting the request, noted that "just what kind of a bill Miss Munson has in mind is not very well understood." A "facetious member of Congress" is said to have written back telling Audrey to take her complaint to Henry Ford.

The idea was not so preposterous. Ford was friendly with the society sculptor C.S. Pietro, who had used Audrey as a model and made busts of both Ford and his wife. When Ford boarded his "Peace Ship" on December 5, 1915, on a failed maverick mission to Norway to try to end the Great War, Pietro accompanied the automobile tycoon to the launch from Hoboken, NJ. Ford also went to Michigan for the dedication of his busts at Ford's house. There is no record, however, that Pietro ever introduced Audrey to Ford.

Rock was always going to be a tough man to beat in court. For him, litigation was a cost of doing show business.

Audrey also faced legal problems on a second front. In June 1921, a group of upstate businessmen advertised the creation of the Audrey Munson Producing Corp. Like other women squeezed by Hollywood's emerging studio system, Audrey was trying to strike out on her own. She was determined to forge ahead despite the poor reviews of *Purity*, the non-release of *The Girl o' Dreams*, and the humiliation of being substituted in *Heedless Moths*. The new company was offering retail investors the chance to share in the profits. The prospectus sought to raise $100,000 in ten-dollar shares.

"Dear Public," Audrey herself wrote in an open letter in the prospectus. "The reception given my work in the past has been highly gratifying and now after a little rest I feel my future productions will meet with still greater favor. . . . My work has heretofore made millions for a few and now an opportunity is given where all can share in the huge profits formerly made by a handful of men who exploit great artists for their own personal gain."

For its first film, the new studio planned to cast Audrey as an Indian

princess in *The Madonna of the Garden*. It was to include several scenes near Rochester. According to the *Rochester Democrat and Chronicle*, "Several thousand feet of film have already been shot taken in exterior scenes in San Antonio Texas and in interior at the company's studios at Cliff-Side New Jersey but Pierce Kingsley, the director of this silent drama, desires to obtain more 'atmosphere' by taking outdoor scenes at the river gorge here and in the vicinity of Portageville. It is expected that these scenes will be taken within three or four weeks and was said yesterday that a heavy snowstorm is one of the requisites of the film that will be sought here." Another project floated was a film called *The Barefoot Trail*, after the song sung by John McCormack. Audrey, at one point, hinted that the new film would feature her riding horseback in flowing Greek robes and "driving cattle in the same attire." Rochester's other famous actress, Ormi Hawley, was originally touted as a fellow star at the company. It was later reported, however, that Hawley would not be making any films for the Audrey Munson Producing Corp. because the two actresses were "not temperamentally suited."

The only problem was that Audrey did an about-face and decided not to back the new company, even though she was its star. She got a better offer. The putative agreement dated back to December 2, 1920—shortly before Audrey struck her *Heedless Moths* deal with Allen Rock for the bogus $27,500 check. Audrey confirmed that there had been discussions but said she had insisted she be president with one nominee as well, to sit on the board alongside backers E. A. Westcott, founder of the American Feature Film Co. in Rochester, and H. R. Northrup, creator of the Better Service Film Co. of Syracuse. The *Rochester Democrat and Chronicle* said it had actually eyeballed the agreement signed by Audrey with Westcott and Northrup, which provided that Audrey would receive stock equal to all the shares allotted to the other parties in return for her pledge to appear and pose exclusively for the new company. But Audrey insisted she had "no inkling" that papers had been filed to set up the company—and it never made any films.

To support herself, Audrey was forced to go back on the road on a

tour of personal appearances in the Midwest. Arriving in East St. Louis, she found another "Audrey Munson" posing in her place. When she complained, the theater suddenly went dark. Imposters, she complained, were cutting into her earnings.

On October 1, 1921, the real Audrey posed naked but for some well-placed silk drapery at the Royal Theater in St. Louis at a screening of *Purity*. She stood under a spotlight on a platform in front of the stage. All her "artistic poses" were fully draped, until the last one, when she sat with her back to the audience and dropped the drapery to bare her flesh. Police stormed the performance and arrested her. She was charged with "conspiracy to commit acts injurious to public morals."

Her trial was packed with local clergy from the Church Federation, as well as several members of the Young Women's Christian Association who had volunteered to witness the show themselves. Undaunted and defiant, Audrey spoke in her own defense.

"A woman sitting on the edge of a table, wearing fine silk hosiery, abbreviated skirts and her legs crossed, is what I consider immoral posing," she said.

To prove her point, Audrey brought her drapery to court and donned it in the witness box—over her street clothing. Her main costume was a sack-like piece of blue crêpe de chine about four feet long, but she also had a smaller length of pink crêpe de chine. To dramatize her art, she dropped to one knee in the courtroom, resting her head in one hand. The pose, she said, was the figure of "Sorrow."

Audrey told the court she had actually covered up for the performance. She voiced shock that her costume could have caused offense, and insisted she was actually wearing tights.

"I never wear the draperies here in Missouri I do in New York," she said.

Before passing judgment, the judge and jury zealously insisted on seeing Audrey pose in a private showing at the Royal Theater. They were quickly convinced. Audrey was immediately acquitted—and as a bonus the jury held that the film could be shown in Missouri for two years without further interference.

Elated, Audrey rushed up to the jury box to shake hands with each of the jurors. She felt she had won an important point of principle. She told the press: "I'll quit my profession if I can't pose nude."

Audrey ran into worse trouble at a tour stop in Peoria, Illinois. Her manager fled with the box-office receipts, leaving her with no money and several months of hotel rent to pay. To survive, she depended on the largesse of "what a few newspaper boys around town contributed."

And one newspaper boy in particular. Audrey fell for a reporter in Peoria. Again, she was thwarted in love. "I was very fond of him. But he mysteriously disappeared. I was terribly hurt for a time, but, oh dear, time soon tramples such affairs into the earth and they are forgotten," she said several months later.

The *Rochester Democrat and Chronicle* reported on her return to the city: "As luck would have it this seemingly fortunate young man became faint of heart, and just when Audrey thought her matrimonial quest had ended she had to start all over again." She described her lost love as "a Perfect Greek God."

24

THE PERFECT MAN

The "Perfect Model" now sought the "Perfect Man." Audrey had been badly battered by the double blow of Oelrichs's rejection and the Wilkins murder-suicide. Her movie career was over and she had been reduced to selling kitchen utensils door-to-door with Kittie. Her manager had robbed her and she was still living with her mother at age thirty. It was time to find a husband.

Audrey never intended her search for Mr. Right to go public, but it quickly became a national obsession. "One day in talking with a news writer of my acquaintance, I happened to remark that if I ever married I wanted to find a perfect specimen of physical manhood, so that if we were blessed with children, they might be as nearly physically perfect as God meant the human race to be," Audrey explained. "The first thing I knew I saw the story in the papers."

The press had sport with the idea. Newspapers launched an early version of a reality contest in which an assortment of physically perfect men would audition for the most perfectly formed woman. The American Venus, it was said, was looking for a man who resembled the Hermes of Praxiteles to found a race of Apollos. The press reported Audrey was seeking a husband "for the good of the race" to "found a pure Greek

colony somewhere in the wilds and bring up children." "She believes it's her duty to perpetuate a figure which some have called Divine."

The Perfect Model's quest for the Perfect Man fed into the new craze for the pseudoscience of eugenics. The *Washington Times* declared that the proposed union would be a "100 percent eugenic marriage." Eugenics was a tragic offshoot of Charles Darwin's Theory of Evolution and its principle of the "survival of the fittest" applied to human beings. The term was coined in Britain by Darwin's half-cousin Francis Galton. At the 1915 Panama-Pacific International Exposition, plant-breeding expert Luther Burbank claimed that "a perfect specimen of manhood" could be achieved by selective breeding in just six generations.

The Second International Eugenics Congress had just been held at the Museum of Natural History in New York, "Why red-headed people dislike one another and seldom marry persons of their own complexion, and why tall men frequently choose short mates and short men tall mates, were among the curious topics touched upon," according to the *New York Times*. Darwin's son, president of the British Eugenics Society, addressed the assembly. Maj. Leonard Darwin rejected criticism that eugenics sought to replace romance with the principles of cattle breeding. "If young people were always allowed to follow their natural inclinations, their mating usually would be wise from the standpoint of eugenics. But many marriages which were made for wealth or social positions do not tend to better the human race," he told delegates.

Some New Yorkers saw the humorous side. Mike Mario, a show-business manager in Manhattan, wrote to the younger Darwin to notify him of the "eugenic" marriage of one Ludwig Consume, unchallenged freestyle eating champion, to Olga Vesuvius, champion middleweight lady wrestler—a union not obviously designed for the betterment of the human race.

The conference's own offspring was the American Eugenics Society, largely funded by Mary Harriman, the mother of future ambassador to the Soviet Union W. Averell Harriman. The society was to attract the support of Henry Ford, John. D. Rockefeller, J. P. Morgan, and other

wealthy luminaries until it was discredited by the horrors of Nazi euthanasia programs, Dr. Josef Mengele's experiments on twins, and the extermination of six million Jews.

Audrey, who had already succumbed to anti-Semitism, admitted she was a "demon for pure races." She said she aspired to breed only with a man of English or Danish descent to perpetuate her children's racial purity. Her theory of child-rearing harked back to the ancient world her artist friends idealized: "For the first 10 years of a child's life I believe he should live as near to nature as possible. He should wear very little clothes, never any shoes, and should learn the recreation of ancient Greece, with it air-like dances to make him graceful. He should spend all his young life in the open air. Cultivation of his mind should come after his body is perfect. His food should be the simplest—fruit and nuts and herbs—the sort of food ancient Greece thrived on."

In private, Audrey confessed she had struggled in her own love life to live up to her racialist ideals. Scorned and impoverished, however, she decided to play along with the search for the Perfect Man. The game appealed to her mischievous side. "I never realized that there were so many men in the world who considered themselves the ideal of physical beauty," she quipped.

Letters addressed to Audrey began pouring in to the Syracuse postmaster, imploring him to forward them to her. The press reported 251 applicants, but Audrey said she got more than a thousand. One hopeful, signing himself "X.Y.Z. from Texas" told the postmaster: "If it is physical perfection she is seeking, I would like to throw my hat in the ring. I am a little bow-legged, caused by years in the saddle on a cattle ranch. I am six feet tall and weigh 185 pounds—no loose flesh. If Audrey is regarded as a perfect woman I would like to know what her measurements are and what she expects her perfect man to measure up to. I can rope anything I throw at and if you will kindly put this matter in her mail I might rope her and present you with a broncho pony." One letter with a proposal of marriage was followed swiftly by a second from the man's wife asking her to wait until she had gotten a divorce from him first. The opportunist

directors of the Audrey Munson Producing Corp. were said to be planning a film titled *The Perfect Man*, with several aspirants in the cast.

Perfect Man candidates ranged from cowboys to convicts and even a dwarf—Mr. Herbert T. Barnett, 36″ tall, "the world's smallest cigarsalesman." Miss Munson remarked that "it didn't make the least difference to her whether her perfect man were butcher, baker or candlestick maker. Whether he ate peas with his knife and has the superb accomplishments of being able to expectorate through his teeth, makes no difference." Paul Havice, a prisoner at the federal lockup at Leavenworth, Kansas, said, despite missing a few teeth: "Audrey's said she didn't care who the man is, just so he's physically perfect, and I'm it."

Facing such applicants, Audrey thought it prudent to issue a clarification that it was not just physical perfection that interested her but also brains. "Miss Munson wished to correct the impression that she admired only physical perfection," the *Rochester Democrat and Chronicle* reported. "She said she had a deep admiration for a 'man with brains' and could not picture herself united in wedlock to a man who was only half a lap ahead of a bottle of soothing syrup."

The early frontrunner in the press was Cleaver "Cleve" Wood, the night jailer at the Dallas county jail, who was a cowboy before going overseas in the Great War and getting gassed in the trenches. "If Miss Munson accepts me we'll go to Arizona at once and start the ranch life," he vowed.

It was Wood's insistence that he was coming to Syracuse to claim her as his bride that forced Audrey to beat a hasty retreat with her mother to a farm outside her father's former hometown of Mexico, New York. On April 19, 1921, the *Binghamton Press* reported: "Miss Munson is throwing a little sand in the wheels by her rapid retreat to the farm of John Bailey, two miles from Mexico, Oswego County, just when things were brightening up. And on top of all this Audrey says she does not want to marry. Anyway, she doesn't want to marry a man who doesn't woo her first." Audrey told the ardent Dallas jailer she was taking a vacation. It was in and around that remote village near the blizzardy shores of Lake Ontario that she would spend much of the next ten years.

Wood, meanwhile, was doing very well from the publicity himself. He received more than twenty letters from young women who, intoxicated by the romance of the West, fancied a cowboy for themselves. Marjorie Badger of Indianapolis wrote: "Get me in contact with a pretty cowboy. I want a real cowboy, one with sense who will have respect for a decent girl. I will be 19 in February. I am five feet tall. Many young men here have asked me to marry them but I have refused all. I have always wanted a cowboy. Tell him send his picture." Gladys Reach of Des Moines told him: "I am 21, and not pretty, but I pass. I was born in New Jersey but always wanted to live on a ranch."

Audrey jokingly told the press she would be willing to marry boxer Jack Dempsey, the world heavyweight boxing champion who had just knocked out French wartime flying ace Georges Carpentier in a title fight in Jersey City before the first-ever million-dollar gate. Newspapers duly reprinted the dimensions of this "Perfect Man": "Weight, 187 lbs; Chest (normal), 42 inches; chest (expanded), 46 inches; neck, 17 inches; waist, 32 inches; thigh, 23 inches; calf, 15 inches; ankle, 9 inches; biceps 14 inches; forearm, 14 inches; wrist, 9 inches." "The only fly in the ointment, speaking figuratively is a little girl in the Hollywood studios to whom Dempsey is reported to be engaged," the *Binghamton Press* reported. "Miss Munson said that she would have written directly to Jack if it hadn't been that she did not think it was fair to lure him away from his little picture miss. Of course, having the superior charms Miss Munson possesses, such a task would be little more than child's play for her." Audrey said later she wouldn't have married him anyway because he was a bad sport for not writing to her.

Audrey's standards were exacting. Suitors were summarily dismissed for physical imperfections including big feet, a flat nose and, in one case, an abnormally long chin that "would if doubled up have reached his eyebrows." She was chuckling to herself. This was the most fun she had had in years. It was nice, after such a harrowing time, to feel wanted again.

After poring over the hundreds of letters, and scrutinizing the photographs, Audrey finally picked five finalists to be her Perfect Man. She kept

up what was described as an "energetic correspondence" with each. "Of course, maybe none of the five men will be really the perfect man, but with all the letters I have in reserve—and they keep coming at the rate of half a dozen a day—I think I shall find my ideal before I get through," she said.

Wood, the Dallas jailer, made the cut for the final five, although Audrey had twice before put him off. Tactfully, she advised that he visit during state fair week so he could indulge his love of horses if by chance they did not hit it off. He never came and soon dismissed the whole rigmarole. In early September, he said: "It's all dope about me wanting to marry Audrey Munson in the first place. I don't want to marry and I'm sure Miss Munson is not serious in her recent telegrams to me. I am not going to Syracuse and you might add that I wouldn't even go to the Union Terminal to meet her if she were coming to Dallas."

Also short-listed was the extraordinary German-Pole adventurer Walter Wanderwell—whose real name was Valerian Johannes Tieczynski—who made quixotic circumnavigations of the globe in a Model T Ford. Wanderwell had been arrested as a suspected German spy in the Great War even though he had been sunk by a German U-Boat while aboard the Norwegian schooner *Cambuskenneth* off Ireland on June 29, 1915. When Wanderwell answered Audrey's call he was in the midst of the Million Dollar Wager, a marathon round-the-world race between two teams racing Model Ts to see which could visit the most countries. He financed his expeditions by selling the newsreel he shot on his travels. On his globetrotting he gathered signatures on his car from those he met. His encounters ranged from the original Hollywood "vamp" Theda Bara and Mexican rebel Pancho Villa to President Woodrow Wilson. Although married at the time, Wanderwell was clearly in search of new female companionship. The following year he found a new wife by placing a newspaper advertisement: "Brains, Beauty & Breeches—World Tour Offer For Lucky Young Woman . . . Wanted to join an expedition . . . Asia, Africa . . ."

"Captain Walter Wanderwell is coming to New York soon to arrange for another world tour and will stop off and see me," Audrey said. "He

has been around the world seven times, walking 26,000 miles in five years, and piloted the first official automobile tour around the globe after the war. He wants me to go with him the next time whether we like each other enough to be married or not. His sister always travels with him, as well as one or two of her friends. I'm sure it would be a wonderful experience."

Other finalists were Clayton Bridgewell, a businessman from Oklahoma City, who said he had a "fine car and a lovely home and could give a girl he married everything her heart desires," and Capt. Arthur C. Griffith of Tucson. Griffith, a widower who thought Audrey would make a good mother for his two little girls. He was an unlikely choice, but he sparked her maternal instinct: "There was something about his letter which touched me, and just as I was hesitating about answering it another came and then another. So I wrote him and he says he is coming east to see me," she said.

The fifth and final finalist was Andre Delacroix, a French skier now living in Omaha as he prepared for the upcoming world ski-jumping championship in Minneapolis the next February. Just nineteen, Delacroix had already served in the French Army's Chasseurs Alpins mountain corps, known as the Blue Devils, in the Great War and recently won a ski-jumping contest at the Swiss resort of San Moritz. As well as a champion ski jumper, he was an accomplished discus thrower and horseback rider and a friend of boxer Georges Carpentier. Delacroix gave Audrey his measurements: height 5'7", weight 160 pounds, reach 69.5", chest 38", and waist 28". Audrey wrote back telling him she had entered him in the "Blue Ribbon class." "As far as Andre Delacroix is concerned, I really don't believe that an interview will do much good, for he is only a youngster— not yet it. But he writes the dearest letters you ever read and he insisted that he intends to see me and has begged me not to become engaged to anyone else until after our meeting. So I am counting him among the five."

At her remote farmhouse outside Mexico, New York, Audrey no longer had the typewriter she had used to write her poison-pen letter to the

State Department, so she wrote her letters by hand. She had to go into the village to collect the mail from the post office. But the days were long, and she had time enough to write back. She enjoyed writing to her would-be suitors—and to the young Delacroix, in particular. She wrote by hand:

Dear Mr. Delacroix,

I must start my letter by apologizing for using pencil. But it is the best you can expect in the country where I have been for a rest. That article in the paper was more or less of a joke and some things I said and some I didn't. However, I am not going to back down on your proposal. I shall ask you to keep up a correspondence with me until we can meet. Your photographs are lovely and I am grateful to you for coming forward so bravely and gallantly. Your athletic work is so interesting to me. I always go to see the Olympic games in New York. If you should win out it might be possible for you to appear in movies with me.

Graciously, your newfound friend,
Audrey Munson

By the time of her next letter, Audrey had progressed to more familiar terms, addressing him as "Andre." Perhaps because his youth made him less of a threat, she let him into her personal world, confessing her doubts about theories of racial purity and describing five men she had been engaged to in the past—even naming three of them.

Dear Andre,

Your very nice letter at hand and also the snapshot. It looks really wonderful. You will have to teach me to say your name. I don't think I say it rightly, but I am studying it. I have only met three Frenchmen in my life—one a God. He married a banker's daughter.

I have been myself a demon for pure races, declaring I would never marry any man unless of pure English or Danish blood in order to have my children of that type. And I'll be darned if I can

live up to it. I never fall in love with anything near that descrip-
tion. The last one that nearly put a dent in my heart was a German
Jew, and he was in love with a cross-eyed woman. Can you imag-
ine that? Isn't it strange how we judge the race by the individual?

You know I was once engaged to lots of men. One was Albert O.
Stark, son of a minister at the Church of the Good Shepherd, New
York City. His father died of heart trouble and the son inherited it.
Dismissed him when I discovered he had valvular heart trouble and
occasional attacks. I was also engaged to Paul Hardaway, a railroad
telegrapher, Southern, also a minister's son. Dismissed him for my
career. I might also mention Bob Grosvenor, owner of lots of cot-
ton mills, and his mother possessed of a social position at Newport.
He was too fat and boyish. I have also been engaged to an English
Jew, 19 years old, a California fellow. A gypsy prophecy made to
me when a little girl had turned out untrue. She said I would be
engaged to six men and marry the seventh. Well, I dismissed the
seventh last week. Well, dear boy, you'll think I'm writing you a let-
ter to read between meals. I am 30 years old. You seem very young.
I will let you know how soon I can come out and "discover" the west.

Audrey Munson

The Perfect Man competition, fun as it was for Audrey at a forlorn time, came to an end when she found what she thought was true love. On April 6, 1922, the *Mexico Independent* announced her engagement to a "Joseph J. Stevenson" of Ann Arbor, Michigan, a Great War aviator. The show-business trade paper *Variety* declared ironically that Audrey had found "the perfect father for her perfect children-to-be." Audrey said the pair would tie the knot in June—possibly in England, but certainly outside the United States.

"Going back to the time when all the talk was going on about my search for the perfect man whom I was supposed to wed when he was found. I really had a great lot of sport over some of the letters I received. Then, too, there were many disagreeable things which entered into it.

Audrey said Joseph H. Stevenson was
"perfect as the eyes of the heart see him."

Letters came from all over the country and in some cases outside of it. Some of those whom I refused on one ground or another proved in some instances to be very mean. They wrote bitter letters and even went so far as to come here to Mexico in an endeavor to see me. One discouraged suitor sent an overzealous relative. I became frightened things were becoming so serious and was decidedly glad when the affair was dropped."

Stevenson may not have been a Hermes or Apollo. But Audrey did not care. He was what she wanted—and that was love.

"Is he really your perfect man?" the local *Syracuse Herald* asked her.

"Really, I do not know. I do know, though, that he is perfect as the eyes of the heart see him. That is enough for me. That 'perfect man'? Why think of him now that the real man has come along."

25

SUICIDE BY POISON

Shortly before directing *Heedless Moths*, Robert Z. Leonard took his wife with the bee-stung lips for a break to Paris. Mae Murray was burned out after shooting *Idols of Clay*. In the film, she plays a South Sea girl who ends up as a dope fiend in an opium den in London's Whitechapel before being reunited with her true love in a Hollywood ending. For the part, Murray had visited the Miami jails to see addicts going cold-turkey in straitjackets. The former Ziegfeld Girl then got a nasty surprise when her dance partner at a charity ball picked her up over his shoulder and hurled her around the stage. Backstage staff explained the dance partner was himself a dope fiend.

Before a movie star goes to Paris, however, she needs to go shopping. Murray wanted tweeds and "lots of chiffon." At the department store in New York she ran into fellow movie star and former Ziegfeld Girl Olive "Ollie" Thomas who, by one of those Hollywood coincidences, was also shopping for a trip to Paris herself. She planned to take fifty trunks.

Thomas and Murray were old friends. The two had appeared together in the celebrated 1915 *Follies* along with W. C. Fields. Thomas had recently become the original flapper when her movie *Flapper* (1920) popularized the term across America. Still just twenty-five, she was now

married to the younger brother of "America's Sweetheart" Mary Pick-ford. But the glamorous young Jack Pickford was far from a Perfect Man.

Sensing Thomas was upset, Murray invited her into the ladies' changing room for a heart-to-heart.

"Jack and I have had a terrible time, you must have read it in the col-umns. . . . Unfortunately, it's sometimes true," Thomas admitted. "Mae, I don't know what's wrong with us. Jack's such a darling. . . . Maybe he's too handsome. The girls adore him, they throw themselves at him. . . . I don't want to believe it, but I can't help it, I almost lost him. Instead, we're going to Paris and I'm going to buy a whole new trousseau. . . . Now we're going to start all over like lovers."

When the two left the powder room, Thomas bought a sexy white nightgown to rekindle the fire with her husband on the trip.

Murray and Thomas agreed to meet at the Paris Ritz for lunch three weeks later when both couples were in France. Thomas and Pickford left for Europe aboard the RMS *Aquitania* followed by Murray and Leonard on the RMS *Olympic*. Once in Paris, Murray took advantage of the ad-vances in cosmetic surgery achieved by operating on mutilated soldiers in the Great War to get a full face-lift. On September 5, 1920, she met Thomas as planned at the Ritz.

Sobbing, Thomas moaned that her movie-star husband had deserted her as soon as they reached the French capital and she had not seen him for a week. She had not even gotten a chance to wear her white night-gown. Trying to console her, Murray invited Thomas to dinner with her and Leonard that night.

At 7:00 that evening, Thomas telephoned to cancel, explaining that her miscreant husband had suddenly appeared and announced he was throwing a party at Zelli's nightclub. Murray and Leonard went along.

Jack Pickford was the life of the party, quaffing champagne and mak-ing toasts, but he refused even to look at his wife. Thomas looked frantic. The two women's eyes met. Murray once again invited Thomas for a pri-vate confabulation—this time in the ladies' room. Thomas announced

she was ready to die. "It's no use," she howled. "I love Jack and he doesn't know I'm here."

Murray muttered a few words about God and about her friend having a precious life, but Thomas ran out of the powder room distraught, saying, "Mae, you're really Hollywood. You live in a dream."

When she and her husband returned to their suite at the Hôtel de Crillon later that night, Thomas drank a solution of mercury bichloride—a highly toxic chemical then commonly rubbed on sores as a treatment for syphilis.

"Suddenly she shrieked: 'My God,'" Pickford said. "I jumped out of bed, rushed toward her and caught her in my arms. She cried to me to find out what was in the bottle. I picked it up and read: 'Poison.' It was a toilet solution and the label was in French. I realized what she had done and sent for the doctor. Meanwhile, I forced her to drink water in order to make her vomit. She screamed, 'O, my God, I'm poisoned.' I forced the whites of eggs down her throat, hoping to offset the poison."

Her kidneys crippled, Thomas died five days later of acute nephritis. Although her death took place halfway around the world in the American Hospital in Neuilly, it was Hollywood's first big scandal. The press speculated that the mercury bichloride had been prescribed to Pickford for syphilis, and that Thomas had deliberately poisoned herself because of her husband's cocaine use and repeated infidelities. Murray was in no doubt who she blamed. The next day, she and Leonard canceled their planned tours of Switzerland and Italy to board the RMS *Olympic* back to New York, where Leonard directed *Heedless Moths*.

Audrey would certainly have known of Thomas's death from the press, but possibly also directly from *Heedless Moths* director Leonard himself—and she tried to copy it.

Two years later, on Saturday, May 27, 1922, Audrey received a telegram at the modest house she shared with her mother on Ames Street in Mexico, New York. The telegram sent her into immediate despair. She ran into her bedroom screaming: "This will end my misery."

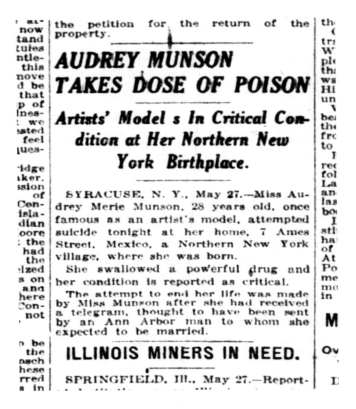

the petition for the return of the property.

AUDREY MUNSON TAKES DOSE OF POISON

Artists' Model s In Critical Condition at Her Northern New York Birthplace.

SYRACUSE. N. Y., May 27.—Miss Audrey Merie Munson. 28 years old, once famous as an artist's model, attempted suicide tonight at her home, 7 Ames Street. Mexico, a Northern New York village, where she was born.

She swallowed a powerful drug and her condition is reported as critical.

The attempt to end her life was made by Miss Munson after she had received a telegram, thought to have been sent by an Ann Arbor man to whom she expected to be married.

ILLINOIS MINERS IN NEED.

SPRINGFIELD. Ill., May 27.—Report-

Audrey put four tablets of mercury bichloride into a glass of water and gulped it down. Kittie ran from the house to get help. Neighbors arrived and forced Audrey to eat egg whites to absorb the poison. Audrey had bought a .22-caliber revolver for an upcoming trip and she was threatening to use it to "finish the job"—but Kittie managed to grab the gun.

Initial reports described Audrey's condition as "critical" and "precarious" and said she was "not likely to live." The local doctor F. D. Stone soon concluded, however, that she would make a full recovery. He cast doubt on whether Audrey had ingested all the mercury bichloride she said she had. Perhaps she had drunk the water down in such haste, he suggested, that there was time only for part of one of the four pills to

dissolve. Told of Audrey's suicide attempt, her father, Edgar, refused to come the forty miles from Syracuse at first because he thought it just "another of Audrey's stunts." He finally turned up the next day.

Ever more paranoid, Audrey was beset by morbid thoughts. The collapse of her movie career had been followed by the collapse of her planned marriage. "Neighbors in Mexico say that Miss Munson seemed greatly distressed lately and had repeatedly declared plots against her had been successful, depriving her of a fortune which she had earned in motion pictures in a screen offering billing her as the queen of the studios," the *Syracuse Journal* reported. Some reports said this was her third suicide attempt. The *Tulsa World*, harking back to the fortune-teller, said: "She was possessed by a delusion she was pursued by a curse."

The provenance of the telegram remained a mystery. Audrey, when she recovered, declared she would never reveal its contents. Kittie blamed her daughter's suicide bid on "the culmination of eight years of persecution." She accused the motion picture companies and the newspapers. "The corporations are responsible," she fumed. "We should be worth two million now but Audrey's pictures are not bringing in what they should."

The story in the village, however, was that Audrey's desperation stemmed from the shattering of her wedding plans. Neighbors told the press they believed the telegram came from her newly betrothed, Joseph Stevenson. Audrey had expected Stevenson in Mexico, New York, by the end of May, and it was May 27 and there was still no sign of him. Indeed, the local newspaper said he had never been seen in the village.

Audrey had given few details about Stevenson: he was a twice-married architectural contractor from Ann Arbor, Michigan, and a University of Chicago graduate who had served as an army aviator in the Great War. Some newspapers gave his middle initial as "J." but others as "A." Audrey said she met him in May 1921 in New Haven, New York, the next village over from Mexico. "There was no romance as romances go; merely the unaccountable force which we call love, brought us closer and closer together until—well at last we just decided to be married. That is the gist of the romance," she said.

For Audrey, the planned nuptials had marked a new start, and even a possible family, after years of torment. She yearned to turn the page on her troubles. Marriage had offered her the prospect of stability and peace, which had eluded her since childhood. She had been hoping oh-so fervently for a new life.

"Joseph is in the architectural contracting business. I have always cherished the desire to take a university course in architecture, and now I hope to be associated with him in business," she had told the press. "I shall never return to either the movies or the studio. I am through with that life forever. The only field or art that I would ever attempt again is concert playing and that only under certain conditions. Right now I feel that if I can only perform the role of a dutiful wife, life will be richer by far than all the laurels of a successful career in art."

Newspapers immediately launched a manhunt for the cad presumed responsible for the near-death of America's first supermodel. To no avail. A *New York Times* piece datelined Ann Arbor on May 28 concluded: "An extensive search in Ann Arbor for Joseph J. Stevenson, reported engaged to Audrey Munson, has failed to reveal any trace of him. So far as can be learned, no man by that name ever lived here."

Others since, also focusing their efforts on Ann Arbor and Chicago, have failed to identify Stevenson. Perhaps it is wiser to focus instead on Stevenson's claim to have been a wartime aviator. Audrey had a lifelong passion for flying sparked by her first trips with Allan Loughead. It is not surprising she would have fallen for a wartime flying ace, as both Edith Mortimer and Alva Vanderbilt's daughter Consuelo also did.

Aviation was in its infancy, and American aviators were still relatively few and far between. There had been a daredevil aviator named Joseph Stevenson from Mineola, Long Island, but he jumped to his death from his faltering biplane in front of thousands of children during a flying demonstration at the Alabama State Fair in October 1912 before thousands of watching schoolchildren.

There was also, however, a second aviator of the same name. His middle initial was neither "J." nor "A." but "H."—the next letter to "J." on

the typewriter and a letter that is both similar visually and phonetically to "A." It seems likely that the earlier newspaper scribes or typesetters made a mistake with his middle initial.

This Joseph Hutchinson Stevenson was born to Mr. and Mrs. Paul E. Stevenson of Cedarhurst, Long Island, in New York, on October 21, 1886, making him five years older than Audrey. He was part of the Harvard class of 1909 and a member of the college's Hasty Pudding social club. When the Great War broke out, Stevenson volunteered for the American Ambulance Corps of the American Hospital in Paris, but he ended up not making the trip. Instead, he became an aviator with the First Aero Co., Signal Corps of the New York National Guard. When the United States entered the Great War, Stevenson was called up to active duty in 1917 by the Second Aviations Section, Signal Officer Reserve Corps, and ordered to report to the commanding officer.

Stevenson had been married before to the daughter of the noted opera critic Gustav Kobbé. Hildegarde Kobbé bore him two daughters, Carol in 1909 and Hildegarde Jr. in 1912. The family moved to Pasadena, California, where Stevenson worked in the "automobile business." According to his grandson, Stevenson left Hildegarde around 1918, after returning from a tour of duty in France in the Great War, telling his first family he could not afford to look after them.

Audrey said she fell in love with her Stevenson in May 1921. If this was Joseph H. Stevenson, the wartime aviator, it is clear why that love was thwarted. To Audrey's misfortune, he had married someone else. On November 27, 1921, Joseph H. Stevenson married Evelyn Hollins (Nicholas) Arnold.

His new wife was divorced. She had two children—Evelyn and Duncan—with her previous husband, Alexander Duncan Cameron, before divorcing. Joseph H. Stevenson adopted both Duncan and Evelyn. His wife died at age thirty-five from pneumonia in 1930. Heartbroken, he moved to Santa Fe, New Mexico, where he worked for nuclear scientist J. Robert Oppenheimer on the Manhattan Project to build the atomic bomb during World War Two, and then went on to be a car dealer, later

setting up his own Stevenson insurance business until his death on March 7, 1956.

Evelyn's daughter, Mimi Long, says she believes Joseph H. Stevenson abandoned his first family with Hildegarde Kobbé and had nothing more to do with them. "On a positive note—My mother and her brother Duncan Cameron Stevenson dearly loved JHS and couldn't say enough nice things about him," she says. Long, Stevenson's adoptive granddaughter, knows nothing about any long-ago dalliance with Audrey. But Stevenson had abandoned a woman before.

Audrey as the Maine Monument in Columbus Circle.

26

ROLLER SKATES

Audrey only ventured into Mexico village from the farm to go to the post office. She made the two-mile trip on roller skates. To steady herself on the macadam road, she pushed an upturned lawn mover, its blades spinning in the air as she skated. She wore a knotted handkerchief on her head, which only added to the strange impression. Locals ushered their children inside so they did not see "Crazy Audrey."

Jeanette Kellogg Backus, one of the oldest residents of the village, saw Audrey on her roller skates. "People knew about her figure and her good points, and they just felt sorry for her that she was not being used right. She was used by those New York men, if you know what I mean," says Backus, whose daughter married one of Audrey's cousins. "She was just an average person when she was here. She just looked ordinary. She wasn't a dresser or a show-off of any kind."

Audrey lived with her mother and her dogs as a virtual recluse—first on Ames Street, where she attempted suicide; then on the main Railroad Street, now called Scenic Avenue; and finally on the farm on Butterfly Road, later renamed Eggelston Road, and now County Road 44. On the farm, Kittie earned the rent by serving as nursemaid to the elderly English-born widower named Fred Croft in the main house, even though

he was only five years older than her. Croft also had a "hired man" named John Schefer, six years younger than Kittie, living as a lodger. Audrey lived in the house next door. After once describing herself as an "actress" in the census and then as an "artist," she now gave her occupation as "none."

Fred Croft's great-grandson, Ron Eggleston, grew up in the house where Croft lived, and his grandparents eventually moved into the house next door house that Audrey and Kittie once occupied. "I remember many things about the house," he says. "There was a fire going in the large cast-iron kitchen stove during cold weather. There was no central heating or indoor plumbing, but there was electricity in the house, and for a while, there was telephone service. There was a well in the wood-shed attached to the back of the house, but it had run dry during the time I was growing up." The house had two small bedrooms upstairs with pitched ceilings. Out back was the outhouse and a henhouse and some berry bushes.

Beyond Audrey's farmhouse refuge, her former world was enjoying the boom of the roaring twenties. Prohibition was forced, but the jazz age was in full swing behind closed doors, in the speakeasies. Woman had won the right to vote and began to dance the Charleston and wear cosmetics. Charles Lindbergh made the first solo nonstop flight across the Atlantic; Greta Garbo shared the first open-mouthed kiss on screen with John Gilbert in *Flesh and the Devil* (1926); and Audrey's old stage mate Al Jolson made the most famous early "talkie" with *The Jazz Singer* (1927).

Audrey never became a flapper. She sought peace—or at least stability—on the farm. She had gone from rags to riches to rags again. The anger and frustration welled up in her, and she was filled with re-gret for what she had lost. She knew her modeling days were over; she had lost hope of making a second movie comeback; even her prospects of finding a husband seemed remote. She increasingly avoided human contact, preferring to walk her half-dozen collie dogs in the fields. Her mother barred the door to all visitors—even the newspapermen she used

to like. Eventually, Audrey was forced to surrender all her dogs to authorities because she could not afford to feed them.

Church was the main activity in the village, and Audrey did not attend. Her one pleasure, at least at first, was painting. A photograph kept by her father shows her sitting proudly with her paintbrush and palette at the easel. The *Ogdensburg Republican-Journal* reported: "Landscape painting in watercolor is a favorite pastime and Miss Munson is never happier than when exhibiting her handiwork or relating her experiences in the movies or in the studios of famous artists."

Audrey began to harbor delusions of grandeur. It was during the Wilkins case that she had first claimed descent from English aristocracy. Now the *New York Times* wrote: "It became known today that since the announcement of her engagement to Mr. Stevenson, Miss Munson has been calling herself Baroness Audrey Meri Munson-Munson, though the derivation of the title is as much a mystery as her effort to commit suicide." As with her anti-Semitism, her mother was feeding her delusion.

During almost a decade, the only man known to have visited Audrey was a Matthew Hemmer. A carpenter, Hemmer lived at 1002 Spring Street in Syracuse and had been in the real estate business like Audrey's father. Kittie later suggested that Hemmer's assistance was one of the reasons they first moved back upstate. Local newspapers recorded him visiting in August and November 1924 and in May 1925. The *Syracuse Journal* made a point of reporting that Hemmer had been "a weekend guest at the home of Audrey Munson" without any mention of Kittie. Hemmer was in his early forties at the time of the visits, and Audrey was in her early thirties. He had lost his wife, Amelie, after just a year of marriage when she died on October 15, 1909, leaving him with an infant son, Hilary, who went on to become a monk. Because he was still a relatively young widower, it is certainly possible that Hemmer had a short romantic relationship with Audrey. His cousin George Sarkus, himself a retired Syracuse real estate developer, remembers Hemmer as a cigar-smoking, classical music–loving artist-artisan with a fun, mischievous streak. It was Hemmer who, at a family gathering, gave Sarkus his first sip of beer

as a child. "This guy was an interesting character and I can see him having the intellect and depth to interest a woman," Sarkus says. "He may have been an artist, but he was certainly an artisan. He had the 'Hemmer look'—that sturdy Bavarian look. I would say he was earthy, but he was a classy guy."

On November 25, 1924, a small ad appeared in the "Business Opportunities" section of the *Oswego Times* that revealed the depths of Audrey's financial plight. So recently the subject of a movie and a nationally syndicated newspaper series, Audrey now sought to raise capital for a new film from local investors—and was willing to sell parts. "Capital from Oswego needed, stocks ready January 15 at $1.00 a share, leading parts for sale for $2,000 invested; $500 entrance fee. If poor, merit is considered." It was signed by M. Martel of Blue Lantern Farm, New Haven, New York, a local businessman and real estate investor, describing himself as "manager for Audrey Munson." Like Audrey's other local business ventures, this effort went nowhere.

A reporter for the *Syracuse Herald* who was able to visit Audrey on the farm found her spending hour after hour walking back and forth between the stoop of her cottage and the hen yard. "Her face bears the mark of heartaches and disappointments, and the figure which won the admiration of the world as it appeared in the work of artists and sculptors of the first rank, in several motion pictures which made record breaking successes, is worn and wasted with illness and suffering," he wrote on May 30, 1926, in the last major feature article on her in her lifetime. "Some people say that Miss Munson has suffered a complete nervous breakdown and that her possible comeback to the world of pearls and motor cars becomes more and more impossible every day that she morbidly thinks of the 'curse' brought upon her by her great beauty."

The old enmity between Edgar and Kittie continued to simmer. Edgar blamed his greedy and profligate ex-wife for all his daughter's woes. Kittie was so intent to separate herself from Edgar that she lodged her Providence divorce decree in Oswego so everyone in the area would know.

Audrey painted landscapes and
described herself as an "artist."

"The poor girl feels as though the whole world has turned against
her and I don't blame her," Kittie bemoaned. "The gang with the money
has used her beauty to bring them wealth and she got nothing from it at
all. Why, there's four of her pictures on the road today and she got only
$4,000 out of them altogether when she should have had $2,000,000 if
she got her lawful share.

"But we are going to fight for our rights. I don't know what we will
do. It's so hard to tell how to go after people with such wealth and power
but I for one am going to keep fighting until I can fight no longer," she

said. "They have been doing everything to keep my poor girl down and they're hanging onto the money that is rightfully hers. That's why we live in this little poor farmhouse. We haven't got a thing in the world."

Audrey really was on roller skates to oblivion. The *Syracuse Herald* reported that records at the local hospital showed she had "turned to drugs to alleviate her woes," although it did not give any details. The report made Kittie mad. "Did you see in any of the papers the write-up about her. It is all false," she fumed in a letter. "It said in paper, Hearst Syracuse Herald of September 2, 1934, that the Dr. said she would never get well and she had been a victim of drugs. All false—my dear girl never took such in her life and our family Dr. here said they ought to be put in prison for such reports. They do that to keep from the public why she does not appear in films again."

Audrey reportedly told her mother she heard voices "on the wires" from the electricity cables strung overhead. Her erratic behavior made her the object of suspicion around the village when the barn of the local Thornhill family went up in flames. Barn burnings were not uncommon in rural America. Seeing the hayloft go up was just too much sport at a time when there was little other distraction outside church. But the Thornhills' barn was just next door to Audrey's cottage—and fingers pointed at her. According to one story, Audrey was actually arrested. But there is no evidence the case went anywhere.

The last straw for Kittie came when Audrey, a devoted animal lover despite losing her dogs, became enraged when she saw the farmhand mistreat a horse. The story, as told by Audrey's late half-brother Hal, is here recounted by his daughter: "There was a farmhand who was beating a horse. Audrey saw what was happening and she grabbed a pitchfork and got him away from the horse. Her mother thought this was probably time to do something. That Audrey was out of control."

After decades of protecting her precious performer, sitting with her in artists' studios, massaging her after shows, caring for her in the cottage in Mexico, Kittie now decided to let go. It was a wrenching decision, the most dramatic that a mother can make, forced on her by Audrey's in-

creasing volatility. But Kittie convinced herself that it was in Audrey's best interest. The shadow of Audrey's failed suicide attempt years earlier hung over them, and their poverty. Kittie could no longer cope. Kittie sadly applied to get her daughter committed to a state hospital for the insane.

Audrey's case came before the Oswego County Court on June 8, 1931, as: "In the matter of Audrey Munson, a lunatic." Audrey's fate was sealed by Petition Certificate of Lunacy & Order #238. She was committed to the St. Lawrence State Hospital in Ogdensburg, New York. She was to live there for almost sixty-five years until her death in 1996 at age 104.

STATE OF NEW YORK

DEPARTMENT OF MENTAL HYGIENE

PETITION, CERTIFICATE OF LUNACY

AND

ORDERS

IN THE CASE

OF

Audrey Munson

Resident _New Haven_

County _Oswego_

Date of Order of Commitment

June 8, 193_1_

Institution _St. Lawrence_

State Hospital

Date of Admission _June 11_, 193_1_

No. of Case Book, Page

No. for Year _3 62_

Consecutive No. _15500_

Identification No.

Legal Status (_State whether indigent, public or private_)

The cover page of Audrey's sealed
committal order.

Edgar Munson's heartbreaking poem about his daughter,
written on the back of her portrait-as-an-artist.

27

THE ASYLUM

Edgar Munson was in no doubt about whom to blame for Audrey's plight. A despairing poem he wrote in pencil script on the back of his daughter's portrait-as-an-artist offers a unique insight into his view of her downfall:

> *Audrey Munson my daughter*
> *who was the world's model in form*
> *& played in the actress game*
> *made millions of dollars*
> *and her mother (my wife)*
> *wasted it all;*
> *Elecrit [Electric] banners were strewn across Broadway*
> *& she filled every theatre where she was ar[r]ayed,*
> *she sailed to England, Paris & Rome*
> *& brought a million dollars home*
> *& her mother threw it away,*
> *stage life to her meant quick tragedy*
> *& her glory came to a sad end,*
> *thus a life of wealth, fortune, pomp & pride*
> *was soon cast aside,*

& she in Ogdensburg does now reside
& her one thought is to commit suicide,
this is why I hate to attend a theatre
for in the background of the stage
I fancy [I] see my dear daughter's grave.

E.M.

Despite Edgar's fulminations, Kittie remained in penury. She nursed Fred Croft until his death in 1933. Then aged seventy, she moved into Oswego, the closest city. Because it was Kittie who had committed Audrey to the insane asylum, she was wracked by guilt. She began to regret her decision but was too poor and powerless to reverse it. Flying in the face of reality, she continued to insist that Audrey lived with her—when in fact she was still incarcerated in the state hospital. In the 1940 census, Kittie listed her daughter as living at her address at 175 Cayuga Street as "Audrey M. Oelrich," still *M* for *married*. In a jab at Edgar, who was still alive, Kittie put herself down not as *D* for *divorced* but as *WD* for *widowed*.

Kittie continued to rage against the moviemakers and newspapermen she blamed for Audrey's plight. But Kittie had been forced to recognize that Audrey suffered from real psychological problems. In a letter on September 9, 1933, Kittie wrote: "My Audrey is in hospital being treated for nervous trouble."

The St. Lawrence State Hospital for the Insane, where Audrey was placed, lay so far north in New York State that it was almost in Canada. From the grounds, patients looked across the St. Lawrence Seaway to the Canadian side. The Ogdensburg Bridge provided an easy crossing between the two countries. One former hospital director used to cross into Canada and back for dinner because the food was better. The hospital's location gave the overwhelming impression that the state wanted its residents out of sight and out of mind, if not quite out of the United States entirely.

Today, the grand old stone buildings where Audrey spent most of

her life are abandoned and the windows sealed up with steel sheets. The once-spacious grounds have been crowded with state institutions. There is a modern mental hospital in the new Trinity Building, two prisons, a halfway house, a unit for abused children, and, by some genius of the bureaucratic imagination, a nearby facility for child molesters, dubbed the Perv Palace by staff.

The state hospitals were originally conceived almost as a utopian project to embed the "insane" in a supportive working community that would enable them to rediscover their self-worth. The layout of the St. Lawrence State Hospital followed the Kirkbride Plan laid down by Philadelphia Quaker Thomas Kirkbride in the mid nineteenth century when the first efforts were made to provide the mentally ill with "moral treatment" rather than just warehousing them in prisons and poorhouses. The first 140 patients had arrived across the snow by horse-drawn sleigh in December 1890.

The asylum was a self-sustaining community with its own electric plant and pumping station, a police precinct and firehouse, a sewing shop where patients made sheets, pillowcases, shirts, and underwear, looms for blankets and rugs, workshops to make shoes and brushes, as well as 500 acres of farmland producing milk, oats, pork, potatoes, corn, cabbage, lettuce, beet, carrots, squash, fruit, and mangel-wurzel for fodder. From 1928, just three years before Audrey was committed, St. Lawrence also became the first state hospital to have its own beauty salon. Perhaps that was one reason Kittie chose it over the Buffalo State Hospital for the Insane where Audrey's godparents worked.

St. Lawrence provided a relatively desirable option for hard-pressed families at the time. "A lot of people has just been dropped off at the door because they would show low IQ and could not take care of themselves," says retired nurse Frank Spotswood. "That was what mental hygiene was back in those days."

Often, the inmates were uneducated farm boys who were a little slow on the uptake. For several years, staff entrusted the keys to all the doors to a former farmhand named Dexter for safekeeping because he had an

exceptional memory. Dexter became the director's pet and used to dine with him and his wife—even though he had been committed for his habit of enjoying carnal relations with farmyard animals.

It was a secret world. The identity of the inmates was kept confidential. One staff member said the institution had housed members of the Rockefeller, Kennedy, and Ford families. Cheryl Rolfe, a nurse who spent forty years working there, said: "You could be committed for anything. We had one woman whose husband committed her and married another woman and had kids. She was a witch. I didn't enjoy being attacked by her. Diagnoses? I never knew if they made them up." The inmates included a lot of mothers-in-law. Merely attempting suicide, as Audrey had done, was enough to get committed.

Audrey's case was reviewed three years after her committal, but doctors found no improvement. In an article datelined Ogdensburg, September 1, 1934, the *Syracuse Herald* announced that Audrey was "doomed" to spend the rest of her life in an asylum. DOCTORS GIVE UP HOPE OF EVER CURING HER OF MENTAL BLIGHT, the sub-head declared. The newspaper reported that the hospital's "alienists and psychiatric experts" had concluded that Audrey would never be cured of her "mental blight."

It was this *Syracuse Herald* article that provoked Kittie's ire by suggesting Audrey had suffered from a drug problem. "So at length her mind clouded, and leading the list of broken Broadway butterflies, her senses lapsed. She turned, hospital records show, to drugs to alleviate her woes. Now cured of the addiction, a semi-blank mind remains," the newspaper said. "But still in her lucid moments, she draws from her little store of mementoes the photographs that once marked her as the most beautiful woman in the world, then with a sign returns them carefully to the hoard of her souvenirs of another life, now faded and gone."

The newspaper drew a poignant parallel with the once-lionized Russian ballet dancer Vaslav Nijinsky, then languishing in a Swiss asylum. The man hailed by Parisian audiences as the God of Dance was once so popular that people stole his underwear from the dressing room while he was onstage. But Nijinsky fell out with his homosexual lover,

Ballets Russes founder Sergei Diaghilev—himself a lover of Oelrichs's love, Boris Kochno—and he felt he could work no more. In his last interview, with the Montevideo newspaper *El Dia*, Nijinksy complained: "After I left school, webs of intrigue were woven around me; people who had no other reason than envy for their hostilities began to appear." Nijinsky lapsed into religious delusion, followed Tolstoy's advice to abjure sex, and suffered sometimes-violent outbursts. In 1920 he was diagnosed with schizophrenia by the very same Swiss doctor who had coined the term just nine years earlier. Born two years before Audrey, Nijinsky spent the next thirty-one years in and out of mental institutions until his death in 1950. "The biography of Audrey Munson, should it be written, would reveal many parallels with Nijinsky's, her friends say," the *Syracuse Herald* said.

Audrey's early experience of St. Lawrence can be traced from Kittie's letters in the 1930s. At first, Kittie clearly believes her daughter's committal is temporary. On February 4, 1936, Kittie says of her daughter: "She was looking good and feeling well, anxious to come home." Two months later, she sent an update: "Audrey has been ill but is better now." Her increasing desperation soon becomes evident as she realizes her daughter is actually imprisoned. On August 4, 1937, she writes: "My poor girl is well and fine but compelled to stay against all I can do." By August 17, 1939, she is giving up hope. "I am past 70 years old and not very well. Of course, I am broken-hearted about my daughter. She is able to come home but money power is keeping her there as her husband is worth twenty-five millions and the rich Jews." Kittie missed Audrey so much that she continued to list her in the 1940 census at her home address at 175 Cayuga Street, Oswego, which she rented for thirteen dollars a month. The last record of Kittie's interaction with Audrey comes in a letter on February 2, 1940, recounting a visit the previous October. "She was not well and very thin," Kittie writes.

It was perhaps symbolic of Audrey's parlous state that her most visible statue collapsed. On February 23, 1935, the right arm of Weinman's *Civic Fame* fell off and plunged through a skylight into a staff cafeteria on

the twenty-sixth floor of the Municipal Building. No one was hurt.

Edgar Munson died in 1945. His obituary in the *Herald-American* newspaper listed his second family but did not even mention Audrey as one of his surviving children. With Edgar gone, Kittie became Audrey's only remaining visitor. Fred Croft's grandson Douglas Eggleston would drive Kittie up to Ogdensburg to see her.

Eventually Kittie moved into a boardinghouse in Oswego, New York, similar to the ones she used to run herself so many years before in Providence. She shared a bathroom and kitchenette with other tenants on the second floor of the property at 60 East Fifth Street. The tenants had their own staircase from the owners, Thomas Stirrat, a maintenance man, and his wife Lucy, who lived on the first floor. Kittie's small bedroom was at the back of the house. In it, she kept a painted portrait of Audrey and the marble bust she had been given by Daniel Chester French. In 1950 Kittie was so strapped for cash that she tried to sell the bust. A small ad appeared in the local newspaper: "Large marble bust of noted Audrey Munson for sale, favorite model of sculptors and painters of New York City; also Panama Exposition girl and star in three silent motion pictures. Inquire 60 East Fifth Street. Phone 2683-J." Eventually, Kittie is believed to have given the bust to her doctor to pay for his house calls. Kittie passed away on July 9, 1958—and was the last visitor Audrey had for decades.

In the cloistered world of the asylum, Audrey enjoyed special treatment as the "resident celebrity." She had never really had a proper home since the schism in her family with her parents' divorce. After moving from rented room to rented room, in the asylum she found safe harbor. She felt threatened in the outside world—from the movie men, the newspapers, the Oelrichses and the Mortimers—but inside three-foot stone walls of the state hospital, she was protected. Occasionally, newspaper reporters would try to impersonate friends or family to sneak inside to find the fallen star, but they were always repelled. The staff became her only family, and they pampered her. She liked that they always addressed her as Miss Audrey, and she liked being waited on.

They nicknamed Audrey the Dime Lady because of her reputation as

Audrey's old ward at the St. Lawrence State Hospital
for the Insane is now abandoned and boarded up.

the model for Weinman's Winged Liberty Head dime. To introduce her
as a patient, the hospital used to show incoming nurses a copy of Wein-
man's dime. Audrey clearly believed she was the figure on the coin. When
one nurse mentioned she had seen sculptures of Audrey on a visit to New
York City, Audrey pressed something in her hand and gestured for her to
leave the room immediately. Once outside, the nurse opened her fist to
see what Audrey had placed in her palm: It was a Winged Liberty Head
dime. Despite numismatists' conviction that Audrey was not the model
for the Mercury dime, Joanne Poore, a nurse who cared for her for fifteen
years, insists she is: "That's her profile—and I know her profile."

The staff who cared for Audrey all agree that she suffered no mental
illness in her final decades. None of her attendants even remember her
taking psychopharmaceutical drugs. In an unpredictable work environ-
ment where inmates were constantly yelling or trying to jump out the
window, staff regarded Audrey with universal affection. "She was always
that type of personality that sticks out: she had that royalty aura to her,"
Spotswood says. "With other patients, many of whom were very inad-

equate and psychologically incapacitated, everybody was equal to her." Nancy Irvine, a nurse, used to dress Audrey and change her when she got old. "She was always smiling. She was always pleasant. She was never surly or rude," she recalls.

Ever the animal lover, Audrey always carried a stuffed cat with her as she moved around the wards. She adored watching the squirrels through the window. Staff would put peanuts on the windowsill and then push her chair close by so she could watch the squirrels snacking, which delighted her. Frank Bruyere, a psychologist who worked with her, remembers her skill at a traditional American handicraft. "She was very clever at what they used to call 'darning,'" he says. "She would take a string and two pencils and make wonderful 'tadding.'"

Each morning for breakfast, Audrey ate a bowl of Cheerios. She called them "Os." Before taking the first spoonful, she would daub the milk on her face for her complexion. "What I remember specifically is that when you gave her breakfast, she would take the cereal bowl and put her finger in the milk and run it slowly around her face," said Spotswood. It was one of her old-fashioned beauty tips. She repeated the procedure every night after she ate her evening meal, rubbing her face, hands, and arms with milk from a glass. "Her skin looked like that of an eighteen-year-old even at the end of her life. She was really a beautiful woman," says Bruyere. Irvine says her skin was so white it was "almost albino-like."

Sometimes, she tried to put her own urine on her face. "It's good for your skin," she explained. In Audrey's day it had been a cheap and available cosmetic. Not surprisingly, Poore, her nurse, tried to stop her—although the treatment apparently worked.

Audrey loved her bubble bath. For many years, she shared a ward with thirty-five patients, but when it came to bath time the staff made a special effort to let her bathe last. Although there was a rush to get everyone to bed, they let her soak in the foam.

Audrey's salty language sometimes surprised the nurses. She once ordered Darlene Demars, while getting washed: "You clean my cunt real good." Demars, who politely spells out the four-letter word "C-U-N-T"

when retelling the story, was shocked. "It startled me," she says. "It's terminology she probably knew as a young person and probably in the back of her mind."

Poore once remarked to Miss Audrey in the bath that she had very pronounced dimples in her back. These were the very same dimples that her sculptors had prized. "Yes, I have two of them," Audrey replied, repeating almost word-for-word the studio conversation between Konti and Scarpitta about her precious dimples more than half a century earlier. "You keep your weight down, because if you lose them the man isn't going to like it."

After being washed, the female patients were put back in their wheelchairs to be collected by male nurses. Audrey was always playful with the male staff. "She did seem to like the men. She would talk about men a lot and dating. She liked the male employees and would talk about them and she liked the attention. She would say something and she would giggle," Rolfe says. "It seemed to be part of her personality that she could be fruity and say things with innuendos. It seems she was quite a gal."

"When our shift was done and we had an hour to sit back and we would talk with people like Audrey. We would be watching TV and would say, 'You like that guy?' She would giggle," Rolfe says.

There was one actor that Audrey showed a special affection for. His mumbled name would sometimes escape spontaneously from her lips: "Fatty Arbuckle."

Silent film funnyman Roscoe "Fatty" Arbuckle was once more popular and better paid than Charlie Chaplin. He formed a comedy partnership with "Madcap Mabel" Normand that stretched for thirty-nine films. The duo are often credited with inventing the screen gag of throwing custard pie. Once Hollywood's first "million dollar man," Arbuckle suffered a spectacular fall from grace when he was accused of killing a former artists' model and actress in his hotel suite in San Francisco on Labor Day 1921. Arbuckle was accused of raping her with a bottle. Although he was finally acquitted after three trials, Arbuckle's career was ruined. The scandal prompted the first wave of self-censorship in

Hollywood and the practice of including a morality clause, still known as an "Arbuckle Clause" in actors' contracts.

Audrey continued to mouth Arbuckle's name into her extreme old age. So much time had passed by then that staff members at the state hospital had to look up who he was. "It was almost like a fixation she had. But no one knew what was behind it," said nurse Spotswood.

Audrey knew Arbuckle's screen partner Mabel Normand as a young art model, and Arbuckle and Normand had made that movie about the Panama-Pacific International Exposition, *Mabel and Fatty Viewing the World's Fair at San Francisco*. Some of those who worked with Audrey— such as *Heedless Moths* director Robert Z. Leonard—knew Arbuckle well. No records in archives or newspaper morgues, however, pinpoint where Audrey and Arbuckle's lives crisscrossed.

Audrey's mumblings may simply have been prompted by memories of Fatty's slapstick antics on-screen. Bruyere, the psychologist, says she whispered his name "generally when there was a lot of activity and noise going on in the room, the TVs were on and the radio."

The closest Audrey ever got to explaining her fixation was a brief exchange with Demars, the nurse who used to bathe her. Demars tried to coax Audrey to talk about movie stars she might have known. "I asked her if she knew other actors, like George Burns, but she did not register," she says. But when Demars pushed Audrey to speak more about Arbuckle, she said: "Yes, Fatty Arbuckle. That was my friend."

To this day, Audrey's hospital records remain under permanent seal. The only family member who could get them released has decided that she does not want to. There was an abbreviated "social history" kept on the ward. Most of the nurses, social workers, and psychologists read it. Written on almost transparent wax paper dating from the 1930s, it ran to six or seven pages long—compared to just a page or a page and a half for an average patient.

One staff member who wants to remain anonymous, however, was so curious about Audrey's illustrious past that she snuck into the hospital's records room one night while working the late shift to read Audrey's full

patient history. It took her six hours until 3:00 in the morning to read through all the files. She describes leafing through Audrey's sealed records as "like reading a mystery novel."

At the distance of more than twenty years, the staffer only has an approximate recollection of the files. But they told a story that seems to cover the two great dramas of Audrey's personal life: her relationship with Oelrichs that broke up his planned engagement to Edith Mortimer, and the Wilkins murder-suicide. And they added another sinister dimension: a run-in with organized crime—perhaps a reflection of Audrey's paranoia.

The patient history referred to "periods of severe depression" and Audrey's suicide attempt. It also mentioned drugs, the staffer says. However, she adds: "There was no indication of any depressive illness. It would lead you to believe it was a response to a situation."

"There was a reference to marriage and to an affair. I do not know if she had an affair and she married the gentleman and he was engaged to someone else at the time, and her family went after her. I rather think that was how it worked," the staffer recalls. "There definitely was reference to mafia connections. Whoever this female was who was two-timed, her family was mafia-connected and went after him and after her."

Perhaps the biggest surprise was that Audrey's leather-bound scrapbooks were filed along with her sealed medical records. These were apparently the scrapbooks into which, as the *Syracuse Herald* noted, she dipped for memories of her lost fame.

"There was a picture in her scrapbook of her and her mother," the staffer says. "It was striking. They were standing next to a full-length mirror. That is how well I remember that picture. I brought it up and showed it to Audrey. She described exactly where the room was."

It was extremely irregular, if not unprecedented, for a patient's personal items to be stored in the secure area reserved for medical records. If the scrapbook had survived the occasional culls of patient files, it may still be there under seal to this day. The New York State Office of Mental Health rejected a Freedom of Information Act request to release it, citing

patient confidentiality laws. "We thought it was very weird her personal scrapbooks were put with her medical records," the staffer said. "We were wondering if they were put there so the wrong person would not come across it. For a long time medical records were off-limits to the general employee population."

Audrey's sealed files were also full of letters trying to get in touch with her—but with no replies. "There were letters after letters after letters from very prominent individuals trying to locate her. There was one from a [US] "president" . . . and a lot of political people, a lot of well-connected individuals trying very hard to connect with her," the staff member says. She cannot, unfortunately, remember with confidence which president wrote to Audrey at Ogdensburg, but thinks it must have been either Eisenhower or Roosevelt. It is perhaps worth recalling that Eleanor Roosevelt was the daughter of Edith Mortimer's aunt.

A striking number of the letter writers mentioned money—even prominent people who would not normally be expected to do so. There were also what the staffer interpreted as veiled threats. "There were some things in the letters that alluded to it. 'Your actions got you in deeper than you anticipated,' 'You have to be careful who you associate with,' 'Remember who this is?' Nothing said: 'Don't screw around with a mafia boss.'"

The staffer and her equally curious colleagues on the ward naturally wanted to know more about their enigmatic charge. Although Audrey was by then a pleasant old woman, she clearly had a glamorous and possibly dangerous past. But Audrey was determined to remain insulated from those memories. When the staff questioned her, as they probably should not have done, Audrey completely shut them out. "We were curious and we did ask," the staffer said. "Not a word. She would get upset with us. She would fold her hands and close her eyes. She was having nothing of you at that point. It was like you did not exist."

28

THE CHRISTIAN

As a child of nine, Darlene Bradley innocently asked the mechanic who ran the small garage near her father's shop in Syracuse why he had never gotten married. The mechanic, Bill, told her: "Well, I have always been in love with your aunt."

Misty-eyed, Bill reminisced: "It used to be wonderful when she would come to Syracuse. There used to be banners across Salina Street, and she was in a chauffeur-driven automobile. And she had these little dogs."

Bill's story made no sense at all to young Darlene. She did have a maiden aunt, Vivian, her father's sister. But she was most definitely not the kind of person who would have a parade down Salina Street. When Darlene asked her parents to explain, they replied, "Another time."

That "another time" was a long time coming—and probably for Audrey it was too long.

Darlene's father, Hal, who ran an appliance store called Hal's Television on Salina Street, was the youngest of Edgar Munson's five children by his second wife, Cora. He was Audrey's half-brother. Darlene, without knowing it, was Audrey's niece.

When she came home from grammar school, Darlene would sometimes hear the name "Audrey" muttered in the repair shop at the store.

When she inquired who this Audrey was, her mother, Marianne, would reply: "Never mind! Go do what you want to do."

The Munson family maintained a conspiracy of silence around Audrey that persists to this day. Tim Wood, the great-grandson of Edgar's brother, Charles, recalls his aunt telling him bluntly: "We don't discuss Audrey." It is not clear whether this rule stems from shame at Audrey's conduct or from a virtuous desire to protect her from inquiring minds—or if it is an extension of Audrey's own paranoia.

Darlene barely knew Edgar. She was just three years old when he died. "My grandfather, Audrey's dad, I just remember as this big, bearded man who loved to bounce me on his knees. And my grandmother was just the kindest woman. I really did not know anything about this daughter," she recalls.

One thing, though, was very clear to Darlene: "I had been told by my dad that for my Grandpa Munson, his number-one thing when it came to Audrey was to protect her."

Darlene, now a widow and a mother of two grown boys herself, living in a suburb of Rochester, New York, reconstructs the unfortunate dynamic of her father's two families. The rivalry and estrangement will be familiar to many whose parents have divorced and remarried. "Aunt Vivian was the eldest of Edgar's second marriage. There was a jealousy," she explains. "Audrey was the daughter of the first marriage. She just wanted everyone to stay away—and they did."

Darlene's is quite obviously the version of a member of Edgar's second family. Surely, it was Vivian who was more jealous of her famous movie-star half-sister than the other way around—except that Vivian had a greater claim on their father's attention. Vivian spent a distinctly unglamorous career in municipal government, becoming the civil service commissioner for Onondaga County, around Syracuse. She never married.

The subject of Audrey came up many years later, in the early 1980s, at a family dinner hosted by Darlene's sister Halette Daniel at her home in LaFayette, New York, south of Syracuse. By then, their father had revealed that the last he heard of Audrey was that she was in the St.

Lawrence State Hospital. Hal had visited Audrey in the Ogdensburg asylum accompanied by his wife, who was pregnant with Darlene. Because Darlene was born in April 1942, that pretty precisely dates what was one of Audrey's last encounters with the outside world.

"My Dad had nothing negative to say about her," Darlene says. "My mother . . . said she thought she was very distant. She did not know if it was medication. She was just very quiet and withdrawn. She could tell she had been a very attractive woman."

The couple was a little disconcerted when Audrey, looking at her much younger half-brother Hal, asked: "Is that my son?"

At the Sunday dinner table, Darlene asked her father, Hal, if he knew whether Audrey had passed away. It was decades since he had heard any news of her. He replied: "No, but, oh my goodness, she must be long gone by now."

The dinner discussion spurred Darlene's determination to find out what had happened to her long-lost aunt. The very next morning, she called the St. Lawrence State Hospital. "I had no idea what I was going to say. I said: 'I am inquiring about an aunt who I had heard had been there and was probably deceased because she would be in her early nineties.' They put me through to the administration, and they said they would look into it. I left my name and number."

Darlene called back at lunchtime and then again in the mid-afternoon. On this third attempt, she was told that a social worker would like to speak to her. The next day she spoke to hospital social worker Frank Bissell. "He asked me what my interest was in Audrey," Darlene recalls. "I said that she was my aunt and I was just wondering if she had passed, which I believed she had, and what was the date of her death? He asked me if I could answer some questions. He asked my birth date, and what I knew about Audrey. I said I just knew she had been at the psychiatric center for many years. He said: 'Can you give me the names of your father's siblings?'"

Just an hour later, Bissell called back with a startling announcement: "First of all, I can tell you your aunt is alive and well."

This was November 1984. Audrey was ninety-three at the time. She

had not had a visitor since the late 1950s, when her mother died.

Bissell said he had presented all the family names to Audrey and she recognized them all. But there was a problem. Audrey insisted she did not want to receive any visitors. Audrey was still fleeing her tormented past and showed no interest in being reunited with the family that had spurned her for so many years.

Darlene persisted. "I said, 'I understand that, given that everyone had disassociated from her.' I asked if I could see her. I said I wanted to tell my dad," Darlene recalls.

She called her father with the news. He greeted the news with sheer amazement. "You have got to be kidding," he said, and whistled. With some trepidation, given the family history, Darlene asked if her father would visit Audrey if it could be arranged.

"Honey, I would love it, but I'm not that well."

Darlene pressed, "If I come down to Syracuse?"

Darlene, a compact woman with benevolent features, describes herself as a devout Christian and comports herself with the modesty and sureness of purpose of her faith. Her search to find Audrey was surely an act of Christian love, of reaching out to someone in need. "I did not know anything about the sculpture [of Audrey's]. I just wanted her to know that she had family, even if it was only me, and that I loved her. And that if she needed anything, I was there," Darlene says. But there was also a more personal motive: not so much mere curiosity but a desire to answer one of her family's open questions, and a yearning to do it for her father—the youngest and last surviving of Audrey's half-siblings—before he died. Her father was suffering from emphysema and was not much longer for this world. Hal Munson died on October 17, 1985.

At the time, Audrey was convalescing in the asylum's infirmary after suffering a broken hip in a fall. Bissell told Darlene that Audrey was the "resident celebrity" and had not needed any psychiatric treatment for many, many years. He said she did not really interact with the other patients, but the staff adored her. Over what was already then more than half a century, the State Hospital had become her only home.

Before paying a first visit, Darlene called a nurse on Audrey's ward to ask what to bring her. The advice: stuffed animals. Audrey loved her little "kitty kat." The nurse also warned that Audrey did not like cake, and recommended bringing soft mint chocolates instead. She said Audrey spent a lot of time reading in the library. "I asked what she liked to read, and they said the *Reader's Digest*," Darlene recalls. "I got the large-print *Reader's Digest*."

Suddenly, the nurse surprised Darlene on the other end of the line by asking: "Do you want to talk to her?" Audrey's first contact with the outside world for more than fifty years was not a raging success. "I just said, 'Hi, Aunt Audrey, I am your niece. My name is Darlene,'" Darlene recounts. "She really did not want to talk to me. She did not want to have anything to do with the phone."

Darlene picked up her parents and sister, hoping for a better meeting in person. Bissell, an alert and sensitive man, met them and gently warned that he did not know how Audrey would react. Halette and her mother went to get coffee while they waited to see how the initial encounter went. Bissell escorted Darlene and Hal into the visiting room and then quickly left, telling them he would be right outside if there was any problem.

Audrey was sitting there in a high-backed, plastic-covered hospital chair with a towel behind her back. Her hair was brushed back carefully away from her face and her skin was luminous. She wore a loose-fitting, short-sleeved dress printed with a red-and-white trellis design.

Darlene was the first to speak. "Aunt Audrey, my name is Darlene."

Then Hal reintroduced himself, after a gap of more than forty years. "Hi, Aud, I am your brother Hal. Do you remember me?"

Audrey eyed him carefully before replying warily, "Oh, yes."

Hal filled the pregnant silence with a question that was so simple and yet had so very many answers. "How are you?"

Audrey parried, "I'm fine."

Once again, Hal filled the void. "It's been a long time."

Audrey, warming up to her visitors, betrayed a twinge of regret. "Pa does not come to see me anymore."

Their father, Edgar, had been dead for almost forty years.

For Darlene, it was her first encounter with her almost-mythical aunt. "What touched me was I went over to her and I had a box of the chocolates. I said, 'I brought them for you,' Darlene remembers. "I said, 'Would you like me to open them?' I took the lid off. She took one and held it up to me and said, 'Would you like one?' I thought, 'What a nice woman.'"

Understanding that the encounter was going relatively well, Bissell ushered Darlene's mother and sister into the visiting room too.

"Audrey, I am Hal's wife, Marianne. It's nice to see you," Darlene's mother said.

Audrey responded politely, repeating the words back to her: "It's nice to see you."

Halette had brought a camera and asked if she could take a picture.

"Oh, yes!" Audrey said, with a flicker of pleasure.

And she posed. Audrey's delight was palpable. For a flash, it was just like the old days in the studio once again. She looked dead straight at the camera and smiled a sweet and very symmetrical smile. Her chin was still very well-defined and her cheeks bunched into little rosy balls. *Click.*

"It was a special moment," Darlene says.

Darlene never discussed the past with Audrey. It was dangerous territory, and she did not want to make Audrey relive it. Darlene's own understanding of Audrey's life story reflects Kittie's belief that Audrey suffered persecution by a powerful clique when she broke up Oelrichs's engagement. Rather like Kittie, she incorrectly repeats that the Oelrichs and Mortimer families are Jewish. "The family believes she was engaged to Mrs. Vanderbilt's nephew, from a Jewish family. He was very smitten with Audrey, but he was engaged, and they were a Jewish family. In Hollywood and anything to do with the arts, there were a lot of Jewish people, so she became 'blacklisted,'" Darlene says.

Summing up the family's crude version, Darlene says: "I heard she had a breakdown because of the Jews." If it sounds like an anti-Semitic slur from the 1930s, that is because it is.

Darlene remains puzzled by Audrey's question about "my son." She wonders whether Audrey ever got pregnant, not an unusual event in

a period where contraception consisted of makeshift diaphragms and douches. Was a son given up for adoption? Was Hermann Oelrichs the father? Were Audrey's psychological problems merely postpartum depression? These are the questions that Darlene still asks. They are reinforced by Audrey's own complaint, in her letter to the State Department, that Oelrichs was spreading word that she was pregnant. Bissell, the social worker, told Darlene that as far as the hospital could tell, Audrey had never given birth.

Darlene's initiative in rediscovering Audrey won her a priceless reward in the form of a letter of thanks from her dying father. "He just said what a wonderful day that was to spend with his family and to see Audrey. He knew he was coming to the end, and he felt it made it much easier for him to go to Whitechapel. That is where he is buried," Darlene says.

About once a year, Darlene would make the three-and-a-half-hour drive north from Rochester to visit Audrey in Ogdensburg. She gave her stuffed animals, which she would rub lovingly against her cheek. "The only time I ever saw her angry was one time I was there, and she had a semiprivate room. I went in her room to get something for her. She was in a wheelchair. I took her back to her room," Darlene says. "There was a patient who was in the room. [Audrey] said: 'What are you doing in that room? You do not belong there. Get out of there now!'"

Darlene took her two adult sons to visit. Audrey treasured a photograph of them she gave her. But Audrey remained strictly off-limits to anybody but Darlene's family. Bob Munson, a Mexico resident who mistakenly claimed he was related, traveled to Ogdensburg to try to see her and was rebuffed. Staff were warned that in the past photographers and reporters had tried to masquerade as relatives to get an interview with the last surviving star of the silent screen. The film historian and expert numismatist Q. David Bowers, when compiling his comprehensive history of the Thanhouser film studio that made Audrey's first film, *Inspiration*, tried to contact her in the Ogdensburg asylum in the mid-1980s. He met a three-foot-thick stone wall.

"I corresponded at length with the Upstate New York facility in which she had been held as a patient for *many* years," Mr. Bowers recalls. "I asked the person in charge if I could interview her. The answer was *no*.

I asked if I could send a message that could be sent to her. The answer was *no*. I pleaded, said I would travel. The answer was *no*."

He says, "My feeling at the time was that she was held in isolation by the State of New York. Certainly, she must have had some feelings, some desire for communication. I felt very sorry for her. There may have been some circumstances of which I was not aware. But, after all, she was a human being."

Mental-health policy was as schizophrenic as some of the patients. When Audrey was committed, it was hard to ever gain release. Later, it became common practice to return even deranged people to the community. There are sad examples on many a street corner. St. Lawrence decided it wanted its longtime resident Audrey to move out to save money and a bed for someone else.

Darlene tried to persuade Audrey to come and live near her in Rochester, which was, after all, her hometown. That would have made Darlene's visits much easier and more frequent. But Audrey bridled at the idea. She did not want to go back to that "dirtiest little town." Instead, Audrey was outsourced to the St. Regis Nursing Home in Massena, New York. She missed home. She missed Ogdensburg. She missed the asylum. Darlene wrote to the director pleading for Audrey her to go back to Ogdensburg.

Audrey was back at the asylum in time to celebrate her one-hundredth birthday. She was now living in the new Trinity Building. For the celebration, staff festooned the ward with helium-filled balloons. Audrey sat in her wheelchair clutching a giant white teddy bear on her lap. Despite hospital rules, she was allowed a sip of wine. Her hair was still perfectly white and her skin still perfectly clear, but her features were more pinched than in her youth, as if she were squinting to see and straining to hear. When Darlene asked her what her birthday wish was, she replied: "To fly in a jet plane." Her romance with flight, though largely frustrated continued to the end.

Darlene took a close friend, Eunice, to the birthday party. Audrey pulled her aside and told her: "I just feel very happy that my niece has such a nice friend." The comment was obviously intended as a compliment, but it reflected the deep absence in Audrey's own life of female

companionship. The beautiful model had many intimate relationships with men but had no good female friends, except her mother.

Soon, a new cost-cutting effort was under way at St. Lawrence, and plans were afoot to move Audrey out to another old-age home. Cheryl Rolfe, Audrey's nurse, had warned that any new effort to ship her out could prove fatally destabilizing. She was right. Audrey's extraordinary life came to an end at the St Lawrence State Hospital on February 20, 1996. She was 104 years, 8 months, and 12 days old.

The only newspaper to run an obituary of the woman who once commanded headlines across the country the local *Ogdensburg Journal*, which ran five short paragraphs. The information came from the state hospital.

"Mrs. Munson was born June 8, 1891 to Edgar and Catherine Mahoney Munson. She married Hermon Oelrich in 1914, until their divorce," the obituary read. "She was a model in New York City and a movie actress in the 1900s, making silent movies. Mrs. Munson modeled for the face on the Liberty Dime."

Darlene received the news of Audrey's passing on holiday in Greece with her husband. By default, she had become the next of kin. By the time she returned, however, Audrey had already been cremated, as required by state law. Audrey's ashes were interred on her father's lot at the New Haven Cemetery. The gravestone records the three members of the family buried there: Edgar, his wife, Cora, and their firstborn, Vivian. To her dismay, Darlene returned to find Audrey had been interred with her eldest half-sister, Vivian, whose rivalry with her was the source of much of the discord between the two halves of the family. Darlene had Audrey dug up and entombed just inches away with her father instead.

The woman once immortalized in stone by the leading sculptors of her day as *Descending Night, Beauty, Wisdom, Liberty* and *Civic Fame,* now lies in the remote cemetery without even a gravestone. Cemetery rules prevent adding a new monument to the lot without removing the headstone for Edgar, Cora, and Vivian. Instead, there is a temporary metal marker forked into the grass. It is a humiliating and unworthy end. It even bears the wrong birth date, 1892 instead of 1891. The World's

Audrey's grave beside her father's headstone has
only a temporary marker with the wrong birth date.

Most Perfectly Formed Model, commemorated on the greatest buildings
and bridges of New York, atop skyscrapers and mansions, on monuments
and fountains, now rests almost entirely unremembered in an unmarked
grave—her only everlasting record, a small temporary metal spike with
the wrong birth date.

29

RATTLESNAKE

The official justification for Audrey's lifelong incarceration has been kept secret for decades—until now. By judge's decree, the Order of Commitment that dispatched her to the St. Lawrence State Hospital was placed under seal, preventing public scrutiny. It took just an eight-page document to imprison Audrey for sixty-five years, until her death.

That document sat gathering dust for decades in the archive of the Oswego County Court. In 1998, a judge rejected a request by the official Oswego County historian to unseal the file, saying it had to remain confidential for at least seventy-five years and could only be released to a family member. Only now has a second judge agreed to unseal Audrey's committal proceedings.

The Order of Commitment clears up once and for all the precise reasons that Audrey was locked up in an asylum. Nowhere is it mentioned that she was a nude model or that her on-screen nudity had transgressed society's norms. There is nothing about a Gypsy curse. Instead, the document tells a heartrending story of human frailty. It is a standardized form, precisely 272 numbered lines long, filled in with typewritten answers. But its terse, dramatic testimony, here made public for the first time, set Audrey's fate forever.

Audrey was the model for the Peace Monument in Atlanta, Georgia.

BY JNO. WILLIAMS INC.

PEACE MONUMENT ATLANTA

The formal request for Audrey to be sent away was made by Kittie, signing as Katherine C. Munson, and witnessed by a notary public. Her petition to the court is titled: "In the Matter of An Application for the Commitment of Audrey Munson, an Alleged Insane Person." Kittie was at the end of her tether. She was committing her only daughter, indeed her only surviving relative, to the madhouse. The petition takes the form of a brief questionnaire. Yet Kittie's short answers concealed a world of pain.

Kittie brought Audrey's mental state before the judge as an "emergency" case. She feared not only for her daughter's safety but also for her own. Audrey's pitchfork attack on the farmhand had made her scared. The emergency procedure is justified by the words: "Very excitable—may do harm to herself or mother when excited."

Kittie may have exaggerated the menace that Audrey posed to get the judge's attention. There is reason to doubt the emergency nature of the application. Kittie's petition is dated June 8, 1931. It is not just any date, but Audrey's fortieth birthday. It seems an extraordinary coincidence that Kittie should finally feel threatened enough by her daughter to want to send her away on such a special day. It was a perverse fortieth birthday present. More likely is that Kittie strove valiantly to care for Audrey for years but gave herself a deadline to surrender in good conscience: when Audrey turned forty.

Kittie's petition was supported by a Certificate of Lunacy signed by two local doctors who had examined Audrey for the court. They were Earl W. Mowry, of the village of Mexico, the father of the lawyer who had rejected Audrey's lawsuit against Allen Rock and the "New York Jews," and Joseph B. Ringland, of Oswego. That is all it took to commit Audrey for life: the word of her mother and two doctors. Edgar, her father, is identified on the form but did not sign off, and does not appear even to have been consulted.

Every typewritten entry is freighted with enormous significance. After answering some basic questions about Audrey—Sex: "Female"; Color: "White"; Occupation: "nothing at present"—the form asks:

"single, married, widowed, divorced (strike out words not required)." The doctors struck out all the words but "single." Unlike Kittie, who later continued to insist that Audrey was married to Hermann Oelrichs Jr., the doctors told the judge that Audrey had never married. By insisting that Audrey had married America's richest bachelor, Kittie was clinging to a delusion of her own.

The rumors swirling about Audrey's supposed arrest for the burning of Mr. Thornhill's farm are also laid to rest. The petition attests that she "is not under a criminal charge or indictment."

Nor was Audrey the victim of syphilis-induced madness, then a much more common condition than today. Audrey's use of mercury bichloride in her suicide attempt raised questions about why she would have such a toxic chemical, normally used to treat syphilis sores, while living with her mother in a remote village in Upstate New York. "Has the patient had treatment for syphilis?" the standard form asks. "No," is the unequivocal response. If it was not Audrey who was using mercury bichloride to treat syphilis, perhaps Kittie was. Or perhaps they had the poison, as some did, as a disinfectant for bites and wounds.

The question-and-answer format also casts new light on the letter from Gates, or "Yates," to Audrey, % her godmother, at the Buffalo State Asylum for the Insane a decade earlier. The public suspicion that Audrey had been secretly admitted to the Buffalo asylum was apparently unfounded. Asked to name any institutions where Audrey had received treatment for "previous attacks," the doctors indicate that she had gone to none.

Audrey's physical condition was found by the doctors who examined her to be "normal—except excessive menstruation at times." Her heavy periods had no necessary connection to her mental health. Audrey, they say, had previously been "considered as of normal mental standard." But the dry legalese breaks down as Kittie and the examining doctors describe Audrey's mental state. Her symptoms, detailed in a mixture of medical terms and Audrey's own confused words, are simply heartbreaking.

Kittie, the person who knew Audrey best in the world, and who had

cared for her single-handedly for a decade, through at least one suicide attempt, summed her daughter's suffering in a devastating catalog of symptoms: "Depression, delusions, hallucinations, moving picture Jews bother her, excitement."

No attempt was made by the court to diagnose Audrey's malady and give it a name. She was judged by the effects of the mental illness, not its cause. Nevertheless, Kittie's description strongly suggests symptoms of schizophrenia, a condition, from the Greek *schizein* (σχίζειν, "to split") and *phrēn, phren*" (φρήν, φρεν-, "mind"), that had only been named by Nijinksy's doctor Eugen Bleuler twenty years before.

The current benchmark for diagnosing schizophrenia is laid down by the fifth edition of the *Diagnostic and Statistical Manual of Mental Disorders*, known as the *DSM-5*, published by the American Psychiatric Association. The key test is that the patient must show at least two of the following symptoms: delusions, hallucinations, or disorganized speech. For women, the first psychotic episode typically occurs in their late twenties—around the time Audrey was making *The Girl o' Dreams*, playing a woman with the mind of "an innocent child of three." Psychotic symptoms tend to diminish over the course of a lifetime, but most patients require lifelong support. Schizophrenics are prone to become withdrawn, and most do not marry or have social contacts outside their family, the manual reports. About half of sufferers complain of depressive symptoms, and sleep disturbance and anxiety is common. Schizophrenics can become hostile or aggressive. About 20 percent attempt suicide on one or more occasions, and 5 to 6 percent currently die by their own hand.

The American Psychiatric Association used to specify a particular form known as "paranoid schizophrenia," characterized by delusions of persecution, but the expert group decided to drop the subclassification of forms of schizophrenia from its latest edition.

Kittie pointedly omitted Audrey's suicide attempt from her catalogue of Audrey's symptoms, even though the questionnaire asked specifically whether her daughter had manifested any suicidal tendencies. Despite Audrey's pitchfork attack on the farmhand, Kittie also dodged

the question on whether her daughter had shown any "homicidal tendencies."

In the petition, Kittie insisted that Audrey's mental problems had first surfaced only four years before, in 1927. That was already five years after Audrey's suicide attempt, a full eight years after her rambling poison-pen letter to the State Department, and more than a decade after *The Girl o' Dreams*. After living with her daughter for almost her entire life, Kittie must surely have known her account was wrong. It casts doubt on Kittie's own ability to recognize and accept the gravity of Audrey's earlier problems.

The two doctors who examined Audrey gave their professional opinion on Audrey's mental state. Their conclusions chimed with Kittie's account. Dr. Mowry and Dr. Ringland described Audrey as: "Sleepless at times. Worrying all the time about her so-called finances. Talks at random. When alone talking to other people she thinks in the room with her. Very excitable at times when talking."

Just as Audrey had fallen into what the investigating agent described as "spy mania" at the end of the Great War, so now Audrey's mental weakness led her into the furious anti-Semitism of the time. Around the world, Jews were being vilified. Within two years, Adolf Hitler would win power in Germany. Despite her own admonition in her letter to Perfect Man candidate Andre Delacroix about judging the individual by the race, Audrey generalized her dispute with Allen Rock into a worldwide conspiracy. The two doctors quoted Audrey as saying in their presence: "The Jews are hanging around, gobbling up everything, until some one breaks through and spoils their game."

Audrey's resentment of William Randolph Hearst, the man whose newspapers had brought "The Queen of the Artists' Studios" series to tens of millions of readers, had grown into a rage. Not only did she apparently blame him for the non-release of *The Girl o' Dreams*, she also understood perhaps that, in cutting out Allen Rock from the *Heedless Moths* deal, Hearst was indirectly responsible for her not getting paid. She saw Hearst's prying newspaper reporters as his agents.

The doctors quoted Audrey as saying: "Mr. Hearst is against people who have Irish & Jewish blood. I'm Mr. Hearst's bitter enemy. I can't work for Mr. Hearst. Trimmed me out of million in pictures. Agents go by here then rush down town to the whore houses and screw."

Even Kittie, who had defended Audrey valiantly forever, attacking the movie men for ripping her off for $2 million, was forced now to recognize that Audrey's obsession had become out of hand. Her attempt to sue Rock was already a decade old, and yet Audrey remained fixated on it. Audrey, using crude slang of the time, believed the Jews were trying to screw her. Describing Audrey's behavior for the judge, Kittie wrote: "rambles in her conversation. Says Jews are after her and trying to 'Rattlesnake' & scheming against her to prevent her getting money that belongs to her. Talks about money she says is coming to her and about her law suit over her pictures."

This was Audrey's madness speaking. Her later refusal to answer the nurses' questions, and the way she shut her eyes as if they did not exist, suggests she recognized she had been wrong and that her delusions had destroyed her life. She did not want to revisit her tumultuous past. She managed to put her "lunacy" behind her.

In her sadly curtailed career, Audrey had graced many of the mansions, monuments, and public buildings that defined her era—becoming an emblem of the Gilded Age that disappeared into the Great War and the uncertainty of the twentieth century. She broke new barriers in film, as America's first naked movie star, before the backlash saw censors and studio chiefs clamp down. She helped pioneer new fashions for women and spoke up for a woman's right to control her own body. But her accomplishments were little recognized and quickly forgotten. They offered her but little comfort when she came before the judge.

Judge Colony made his decision the very same day, Audrey's fortieth birthday.

"Ordered," he wrote, "that the said Audrey Munson be and hereby is adjudged insane and that she be committed to St. Lawrence State Hospital-Ogdensburg, New York, an institution for the custody and treatment of the insane."

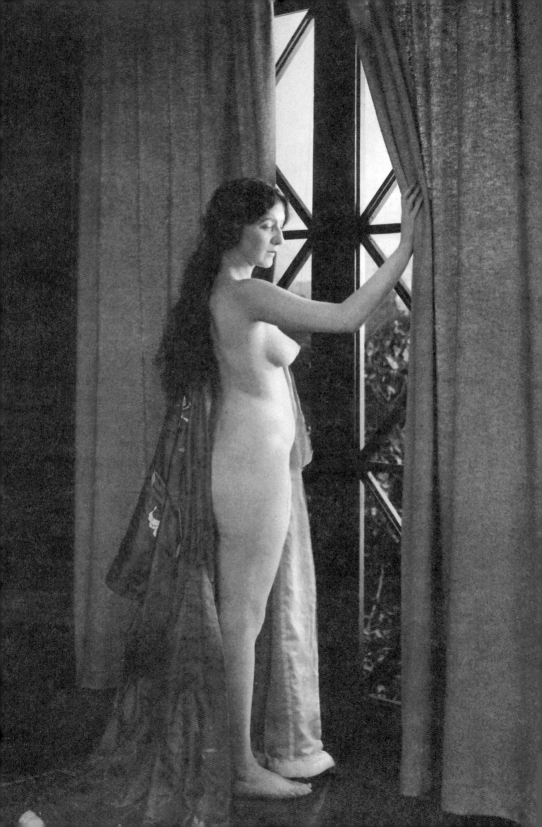

A NOTE ON SOURCES

When Audrey was committed, her leather-bound scrapbook followed her to the asylum, where it remains locked away today. But Kittie kept a dome-topped trunk full of Audrey's mementos, from press clippings and publicity photographs to fragile scrapbook pages and souvenirs. Even decades after her mother's death, Audrey used to ask for her treasure chest—but she never saw it again. Darlene Bradley, her niece, told me, "Audrey wanted that chest. She said there was a chest."

When Kittie died, the trunk full of Audrey's memories was not passed on to Audrey in the hospital. Instead, the memorabilia was taken by the couple that shared the same floor of Kittie's boardinghouse in Oswego. Louise and Leonard Doersam clearly knew that Kittie's collection was precious to her because Kittie used to regale them with stories of Audrey's glamorous past. But, they apparently made no attempt to return these treasured possessions to Audrey.

Louise Doersam used to show Audrey's photographs to her young great-nephew, Justin D. White, carefully censoring the nudes. For his tenth birthday, she let him choose anything he wanted from the curious cabinet she had in the pantry off her kitchen. He chose Audrey's ruby-red glass souvenir from the Buffalo World's Fair.

White's glimpse of Audrey's forgotten life spurred his own interest in history. He would grow up to become the official historian of Oswego County, where Audrey used to live. He now has the memorabilia he received from his aunt, although his ownership of it is highly dubious. In his account of how he came by the collection, he wrote: "When Mrs. Munson died, she had no surviving family, and her possessions were scattered. This is how my grand-aunt and uncle inherited some of the treasured memorabilia." This is clearly untrue, since Audrey was still alive, and it is hard to believe that the Doersams did not know that.

White says he has been "enthralled" by Audrey since first seeing her pictures as a child. He casts himself as her protector—even though he kept the chest. He has shared some of the collection but not all of it with me, Audrey's biographer. I am grateful for what he did show me, including being the first to show me the letters that Kittie wrote to a Munson

genealogist in the 1930s. But he took offence at the title of this book and disagreed with my endeavor to tell Audrey's story from her cradle to her unmarked grave. "In my opinion, it would be best to focus on Audrey's phenomenal career and her achievements; not just some scandalous stories linked together or interpreting her as cursed. Unless there was a more sensitive title and accurate text, I don't see how I could be involved further," White wrote. He is a professional historian—but sees no obligation to share this archive with other scholars so they can tell Audrey's story in their own way. I trust that by my exhaustive reporting—far beyond anything he has been able to unearth—I have been able to prove White wrong.

When, in the face of his refusal to share all the materials, I questioned White's ownership of Audrey's memorabilia, he called the police to try to have me arrested. The three squad cars of police officers that responded were very interested in Audrey—and not very interested in his bogus complaint.

As a veteran newspaperman well used to the battles of the daily press, I naively assumed it would be uncontroversial to write the biography of a dead woman whose heyday was one hundred years ago. Audrey, however, still arouses fierce passion and even remnants of her own paranoia. The family remains extremely conflicted about her.

Darlene Bradley deserves immense praise for breaking through her family's taboos and visiting Audrey in her final years. Darlene clearly regrets that Audrey was estranged from her family for so long, and is happy she was able to offer her friendship at the end of her life. I am very grateful to Darlene for sharing with me Edgar's heartrending poem about Audrey, which offers a father's view of his daughter's travails. Darlene's cooperation has nevertheless been limited by family pressure and her own loyalty to Audrey. At one point, Darlene sent me the photograph that her sister took of Audrey in the hospital—the one for which Audrey struck a pose, just like the old days—for use in this book. Her sister, Halette Daniel, then vehemently objected to its use—and so it is not included.

I received the following email in explanation:

Dear James,

> In speaking with my sister, she told me she is very upset about more money being made off our Aunt Audrey's unhappy life. She doesn't want her senior picture published. She thinks that just the thought of that is terrible! That would be continuing to exploit her in old age! I believe she may be correct.
>
> Regards,
> Darlene

Darlene insists that she knows very little about Audrey's past. Frank Bissell, the social worker, says he gave her a hospital file on Audrey. But, Darlene denies she ever got it. Strangely, many verifiable details of Audrey's life appeared in a chapter of an amateur local history book written by Donovan A. Shilling and titled *Rochester's Myths and Marvels*. Shilling's note-taking leaves a lot to be desired, and his chapter offers a topsy-turvy

account of Audrey's life with gaping holes, omitting such major events as the Wilkins murder-suicide. But, the chapter contains many accurate names that would simply be unknowable without specific information. Some of these, such as Herzog's, Darlene confirmed came from what Kittie told the hospital. Shilling says the chapter is based solely on what Darlene told him; Darlene agrees she spoke to him but says she has no idea where all the detailed information came from.

One family member who has been spectacularly helpful is Jim Hotchkiss, the great-grandson of Edgar's sister Hattie Munson. With my encouragement, Hotchkiss went to court to ask a judge to unseal Audrey's committal proceedings. He did a service to history. The newly unsealed records, now available for all to see at the Mexico New York Historical Society, are an indispensable part of the record. I would also like to thank Audrey's cousins Tim and Betsy Brown for their enthusiastic support.

Throughout this book, I have striven to reconstruct Audrey's life as minutely and accurately as possible. Every quotation is taken exactly from documents—whether newspaper clippings, letters, archives, memoirs, or court papers. I was able to retrieve court papers from Audrey's lawsuits against the United Booking Office and later against Allen Rock, as well the spin-off actions that enabled me to identify H. L. Gates as her ghostwriter. The court docket on Dr. Wilkins's capital murder trial, however, is mysteriously missing from the Nassau County Court, despite the enormous gravity of the case.

Audrey's "Queen of the Artists' Studios" newspaper series offers abundant and colorful material, but I have treated it with some caution because, although it was written under Audrey's name, it was ghostwritten by Gates. Some stories were clearly taken verbatim from Audrey's lips, as she was still repeating the same words about her dimples to her bath attendant decades later. Others stories, usually where Audrey is only peripherally involved, seem like Gates's embellishment. In yet others, such as the episode on "Auction of Souls," it seems clear Gates is recounting his own direct experience—and it is a valuable historical record, as such. The unexpected role of H. L. Gates in Audrey's story put me in touch with film historian Anthony Slide, author of *Ravished Armenia and the story of Aurora Mardiganian*. I am grateful for his help. The original quotes from Aurora Mardiganian come from Slide's crucial interview with her to preserve her story before she died. Atom Egoyan's description of the film also comes from Slide's book.

I have not attempted to list every artwork for which Audrey posed. She said she posed for two hundred artists—and I roughly believe her. There are some sculptures that have been misattributed to her; and others that were inspired by her that have not been identified. My rule has been to mention only artworks that were attributed to her in the press at the time, or by her or Kittie themselves, and only those that fuel the narrative. This is not intended as a catalogue raisonné.

Among the many family members, researchers, and historians who have offered their help I have found a universal fascination with Audrey's incredible life. I would like to single out for special thanks the eminent numismatologist and sometime film histo-

rian Q. David Bowers, who actually tried to contact Audrey in the hospital while she was still alive. His doggedness is a quality I prize.

I wish also to thank: Patricia Lofthouse, Chicago archive research; Marie Derrey Tourres, Paris archive research; Jeanette Kellogg Backus and Brenda Hotchkiss; Ronald Eggleston; Michael Mowry; George Sarkus, Christine Hemmer and John Hemmer; Marian "Mimi" Torobin Long, granddaughter of Joseph H. Stevenson; David Hard, grandson of Joseph Hutchinson Stevenson; Paul C. Bandilli, grandson of Paul Hardaway; Ned Thanhouser, director and producer, *The Thanhouser Studio and the Birth of American Cinema*; Jim Munson, Melvyn Douglass, Tom Munson, Cindy Howard, James Markello, of the Thomas Munson Foundation; Frank Spotswood, Nancy Irvine, Darlene Demars, Cheryl Rolfe, Frank Bissell, Frank Bruyere, Joanne Poore, Alma Skaggs, and my informant, all formerly of the St. Lawrence Psychiatric Center; Laura Ackley, author of *San Francisco's Jewel City: The Panama-Pacific International Exposition of 1915*; Laura Vookles, chief curator of collections, Hudson River Museum; Gayle Martinson, Wisconsin Historical Society; Barry Popik; Charles R. Nuckolls, author of *The Roses* on the Lyman family; Caroline Patte, Centre National du Cinéma et de l'Image Animée, France; Victoria Kastner, Hearst Monument; Karen Kukil, Sophia Smith Collection, Smith College; Robert Yahner, the National Arts Club; Nancy Hadley, the American Institute of Architects; Dawn Mullin, South Carolina State Library; Sekiji Kazuko, curator, Tokyo Metropolitan Museum of Photography; Yoshinori Marui, Tokyo Polytechnic University; Miya Elise Mizuta Lippit, University of Southern California; Terri Clark; Peter Duchin; Jim Leonhirth; Winthrop Aldrich; Phoebe Bean, Rhode Island Historical Society; Roger Burdette; Rachel Bernstein and Jenny Romero, Margaret Herrick Library, Academy of Motion Picture Arts and Sciences; Amanda Neal, Santa Barbara Central Library; Pantelis Michelakis, Bristol University; Edward Fields, Davidson Library, University of California, Santa Barbara; David H. Mortimer; F. Richard Barr; Romie Minor, Detroit Public Library; Bethany Fiechter, Indiana State Library; Shauna L. Hidlebaugh, Lockheed Martin Corp; Jennifer Fauxsmith, Massachusetts Archives; Jonathan Eaker, Prints and Photographs Division, Library of Congress; Sister Eleanor Little, Sisters of Mercy; Ken Carlson, Office of the Secretary of State, Rhode Island; Steve Gittelman; Amma Kyei-Mensah; and everyone else who helped me. You do valuable work.

To help future scholars, and enable them to check my work, I will ensure my archive on Audrey Munson is available to the public.

BIBLIOGRAPHY

Ackley, Laura A. *San Francisco's Jewel City: The Panama-Pacific International Exposition of 1915*. Berkeley, CA: Heydey, 2015.

American Psychiatric Association. *Diagnostic and Statistical Manual of Mental Disorders, Fifth Edition (DSM-5)*. Arlington, VA: American Psychiatric Association Publishing, 2013.

Ardmore, Jane. *The Self-Enchanted*.

Ashby, LeRoy. *With Amusement for All: A History of American Popular Culture Since 1830*. Lexington, KY: University Press of Kentucky, 2012.

Barnes, Djuna, and Phillip F. Herring and Osias Stutman, eds. *Collected Poems: With Notes Toward the Memoirs*. Madison, WI: University of Wisconsin Press, 2005.

Athenaeus. "Book 13." In *The Deipnosophists*, trans. by Charles Burton Gulick, 589–99. Cambridge, MA: Loeb Classical Library, 2009.

Bernays, Edward L., Samuel Hoffenstein, Walter J. Kingsley, and Murdock Pemberton. *The Broadway Anthology*. New York: Duffield & Co., 1917.

Biddle, Flora Miller. *The Whitney Women and the Museum They Made: A Family Memoir*. New York: Arcade Publishing, 1999.

Brown, Ivor. *The Way of My World*. Glasgow, Scotland: Collins, 1954.

Burns, Sarah, and Vanessa Lecomte. *Portrait of a Lady: Peintures et Photographies Americaines en France 1870–1915*. Chicago: Terra Foundation for American Art, 2008.

Camfield, William, Beverley Calté, Candace Clements, Arnauld Pierre, and Pierre Calté. *Francis Picabia: Catalogue Raisonne 1898–1914*. Brussels, Belgium: Mercaterfonds, 2014.

Chapin, Anna Alice. *Greenwich Village*. New York: Dodd, Mead & Co, 1920.

Chris, Cynthia. "Censoring Purity." *Camera Obscura* 79, no. 1 (2012): 97–125.

Craven, Wayne. *Gilded Mansions*. New York: W. W. Norton & Co., 2009.

Davies, Marion. *The Times We Had: Life with William Randolph Hearst*. New York: Ballantine, 1985.

Davis, Deborah. *Gilded: How Newport Became America's Richest Resort*. Hoboken, NJ: John Wiley & Sons, 2009.

De Zayas, Marius. *How, When, and Why Modern Art Came to New York*. Cambridge, MA: MIT Press, 1996.

Du Maurier, George. *Trilby*. New York: Harper & Brothers Publishers, 1894.

Edmonds, Andy. *Fatty: Villain or Victim?—The Real Story Behind One of Hollywood's Most Notorious Tragedies*. Austin, TX: Futura Publishing, 1990.

Friedman, B. H. *Gertrude Vanderbilt Whitney*. New York: Doubleday & Co., 1978.

Gabler, Neal. *An Empire of Their Own: How the Jews Invented Hollywood*. New York: Crown Publishers, 1988.

Gavan, Terrence. *The Barons of Newport*. Newport, RI: Pineapple Publications, 1998.

Gittelman, Steven H. *Willie K. Vanderbilt II: A Biography*. Jefferson, NC: McFarland & Co., 2010.

Goodrich, Lloyd. *The Whitney Studio Club and American Art 1900–1932*. New York: Whitney Museum of American Art, 1975.

Griffith, Linda A. *When the Movies Were Young*. New York: Arno Press, 1972.

Hoffman, Katherine. *Stieglitz: A Beginning Light*. New Haven, CT: Yale University Press, 2004.

Hopkins, Arthur. *To a Lonely Boy*. New York: The Book League of America, Inc., 1937.

Keaton, Buster, with Charles Samuels. *My Wonderful World of Slapstick*. New York: Doubleday, 1960.

King, Greg. *A Season of Splendor: The Court of Mrs. Astor in the Gilded Age of New York*. Hoboken, NJ: Wiley, 2009.

Larson, Barbara Jean. *The Art of Evolution: Darwin, Darwinisms, and Visual Culture*. Lebanon, NH: Dartmouth College Press, 2009.

Lasky, Jesse L. *I Blow My Own Horn*. New York: Doubleday, 1957.

Latham, Angela J. *Posing a Threat: Flappers, Chorus Girls, and Other Brazen Performers of the American 1920s*. Middleton, CT: Wesleyan University Press, 2000.

Levine, Nancy J. "Bringing Milkshakes to Bulldogs: The Early Journalism of Djuna Barnes." In *Silence and Power: A Reevaluation of Djuna Barnes*, edited by Mary Lynn Broe. Carbondale, IL: Southern Illinois University Press, 1991, 27–37.

Merritt, Greg. *Room 1219: The Life of Fatty Arbuckle, the Mysterious Death of Virginia Rappe, and the Scandal that Changed Hollywood*. Chicago: Chicago Review Press, 2013.

Messinger, Lisa Mintz, ed. *Stieglitz and His Artists: Matisse to O'Keeffe*. New York: Metropolitan Museum of Art, 2011.

Mordden, Ethan. *Ziegfeld: The Man Who Invented Show Business*. New York: St. Martin's Press, 2008.

Morgan, Wayne. *Yesterday's Addicts: American Society and Drug Abuse 1865–1920*. Norman, OK: University of Oklahoma Press, 1974.

Norman, Dorothy. *Alfred Stieglitz: An American Seer: An Aperture Biography*. New York: Aperture, 1960. Published originally as an issue of *Aperature* (viii,1,1960).

Pezza, Kelly Sullivan. *Murder at Rocky Point Park: Tragedy in Rhode Island's Summer Paradise*. Charleston, SC: The History Press, 2014.

Rennella, Mark. *The Boston Cosmopolitans: International Travel and American Arts and Letters*. New York: Palgrave Press, 2008.

Rose, Frank. *The Agency: William Morris and the Hidden History of Show Business*. New York: HarperCollins, 1995.

Rozas, Diane, and Anita Bourne Gottehrer. *American Venus*. South Pasadena, CA: Balcony Press, 1999.

Scannell, John James and William Edgar Sackett, eds. *Scannell's New Jersey's First Citizen's and State Guide: Biographies and Portraits*. Volume 2. New Jersey: Paterson, 1919.

Schevill, Ferdinand. *Karl Bitter: A Biography*. Chicago: University of Chicago Press, 1917.

Schneider, Dorothy and Carl J. *American Women in the Progressive Era 1900–1920.* New York: Anchor Books, 1993.

Shilling, Donovan A. *Rochester's Marvels & Myths.* Victor, NY: Pancoast Publishing, 2011.

Slater, David. *The Fount of Inspiration: Minnie Clark, the Art Workers' Club for Women, and Performances of American Girlhood Winterthur Portfolio,* Vol. 39, No. 4 (Winter 2004), 229–58.

Slide, Anthony, ed. *Ravished Armenia and the Story of Aurora Mardiganian.* Jackson, MS: University Press of Mississippi, 2014.

Stieglitz, Alfred. *Camera Work: The Complete Photographs.* Cologne, Germany: Taschen, 2013.

Storke, Thomas M. *California Editor.* Tucson, AZ: Westernlore Press, 1958.

Traub, James. *The Devil's Playground: A Century of Pleasure and Profit in Times Square.* New York: Random House, 2004.

Wetzsteon, Ross. *Republic of Dreams: Greenwich Village: The American Bohemia.* New York: Simon & Schuster, 1998.

Wharton, Edith. *After Holbein.* New York: Charles Scribner's Sons,1928.

Wilson, Richard Guy. *The American Renaissance 1876–1917, Part 1.* New York: The Brooklyn Museum, Distributed by Pantheon Books, 1979.

Yallop, David A. *The Day the Laughter Stopped: The True Story Behind the Fatty Arbuckle Scandal.* New York: St. Martin's Press, 1976.

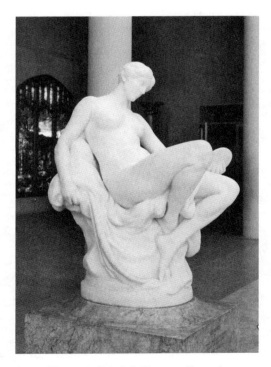

Memory, Daniel Chester French

PRINCIPAL ARTICLES CITED

These are the primary articles that were critical in my research, though there are hundreds of others, for which there is not space in this book. I've arranged them in chronological order so they can be referenced as you read through Audrey Munson's life.

"Royalty Was Here." *Syracuse Herald*, August 23, 1896.

"They Swap Horses." *The Evening Telegram*, May 29, 1899.

"Gypsies Meet Prosperity." *New York Sun*, June 16, 1899.

"Rival Gypsy Camps." *Syracuse Herald*, June 5, 1901.

"Fair Will is Broken." *New York Times*, March 20, 1902.

"Mr. and Mrs. Charles L. Fair Killed Instantly." *The New York Herald*, August 15, 1902.

The American Amateur Photographer, vol. 17 (1905): 237.

"Society Shocked." *Dawson Daily News*, October 6, 1906.

"Oelrichs Will Fight Ended by Compromise." *New York Times*, November 25, 1906.

Caffin, Charles "Charles Caffin on F. Benedict Herzog." *Camera Works*, Number 17, 1907.

"Through the Studios of Macdougal Alley." *New York Times*, October 27, 1907.

"Social Gossip." *Washington Post*, July 29, 1908.

"Life of a Chorus Girl." *Fort Wayne Journal-Gazette* (Indiana), December 27, 1908.

"Art at Home and Abroad." *New York Times*, January 31, 1909.

"Strong Bill at Keeney's." *Brooklyn Daily Eagle*, March 30, 1909.

"Historic Bronx Estates." *New York Sun*, May 9, 1909.

"Chorus Girls Lay Brick." *The New York Press*, October 8, 1909.

"Vaudeville." *New York Dramatic Mirror*, April 3, 1909.

"Gerald Hampton and 'Dancing Dolls.'" *Variety*, April 10, 1909.

"East Syracuse." *Syracuse Herald*, April 24, 1909.

"Famous Sculptors at Work Within Their Studios." *New York Times*, May 30, 1909.

"Bernard, Sam in The Girl and the Wizard." *New York Dramatic Mirror*, October 2, 1909.

"The New Ballroom of the Hotel Astor." *New York Times*, December 19, 1909.

"Prison for Tyrant Janitor." *The New York Press*, January 20, 1910.

"Czar of Flat Given Penitentiary Sentence." *Los Angeles Herald*, February 1, 1910.

"The Gibson Girl Analyzed by her Creator." *New York Times*, November 20, 1910.

"Civic Fame and her Neighbors." *Christian Science Monitor*, January 18, 1912.

"Oelrichs Sues Relatives." *New York Times*, January 25, 1912.

"Mr F. B. Herzog, Inventor, Dead." *New York Herald*, April 22, 1912.

Barry, Richard, "As to Bucking the Social Tiger." *New York Times*, April 14, 1912.

"Oelrichs Wager." *Toledo Blade*, November 7, 1912

F.B. Herzog, obituary, *Photo-Era Magazine*, Vol. 28 (1912).

"Fete Day of the Associated Architectural Societies." *Architecture Magazine*, vol. 27-28 (1913): 229.

"All New York Bows to the Real Miss Manhattan." *New York Sun*, June 8, 1913.

"Picabia, Art Rebel, Here to Teach New Movement." *New York Times*, February 16, 1913.

"If the Venus de Milo Came to New York." *New York Press*, April 27, 1913.

"Models Take Roles." *New York Press*, September 9, 1913.

"Woman Help Architects." *The Evening Post* (New York), September 9, 1913

"Architects' Outing." *New York Times*, September 10, 1913.

"New York Sculptors Busy on Models for Colossal Statuary." *The (Newport) News*, September 19, 1913.

"H. Oelrichs in Cell." *Washington Post*, October 2, 1913.

"Girl Clears Oelrichs." *Washington Post*, October 4, 1913.

"Lies About Oelrichs, Girls Says, Not Stabbed" *New York Tribune*, October 4, 1913.

"Western Men are Returning East." *Syracuse Herald*, September 20, 1914.

"The 'Most Coped Girl in America,'" *Indianapolis Star*, March 22, 1914.

"Vincent Astor Weds." *The News-Palladium*, May 1, 1914.

"All New York's Outdoors Now Studio for Painters and Sculptors." *New York Press*, August 9, 1914.

"Style Show at the Palace." *Silk Magazine*, 1915.

"Venus Surpassed in Beauty and Form." *The Illustrated Milliner*, May 1915: 21.

"Audrey Munson, the 'Exposition Girl.'" *Variety*, 1915.

"Palace Fashion Show." *Variety*, 1915.

"Two Vaudeville Headliners Furnish Peculiar Contrast." *Variety*, 1915.

Teall, Gardner. "Art, The Mirror of American Genius." *Hearst's Magazine* vol. 27-28 (1915): 434.

"Woman in the News." *Up to the Times* magazine, 1915.

"The Exposition Statuary and the Girl Who Posed for It." *San Francisco Chronicle*, June 6, 1915.

"How'd You Like to Talk with Nearly All the Statuary at the Big Panama-Pacific Expo?" *Tacoma Times*, January 7, 1915.

"Panama Girl, the Exposition Medal and the Sculptor for Whom She Posed." *The Evening World* (NY), February 10, 1915.

"Girl to be Immortalized by Frisco Fair." *Washington Times*, February 26, 1915.

Marbourg, Nina Carter. "The Panama Girl." *The Atlanta Constitution*, March 7, 1915.

"The Exposition Girl." *The Brooklyn Eagle*, March 17, 1915.

"Miss 'Audrey'—The Panama-Pacific Expo Girl." *American Magazine*, section of the *New York Sunday American*, March 21, 1915.

"Young Model for Exposition Sculptures." *Syracuse Post-Standard*, March 22, 1915.

"Miss Audrey Munson, the Girl with the Perfect Physical Figure." *The Gloversville Morning Herald* (NY), March 23, 1915.

"Model in Vaudeville." *New York Herald*, April 11, 1915.

"Karl Bitter Dies of Auto Injuries." *New York Times*, April 11, 1915.

"Fashion Parade in Theater Ignores the Weather Man." *New York Tribune*, April 13, 1915.

"Panama Girl, Sculptor's Model, Goes from Studio to Stage." *New York Herald*, April 15, 1915.
 "Fountain Head of Modes Shifts to Daily Fashion Show at the Palace." *New York Tribune*, April 16, 1915.

"Panama Girl is Now Going on Stage." *Boston Post*, April 18, 1915.

"Shocking She Calls Exposition Figures." *Philadelphia Inquirer*, April 18, 1915.

"Nude Statue Shocks This Woman." *Oakland Tribune*, April 18, 1915.

"Exposition Girl Everybody's Idol." *Waco Morning News*, April 25, 1918.

"Miss Munson, Fashion Model, Sues for $20,000." *New York Herald*, April 30, 1915.

"Audrey Munson Sues." *New York Times*, April 30, 1915.

"Vaudeville." *New York Tribune*, June 13, 1915.

"Gossip of the Theater and the Actor Folk." *New York Sun*, June 13, 1915

"Gossip." *New York Evening World*, June 15, 1915.

"The Broad Minded Romance of the Famous Panama-Pacific Girl." *Washington Post*, June 27, 1915.

"Margaret Edwards Defends Appearance as 'Naked Truth' in 'Hypocrites,'" *The Leavenworth Post* (KS), July 12, 1915.

"Again the 'Third Degree' for Human Form." *New York Herald*, September 19, 1915.

Munson, Audrey. "Why Do So Many Women Grow Old Quickly." *The Omaha Bee*, September 23, 1915.

Munson, Audrey. "How Women Can Ward Off Spectacle Spectre." *The Omaha Bee*, October 28, 1915.

Review of *Inspiration*, *Variety*, November 5, 1915.

Review of *Inspiration*, *The Moving Picture World*, November 13, 1915.

"Thanhouser Does Not Advocate Nudity." *The New York Morning Telegraph*, November 14, 1915.

"Inspiration." *The New Orleans Item*, December 27, 1915.

"How Big 'Flying A' Studio Will Look When the Tower Is Completed." *New York Dramatic Mirror*, July 1, 1916.

"Inspiration." *The Evening Standard* (New Rochelle, NY), January 22, 1916.

"Actress Takes to Hydroplaning." *Syracuse Herald*, August 6, 1916.

Review of *Purity*, *Variety*, 1916.

"World Famous Model is a Syracuse Girl." *Syracuse Herald*, January 9, 1916.

"'The Nude' in Motion Pictures." *Ogden Standard* (UT), January 14, 1916.

"Says Every Woman Should Take Exercise." *The Daily Capital Journal* (Salem, OR), January 5, 1916.

"Hunting Down the Near Bohemia of New York." *The New York Sun*, February 6, 1916.

"Many Volunteer Aviators." *New York Times*, February 26, 1916.

"Fire in Sculptor's Studio Destroys Valuable Art Works of Vanderbilts and Goulds." *New York Sun*, April 30, 1916.

"New York's Municipal Building Symbolizes Ideals of a Great City." *Christian Science Monitor*, May 27, 1916.

"The Theatres." *Lincoln Star* (NE), June 25, 1916.

"Notes Written on the Screen." *New York Times*, July 16, 1916.

"Fail to Show Film 'Purity,'" *New York Times*, July 19, 1916.

"News of the Stage and Notes of Players." *New York Tribune*, July 22, 1916.

"Audrey Munson Seen as Screen Purity." *New York Tribune*, July 24, 1916.

"Censored Purity Opens at Liberty." *New York Sun*, July 24, 1916.

Dean, Daisy. "New Notes from Movieland." *El Paso Herald*, August 10, 1916.

Ricketts completes feature. *Motography*, August 19, 1916.

"Theater Activities." *New York Dramatic Mirror*, August 26, 1916.

"Sun and Air Nature's Best Tonics, Says Audrey Munson, Artist's Model." unidentified Ohio newspaper, August 31, 1916.

"Famous Model Raps Prudes Who Attack Art Poses." *Winnipeg Evening Tribune*, September 2, 1916.

"Ricketts Completes Second Audrey Munson Film." *Motion Picture News*, September 2, 1916.

"Should the Nude in Art be Shown in Motion Pictures?" *Seattle Star*, September 29, 1916.

"Art Critics Declare Audrey Munson the Venus of Today." *Atlanta Constitution*, October 21, 1916.

"Owen Johnson "Discovers a New Bohemia Here." *New York Times*, October 22, 1916.

"Audrey Munson Back Home with $15,000 Bank Book." *Seattle Post-Standard*, October 28, 1916.

"At the Orpheum." *Ogden Standard* (UT), November 13, 1916.

Review of *Purity*, *Philadelphia Evening Ledger*, December 5, 1916.

"Says Baby's Morals Were Corrupted by Nude Film Picture." *New York Herald*, January 22, 1917.

"Drop Prosecution." *New York Dramatic Mirror*, February 3, 1917.

"*Purity* Censored and Gets O.K." *Sandusky Star Journal*, February 23, 1917.

"Christmas Spirit Unchecked by War." *New York Times*, December 25, 1917.

"Wilkins Murder Mystery is Near Solution, Belief." *Brooklyn Daily Eagle*, March 13, 1919.

"Wilkins Mystery Deepens Despite Talk of an Arrest." *Brooklyn Daily Eagle*, March 14, 1919.

"Dr. Wilkins Missing as Wife Murder is Charged." *New York Tribune*, March 18, 1919.

"Dr. Wilkins, Wanted for Killing his Wife, Is Found in Baltimore." *Washington Times*, March 19, 1919.

"Country Wide Search is on for Wilkins." *Washington Herald*, March 19, 1919.

"Dr. Wilkins Caught After 4-Day Flight." *New York Tribune*, March 20, 1919.

"Dr. Wilkins Jovial as he's Arraigned for Wife Murder." *Brooklyn Daily Eagle*, March 20, 1919.

"Pretty Woman in Wilkins Case." *Washington Times*, March 21, 1919.

"Dr. Wilkins Is Sent to Prison in Murder Case." *Harrisburg Evening News* (PA), March 21, 1919.

"Dr. Wilkins Indicted as Slayer of Wife." *New York Tribune*, March 21, 1919.

"Dr. Wilkins Pleads Not Guilty to Slaying Wife." *New York Tribune*, March 22, 1919.

"Third Wilkins Will Sought by Police in Mineola Murder Case." *Pittsburgh Post*, March 23, 1919.

"Syracuse Model Wanted in New York Tragedy." *Syracuse Journal*, March 25, 1919.

"Seek Wilkins Witness." *New York Times*, March 25, 1919.

"Model Sought in Wilkins Inquiry." *New York Sun*, March 25, 1919.

"Model Sought in Death Case." *Rock Island Argus*, March 25, 1919.

"Wilkins Clues Grow Weak." *The Daily Long Island Farmer*, March 26, 1919.

"Miss Munson Not in Hiding, Says Father." *Syracuse Post-Standard*, March 26, 1919.

"Tailors Tell of Stained Clothing as Wilkins Clew." *New York Herald*, March 27, 1919.

"Evidence Sought in Wilkins Clothes." *New York Sun*, March 27, 1919.

"Writing Experts to Examine Wills of Mrs. Wilkins." *New York Evening World*, March 28, 1919.

"Red Stain Found on Money Given Up by Dr. Wilkins." *New York Evening World*, March 29, 1919.

"Typewriter Used on Last Wilkins Will Found." *New York Tribune*, March 30, 1919.

"Seal Wilkins Home to Guard Evidence." *Washington Times*, March 31, 1919.

"Actress Steps into Wilkins Case." *New York Sun*, April 1, 1919.

"Dr. Wilkins Denies Having Clothes he word Cleaned." *New York Herald*, April 1, 1919.

"Wilkins Crime Long Planned, Say Detectives." *New York Tribune*, April 1, 1919.

"Actress May Testify in Wilkins Murder." *Philadelphia Inquirer*, April 2, 1919.

"Knives in Wilkins Home." *The Daily Long Island Farmer*, April 2, 1919.

"Says Wilkins is a Gentleman." *Watertown Daily Times*, April 15, 1919.

"Audrey Munson Spy Trailer for Nation." *Syracuse Post-Standard*, April 20, 1919.

"Passport of Audrey Munson Refused." *Watertown Daily Times*, May 3, 1919.

"Denies Dr. Wilkins Told her Marriage Would Spoil her Figure." *Syracuse Journal*, May 16, 1919.

"Munson Girl is Not to Testify." *Watertown Daily Times*, May 21, 1919.

"Miss Munson Declines to Testify for State." *Watertown Daily Times*, May 29, 1919.

"Miss Mortimer to Wed Italian Count." *New York Times*, May 29, 1919.

"Wilkins Trial to Begin Monday." *Brooklyn Daily Eagle*, June 3, 1919.

"Dr. Walter K. Wilkins Will Face Jury Soon." *Richmond Times-Dispatch*, June 8, 1919.

"Knowledge of Girl Missed at Trial." *Syracuse Herald*, June 16, 1919.

"Wilkins Blanches at 'Murder' Brand as Trial is Opened." *Brooklyn Daily Eagle*, June 16, 1919.

"Wilkins Neighbors Tell Story of Night Woman Was Killed." *Brooklyn Daily Eagle*, June 17, 1919.

"Dogs Mute Evidence Big Factor in Case Against Dr. Wilkins." *Brooklyn Daily Eagle*, June 18, 1919.

"Trace Paper Used to Wrap Hammer in Wilkins Murder." *Brooklyn Daily Eagle*, June 19, 1919.

"Trial of Prominent New York Doctor for Wife Murder Attracts Attention." *The High Point Enterprise* (NC), June 20, 1919.

"Find Wilkins Watch Stuffed into Sofa, Blood on Wrist." *Brooklyn Daily Eagle*, June 20, 1919.

"Find New Witness Against Wilkins, to be Trump Card." *Brooklyn Daily Eagle*, June 21, 1919.

"State to Finish its Case Against Wilkins Monday." *New York Evening World*, June 21, 1919.

"Strange Features of the Dr. Wilkins Murder Trial." *New York Tribune*, June 22, 1919.

"Dr. Wilkins Feared Wife's Will would link him to Murder." *Brooklyn Daily Eagle*, June 23, 1919.

"Wilkins on Stand Swears Three Burglars Murdered his Wife." *Brooklyn Daily Eagle*, June 24, 1919.

"Wilkins Murder Case Goes to Jury Late Today, Visit Murder Scene." *Brooklyn Daily Eagle*, June 26, 1919.

"Dr. Wilkins Breaks Down in His Cell and Weeps Bitterly." *Brooklyn Daily Eagle*, June 28, 1919.

"Dr. Wilkins, Condemned Wife Slayers, Hangs Self." *New York Tribune*, June 30, 1919.

"How Surprising Miss Mortimer Ran Her Own Romance After All." *Buffalo Courier*, August 3, 1919.

"Sad Plight of Beautiful Audrey Munson." *Buffalo Courier*, 1920.

"Audrey Munson, Forsaken, in Need." *Watertown Daily Times*, October 16, 1920.

"Audrey Munson, 'Most Perfect Model in World,' is in Syracuse Living Out Story of Gripping Need." *Syracuse Herald*, October 17, 1920.

"Audrey Munson, Through the Journal, Has Chance to Stage 'Comeback.'" *Syracuse Journal*, October 21, 1920.

"Why the Beautiful Audrey Munson Wanted Her Death Announced." *New York Evening World*, October 23, 1920.

"Blames Wilkins Tragedy for Loss of Her Career." *Brooklyn Standard Union*, October 24, 1920.

"Audrey Munson, Beauty, Gets Job." *New York Evening World*, October 25, 1920.

"Audrey Munson Gets Many Offers of Employment." *Watertown Daily Times*, October 30, 1920.

"Beautiful Exposition Girl and Idol of Artists, and Once Celebrated Movie Star, Now in Shadow of

Starvation." *San Francisco Chronicle*, November 7, 1920.

"Plans Being Completed for Audrey Munson's Return to the Screen." *Syracuse Journal*, November 20, 1920.

"The Tragedy of America's Perfect Model." *Washington Post*, November 28, 1920.

"World's Perfect Model in New Broadway Star." *Syracuse Post-Standard*, December 25, 1920.

"Audrey Munson Signs Contract With Movie Company." *Syracuse Journal*, January 3, 1921.

"Audrey Munson Again in Movies." *Watertown Daily Times*, January 4, 1921.

"Comeback." *Evening Independent* (NY), January 7, 1921.

"Perfect Model Wins New Chance." *Ogden Standard-Examiner*, January 9, 1921.

Munson, Audrey. "The Queen of the Artists' Studios." written for *New York American*, quoted in version syndicated to *Pittsburgh Press*, 20 weekly installments beginning January 9, 1921.

"Star of Audrey Munson Ascends Again After Whole Year of Suffering." *Syracuse Herald*, February 3, 1921.

"Armenian Refugee Got $15 a Week As Star of Film Play." *New York Evening World*, February 25, 1921.

"Cowboy Heads to Syracuse to Rope Audrey." *Binghamton Press* (NY), April 19, 1921.

"Miss Audrey Munson, Noted Model, Demands $15,000 on Movie Contract." *Syracuse Post-Standard*, May 19, 1921.

"New York Stories Anger Miss Munson." *Syracuse Journal*, June 1, 1921.

"Descending Night sets Village Agape." *New York Times*, June 7, 1921.

"Inside Stuff on Pictures." *Variety*, June 10, 1921.

"Kenyon has Legal Interest in Audrey Munson Film Company." *Auburn Citizen* (NY), June 10, 1921.

"Chester Men in Control of New Photoplay Company; Audrey Munson to be Star." *Rochester Democrat and Chronicle*, June 10, 1921.

"Don't Understand New Co." *New York Clipper*, June 15, 1921.

"Incorporation of Audrey Munson Producing Co announcement." *Rochester Daily Record*, June 26, 1921.

"Dempsey Stands Show Now She's Turned Down 7." *Binghamton Press*, August 9, 1921.

"Husky Frontiersman Eager to Wed Lovely Audrey Munson." *Washington Times*, August 15, 1921.

"Texas Cowboy May Wed Model." *Watertown Daily Times*, August 16, 1921.

"XYZ Texan Wants to be Audrey's Man." *Port Arthur News*, August 19, 1921.

"Artist's Model Runs Away to Escape Perfect Man." *Pittsburgh Post Gazette*, August 21, 1921.

"Six Loves of Audrey Munson." *Portsmouth Daily Times* (OH), August 29, 1921.

"Audrey Scoffs at Texas Hermes." *North Tonawanda Evening News* (NY), August 30, 1921.

"Audrey Bares her other 'Six Loves' so Number 7 Won't be Disappointed." *The Wichita Beacon*, August 31, 1921.

"Perfect Man Soon to Meet Perfect Woman: They May be Wedded If." *Winfield Daily Press* (Kansas), September 7, 1921.

"Audrey Munson Invited Five Seeking Her Hand to City for Interview." *Syracuse Post-Standard*, September 7, 1921.

"Model who Posed in Theater to be Tried." *St. Louis Post Dispatch*, October 3, 1921.

"Miss Munson Arrested for Posing in Nude." *Rock Island Argus*, October 3, 1921.

"Model Declares Ministers are Short-Sighted." *Wilkes-Barre Times Leader* (PA), October 5, 1921.

"Arguments Heard in Trial of Model." *St. Louis Post Dispatch*, October 6, 1921.

"Audrey Munson Promptly Acquitted by St. Louis Jury." *Freeport Journal Standard* (IL), October 7, 1921.

"Audrey Munson Insists on Posing in the Nude." *Lebanon Daily News* (PA), October 7, 1921.

"Acquit Miss Munson and Her Manager." *Variety*, October 14, 1921.

"Audrey Munson is Now Stranded in Peoria, Ill." *Syracuse Herald*, December 7, 1921.

"Audrey Munson to be in Film Shot Near City." *Rochester Democrat and Chronicle*, December 8, 1921.

American Art News Vol. 20 (1921), No. 10.

"Audrey Munson Persecuted? She Appeals to Congress." *Syracuse Herald*, February 10, 1922.

"Engagement Announced." *Mexico Independent*, April 6, 1922.

"Audrey Munson, Perfect Model, Picks Michigan Man as her True Ideal." *Syracuse Herald*, April 9, 1922.

"No Wonder the Palm Beach Gossips Gasped." *Ogden Standard-Examiner*, April 9, 1922.

"Seven Loves of Audrey: Famous Model Tells How She Found Right Man." *Utica Sunday Tribune* (NY), April 14, 1922.

"Audrey Finds Perfect Man as Gipsy Promised After Missing 6 Times." *The Seattle Star*, April 14, 1922.

"Audrey Tells of Her Seven Love Affairs; Says She has Found Perfect Man." *Bisbee Daily Review* (AZ), April 16, 1922.

"The Seven Loves of Audrey Munson." *The Springfield Leader* (MO), April 16, 1922.

"Audrey Munson Takes Poison At Home in Mexico." *Syracuse Herald*, May 28, 1922.

"Audrey Munson Takes Dose of Poison." *New York Times*, May 28, 1922.

"Audrey Munson Out of Danger, Says Physician." *Geneva Daily Times* (NY), May 29, 1922.

"Audrey Sorry She Tried to End Life." *Wichita Daily Eagle*, May 29, 1922.

"Audrey Munson Better." *Oswego Palladium*, May 29, 1922.

"Audrey Munson Out of Danger." *Evening Public Ledger—Philadelphia*, May 29, 1922.

"Audrey Munson is Out of Danger." *New York Times*, May 29, 1922.

"I Want to Live Says Model, Saved From Death She Sought." *New York Evening Telegram*, May 29, 1922.

"Think Message Caused Audrey to Seek Death." *Syracuse Journal*, May 29, 1922.

Hartmann, S. "Hands in Portraiture." Bulletin of Photography v.30, no 773 (1922): p.679. 5-30-1922 1912

"Audrey Munson Fails." *Variety*, June 2, 1922.

"Audrey Munson Tries 3rd Time to Kill Herself." *Tulsa World*, June 3, 1922.

"Is Curse Pursuing Audrey Munson, Actress and Artist's Model." *Buffalo Courier*, June 4, 1922.

"The Tragic Life of Audrey Munson." *Movie Weekly*, July 1, 1922.

"The Story of 'Heedless Moths.'" *Movie Weekly*, July 8, 1922.

"Enumerators to Start on June 1." *Oswego Palladium*, May 27, 1925

"Woman Dead 3 Days Before Body is Found." *Syracuse Journal*, April 21, 1926.

"Audrey Munson Fights to Recover Lost Beauty." *Syracuse Herald*, May 30, 1926.

"World-Famous Model Cursed by Her Great Beauty." *Syracuse Herald*, October 24, 1926

"Once Called 'World's Most Beautiful Girl' Audrey Munson Must Pass Life Secluded." *Syracuse Herald*. October 24, 1926

INDEX